Practice-led Research, Research-led Practice in the Creative Arts

RESEARCH METHODS FOR THE ARTS AND HUMANITIES

Published Titles

Research Methods for English Studies
Edited by Gabrielle Griffin

Research Methods for Law
Edited by Mike McConville and Wing Hong Chui

Research Methods for Cultural Studies
Edited by Michael Pickering

Practice-led Research, Research-led Practice in the Creative Arts
Edited by Hazel Smith and Roger T. Dean

Forthcoming Titles

Textual Editing in English Studies
Research Methods for History
Research Methods for Film Studies
Research Methods for Linguistics
Research Methods in Theatre Studies
Research Methods for Geography
Resarch Methods for Education

Practice-led Research, Research-led Practice in the Creative Arts

Hazel Smith and Roger T. Dean

Edinburgh University Press

© in this edition, Edinburgh University Press, 2009
© in the individual contributions is retained by the authors

Edinburgh University Press Ltd
22 George Square, Edinburgh

www.euppublishing.com

Reprinted 2010 (twice), 2011, 2012, 2014

Typeset in 11/13 Ehrhardt by
Servis Filmsetting Ltd, Stockport, Cheshire, and
printed and bound in Great Britain by
CPI Group (UK) Ltd, Croydon, CR0 4YY

A CIP record for this book is available from the British Library

ISBN 978 0 7486 3628 0 (hardback)
ISBN 978 0 7486 3629 7 (paperback)

Contents

List of Figures and Tables

All figures are copyright the author, or the author and collaborator, and published with their permission.

FIGURES

TABLES

Introduction: Practice-led Research, Research-led Practice – Towards the Iterative Cyclic Web

Hazel Smith and Roger T. Dean

This book addresses an issue of vital importance to contemporary practitioners in the creative arts: the role and significance of creative work within the university environment and its relationship to research practices. The turn to creative practice is one of the most exciting and revolutionary developments to occur in the university within the last two decades and is currently accelerating in influence. It is bringing with it dynamic new ways of thinking about research and new methodologies for conducting it, a raised awareness of the different kinds of knowledge that creative practice can convey and an illuminating body of information about the creative process. As higher education become more accepting of creative work and its existing and potential relationships to research, we also see changes in the formation of university departments, in the way conferences are conducted, and in styles of academic writing and modes of evaluation.

We wish to suggest that there are many rich and innovative ways in which creative practice can constitute, or contribute to, research in the university environment. But we are also committed to the reciprocal relationship between research and creative practice. So as well as considering how creative practice can revolutionise academic research, we wish to ponder how academic research can impact positively on creative practice: this bi-directional focus is evident in the title of our book, practice-led research, research-led practice. Together with our contributors, we unpick the issues arising out of creative practice across different disciplines; we document, conceptualise, analyse and debate the proliferating relationships between creative work and research; we look at the histories of those relationships and tease open the political difficulties and opportunities within the higher education environment that the conjunctions between research and creative practice generate. In addition, we discuss the relevance of these questions as part of broader issues such as: what is knowledge, what is research and how can we understand the creative process?

Creative work within the university environment is now often referred to as practice-led research, practice-based research, creative research or practice as research. The terminologies are a means to characterise the way in which practice can result in research insights, such as those that arise out of making a creative work and/or in the documentation and theorisation of that work. Several of our authors suggest that practice-led research can develop unique processes for creative work and for research. But this book will also explore the reverse idea – an idea already possible and operative within practice-led research discourse but often not forcefully pursued – that academic research can lead to creative practice. We do not see practice-led research and research-led practice as separate processes, but as interwoven in an iterative cyclic web, a model we develop later in the chapter.

In this introduction we set some of the groundwork for the book: we consider the concepts of research and knowledge; introduce the terms practice-led research and research-led practice and the issues they throw up about the relationship between creative work and research; explain our objectives in developing the book; outline the processes in our own theory and practice to date; give the results of a survey we conducted of researcher/practitioners; put forward our model for the interaction of creative practice and research; discuss some of the political issues both within the university and the wider community; and summarise the arguments of the contributors.

THE CONUNDRUM OF KNOWLEDGE AND RESEARCH

In the humanities, theory, criticism and historical investigation have been heavily prioritised over arts practice. Traditional courses in English departments, for example, were concerned with the study of literature. They rarely, if ever, included creative writing or discussion of the creative process, and if academics wrote novels this was regarded largely as a hobby. However, in the last two to three decades, the idea that arts practice might be a form of research has been developing ascendency. Terms such as practice-led research have been developed by creative practitioners, partly for political purposes within higher education, research and other environments, to explain, justify and promote their activities, and to argue – as forcefully as possible in an often unreceptive environment – that they are as important to the generation of knowledge as more theoretically, critically or empirically based research methods.

At the basis of the relationship between creative practice and research is the problematic nature of conventional definitions of 'research', which are underpinned by the fundamental philosophical quandary as to what constitutes 'knowledge'. Definitions of research used in higher education are almost always similar to the OECD definition:

> Creative work undertaken on a systematic basis in order to increase
> the stock of knowledge, including knowledge of humanity, culture and
> society, and the use of this stock of knowledge to devise new applications.

This suggests that research is a process which generates knowledge, but takes knowledge as being an understood given. There is in this definition an implication that knowledge is generalisable (that is, applicable to some other process or event than that which has been studied in its production), and transferable (that is, can be understood and used by others in a manner which is essentially congruent with that of the original). It can be argued that artworks often embody such generalisable and transferable knowledge, so that aspect of the definition is not necessarily problematic to creative arts practitioners (if they 'increase the stock'), though higher education administrators may find the idea that art can transmit knowledge more problematic. However, there is also an unstated implication in this definition, or at least in most interpretations of it, that knowledge is normally verbal or numerical. Since it is clear that a sonic or visual artwork can sometimes transmit knowledge in non-verbal and non-numerical terms, we believe that any definition of knowledge needs to acknowledge these non-verbal forms of transmission. It also must include the idea that knowledge is itself often unstable, ambiguous and multidimensional, can be emotionally or affectively charged, and cannot necessarily be conveyed with the precision of a mathematical proof. This concept of knowledge as unstable is fundamental to a postmodernist view of the world. But the idea that there are only falsifiable hypotheses, not absolute truths, is also at the core of a conventional Popperian approach to scientific knowledge.

Research, therefore, needs to be treated, not monolithically, but as an activity which can appear in a variety of guises across the spectrum of practice and research. It can be basic research carried out independent of creative work (though it may be subsequently applied to it); research conducted in the process of shaping an artwork; or research which is the documentation, theorisation and contextualisation of an artwork – and the process of making it – by its creator. Although they overlap, and one of purposes of the book is to show this, it is important to distinguish between these different modes of research. For example, research undertaken for the writing of a novel may involve the consultation of known historical sources. However, this research is normally 'secondary' rather than 'primary' because it does not usually constitute activities which are central to basic historical research, such as comparative interpretation of sources or the discovery of new sources. Having said that, the novel may convey the impact of historical events on the lives of ordinary people in ways which are difficult to glean from those sources, which show the information they contain in a new light, and which are intellectually and emotionally extremely powerful.

Attempts at definitions of research, creative work and innovation are all encircled by these fundamental problems – that knowledge can take many different forms and occur at various different levels of precision and stability, and that research carried out in conjunction with the creation of an artwork can be both similar to, and dissimilar from, basic research. It is essential to bear these complexities in mind in thinking about how we can usefully develop and promote creative practice, particularly with respect to research in higher education and the arts community more broadly. But it also important to relate the research which leads into or out of creative practice to the more conventional trajectories of qualitative, quantitative and conceptual research.

An assumption behind qualitative research is that the best way to gather data about an issue or idea is to allow the subjects to express their thoughts in their own way, rather than making it essential for them to respond to a preconceived analytical framework drawn up by the researcher. The qualitative approach to gathering data permits both documentary evidence (where the researcher has no contact with the person who provided the evidence) and investigational evidence (where the researcher talks with those who can provide information).[1]

In contrast, the essential ideal of quantitative science is that the subjects or entities under observation are only exposed to changes in a single factor, while everything else remains in a constant state. Quantitative science is normally set up such that a numerical entity can be measured, whereas the qualitative researcher gathers verbal, and occasionally visual or sonic, evidence. Although qualitative and quantitative research are distinct, qualitative researchers often turn to analytical methods which are intrinsically quantitative at some stage in the process. For example, discourse analysts who are fundamentally qualitative researchers sometimes use Leximancer – a software for discourse analysis which uses mathematical or statistical quantitative methods – in order to extract commonalities, or recurrent 'themes', in the recorded discourse.

The two approaches, the quantitative and the qualitative, differ in their assumptions about the possible degree of separation between the researcher and the researched. The qualitative researcher, like the contemporary anthropologist (see Chapter 13 by Sharon Bell), recognises that their presence inevitably influences the situation. However, the quantitative researcher, such as the cell biologist observing cultured cells, hopes and expects that the results will not be influenced by the human environment in which the data is gathered.

Conceptual research is often seen to sit within the qualitative tradition but is not necessarily identical with it. Conceptual research is more to do with argument, analysis and the application of theoretical ideas, and is central to humanities research. It usually involves reading and textual analysis, although

the way that conceptual research is conducted has changed over time. Practice-led research practitioners who are particularly concerned with the relationship between theory and practice will see this kind of research as being most relevant to them. We similarly argue for its importance, but also point out that it is only one of many methodologies on which the practitioner/researcher can draw.

The relationship of practice-led research and research-led practice to all these research approaches is complex, and some commentators take the view that practice-led research is a new and distinctive form of research that is developing its own domain-specific methodologies. Our own view is that qualitative, quantitative and conceptual research are all approaches to research which creative practitioners will benefit from knowing about and engaging with, and the broader the research horizons of the creative practitioner the better. At the same time we would argue that that the unique combination of creative practice and research can sometimes result in distinctive methodological approaches, as well as exhilarating findings and artworks.

PRACTICE–LED RESEARCH AND RESEARCH–LED PRACTICE

The term practice-led research and its affiliates (practice-based research, practice as research) are employed to make two arguments about practice which are often overlapping and interlinked: firstly, as just indicated, that creative work in itself is a form of research and generates detectable research outputs; secondly, to suggest that creative practice – the training and specialised knowledge that creative practitioners have and the processes they engage in when they are making art – can lead to specialised research insights which can then be generalised and written up as research. The first argument emphasises creative practice in itself, while the second highlights the insights, conceptualisation and theorisation which can arise when artists reflect on and document their own creative practice. Candy (2006) helpfully uses the terms 'practice-based' and 'practice-led' to distinguish between these different emphases. For her, in practice-based research the creative work acts as a form of research, whereas practice-led research is about practice leading to research insights; however, these terms are often used much more loosely. Increasingly it seems that practice as research can best be interpreted in terms of a broader view of creative practice which includes not only the artwork but also the surrounding theorisation and documentation.

In the discourse of practice-led research, the idea of the artwork as research, and the artwork plus surrounding documentation as research,

occurs with different degrees of emphasis in the work of different commenta-tors. In previous work Brad Haseman (a contributor to this book) concep-tualised the new research paradigm generated by practice-led research as performative research, which he saw as distinct from both qualitative and quantitative research (Haseman 2006). He argued that an artwork embodies research findings which are symbolically expressed, even while not conveyed through numbers or words (which are themselves symbols). He also elabo-rated on the various research strategies that can be employed in the making of an artwork, and the role of self-generated commentary about it. His concept of performative research stems from J. L. Austin's notion of per-formative speech acts as 'utterances that accomplish, by their very enuncia-tion, an action that generates effects' (Haseman 2006: 102). In this category of research 'symbolic data work performatively. They not only express the research, but in that expression become the research itself' (Haseman 2006: 102). In performative research 'practice is the principal research activity' (Haseman 2006: 103) and Haseman emphasises the way practitioners 'tend to "dive in", to commence practising to see what emerges' (Haseman 2006: 100). At the same time Haseman sees practitioners implementing strategies from the qualitative research tradition:

> But these will typically be inflected differently from their qualitative application. Most commonly, performative researchers progress their studies by employing variations of: reflective practice, participant observation, performance ethnography, ethnodrama, biographical/autobiographical/narrative inquiry, and the inquiry cycle from action research. (Haseman 2006: 104)

So for Haseman both the artwork itself and the surrounding practices are research.

Barbara Bolt emphasises less the artwork as a research expression in itself (though she by no means discounts this) and more the kinds of research insights which can develop out of practice and can then have a more general applicability. To do this she distinguishes between practice and 'praxical knowledge'. Using Heidegger's examination of 'the particular form of knowl-edge that arises from our handling of materials and processes' (Bolt 2007: 30) and his concept that 'we come to know the world theoretically only after we have come to understand it through handling' (Bolt 2007: 30), she argues, sim-ilarly to Haseman, that there can arise out of creative practice 'a very specific sort of knowing, a knowing that arises through handling materials in practice' (Bolt 2007: 29). This is what she means by 'praxical knowledge' (Bolt 2007: 34); its insights, she argues, can induce 'a shift in thought' (Bolt 2007: 29), and while she suggests a reciprocal relationship between theory and practice,

'theorising out of practice is . . . a very different way of thinking than apply-ing theory to practice' (Bolt 2007: 33). She posits that when such knowledge is written up (for example in the case of the postgraduate student in a thesis 'exegesis'), 'particular situated and emergent knowledge has the potential to be generalised so that it enters into dialogue with existing practical and theoretical paradigms' (Bolt 2007: 33). For her, creative practice as research must involve such writing-up, and she argues that 'practice-only postgraduate research can disable practice-led research by confusing practice with praxical knowledge and severing the link between the artwork and the work of art' (Bolt 2007: 33–4).

In using the term practice-led research, we as editors are referring *both* to the work of art as a form of research and to the creation of the work as generat-ing research insights which might then be documented, theorised and gener-alised, though individual contributors may use this and related terms rather differently. Ideally we would expect a research element to be present in both research and work creation, though we would normally see the documentation, writing and theorisation surrounding the artwork as crucial to its fulfilling all the functions of research. In our view for an artwork itself to be a form of research, it needs to contain knowledge which is new and that can be trans-ferred to other contexts, with little further explanation, elaboration or codifica-tion, even if this transferral involves a degree of transformation. However, we also recognise that debates about how much a particular work of art constitutes research are not likely to be productive.

Research-led practice is a terminology which we use to complement practice-led research, and which suggests more clearly than practice-led research that scholarly research can lead to creative work. For us it originates in the contemporary modus operandi of science, engineering, technology and medical research, in which research work is directed not only towards the elucidation of falsifiable ideas but also towards the production of practical out-comes, whether they be pharmaceuticals or physical machines.[2] But research-led practice is potentially not only primary to science, but also important in the creative arts. Many new fields of artistic endeavour have been initiated as a result of basic research work which was not originally intended for that purpose; this has been particularly important at a technical and technological level and is currently intensifying. For example, the evolution of computer music has been facilitated by the development of faster and cheaper computers and by the science of digital signal processing, originally intended for quite pragmatic (often military) technological purposes. Similarly, video and new media technology has propelled a massive growth of intermedia art forms and processes and their distribution on the Internet in a manner which now domi-nates the consumption of most avid creative arts enthusiasts. Smaller-scale research outcomes may initiate and inform other aspects of creative work:

for example, recent research findings about the plausible intended medical functions of Stonehenge – particularly as conveyed by their journalistic coverage (Kennedy 2008) – may in the future trigger artworks that present the socio-economic contexts of the stone structures in a previously unexpected light.

Both practice-led research and research-led practice are often carried out collaboratively. Creative practitioners sometimes join forces with a researcher more specifically oriented towards basic research work. Occasionally, one or a group of collaborators may be active in both creative work and research, but more often several people with differentiated roles interact effectively with each other.

Research-led practice takes different forms in different fields and is more prominent in some areas than others: we have already mentioned new media and music as disciplines in which it has been quite strong. In other areas the full impact of research-led practice is still to be fully felt, and we can regard it as a developing area as much as practice-led research. In creative writing, for example, research-led practice is mainly conceptual and tends to be driven by critical and cultural theory: see Krauth and Brady (2006) and Dawson (2005). The impact of theory on practice can be found not only in novels and poems but also in hybrid genres such as fictocriticism which bring creative and critical writing together (see Chapter 6 by Anne Brewster). But there are many other relatively untapped possibilities for research to feed into creative writing. For example, experimental cognitive research into the activity of creative writing could be carried out by assemblages of psychologists and writers. Such research could lead to more understanding of the writing process and suggest how new approaches to writing might be developed – experiments of this kind could also provide a basis for computational models for the generation of text. We will see, later in the book, examples of such cognitive research in relation to contemporary dance.

As editors we envisage that those involved in the creative arts – in the higher education context, in particular, and to some degree in the community at large – will increasingly recognise the existence of both patterns of activity: practice-led research and research-led practice, and that more and more people within the university environment will be energised with regard to both. However, we do not see the two patterns as separate, but as interconnected in ways which are very complex. Hence our construction of the model which we elucidate later in this chapter, a model we call the iterative cyclic web. This model combines the cycle (alternations between practice and research), the web (numerous points of entry, exit, cross-referencing and cross-transit within the practice-research cycle), and iteration (many sub-cycles in which creative practice or research processes are repeated with variation).

It will also be obvious by now that the interweaving of research and creative

practice is generating new pedagogical tools and shifting educational paradigms. For example, students of literature who find the modernism of James Joyce or the contemporary experimentalism of American language poets difficult may start to understand those texts much better if they try out some of the techniques that drive them. Conversely critical and cultural theories (even sometimes ones which are out of favour) can, with some effort, be adapted to the process of making an artwork.

OUR OBJECTIVES IN DEVELOPING THE BOOK

Our primary objective in developing the book was to discuss the methodological, theoretical, practical and political issues surrounding creative practice and research within the university. It seemed to us that the discourse of practice-led research was very illuminating about the theoretical and technical insights practice could produce, and the significance of creative work and its surrounding practices as a form of research and contribution to knowledge. However, in emphasising the value of creative work, this discourse sometimes underplayed and under-conceptualised the impact that primarily academic research could have on creative practice, and the rich results the appropriation of a wide range of research practices by creative practitioners could bring. Our experience of postgraduate supervision also convinced us that practitioners who were uncomfortable with research (particularly theory) often benefited from exposure to it early on in their degrees and that, in some cases, this was more likely to cause a paradigm shift in their thinking than working outwards from creative practice. Hence we wanted to consider research-led practice as well as practice-led research.

Another important objective of the book was to propose models and methodologies for the relationship between creative practice and research which would enable practitioner/researchers to understand and develop the processes involved. It is evident from all the chapters in this book that practice-led research and research-led practice are creating not only new forms of research and creative work, but also a significant body of knowledge about creative processes which will feed back into the work of future practitioners.

Our desire to produce the book was also predicated on our view that it is pointless for creative practitioners to work within the university unless the university environment responds to them and they respond to it. In other words we argue that creative practice in the university will be most fertile if its practitioners actively engage with other kinds of research activity rather than being somewhat estranged from them. We hope that the book will be used not only by creative practitioners, but also by researchers in the humanities and sciences who wish to understand more fully the work that creative

practitioners do, and the way that it relates broadly to research practices and possibly to their own research. We also hope that the book will be perused by university leaders and research administrators, and that it might increase their understanding of the rich possibilities in this area as well as the issues involved in its evaluation. Similarly, we would like the book to be read by scientists and social scientists who might regard their research as quite separate from creative practice, but whose work might well relate to it, and have an impact on it, in ways of which they are unaware (for example, through the possible application of a new technology they are developing).

In commissioning the essays we were keen to keep the focus tight but also to probe issues around the increasingly developing discourse of practice-led research. Contributors were given an outline of the aims of the book: 'to view the relationship between research and creative work not only in terms of practice-led research but also in terms of research-led practice' and 'to explore the multidimensional, reciprocal and iterative relationship between research and practice, including comparisons between research and practice in the creative arts and sciences'. Different suggestions were then made to the authors of different sections of the book. So in approaching our authors, we pointed to both patterns (practice-led research and research-led practice) and in some cases to the idea that they could form a cycle. However, throughout the book, authors were free to engage with whichever issues seemed particularly pertinent to them, to focus on some more than others and to take any perspective on them. While we provided both conceptual and detailed feedback on the drafted articles, these were only to be taken as queries for authors to consider rather than as ideas which should necessarily be pursued.

While there are literally hundreds of books about 'qualitative research' and even more about 'quantitative research' methods (many not revealing their focus in their titles), there are still relatively few about practice-led research and the other issues which are central to our book. The edited volume by Barrett and Bolt has been mentioned already; it is an important contribution to the field, though it is characteristic of other volumes in this area in being restricted to authors from a small number of countries, in this case solely from Australia. Editors and authors in two other valuable volumes in the area are also locally concentrated; in Cahnmann-Taylor and Siegesmund (2008) they are exclusively from the US and Canada; and in Macleod and Holdridge (2006) they are largely from the UK and Ireland. We have sought a broader geographic span of contributors. The previous volumes are heavily focused on the visual arts, where the terminology and debates probably most pointedly originated, with some discussion of creative writing and dance. Within the field at large, and within these books, there is a relatively small number of articles on theatre, film and music. In our collection we have tried, to some degree, to redress this imbalance.

RESEARCH AND CREATIVE PRACTICE IN OUR OWN WORK

Our own work, much of which has been produced collaboratively, has evolved through a considerable melding of research and creative practice, and we have engaged with both practice-led research and research-led practice. The reciprocal relationship between the research and the creative work has taken numerous different forms. It has included symbiosis between research and creative practice in which each feeds on the other; hybridisation of the many discourses surrounding them; transference of the characteristics of research onto practice and vice versa; and alternations between research and creative practice, often within a single project.

Our creative practice has involved many types of activity and process, from works of music (Roger) and literature (Hazel), to a variety of collaborative multimedia and performance works usually employing new technologies. Our research practice has also been diverse, including free-standing research theoretical, qualitative, quantitative and empirical; research undertaken as part of the genesis of a creative work in relation to both its technical aspects and its content; and research as documentation and theorisation of the creative work. Roger has a background in research in biochemistry as well as in the humanities and the creative arts.

There are many examples within our work, both individually and collaboratively, of projects starting with a research idea or with creative work and then forming a chain of alternations between creative research and creative practice as well as fusions between them, with outputs of several different types. Below we both give examples of pathways of this kind in and around our creative arts work.

Hazel

One example of a trajectory in my work where research and creative practice inform each other is as follows – though I could produce scores of others. In 2000 I published an academic book *Hyperscapes in the Poetry of Frank O'Hara: Difference, Homosexuality, Topography* (Smith 2000). The book is scholarly in format but shows the application of my creative writing techniques to my scholarly writing in the invention of neologisms to theorise various aspects of O'Hara's work. It includes a short section on gossip; I realised as a result that I was fascinated by the concept of gossip and enthusiastic about producing a creative work about gossip: I imagined this as a collaboration with Roger and discussed it with him. In 2000 Roger and I put a proposal to the Australian Broadcasting Corporation's 'Listening Room' programme

for a new work with the proposed title, *The Erotics of Gossip* (Smith 2008). The piece was to be what we call a sound-technodrama, combining sound, text and digital manipulation of both sound and text. To write the piece I researched the academic literature about gossip, which is fascinating because it stretches over so many disciplines including anthropology, history, philosophy and linguistics. I read about gossip in western and non-western societies, and I perused the academic literature surrounding slander, rumour, talk and conversation. I found that there were essentially two camps of thought about gossip: the first camp sees gossip as creative, as subverting social norms and as ethical; the other sees gossip as destructive, as making people conform to social norms and as unethical. In the piece I tried to project both faces of gossip by fictionalising, narrativising and dramatising material from the articles and books I had read. These included legal cases from early Modern England and nineteenth-century America, different anthropological rituals with regard to gossip in non-European societies, and ideas about gossip and the media.

However, this was not the end of the process. In 2003 Roger and I jointly wrote an article together in which we theorised various technical aspects of the piece, particularly the incorporation of voicescapes – a voicescape being a multidimensional and multidirectional projection of the voice into space which also involves digital transformation of the voice (Smith and Dean 2003). Subsequently I documented this work in another essay which focused exclusively on *The Erotics of Gossip*, and theorised it in the light of a concept I invented: 'performative fictocriticism' – fictocriticism is a well-established concept but performative fictocriticism is not (Smith 2005). In this same article I also considered, more expansively, the theories about gossip which had informed the piece, and developed my own theory of gossip: that it could be both creative and destructive, ethical and unethical, depending on the historical and social circumstances.

It would be difficult to characterise the trajectory I have just outlined as entirely research-led practice or practice-led research; it clearly constitutes both, and what is important here is the mutual reciprocity. It started with an academic research project (the book on O'Hara) which was not directed towards the production of creative work, and the creative practice arose out of one very small section of that project – in that sense the creative trajectory which evolved was quite tangential to the original project, demonstrating the diffuse and indirect nature of the stimuli involved. However, other creative projects also arose out of the writing of the book, producing many examples of the way the connections between practice and theory can proliferate. The creative

practice (the writing of *The Erotics of Gossip*) was itself informed by research but of a somewhat different kind. I assembled and read the literature about gossip without attempting to write a research paper on it or make an original contribution to the field. Rather the original contribution would be the radio piece, a work which contained fiction and poetry but also some theoretical allusions. This process was then (temporarily) rounded off with two attempts at documenting the process and theorising some aspects of the piece, also resulting in the first beginnings of a more general theory about gossip. But the process I have outlined here is actually an ongoing one, and putting a boundary round it – as if the process had a definite beginning and end – is somewhat falsifying. For instance, the notion of the voicescape is one that Roger and I have worked with in subsequent creative works (Smith 2008); I have also developed it in further critical writing with respect to work other than my own (Smith forthcoming). And I could easily imagine myself engaging in further projects on gossip in either a research or creative capacity.

 This is one example of the way research and creative practice speak to each other in my work, but I have also been strongly involved in practice-led research and research-led practice through analysis of the creative process in a pedagogical context. Many of the ideas for my book *The Writing Experiment: Strategies for Innovative Creative Writing* arose out my own creative practice (Smith 2005). The book aims to demystify the creative process by breaking it down into incremental stages, thereby recuperating consciously some of the more hidden or unconscious aspects of the writing process. The philosophical stance driving the book is that a systematic approach to writing can lead to open-ended outcomes, that any lively creative practice is a form of experimentalism in the sense of trying out different approaches, and that practice makes perfect. However, again the bi-directional relationship between research and practice is evident because the exercises in *The Writing Experiment* arise both out of practice itself and also out of the application of theory to practice; this combination informs the pedagogical focus of the book at every turn.

Roger

I have long been interested in algorithmic (computational) techniques for generating and controlling musical flow for composition and real-time improvisation. In the mid-1990s, using the programming platform MAX, one of my long-term creative projects involved a continuing series of algorithmic works which related to minimal music, the

rhythmic repetitive and usually melodic style initiated in the 1960s by Terry Riley, Steve Reich and others. The repetitions often create 'phase changes' in the relationships between multiple streams of an unchanging melody. Like the American computer music composer Bill Duckworth in the late 1980s, I wanted to develop a compositional, algorithmic variant of minimalism, in which the melodic patterns were also subject to progressive change and might be rather less tonal (key-centred) than previously: compositions of this kind later became known more widely as post-minimalist. So from 1996 onwards I used MAX to generate such algorithmic transformations of melodic streams which were then realised on synthesisers or sampled keyboards [for example Smith and Dean 2001]. This practice was facilitated by developments carried out by researchers in hardware and in computing which produced fast computer processors and the programming platform MAX.

This creative work then led back into my research. In 2004 I became involved in research in music cognition. In a project designed to research listeners' capacity to segment musical streams, to perceive change and to identify affect, I used algorithmically generated sounds and music – related to those I had developed in my creative work – as empirical material. Among the benefits of this approach is the opportunity to rigorously control features of the music so as to set up experimental comparisons (Bailes and Dean 2007). For example, algorithmically generated sounds can be designed to test whether a note within a musical phrase is perceived as segmenting the phrase when it is transformed in pitch or dynamic. Currently, in collaboration with Freya Bailes from MARCS and Geraint Wiggins (Goldsmiths College, University of London), I am also investigating whether computational prediction of segmentation perception can succeed with these precisely controlled musical patterns.

Research-led practice and practice-led research are repeatedly interacting in this work as in the computer music field more broadly. I expect that an eventual outcome will be the construction of a software entity for making music based on a cognitive model which applies statistical approaches to predict the perception of segmentation and affect computationally. If this happens, it will represent a successful instance of basic research leading to a significant creative practice outcome.

In another example of the way in which practice and research can interconnect, I have suggested elsewhere that algorithms can produce a translation of image into sound which mimics synaesthesia, either through the sharing of data or through a manipulative process which

acts simultaneously on both an image and sound stream. This research has not only led to several image-sound creative works, but also fed into empirical studies of the impact of auditory events on the perception of flashes (Wilkie et al. 2008). In this work we confirm that multiple auditory events can create the illusion of multiple flashes, and find that this effect can be influenced by musical parameters such as the pitch patterns of the auditory events. Such studies of cross-modal perception will eventually be quite important for the ongoing artistic development of intermedia real-time creative work, since a creator must inevitably take an interest in user perception.

Just as Hazel has contributed to the development of practice in her creative arts field through her book *The Writing Experiment*, so I have written a book specifically for those wishing to learn musical improvisation techniques (Dean 1989). I have also followed up with research books which provide a counterpoint useful to both practitioners, appreciators, and academics (e.g. Dean 1992, 2003; Smith and Dean 1997).

Hopefully these examples of our research and creative work indicate our enthusiasm for their interfaces, and more broadly, their continuously dynamic interaction.

A SURVEY OF PRACTITIONER/RESEARCHERS IN HIGHER EDUCATION

As part of our research for this project, we sent out a questionnaire to prac- titioner/researchers.[3] Respondents were invited to contribute their thoughts in the context of the present book, whose title was defined. The question- naire begins by simply raising the topics of 'creative work' and 'research', without describing them but implying that they might bear any relation to each other (from congruent to mutually exclusive). This was intended to allow the respondents to approach the topic relatively freely, and initially almost entirely from their own current perspective. After the first five, the questions become more specific and more concept-laden, but we always imply a wide range of choice. These later questions are prefaced by an indication that they penetrate further into the previous topics and that respondees may wish to answer in a manner that depends on their response to the more open-ended group. Finally, there is an opportunity for comment on any topic or opinion not addressed elsewhere.

There were eighteen responses, seventeen substantial and virtually com- plete. They came from Australia, the UK and the USA, and four were from

contributors to the volume. All but three of the respondees considered themselves significantly active in creative arts work and release their work regularly to the public. All were employed in higher education, as well as possibly otherwise. Naturally the editors did not complete the questionnaire. Some of the answers can be fairly categorised into yes, no or 'unsure/ambivalent' and some are numerical. Table 1.1 summarises these particular responses (please check the questionnaire in the Appendix for the precise wording of the questions).

The striking features of the categorical or quantitative responses are the large number of hours most researcher/practitioners report working in the university environment, their preference for that environment and their corresponding longevity of service. It is notable that only about one-third of total work hours are construed as time for creative work, and perhaps correspondingly six out of fourteen respondees would like to change their work time distribution, in all cases to permit more creative work time. It is apparent that respondees perceive a considerable divergence of views about creative work and research not only within universities, but also amongst their creative peers outside the university. As might be anticipated amongst academics, fourteen out of fifteen respondees feel that they combine research and creative work in some of their activities, twelve out of sixteen document and/or theorise their creative arts work, twelve out of sixteen believe familiarity with cultural theory is valuable for practitioners, and ten out of seventeen believe familiarity with the arts is desirable for academics at large.

There was a wide range of views about terminology, probably reflecting its current instability. And while a majority of researcher/practitioners find the university environment supportive or stimulating, thirteen out of fifteen believe the status of creative practice in universities could be improved. Indeed they confirm the need for books of this kind, and for a significant advance in both the understanding, role and impact of creative arts work in universities, as we argue in this chapter.

Amongst the more discursive and distinctive answers, most people tried to balance both the reciprocity and the independence of research and creative work. Jennifer Webb (University of Canberra, Australia), for example, brings out the characteristics of both while also suggesting that they cannot be kept entirely separate:

> Creative work: the use of the imagination, what Paul Carter calls 'material thinking', and technical skills to make an object that can be understood as a matter of 'thinking out loud', of thinking visually, of testing the limits of form . . . and etc.: it's so broad! But I do see the combination of imagination and technique as central to this work.
> Research: the systematic, analytical, reflective gathering and analysis of

Table 1.1 Categorical responses to the questionnaire

Question	Y	N	A	Avg.
1. Are 'research' and 'creative work':				
separate?	2		1	
overlapping?	10		3	
one thing?	2	2	3	
3. Do you work within a university?	18			
How many hours/week?				50 (14)
How many years? (approx. fte)				13 (17)
Is it your preferred workplace?	12	1	1	
4. Do you make creative work and release it?	15	3		
Hours/week?				18 (12)
Years of activity?				21 (14)
Would you like to change the distribution of your work time?	6	7	1	
5. Is your view of the research/creative work relationship similar to				
your university colleagues'?	5	8	2	
your creative arts peers' (outside the university)?	7	5	3	
6. Do you combine research and creative work?	14	1		
Do you regard creative work as a form of research?	10	2	2	
Do you engage in some research which is independent of your creative work?	11	4		
Do you usually start with research and move into creative work?	2	5	5	
Would you describe your work as 'practice-led research' ?	3	3		
or 'research-led practice'?	1			
or was the response both/ambivalent			6	
or was the response neither		3		
Do you document/theorise your own creative work?	12	3	1	
Do you work with hybrid forms which combine creative and critical work?	7	2	2	
7. Do you find the university environment supportive/stimulating with regard to your creative practice?	8	6	1	
Could the status of creative practice in universities be improved?	13		2	
8. Is it useful for a creative practitioner to be familiar with cultural and critical theory?	12	2	2	
9. Should academic researchers have familiarity with the arts?	10	4	3	

The table summarises the numbers of explicit responses to certain questions, as yes (Y), no (N), ambivalent or unsure (A), or in some cases as a numerical average together with the number of responses averaged (presented as average followed by number of respondees in brackets). Note that not every respondee gave an explicit answer to every question, and so the numbers of responses are in all cases less than the number of respondees (18).

material that is directed to finding something out, answering a question, filling a gap in knowledge. I would see the combination of rigour and technique as central to this work. Of course they do overlap at times, and in places. Depends on the project.

The response from Glen McGillivray (University of Western Sydney, Australia) focuses on the way each can enhance the other:

> I believe there are activities involving a creative outcome that are not necessarily research and research activities that do not have creative outcomes (apart from a general definition of creativity that relates to human imagination). That being said, particularly in the performance area, aspects of research can be enhanced by creative projects and vice versa . . . practice-led research, I believe, requires the rigorous formulation of a research question and methodology.

Simon Biggs (Edinburgh College of the Arts, UK) draws attention to the various kinds of research which feed into his creative work:

> I do applied research to develop new software and hardware systems that are used in my creative art practice. I do theoretical research to support the development of my creative work and in order to develop critical perspectives on artistic practice in my field. I do contextual research to keep abreast of developments in my artistic field. I do pedagogical research to inform my work as an academic and to seek ways in which creative practice and research can function in a complementary manner.

Similarly Nicholas Till (University of Sussex, UK) sees himself as engaged in different modes of research for different purposes; they are distinct but not entirely separate:

> I do to some extent differentiate between research undertaken *for* creative work and research *through* creative practice – the latter is often more concerned with formal or technical aspects, but to the extent that my work is theoretically informed the distinction is not absolute.

The degree of satisfaction with regard to the status of creative work varied from country to country. There was more satisfaction in the UK, perhaps because creative work is explicitly regarded as research within the Research Assessment Exercise (RAE). In Australia the federal Department of Education Science and Training (DEST) has not up until now – except for a short period in the 1990s – included creative works in the calculation of the Research Infrastructure Grants, and the future situation is unclear. Consequently, there were seen to be more incentives for producing research than creative work. Marcelle Freiman (Macquarie University, Australia) says, for example:

DEST outcomes value creative work as lesser than research output,
and it's hard not to be caught up in this, as the pressure is on to remain
'research active' and produce articles that appear in refereed journals.
My poetry in literary journals, anthologies and book form just isn't seen
as significant in comparison to those refereed articles.

Overall, the impression the answers gave was that the respondees were search-
ing for ways of articulating the relationship between creative practice and
research, and did not necessarily feel that any one way of speaking about that
relationship was adequate. Similarly, there did not seem to be a very strong
pre-existing vocabulary or conceptual framework into which they could easily
fit their thoughts about the issues. Nevertheless, there was a strong conver-
gence that research and creative practice overlapped, and it was notable that
many participants claimed to be active in independent research.

OUR MODEL: THE ITERATIVE CYCLIC WEB

Figure 1.1 illustrates our model of creative and research processes; it accom-
modates practice-led research and research-led practice, creative work and
basic research. The structure of the model combines a cycle and several sub-
cycles (demonstrated by the larger circle and smaller ovoids) with a web (the
criss-cross, branching lines across the circle) created by many points of entry
and transition within the cycle. One intention of Figure 1.1 is to suggest how a
creative or research process may start at any point on the large cycle illustrated
and move, spider-like, to any other. Very important in the model, with regard
to the sub-cycles, is the concept of iteration, which is fundamental to both
creative and research processes. To iterate a process is to repeat it several times
(though probably with some variation) before proceeding, setting up a cycle:
start–end–start. The creator must chose between the alternative results created
by the iteration, focusing on some and leaving others behind (temporarily or
permanently). In a research phase, this can be viewed as a selection based on
empirical data or an analytical/theoretical fit; in a practice phase the choice
might be aesthetic, technical or ideological, or somewhat random. Iteration is
particularly relevant to the sub-cycles but also to the larger cycle.

The outer circle of the diagram consists of various stages in the cycle of
practice-led research and research-led practice, and the smaller circles indicate
the way in which any stage in the process involves iteration. The right-hand
side of the circle is more concerned with practice-led research, the left-hand
side with research-led practice, and it is possible to traverse the cycle clockwise
or anti-clockwise as well as to pass transversely. Moving clockwise, a creative
arts practitioner may start at the top middle with an idea or play with materials

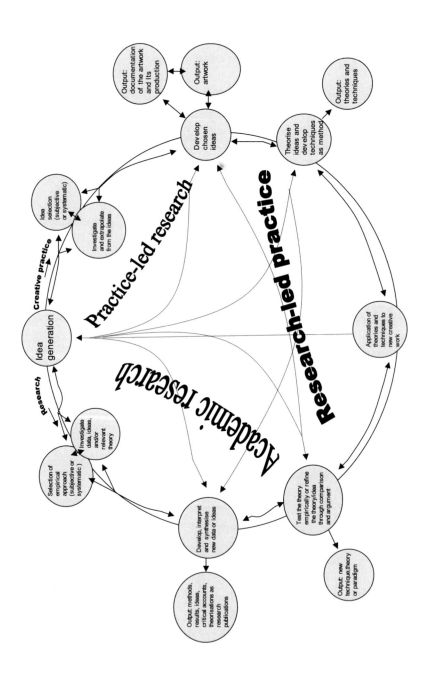

Figure 1.1 A model of creative arts and research processes: the iterative cyclic web of practice-led research and research-led practice.

to generate ideas. This process is followed by the selection of ideas (which may be sounds, images, formations of words) which are pursued through investigation or research. These ideas are then developed and released through publication or other public outlets. If we advance round the circle clockwise we note that publication may be followed by formulation and theorisation of the ideas, processes and techniques which have developed through the creation of the published artwork. These formulations and theorisations may, in turn, also be published and/or applied to the generation of future creative works. However, at every stage of the cycle it is possible to go back to previous stages. So, for example, selection of an idea might instigate a return to the idea/generation stage. Similarly, the investigation/research stage might also result in a revisiting of the generation of ideas and so on. The cycle structure is combined with a web-like structure to demonstrate how it is also possible to jump from one point in the circle to any other. Publication, for example, might result in a reversion to the ideas stage.

Starting at 'idea generation' and moving anti-clockwise is a representation of the research process found in both science and the humanities. If we begin with idea generation and follow the circle anti-clockwise, we move through a series of processes which counterbalance those on the right-hand side of the circle but are more geared towards academic research. The sub-circles refer to different kinds of research from more scientific and empirical approaches to more theoretical or historical approaches. These emphases are, of course, themselves fluid: for example, designing experiments has been thought central to science for a long time, but the extent of empirical work in the humanities is now increasing dramatically. If we pursue the circle round, idea generation leads to experiments, gathering of data and/or analysis of theory or criticism. This may be followed by the development or synthesis of material and can, in turn, lead to the testing of the theory, either empirically or by argument and comparison, with outputs at a number of possible stages.

It is now obvious that this is a reversible cycle and that it is possible to move round it fully in either direction. So theories developed through creative practice on the right-hand side of the cycle might be refined and generalised as part of the research process at the left-hand cycle side, and the web-like structure allows for movement across to the more basic research at any time.

The web-like aspect of the model clearly suggests connections with the Deleuzian rhizome in which any point can be linked to any other and there are 'multiple entryways and exits' (Deleuze and Guattari 1987: 21). For Deleuze and Guattari, 'A rhizome has no beginning or end; it is always in the middle, between things, interbeing, *intermezzo*' (Deleuze and Guattari 1987: 25). Such analogies to the Deleuzian rhizome have been made before in the area of practice as research, for example by Irwin and Springgay (in Cahnmann-Taylor and Siegesmund 2008). They apply the notion of the rhizome to arts-based

research in education through the movement of 'a/r/tography' which 'as prac-
tice-based research is situated in the in-between, where theory-as-practice-
as-process-as-complication intentionally unsettles perception and knowing
through living enquiry' (p. 107). For Irwin and Springgay the rhizome is 'an
interstitial space, open and vulnerable where meanings and understandings
are interrogated and ruptured' (p. 106). They continue by arguing for its rel-
evance to their own enterprise, 'building on the concept of the rhizome, a/r/
tography radically transforms the idea of theory as an abstract system distinct
and separate from practice' (p. 106). Strongly influenced by feminist and
poststructuralist theory, a/r/tography is concerned with 'relational inquiry,
relational aesthetics and relational learning' (p. 115). While these formulations
of a/r/tography are elusive, the element of continual and reciprocal transfer-
ence they suggest is coherent with our model.

As mentioned, Figure 1.1 illustrates how each stage of the large cycle itself
usually involves iterations (symbolised by the smaller cycles straddling the
main circular cycle) and selections from those iterations. In the process of
selection the researcher/practitioner decides which are the best or most useful
realisations derived from the task, and discards or temporarily puts to one
side the others. Here each iterative step is an example of the operation of a
selective pressure, somewhat like those that over aeons determine biological
evolution and the success of genes and organisms. Biological processes hinge
on the survival of the fittest, but fitness depends on the environment, so not
all impressive species survive. Artistic selection processes are likely to be even
more arbitrary, and there may be many fine specimens amongst the practi-
tioner's rejects. This occurs because practitioners are making these decisions
in relation to the specific artworks they are shaping (what would be suitable
for one may not be appropriate for another), or because they might miss a
good idea at an early stage of the process where its relevance or potential is
not apparent. In addition, although we might be tempted to think of these
choices as individually motivated, they are made in response to broader social
and artistic forces. So the selection process is more cultural than biological and
analogous to the activity of memes – ideas, theories or artefacts which evolve
through mutation and competition and are suggested by Richard Dawkins to
be the cultural equivalent of genes though over somewhat shorter lengths of
time. Memes are discussed in Chapter 4 by McKechnie and Stevens; Estelle
Barrett also suggests that the critical exegesis is a kind of meme because it 'may
be viewed both as a replication or re-versioning of the completed artistic work'
(Barrett 2007: 160).

Another type of selection process is fundamental in A-life (Artificial life)
artworks, such as those created by Jon McCormack, which involve silicon-
based (computational) organismal systems (McCormack 2003). Here selec-
tion is partly determined by the artist but then becomes built into the system.

In fact selective processes are at the core of most models of creativity, from the Geneplore model which characterises the creative process as generate–explore–select–generate, to the 'flow' model of Csikszentmihalyi (1997). But selection is also, as our model shows, relevant to research processes, where choices will occur along the continuum from arbitrary to exact, though usually with more emphasis on precision and contextual relevance than is the case with artistic choices.

Fundamental to our model are at least two different ways of working which are to be found in both creative practice and research: a process-driven one, and a goal-oriented one. To be process-driven is to have no particular starting point in mind and no pre-conceived end. Such an approach can be directed towards emergence, that is the generation of ideas which were unforeseen at the beginning of the project. To be goal-orientated is to have start and end points – usually consisting of an initial plan and a clear idea of an ultimate objective or target outcome. In Figure 1.1 these two different mindsets are signalled at various points, for example the initial idea generation can be one of surrender to the process or one of setting goals, while the ideas selection stage can be subjective (more process-orientated) or systematic (more goal-orientated). However, these two ways of working are by no means entirely separate from each other and often interact, as the model implies. For example, while the process-driven approach obviously lends itself to emergence, in fact at any moment an emergent idea may lead the way to more goal-oriented research. Similarly, a plan is always open to transformation as long as it is regarded flexibly.

The process-driven approach is usually thought to be more common amongst creative practitioners than researchers and almost certainly is, but many practitioners oscillate between process and goal, and may sometimes have an initial plan and/or some eventual endpoint in mind, however inexplicit it may be. Similarly, although research workers in both the humanities and the sciences usually have clear goals, engaging with processes along the way which allow for emergence, and permitting the project to shift in relation to them, is quite common and is often the secret of success. In a pleasingly hybrid way, the human genome project was one with a clear objective (defining the sequence of the DNA constituting the human genome) but also emergent outcomes (defining new and unexpected genes as well as acquiring better understanding of the function of metabolic pathways and the mechanisms of some diseases).

Implicit in Figure 1.1 is also the idea that the large cycle might represent not just the work of one person but that of a collaborative group with distributed expertises. Thus the creative practitioner might develop research skills but at the same time collaborate with a researcher who through engagement in the project takes an enhanced interest in more emergent and less preconceived outcomes. It is obvious that the creative, intellectual and financial environment

in which such collaboration and cyclic reciprocation is most feasible is that of higher education. Within creative arts companies it is more difficult, sometimes because of funding, though a few collaborative groups such as Canadian theatre director Robert LePage's Ex Machina manage to overcome this. Such companies may also have limited access to the complementary expertise of the scientist, the computer scientist or the research anthropologist. In higher education, such expertise would normally be part of the same community, and hence accessible. But the model's rhizomatic structure implies that interactions can take place between individuals from quite different communities and across cultures.

Figure 1.1 highlights some of the many points at which there might be transmissible outcomes. These outcomes can range from artworks to research papers, and might variously take the form of sound, text, image, video, artwork, numerical analysis of empirical data, argument, analysis or description. They might also include hybrid genres such as fictocriticism, itself a product of the rise of practice-led and research-led practices in the university. In the case of the numerical analysis of empirical data, or of argument, analysis or description, these outcomes might contribute to knowledge in humanities or science. If devolved from the process of making a creative work, they might embody understanding of the techniques which have been employed in creating an artwork and contribute to knowledge about the creative process. As we have suggested above, and as discussed elsewhere in the book, the transmission of technical possibilities through increased understanding of method and practice is potentially one of the most valuable outcomes of the rise of practice-led research.[4]

Our model also allows for the possibility that collaboration might not only be between scientists and artists or humanities researchers and artists, but equally between musicians, writers and visual artists, leading to the enhanced possibility of hybrid intermedia outputs. The mutual engagement on a project of practitioners with such a wide range of expertises and backgrounds is one of the most appealing aspects of creative arts collaboration, and potentially one of its most productive and valuable. The creative industries – the moving feast comprising the creative arts, film, TV, digital media and the Internet – in which such collaborations are particularly relevant, require such stimulus and synergy to thrive.

We hope that researcher-practitioners who read this book may use the model in Figure 1.1 to consider how much of the cycle they are actually engaging with, and to consider initiating projects from other entry points to it than those they normally engage. We also like to think it may encourage practitioners and researchers to participate in parts of the cycle in which they are currently absent. Several chapters of this book illustrate various ways in which essentially the complete outer cycle in Figure 1.1 can be fulfilled within projects: for example, Simon Biggs, and Andrew Brown and Andrew

Sorensen, with research in IT and creative arts practice in digital media; Sharon Bell with research in anthropology and creative practice in documentary film; Shirley McKechnie and Kate Stevens, and also Roger Dean, with repeating interactions between cognitive science and creative practice in dance and music respectively; and Hazel Smith and Anne Brewster with theorised humanities research combined with creative writing (in Hazel's case intermedia processes are also involved).

THE OUTPUTS: EVALUATION AND PROMOTION

Creative practitioners have sometimes argued that theorisation or documentation of the creative process risks subduing the creative fire or reducing the range of responses to their work. But such arguments reinforce the mystification of the creative artist and romantic ideas about the spontaneity of the creative process. Creative practitioners traditionally had an ideological investment in such mystification because it shored up the idea of the creative genius. However, there have been numerous examples of influential creative pioneers who laid out their ideas, strategies and critical positions through essays or manifestos: the composer Iannis Xenakis, the Surrealist painters and writers, and members of the writers' group Oulipo are good examples from sonic, visual and literary work. Similarly, there is also a wealth of work by contemporary writers and artists, such as the American language poets, which fuses practice and theory (see, for example, Bernstein 1999). All this suggests that there is no necessary contradiction between theorisation and creative practice, but rather that the combination can be valuable.

Currently there is an increasing trend towards documentation and self-description of creative work – as well as growing recognition of the self-critical awareness which is always a part of creating an artwork – whether or not it is externalised. Nevertheless, there may be certain aspects of the work that practitioners do not want to talk about, such as possible interpretations of it, and the role of the practitioner in these respects remains distinct from that of the critic.

The output points illustrated on our model must necessarily also be the points at which creative and research work is evaluated by others. In higher education such evaluation is necessary to demonstrate to governments that public subsidy is being usefully and valuably spent. But evaluation of outcomes is also requisite within the university to justify the apportioning of resources to creative practice and hopefully to increase the flow of resources to it. In the period in the early 1990s in Australia when creative work itself was argued to be 'equivalent' to research output, many university leaders lacked sympathy for the idea that creative work and research should be treated as equal. As

mentioned above, in Australia creative work has not up to now – apart from a brief period in the 1990s – impacted on the federal government Infrastructure Grants Scheme. However, the situation is different in the UK.

In the current higher education environment, if creative arts work itself can be presented as not only co-equal with research outcomes but also concomitant and interactive with them, it is more likely that support for it will be forthcoming. Thus the juxtaposition and interweaving of practice-led research and research-led practice is critical for the development of both endeavours, and especially for the future of creative arts in higher education.

How can the evaluation proceed? The general evaluation of a particular field by peer-researchers in science remains the most feasible approach, and garners the most acceptance among researchers, though it is far from precise, for example as judged by a detailed study of the peer-review process of the Australian Research Council (Marsh et al. 2008). Currently peer assessment of artistic work does occur at an informal level but hardly operates in a formalised way, so processes for peer review are at an embryonic stage in creative arts in many countries. But peer assessment similar to that common in academia could operate for initial assessment of artistic products; a peer group of practitioners could assess the outputs and methodologies for this have been developed and analysed. The 'consensual assessment technique' using domain experts, developed and applied by Amabile and colleagues, exemplifies this (Amabile 1996). We argue that such an approach is essential, even though peer-assessment in the arts is something of a minefield because of the highly subjective element in judging artistic work, and the tendency for ground-breaking work to be greeted with opprobrium rather than praise.

Peer review is anyway only the first stage in a process of evaluation because as long as the artwork is retained in circulation, recorded or documented, then – as with the scientific paper – a re-evaluation can take place later, and matters of public acceptance can play a more significant role. This public acceptance constitutes a major aspect of the 'impact' of artworks. Here we use impact to mean the degree to which the public engages with the artworks and appreciates them; we are not equating impact necessarily with cultural value, since a work which is esoteric can be extremely rich culturally but have a very limited public impact. In the short term, unfamiliarity – or perceptual fluency as it is known in cognitive research – can limit the impact of the work for some members of the public, but in the long term this issue of unfamiliarity can often be overcome: Harold Pinter's early plays were originally reviled by many, but he is now firmly established in the mainstream. Impact has always been notoriously difficult to assess but the degree to which the public interacts with artworks may become easier to measure through the Internet.

If the impact of an artwork arises out of the degree to which the public engages with it, then it is very different from the way that the public impact of science

operates. The main 'impact' of biomedical science, for example, is practical, whether it leads to useful pharmaceuticals or public health initiatives which reduce disease or enhance quality of life – and public use of published scientific articles is a minor factor in comparison with such practical impact. Of course sometimes artists may be able to engineer social and practical changes through their work, or may be able to liaise with scientists or engineers to further the public good. Rust, for example, discusses convincingly the way designers can work with scientists to considerable social and practical effect (Rust 2004).

Another measure of impact is the issue of long-term peer recognition and use. In the case of scientific research, citation analysis of research publications estimates the number of times other peer researchers have quoted the work of a particular researcher in their own publications and so indirectly how much the work has been used. Again the Internet, together with increased documentation of artists' processes, might eventually permit a similar assessment of peer usage in the creative arts, but this does not exist adequately yet.

As far as processes of evaluation are concerned, therefore, creative arts research could usefully borrow from the scientific model, though the criteria of assessment would need to be radically different. University leaders can no longer dismiss creative work from such consideration, and creative practitioners must be open to it. In fact their mutual participation in evaluative processes is both a necessary and desirable step towards the complete equality of creative arts with other intellectual endeavours within higher education.

One of the reasons that such equality is important is that those involved in higher education need to convince politicians of the importance of both the arts and other academic activities for the maintenance and development of our societies. Many artists are reluctant to couch any argument about the value of art in economic rather than socio-cultural terms, even though they appreciate that politicians tend mainly to be interested in finance. But creative industries are very large industries in developed and some developing countries, and there are considerable differences in the percentage of GDP they contribute between the UK, the USA and Australia. They often supply between 5 and 8 per cent of GDP, but have increased more dramatically in some countries (such as the UK) than others during the last decade. The scope remains for considerable further enhancement of the economic contribution which can be made by art, and one of the roles of higher education academics and creative practitioners is to try to ensure that this happens and that valuable artistic and socio-cultural outputs and impacts ensue, not just direct economic gains. Throsby and others have shown that, in the case of the visual arts, for example, the estimated financial impact of artistic work derives not so much from the sale of work but from other socio-economic factors (Throsby 2006). Quite probably the economic impacts of medical research have been so successfully argued that they are overestimated, while almost certainly those of the creative arts have been both

under-argued and underestimated. But politicians can potentially be engaged and energised by all of these kinds of argument and evidence. This is more likely to be achieved if methods of evaluation are demonstrated and equality of the potential significance of creative arts work, practice-led research and research-led practice is claimed, exploited and promoted.

THE CONTRIBUTORS: KEY ARGUMENTS

The authors in this book engage with a wide variety of arguments about practice-led research or research-led practice. In the opening chapter of Part 1, while focusing on practice-led research in the visual arts, Graeme Sullivan argues that 'artists themselves have the capacity to explore and explain complex theoretical issues that can have significance across broad areas of knowledge' and can make 'intuitive and intellectual leaps towards the creation of new knowledge': for Sullivan 'the artist intuitively adopts the dual roles of the researcher and the researched' in 'a reflexive process'. Consequently, he says, they should be aware of 'the necessity of communicating across fields of inquiry'. Sullivan continues the arguments raised above about the potential importance of practice-led research in universities, pointing to the desir- ability of 'research practices that are inherently discipline-centred in the arts and humanities'. For him practice-led research implements methodologies which move from the 'unknown to the known', rather than more traditional research methodologies which move from the 'known to the unknown'; he also emphasises processes of data 'creation' rather than 'collection'. Sullivan notes that the work may have outputs which are emergent, including some that are non-verbal – the concept of emergence appears throughout this volume. His chapter concludes with an illuminating discussion of a collaboration in which a New York 'exhibition space was conceived as a research site'.

Simon Biggs (Chapter 3) focuses on 'practice as research' in new media and its recurrent emphasis on 'development and/or application of emergent mediating tools and systems', resulting in its capacity to be highly divergent. In dedicating a section of his chapter to terminology, he points out that there are quite disparate views among practitioner-researchers as to what constitutes practice-led research, that many have not routinely distinguished research-led practice or do not wish to do so, and that there is clearly substantial instabil- ity and slippage in the larger discourse about practice and research at present. This is obviously relevant to our own objective of bringing these different axes (practice-led research, research-led practice) into clearer view and our wish to create, if possible, greater stabilisation of terminology. Biggs quotes the UK Research Assessment Exercise (RAE) definition of research which extends from the terminology 'knowledge' to what we might call the 'softer' terms

'understanding' and 'insight'. He discusses the situation of new media artists working in 'what were, for them, alien environments', such as scientific and IT organisations and art galleries. Biggs then presents fascinating results from his survey of new media arts practitioners working in research environments. All of his respondents agreed with the view that research and practice are reciprocal, but many conformed with Stuart Jones' view, quoted by Biggs, that 'the community of my practice is largely different from the community of my research.' Respondents also evinced a wide range of 'formal research methods', listed by Biggs as 'contextual reviews, case studies, interviews, practical experiments, scenario building, action research, user monitoring and evaluation, external assessment through structured audience engagement, version control systems and ethnographic observation/analysis, among others'. Nevertheless, Biggs asks in his conclusion: 'Is it contradictory to employ artists within an institution that then requires them to submit their creative practice for assessment as research?' He continues, in contrast, by asking 'what value artist-led research contributes to art and, indeed, whether it might function to compromise those things we esteem most in artistic practice and its artefacts?' He is optimistic that 'emerging practices and actual outcomes' will eventually provide stronger answers to these important questions.

Shirley McKechnie and Catherine Stevens address practice-led research in dance and its interface with research on cognitive aspects of dance. In response to our book title, they also elaborate significantly on how such academic research on dance cognition may be able to feed back ideas to dance practitioners which influence their creative work, thus generating a cycle similar to that we elaborate in our model in this chapter. Their research is, echoing Christopher Frayling (see Chapter 9 by Judith Mottram), 'in, about and for contemporary dance'. Here knowledge may be procedural and implicit, or declarative and explicit, but it is fundamentally non-verbal: 'contemporary dance declares thoughts and ideas not in words but expressed kinaesthetically and emotionally through movement.' As they argue, knowledge may either arise out of understanding the processes involved in learning dance skills or in developing a dance piece. Their empirical studies of audience responses to dance, and their action research concerning the influence of information provision on these responses, are instructive for practitioners of most non-verbal and temporal arts. They also offer ideas on the documentation of dance which have a broader relevance to creative practice at large, documentation which is now developing in part as a consequence of practice-led research in the higher education environment. In line with our model, McKechnie and Stevens point out that the dance ensemble can be a 'self-organising dynamical system' whose generated variety is subject to 'variation, selection and replication'. Following current understanding of biological evolution, they also emphasise the need for the preservation of diversity in creative practice.

Baz Kershaw (Chapter 5) shares McKechnie and Stevens's focus on what he calls 'practice as research through performance', but with respect to theatrical and performance art, particularly movement based. In an opening illustration flowing from Wittgenstein, Kershaw touches on some of the essential problems of the concept of knowledge as briefly alluded to above. He discusses a 'paradoxology of performance', treating 'theatre and performance as operating in a continuum with natural phenomena, such as seashores and forest perimeters, so that the same principles of ecology can be seen to shape both cultural and natural processes'; this nicely complements the ecological ideas underpinning the preceding chapter by Keith Armstrong. In discussing the evaluation of research through performance, Kershaw illustrates the ambivalences and mutations of the UK Research Assessment Exercise and is notably less optimistic about its openness or positivity for the arts than is Biggs (Chapter 3). He advocates the importance of the 'hunch' in creative and research work: the significance of such hunches is alluded to in a number of the chapters and is also a feature of our model with its indication of 'subjective' selection steps. Kershaw discusses a performance piece nominally investigating the 'aesthetics of . . . body-based spectacle' and also targeting an objective of enhancing 'conservation messages' enacted at Bristol Zoo; again issues of documentation, and its value as well as impact, are analysed. Although documentation and performance can also enter an iterative and productive cycle, Kershaw poses the question: are there dangers in documentation? He puts forward the view, held by some practitioners, of 'ephemerality as *the* essential quality of performance' and the need to be wary of documentation as 'the devil of commodification', but on balance seems to see a positive role for the documentation process.

Anne Brewster's Chapter 6 is a stimulating example of fictocriticism – a hybrid of critical and creative writing – with which she engages to investigate 'contemporary Australian intercultural relations between indigenous and non-indigenous people'. In the chapter she relates fictocritical practices to personally-situated writing in critical whiteness studies, 'a body of theory which aims to open up the cultural reproduction of whiteness and the white subject to scrutiny'. She also argues that in textual studies the juxtaposition of the terms practice and research 'usually signifies the inclusion of bodily experience in writing', and interweaves her argument with reflections relating to fossicking on the beach, an activity which resonates with intimations of the colonial encounter. Her chapter includes a broad discussion of the relationship between research and practice: as she says methodologies are practices and we need to be careful to see these activities as intertwined rather than opposed. Her fictocritical approach embodies the 'doubling' or 'mirroring' by which we can construe practice-led research and research-led practice as complementary and yet part of a single iterative cycle.

Part 2 presents four briefer 'case histories'. As well as distinguishing usefully

between different forms of research – general and academic, experimental and conceptual – Andrew Brown and Andrew Sorensen write lucidly of the fluidity of digital media and the capability of 'the computer as an idea amplifier'. Their algorithmic sound and image 'live-coding' practice, in their ensemble aa-cell, has involved the development of an entirely new programming and performance platform (Impromptu), and continually exploits aspects of the whole 'interdependent' and 'iterative' cycle of practice-led research and research-led practice summarised in our model: as they say, 'the computer system is directly in play and its behaviour and outputs are [among] the objects of inquiry'. They describe the continually changing relationship and nature of their overall goals and their emergent activities, particularly in the context of performance. Discussing the selective steps repeatedly involved in choosing future research paths, Brown and Sorensen also point to the way they try to use the aesthetic responses of their peers as one means of assessing their work.

Kathleen Vaughan provides a substantial contrast to the 'peer community' aspect of the processes described in the preceding chapter. Rather, she provides a highly personalised narrative of the process of production of a particular visual artwork using an approach based on collage. She talks of the aspect of rediscovery – a kind of process of defamiliarisation – in research (in this case with regard to butterflies) and its utility in her artistic process. For her art as research is a 'calling forth, pulling together and arranging the multiplicities of knowledges embedded within' more than a means to create new knowledge; nevertheless the process can have a transformative effect. Although her approach is personal, she includes in her preparation a step of engaging with work by other visual artists concerned with the butterfly or other insects – noting some who collaborated with scientific researchers in their works – and she also plans to take advantage of the opportunity in her present institution for collaboration with digital artists. Vaughan's delineation of the position of creative work within the Canadian higher education funding schemes, notably those of the Social Sciences and Humanities Research Council, is amongst the most optimistic in the book.

Keith Armstrong (Chapter 9) introduces his long-standing 'ecological-philosophical approach to artmaking . . . ecosophical praxis'. The scientific bases of the ecological approach can influence the work at very specific levels, for example in seeking to relate 'energy transfers' in the work to those in the ecosystem at large. But he also considers four ecologies: the 'biophysical', the 'artificial', the 'social' and that of the 'image', which 'strongly mediates the other three'. His interactive group practice involves iterative cycles and collaborations with others of complementary expertise. He idealistically and purposefully 'hopes for the continued emergence of a contemporary eco-political modality of new media praxis that self-reflexively questions how we might re-focus future practices upon "sustaining the sustainable"'.

Novelist and academic Jane Goodall concludes Part 2 with a discussion of popular novels and whether writing such novels can be a research-led practice. She describes, for example, how her academic work in cultural history fed into her first thriller, *The Walker*, including 'hints of an alchemical experiment gone wrong'. Yet she suggests that research alone cannot drive a narrative and relates how she has learnt that 'the spooky art of fiction writing involves a commitment to improvisation and randomness, a submission to the erasure of authorial design, a readiness to be mesmerised by place and possessed by psychological energies from competing directions'. It is important for the novelist not to become weighed down by factual information or technical demands: 'research in the context of the creative arts can actually serve to calibrate awareness of the psychological displacements required to keep the work alive'.

In Part 3, our contributors address some of the educational and political issues surrounding practice-led research. Brad Haseman and Daniel Mafe discuss how practice-led researchers can acquire specific expertise during research training in higher education through the completion of higher degrees. They focus on the case of established creative practitioners who 'undertake higher research degrees and so bring the benefits of research to their practice and discipline'. In most of their discussion 'practice leads the research process' and in this context they delineate and assess 'six conditions of practice-led research', including 'repurposing methods and languages of practice into the methods and language of research'; developing and using peer, professional and critical contexts as well as deciding on the forms in which the outcomes will be embodied; and 'deliberating on the emerging aspirations, benefits and consequences which may flow from the demands and contingencies of practice'. They discuss emergent practice in which aims need not be finely preconceived, the reflexive steps involved in proceeding with emergent outcomes and, importantly, how one can develop 'research training to manage emergence through reflexivity'. At the same time they provide a positive and informative case study on this process and the psychological challenges it presents for its participants. They conclude positively that after completion of their research training often 'practice-led researchers will work in teams with collaborators possessing different methodological strengths, and it will be the supervisor/candidate relationship and its reflexive honesty that will prepare practice-led researchers for this larger contribution to our research and innovation industries'.

Haseman and Mafe's chapter mainly focuses on experienced practitioners who undertake postgraduate degrees. However, there are also graduate research students who wish to become both academic researchers and creative practitioners but who, unlike the participants Haseman and Mafe discuss, want to enter research training soon after completing an undergraduate course rather than becoming established creative practitioners first. We suggest that this will increasingly be an important and popular trajectory for graduates, again

promising to contribute positively to our research and innovation industries (as documented already to some extent in the UK context and discussed in Chapter 12 by Judith Mottram). Furthermore, on a pragmatic level, once attainment of a doctorate becomes a more common feature of the careers of creative practitioners, it will also be one that they anticipate at the outset of their careers, hence creating the demand to which we point. These postgraduates will have rather different needs from their more established counterparts, and are particularly likely to benefit from combining practice and research within the environment of the university. With regard to postgraduate students who are already established practitioners, we note in passing that the chequered history of 'professional doctorates' outside the creative arts must give us pause for care with regard to their equivalents in the creative arts. The Master of Business Administration (MBA) has become a somewhat tarnished commodity, with its extent and demands reduced considerably in some universities from those it originally presented (for example, what formerly required two years of full-time study in some universities now requires one or less). In all such cases, as Haseman and Mafe argue, what is crucial is that high standards be required, and that participants are encouraged (even pushed, but with strong support) to extend their intellectual and creative processes during their research training.

Closely related issues of assessment and establishing value within higher education are central to Judith Mottram's discussion of research and creative practice in relation to the fine arts (Chapter 12). Mottram uses the current codification of a UK Arts and Humanities Research Council review of practice-led research as 'research in which the professional and/or creative practices of art, design or architecture play an instrumental part in an inquiry'. As she says, 'within art and design schools, the focus has not so much been on advancing knowledge as upon generating new objects of attention'. According to her, and in contrast to the feelings of many of our questionnaire respondents, 'the value given to the creative practice of teaching staff in arts disciplines in UK universities has reached almost mythical status', and she finds little overt explanation for this. But she goes on to argue that the 'rising numbers of fine art PhDs provide a new opportunity for conceptualising the nature of the disciplinary academic in the field'. It is in this context that she discusses the development of such doctoral training in the UK, again framing this with Frayling's concepts of 'research in art and design' as research 'for practice', 'through practice' and 'into practice'. She argues that 'if there is no hypothesis, question or objectives, the practice is "normal" practice, not research-led practice'. But she describes her impression that currently, in late 2008, 'the usefulness of stressing "practice" is being questioned' in the UK, and that there is a 'desire to move beyond dependency on the use of the prefix "practice"'. Yet noting that participants in fine art departments in UK universities still make a distinction between research and practice, she indicates

no strong solution to this quandary. Rather, after a brush with geology echoing some of Anne Brewster's 'fossicking', she concludes that in the fine arts, apparently in both practice and research, 'the challenge remains to demonstrate that new understanding is achieved and that this has an impact upon future culture and society'.

Our final chapter, by Sharon Bell, was initially invited as a 'case history', but because of its powerful involvement with educational issues and with politics (particularly those to do with Sri Lanka), we decided to reposition it in Part 3; this decision also acknowledged Bell's own change of emphasis during the writing of the chapter, which she notes. In the context of her film work, together with her experience in academic leadership, and of her own disciplines of anthropology and ethnography, she asks what might be 'ideals for creative production in the academy'? She responds:

> It is tempting to argue that such works of art, in comparison with those produced outside the academy, might be expected to be: more nuanced for the underpinning research; more sensitive for the prolonged and intense processes of reflection; more competently realised due to the practitioner's mastery of technique; more communicative due the artist's sophisticated understanding of their art form and the context in which a body of work has been produced; more 'authentic' due to the lack of a commercial imperative; or more confronting due to the intensely critical and analytical academic environment which at its best encourages risk taking and innovation.

Her discussion is in part about the difficulties in, and barriers to, achieving these ideal outcomes. She contrasts the limited ethnographic studies of the 'tribal territory' of the medical research institute (of which Roger Dean has been a part) with the even more modest studies of the 'academic mode of creative production'. Bell's 'journey from anthropologist (academic) to filmmaker (creative practitioner) was in fact a journey borne of frustration with the reified world of Anthropology', but it is also a journey that might now be taken without frustration by the early career practitioner of both research and creative arts during an appropriate doctorate due to the changes in higher education which are making it more receptive to the influence of creative practice. Her chapter also shows her intense commitment to politics, as well as the unstable nature of politics itself: her film *The Actor and The President*, concerning President Chandrika Bandaranaike Kumaratunga and her assassinated husband, Vijaya, is now being read, contrary to some of its intentions, through the lens of the new politics in Sri Lanka. Her later documentary *The Fall of the House* is a reflection on creative arts processes themselves in the case of composer-conductor Eugene Goossens. Arguing for the potentially important

contribution ethnography has yet to make to our understanding of creative work in higher education, she concludes that:

> Forms of intelligence gathering, which are not institutionalised, especially those designed to collect 'dirtier data' and generate a discourse that is 'generically disrespectful and promiscuous' may contribute to discomfort in the sector. Yet more open research paradigms and methodologies are needed to generate understanding of our academic modes of production and a more nuanced understanding of the place of creative production within the academy.

'Intelligence gathering' may be read as embracing both research and practice in the creative arts and as an approach to understanding their place.

The idea that practice can be a form of research is creating a transforming environment within academia. There is an acceleration of conferences devoted to the work of researcher/practitioners, and an increasing number of research publications which include contributions from practitioners. The input of practitioners is, in turn, broadening concepts of how a conference paper can be given (for example, it might take the form of a performance) or how an essay might be written (it might consist of a mixture of creative and critical writing). Disciplines are also changing in response to the greater incorporation of practice. Literary studies, for example, has been shaken up by the inception of creative writing programmes which put the emphasis on process rather than products, writers as much as readers. Similarly the idea of the research group or centre within the university is transforming: the Writing and Society Research Group at the University of Western Sydney, of which Hazel is a member, is as much driven by writing as literature; its title salutes the idea that both creative writing and critical writing are research. It is within this developing environment that we present the fine contributors in this book, and their different perspectives on research, creative practice, art and knowledge.

NOTES

1. Just as there are numerous books on the scientific method, so there are several important series of books on qualitative research, emerging mainly from sociology and cultural studies and ranging to hundreds of items.
2. Research scientists are often aware of the philosophical quandaries research presents, yet are usually much less engaged in their discussion than either humanities academics or creative practitioners. The studies of Bruno Latour, Steve Woolgar, Max Charlesworth and others reveal the relative

lack of involvement of scientists in epistemological discourse despite their intellectual commitment.

3. The questionnaire we sent to creative arts practitioners in higher education is given in the Appendix.

4. This brief discussion of outcomes complements the forthright emphasis that Eisner presents in his discussion of 'persistent tensions in arts-based research'. As the editors Siegesmund and Cahnmann recognise, Eisner's five tensions are illuminating. They characterise the five as: '1) The imaginative vs. the referentially clear; 2) The particular vs. the general; 3) Aesthetics of beauty vs. verisimilitude of truth; 4) Better questions vs. definitive answers; 5) Metaphoric novelty vs. literal utility' (Cahnmann-Taylor and Siegesmund 2008: 232) and their volume addresses most of these. We would not express the ideas in the way Eisner does, but there are parallels between each of these 'tensions' and the ideas implicit in our model.

REFERENCES

Amabile, T. M. (1996), *Creativity in Context*, Boulder, CO: Westview Press.

Bailes, F. and R. T. Dean (2007), 'Listener detection of segmentation in computer-generated sonic texture: an experimental study', *Journal of New Music Research*, 36 (2), 83–93.

Barrett, E. (2007), 'The exegesis as meme', in E. Barrett and B. Bolt (eds), *Practice as Research: Approaches to Creative Arts Enquiry*, London and New York: I. B. Tauris.

Bernstein, C. (1999), *My Way: Speeches and Poems*, Chicago: University of Chicago Press.

Bolt, Barbara (2007), 'The magic is in handling', in E. Barrett and B. Bolt (eds), *Practice as Research: Approaches to Creative Arts Enquiry*, London and New York: I. B. Tauris, pp. 27–34.

Cahnmann-Taylor, M. and R. Siegesmund (eds) (2008), *Arts-Based Research in Education: Foundations in Practice*, London and New York: Routledge.

Candy, L. (2006), *Practice-based Research: A Guide*, Creativity and Cognition Studios Report 2006-V1.0, Sydney: Creativity and Cognition Studios, University of Technology. Available at: http://www.creativityandcognition.com.

Csikszentmihalyi, M. (1997), *Creativity: Flow and the Psychology of Discovery and Invention*, New York: Harper Perennial.

Dawson, P. (2005), *Creative Writing and the New Humanities*, New York and London: Routledge.

Dean, R. T. (1989), *Creative Improvisation: Jazz, Contemporary Music and Beyond*, Milton Keynes: Open University Press.

Dean, R. T. (1992), *New Structures in Jazz and Improvised Music since 1960*, Milton Keynes: Open University Press.

Dean, R. T. (2003), *Hyperimprovisation: Computer Interactive Sound Improvisation*, with CD(R) of sound works, intermedia, and performance software patches, Middleton, WI: A-R Editions.

Deleuze, G. and F. Guattari (1987), *A Thousand Plateaus: Capitalism and Schizophrenia*, Minneapolis, MN and London: University of Minnesota Press.

Edmonds, E. A., A. Weakley, L. Candy, M. Fell, R. Knott and S. Pauletto (2005), 'The studio as laboratory: combining creative practice and digital technology research', *International Journal of Human–Computer Studies*, 63 (4–5), 452–81.

Haseman, B. C. (2006), 'A manifesto for performative research', *Media International Australia incorporating Culture and Policy*. Available at: http://www.emsah.uq.edu.au/mia/issues/miacpl18.htm.

Kennedy, M. (2008), 'Stonehenge: "ancient A & E"', *Guardian Weekly*, 3 October, p. 15.

Krauth, N. and T. Brady (2006), *Creative Writing: Theory beyond Practice*, Teneriffe, QLD: Post Pressed.

McCormack, J. (2003), 'Evolving sonic ecosystems', *Kybernetes*, 32 (1/2), 184–202.

Macleod, K. and L. Holdridge (2006), *Thinking Through Art: Reflections on Art as Research*, London and New York: Routledge.

Marsh, H. W., U. W. Jayasinghe and N. W. Bond (2008), 'Improving the peer-review process for grant applications: reliability, validity, bias, and generalizability', *American Psychologist*, 63 (3), 160.

Rust, C. (2004), 'Design enquiry: tacit knowledge and invention in science', *Design Issues*, 20 (4), 76–85.

Smith, H. (2000), *Hyperscapes in the Poetry of Frank O'Hara: Difference, Homosexuality, Topography*, Liverpool: Liverpool University Press.

Smith, H. (2005a), 'The erotics of gossip: fictocriticism, performativity, technology', *Continuum*, 19 (3), 403–4.

Smith, H. (2005b), *The Writing Experiment: Strategies for Innovative Creative Writing*, Sydney: Allen & Unwin.

Smith, H. (2008), *The Erotics of Geography: Poetry, Performance Texts, New Media Works* (book plus CD Rom), Kane'ohe, HI: TinFish.

Smith, H. (forthcoming), 'The voice in computer music and its relationship to place, identity and community', in R. T. Dean (ed.), *The Oxford Handbook of Computer Music*, New York: Oxford University Press.

Smith, H. and R. T. Dean (1997), *Improvisation, Hypermedia and the Arts Since 1945*, London and New York: Harwood Academic.

Smith, H. and R. T. Dean (2001), 'The egg, the cart, the horse, the chicken', *infLect: A Journal of Multimedia Writing*. Available at: http://www.canberra.edu.au/centres/inflect/01/eggsite.3/theegg/eggfset1.html.

Smith, H. and R. T. Dean (2003), 'Voicescapes and sonic structures in the creation of sound technodrama', *Performance Research*, 8 (1), 112–23.

Throsby, D. (2006), 'An artistic production function: theory and an application to Australian visual artists', *Journal of Cultural Economics*, 30, 1–14.

Wilkie, S., C. Stevens and R. T. Dean (2008), 'Psychoacoustic manipulation of the sound-induced illusory flash', *Lecture Notes in Computer Science*, 4969, 1–15.

Methodologies of Practice-led Research and Research-led Practice

Making Space: The Purpose and Place of Practice-led Research

Graeme Sullivan

CEZANNE'S NEW VIEW

Over 100 years ago artists pressed into view images that so shocked common sense the world would never be seen the same again. The creation of images that disturbed the sightlines of a seemingly ordered universe of people, places, events and things should not have been a surprise. After all, artists had long been testing their visual intuitions against the logic of what was seen and known. So when Cézanne nudged aside the single point of view in favor of multiple perspectives, he anticipated what the physicists at the time were scratching their heads about: maybe space and time were not so inviolate after all. Cézanne saw that we lived in a dynamic world where space, time and light could never be isolated or rendered motionless. The way light bends around forms, time varies with position, and space is neither flat nor far, give a sense of a world being understood in all its complex simplicity. Cézanne's still life paintings are anything but still.

Nor was Cézanne satisfied with trusting the eyes and minds of others as a basis for his observations. As he explained to Emile Bernard in 1905,[1] once understood, conventional practice served best as a basis for what *not* to do.

> The Louvre is the book in which we learn to read. We must not, however, be satisfied with retaining the beautiful formulas of our illustrious predecessors. Let us go forth to study beautiful nature, let us try to free our minds from them, let us strive to express ourselves according to our personal temperament. Time and reflection, moreover, modify little by little our vision, and at last comprehension comes to us. (Cézanne, in a letter to Emile Bernard, 1905)

The understanding that unfolded for Cézanne through his visual experiments followed a process that was at variance with accepted procedures. He created things that could not be accommodated within the realms of tradition. Although Cézanne's insights came to challenge the very basis of what was believed to be 'true', his visual studies were mostly a well-kept secret at the time. Only a few fellow artists and discerning critics appreciated the radical changes Cézanne was proposing to the way nature could be explained. Interestingly, once his observations became more widely known many interpretations still managed to distort his view. For example, studio art teachers can still be found who claim that Cézanne showed how nature was composed of a stable Euclidean structure of cylinders, spheres and cones. But it was a dynamic world of changing relationships that Cézanne saw. Even theoretical physicists in Cézanne's day were seeking to discover the building blocks of life based on the assumption that simple, elegant structures could be found to explain how the world works. Scientists later realised that a combination of simple and complex solutions was necessary to understand the uncertain relationships surrounding human and physical structures and systems.

Today, as in Cézanne's time, the need to understand how things are related is just as important as the need to explain what they are. There are two important lessons to be learned from Cézanne's era and these frame the arguments presented in this chapter. First, artists themselves have the capacity to explore and explain complex theoretical issues that can have significance across broad areas of knowledge. In most cases, this process is clarified in retrospect as issues and ideas are revealed through the process of reflexive and reflective inquiry. Generally, artists have left the responsibility of assessing the significance of what it is that they do to others, preferring to let critics, historians and cultural theorists do the talking. If artists today pursue their art practice within the academy as well as the artworld, then it is necessary that they take on the roles of the practitioner, researcher and theorist, and in some cases, artwriter and teacher as well. In an age of multiplicity, plurality and networked cultures (Taylor 2001), this is a capacity many artists today share with artists of the past.

A second lesson to be taken from artistic and scientific investigations of a century ago is the realisation of the necessity of communicating across fields of inquiry. Although the knowledge revolution has produced an enormous amount of new information in an equally dizzying array of form and content, a prevailing attitude is to honour expertise and authority, for this is the means by which new knowledge is framed and acclaimed. Yet the wry quip that an 'expert' is someone who knows more and more about less and less suggests that inward thinking may not be the best way to encourage outward looking if the quest for new realms of inquiry is valued. Collaborative research and cross-discipline inquiry has not been a feature of academic life in most institutions, yet there are plenty of examples today of imaginative investigations taking

place beyond discipline boundaries and many of these involve artists working alongside their colleagues in the sciences and humanities (Wilson 2002). Coming to understand the interconnections among visual forms, patterns of inquiry and different perspectives offers the possibility of making intuitive and intellectual leaps towards the creation of new knowledge.

The approach to inquiry characterised by Cézanne and others who pursue artistic ends as a means to discover new ideas and knowledge is that a creative impulse reveals an imaginative insight that challenges what we know. This process describes a key feature of 'practice-led research' explored in this chapter. The emergence of practice-led research and other practice-based descriptions of how artists explore, express and communicate their views is evident in the new roles and responsibilities they are taking on within institutional settings. To better assess how artists can contribute in important ways to the culture of research, a brief conceptual critique charts the circumstances surrounding the introduction of practice-led research in the university setting. In particular, some limiting conditions that were imposed and which still persist are discussed. This serves as a prelude to describing a schema for considering practice-led research and the methods that might be developed. Finally, an example is presented that describes how the ideas and approaches that characterise practice-led research were adapted in collaboration with artist-researchers in an art gallery project in New York.

A NARROW VIEW: DEFINITIONS AND EQUIVALENCE

In the academy it is expected that policies, procedures and programmes are clearly defined in order to be adequately defended. It is assumed that common understandings and shared agreement about ends and means, the design and delivery of programmes and institutional accountability provide an identifiable benchmark for maintaining quality control. It was this climate of rationalist planning that faced artists and educators in Australia in the late 1980s and early 1990s as they responded to the demands of widespread institutional change. At the time, art schools and teacher training colleges were absorbed within university structures as governments saw education and training as part of microeconomic reform. The view that higher education should contribute more directly to economic development radically altered perceptions about educational expectations and productivity. New arenas of debate and policy development surrounding concepts such as 'creative industries'[2] opened up. This raised possibilities and problems for artists and art educators. The understanding that academic practice involves research and teaching posed particular challenges for artists entering the university. Although it was apparent that artists teach, a perplexing question arose about whether or not they did 'research' in their studios.

For some it was unquestionable that studio activity could be defined as a form of research. For others, the idea that creativity could be reduced to an accountable activity was a travesty. The debates that occurred in Australasia and the UK at the time were provocative, generative and often divisive.

The initial effort in claiming a place within the scholarly community of the university was to adopt a definition of research that was credible yet flexible. The terms of reference used drew on descriptions from the Organisation for Economic Cooperation and Development (OECD), which served as an international standard for defining research and development. In the early 1960s the OECD compiled the *Frascati Manual*, which was an attempt to codify the definitions and language for preparing policies on research and development that linked science and technology to economic development. The purpose was to establish standards that would assist countries to respond to market-driven economies being fuelled by science and new technologies. Defining strategies for moving from basic research to applied research was seen to be important in the development of new processes, products and practices. In later iterations of the Frascati Manual the inextricable role of 'creativity' was acknowledged as an essential component of systematic inquiry and the OECD definition of research became a popular citation in many arts research policy documents. Research was thus described as

> creative work undertaken on a systematic basis in order to increase the stock of knowledge, including knowledge of humankind, culture and society, and the use of this stock of knowledge to devise new applications. (OECD 2002: 30)

Variations of this definition are found in many of the early reports, position papers and university policy statements prepared in support of the argument that creative arts practices can be rationalised as a form of research because of the unique contribution made to the generation of new knowledge. For instance, in accounting for the level of research carried out in Australian universities, the Federal report *Research in the Creative Arts* (Strand 1998) describes how government reporting structures and various funding agencies adopted the OECD definition for research and development. This approach echoed reports from the early 1990s in the UK that sought to establish national frameworks and institutional guidelines for the inclusion of practice-led doctorates in higher education.[3]

Despite confirming the capacity of practice-led research to contribute to knowledge construction and the associated creative industries, the terms and conditions framing such a definition distort the potential of the arts as a fully accredited participant in the research enterprise. The conception of research adopted by the OECD and other institutions and agencies was firmly entrenched

in notions of basic and applied research, whereby new knowledge gave rise to new applications, products and services that had sustainable economic value. The role of creativity was clearly seen to be important within this tradition of research and development, irrespective of whether it was pursued by the inventive scientist or the imaginative artist. What was common was the assumption that new knowledge was built on iterative practices that drew on what was known, even if the outcomes were not. This mode of inquiry had proved successful in the past in building new industrial economies and was assumed to be the way to produce successful enterprises within new information economies. But to bind studio-based and performative practices distinctive to the arts to terms of reference that were guided by descriptions of research based on science and technology severely undervalues the particular ways the arts contribute to the creation of new knowledge in the information age of cultural economies.

Because research activity was defined in the language and methods of science and technology, it was logical to use the sciences as the benchmark when considering how the arts contributed to the research enterprise in the university setting. The argument used was the strategy of defining 'equivalence'. If the creative process involved in practice-led research was accepted as a form of research in its own right then it had to be shown to be equivalent to acknowledged research traditions. If 'research activity' could be readily defined according to the long tradition of institutional practices in place it seemed possible to define 'research equivalent activity' (Strand 1998: 46) to account for those inquiry processes that sought the same ends but pursued different means. Equivalency, it was claimed, was a viable approach for framing research policy statements because it positioned practice-led research relative to criteria used to define conventional research practices. The stance taken in Australia at the time was explained in the Federal report *Research in the Creative Arts* (Strand 1998), which included the following recommendation:

> In addition to the conventional definitions of research, individual universities and the major funding bodies . . . should adopt the notion of research equivalence as an appropriate and valid concept for recognition of research-based practice and performance in the creative arts, and incorporate it into their documentation and processes for allocating research funds. Research equivalent activity should be recognised as being equivalent to research and scholarly activities in traditional fields. (p. xvii)

Defining how the processes and products of creative arts inquiry were equivalent to the procedures and outcomes of research in the human and social sciences was a tricky translation. It involved a process of comparison, alignment and no small amount of squeezing square pegs into round holes if, for example,

a solo art exhibition was to be 'equivalent' to a chapter in a research anthology or some similar peer-reviewed scholarly publication. The need to account for the research activity of all faculty in universities was significant because it was used as a direct measure in allocating Federal funding, as well as research support that could be sought from other funding agencies.

The hope that research in the creative arts could be granted parity based on arguments of equivalence offered false hope because the conditions of accepting the arts into the research community were fully controlled by those granting entry. Research is a reified entity within university life and the common perception is to maintain codified practices that determine not only what is endorsed as legitimate inquiry but also the conditions under which research is conducted and sanctioned. In effect, the assumption was the arts could be accepted as a form of creative social science or inventive applied technology and others defined what was acceptable.

The unfortunate legacy of aligning with definitions of basic and applied research extracted from sources such as the OECD and the adoption of equivalence as the strategy for claiming inclusion in the university research community is apparent in the way most art schools within universities currently define their research policies. In many cases there is a curious adherence to a research language that is beholden to a set of methodological conventions that are imported from other fields, mostly the social sciences. This may have helped gain entry to the academy in the 1990s, but the policies bear little resemblance to research and inquiry that is grounded in art practice. What is offered instead is guidance in doing social science research, but using themes and issues that are generated in the arts. Under these conditions the outcomes can be, at best, poor social science and poor art.

MUTABLE VIEWS: MULTIPLE POSSIBILITIES

If arguments that seek to justify research identity from outside the arts cannot be sustained, the challenge for arts educators is to reassess the principles that describe practice-led research undertaken in the university so that the similarities and differences from more traditional modes of inquiry can be cogently argued. Recent theorising about practice-led research has sparked a growing market of texts and online resources.[4] Some reflect a discipline focus on art and design research practices (Mäkelä and Routarinne 2006a; Sullivan 2005), or focus on the theory and practice of practice-led research within institutional settings (Barrett and Bolt 2007; Macleod and Holdridge 2006), while others position arts-based research within educational contexts and qualitative research (Cahnmann-Taylor and Siegesmund 2008; Knowles and Cole 2008). As scholarly support builds, so too does systemic assistance. For instance, the

Arts and Humanities Research Council in the UK[5] is clear in advocating an agenda that endorses research practices that are inherently discipline-centered in the arts and humanities whereby practice-led research in the arts is considered an area of inquiry that is important in its own right.

> Practice-led research is a distinctive feature of the research activity in the creative and performing arts. As with other research conducted by arts and humanities researchers, it involves the identification of research questions and problems, but the research methods, contexts and outputs then involve a significant focus on creative practice. This type of research thus aims, through creativity and practice, to illuminate or bring about new knowledge and understanding, and it results in outputs that may not be text-based, but rather a performance (music, dance, drama), design, film, or exhibition. (Arts and Humanities Research Board 2003: 10)

Practice-led research, as it is enacted, has a distinctive trajectory of inquiry that is best seen in the way that conceptions and constructions of new knowledge are framed. The status of knowledge production in the visual arts remains a vexed question for many. A typical distinction asks whether knowledge is found in the art object or whether it is made in the mind of the viewer. This debate is ongoing and insightful accounts seek a more profound philosophical basis for situating practice-led research within institutional settings. Brown (2003), for instance, presents a realist perspective whereby artworks as institutional artefacts are seen to exhibit properties that are primarily objective, theory-dependent and knowable, and this gives access to insights that can be intuitive, mindful and discoverable. When seen in relation to the demands of research, Brown maps a set of 'symptoms of practice' that highlight different areas of shared emphasis between art making and research practice. If taken from the perspective of the artist, both knowledge production and the functions to which knowledge is put are best seen to be a dynamic structure that integrates theory and practice and contributes to personal, social and artefactual systems of understanding. A good example of the interdependent relationship among the artwork, the viewer and the setting can be seen in conceptualising practice-led research within higher education as all these forms interact within an interpretive community. In this instance, knowledge embedded in practice, knowledge argued in a thesis and knowledge constructed as discourse within the institutional setting all contribute to new understanding.

In its broadest sense, practice-led research is circumscribed by an equally important emphasis placed on the artist-practitioner, the creative product and the critical process. The locus of inquiry can begin at any of these three points. What is critical, however, is the interdependence of these domains and

the central role that making plays in the creation of knowledge. Mäkelä and Routarinne explain it this way:

> In established fields of research, making is generally regarded
> as consequent to thinking – at least in theory. Thus a series of
> experiments, for example, is carried out in order to test a certain
> assumption, i.e. to solve a problem or answer a question. In the field
> of practice-led research, praxis has a more essential role: making is
> conceived to be the driving force behind the research and in certain
> modes of practice also the creator of ideas. (2006b: 22)

A relatively simple way to consider this distinction is to acknowledge that some approaches to research involve moving from the 'known to the unknown' as new knowledge is constructed within the spaces and places opened up by the gaps in existing information systems. These procedures draw on established methods that confirm the probability or plausibility of outcomes and make use of accepted conventions and practices. What is of interest to practice-led researchers, however, is the possibility of new knowledge that may be generated by moving from a stance more accurately seen to move from the 'unknown to the known' whereby imaginative leaps are made into what we don't know as this can lead to critical insights that can change what we do know.

A useful way to think about how knowledge is created is to accept that in many instances it is productive to explore creative possibilities that are informed by, but not captive to, existing frameworks of knowledge. Even if there is ready acceptance that prior knowledge helps to compile knowledge that builds on the 'shoulders of giants', this can, in many cases, limit the opportunity for seeing things anew. Serendipity and intuition that direct attention to unanticipated possibilities has long been a valued part of experimental inquiry. Many scientific breakthroughs have occurred as a result of an unpredictable turn of events and in many instances these have opened up entirely new directions for research. Recent studies in cognitive neuroscience offer tantalising evidence that 'insight' is a consequence of precisely the opposite approach to the thinking advocated by the clinical model of inquiry that promotes progressive focusing, the elimination of confounding variables and distractions and exercising control. It is this intense attention to detail that is framed by prior knowledge that can limit creative links that may lead to insightful outcomes (Bowden et al. 2005; Kounios et al. 2006). The implication is that creative options and new associations occur in situations where there is intense concentration, but within an open landscape of free-range possibility rather than a closed geography of well-trodden pathways.

Therefore practice-led research that is supported by critical reflection and reflexive action can be seen to invert the research process because it encourages

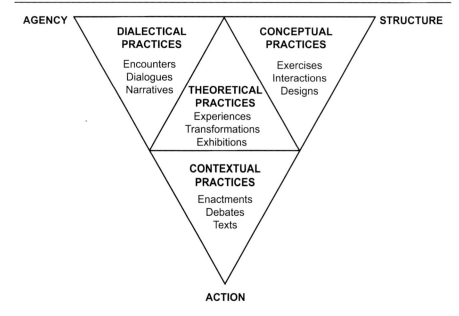

Figure 2.1 Practice-led research: a framework of practices.

working from the 'unknown to the known' and it is purposeful yet open-ended, clear-sighted yet exploratory. Practice-led research makes good use of this creative and critical process and may provide novel perspectives in reviewing existing knowledge structures. When studio inquiry is undertaken within a research context in an academic setting the imaginative outcomes generated consequently serve as a means to critique existing knowledge. It is evident from past discipline histories that imaginative investigations that breach accepted practices and challenge assumed canons contribute in a profound way to the core of our understanding. This is the legacy of what artist-researchers have to offer.

Figure 2.1 describes the scope of research practices pursued by artist-researchers. It describes the various domains of inquiry that encompass areas typically opened up in artistic research undertaken in studio contexts within university settings. The central strand that binds the four interconnected areas of practice is inherently *theoretical* and is the site where research problems and issues are found and explored – this is the 'making space' of the studio experience which is central to theorising practice *as* research (Sullivan 2005). Practice-led researchers subsequently move eclectically across boundaries in their imaginative and intellectual pursuits. When seen in relation to the surrounding areas, different perspectives and practices may emerge as inquiry twists and turns towards various sources in the exploration of forms, purposes and actions. As such, the border areas labelled *conceptual, dialectical* and *contextual practices* encompass those features that are part of research activity.

Conceptual practices are at the heart of the thinking and making traditions whereby artists give form to thoughts in creating artefacts that become part of the research process. Here the artist-researcher engages in practices that make good use of the capacity to 'think in a medium' utilising the distributed cognitive modalities associated with visual knowing. *Dialectical practices* are forms of inquiry whereby the artist-researcher explores the uniquely human process of making meaning through experiences that are felt, lived, reconstructed and reinterpreted. These may be personal or public and may result from experiences of art-making processes or outcomes of encounters with artworks. Consequently meanings are 'made' from the transactions and narratives that emerge and these have the power and agency to change on an individual or community level. Here the artist-researcher utilises the cognitive capacity of the arts as socially mediated processes and the process of 'thinking in a language' whereby images and objects are texts that carry forms of cultural coding that require analysis and dialogue to create and communicate meaning. *Contextual practices*, on the other hand, reflect the long tradition of the arts as critical forms of inquiry whose purpose is to bring about social change. Contextual art practices make use of cognitive processes that are best described as 'thinking in a setting' that is situational and makes use of visual texts, issues, debates and desires that are local in focus but global in reach.

Similarly, the various elements within these research practices sample those features typically associated with studio inquiry. For instance, research practice involves some form of information or image retrieval that serves as the basis for investigation. Traditional research methods label these exploratory processes 'data collection'. From the perspective of the artist-researcher, notions of data collection are necessarily expanded because there is a creative imperative that demands existing knowledge is less of an a priori condition framing inquiry and more of a stepping off point for imaginative interrogation during artmaking. The outcomes subsequently provide the basis for a critique of existing knowledge after the event and this can be surprising or salutary, for most creative solutions often appear alarmingly obvious and logical in retrospect. Consequently, for the artist-researcher, 'data creation' becomes a crucial component in the research process. Artist-researchers respond to these rich theoretical and procedural challenges and make use of multiple ways of giving form to thought that embodies meaning and this is negotiated in many contexts. An important part of practice-led research involves making sense of the information collected so that it can be translated into interpretive forms able to be communicated to others. The reflexive tradition of the arts enables both the artist and the viewer to participate in an exchange that is mediated by an artwork whereby change and transformation often results. This is the nature of aesthetic experience: it is interactive, encourages dialogue and generates debates. These are the kind of critical-analytical processes associated

with practice-led inquiry and reflect forms of engagement and the creation of meaningful artefacts. The means of representation are only limited by the imagination of the practitioner-researcher and can readily be found in exhibitions, designs, narratives and other visual-verbal texts as the artist-researcher takes on the roles of the theorist, designer, storyteller and cultural critic. Some examples bring this chapter to a close.

A REAR VIEW THAT LOOKS FORWARD

When art practice is theorised as research I argue that human understanding arises from a process of inquiry that involves creative action and critical reflection. There is an inherently transformative quality to the way we engage in art practice and this dynamic aspect is a unique quality of the changing systems of inquiry evident in the studio experience. The artist intuitively adopts the dual roles of the researcher and the researched, and the process changes both perspectives because creative and critical inquiry is a reflexive process. Similarly, a viewer or reader is changed by an encounter with an art object or a research text as prior knowledge is brought into doubt by new possibilities. Many artists and educators acknowledge the reality of reflexive inquiry, which 'works against' existing theories and practices and offers the possibility of seeing phenomena in new ways (Alvesson and Sköldberg 2000).

To discuss in more detail the approaches used by artist-researchers described in this chapter, an account is presented of a project undertaken in a small New York art gallery where the exhibition space was conceived as a research site.[6] In 2007 I worked with a group of Australian artists on a studio-based project that resituated the artist as social-historical critic. The exhibition, *New Adventures of Mark Twain: Coalopolis to Metropolis*, relocated a body of artwork created by several artist-scholars from the University of Newcastle that was first shown in Australia in May 2007. The purpose was to position the historical interpretations created by the artists within a context that offered a different perspective on mainstream views about the life and times of Mark Twain.

The exhibition was held at the Pearl Street Gallery in Brooklyn, from 28 September to 4 November 2007. The subtitle, *Coalopolis to Metropolis,* referred to an incongruous connection in 1895 between Mark Twain, the urbane American folklorist, and Newcastle, the industrial township north of Sydney, Australia. The exhibition featured creative and critical interpretations of themes inspired by an obscure incident involving Twain that occurred in Newcastle during his Australian lecture tour. Forced to take on a gruelling trip to the southern hemisphere to raise funds to cover his debts, Twain spent three months travelling by train around the southern reaches of Australia. His witty and worldly views were later chronicled in his book, *Following the*

Equator: A Journey around the World. At the time, Twain wryly observed, 'Australian history is always picturesque; indeed, it is so curious and strange, that it is itself the chiefest novelty the country has to offer . . . it does not read like history, but like the most beautiful lies' (1897/1899: 169–70).

During a trip to deliver a lecture northwest of Sydney, Mark Twain passed through Newcastle, 'a rushing town, capital of the rich coal regions' (Twain 1897/1899: 343). His visit to Newcastle, however, was not planned; he sought relief for a toothache. The recent discovery of an original letter of gratitude sent by Twain to a Newcastle dentist inspired the creation of a diverse body of work by several artist-scholars and authors from the University of Newcastle. The letter was sent in appreciation for the relief of a toothache suffered by Twain. Each artist and writer used the incidental discovery of Twain's letter as a point of departure that opened up a broader context for creative and critical interpretation. Themes explored included travel, place/time and the landscape, marking, writing and performance, social commentary, gender, sexuality and identity politics.

A pointed stab is made at the effigy of Mark Twain by Anne Graham (Figure 2.2) and Brett Alexander (Figure 2.3). Anne Graham takes on Twain (a.k.a. Samuel Clemens, a.k.a. Mr Brown) and his many identities with a theoretical and imaginative relish. She calls his bluff, strips him bare and hangs him out to dry. Graham lets us into Twain's world of fleeting finery where his devilish sense of self was always multiple and his identity questionable, yet as Graham shows, this is relatively easy to see through. She uses an ensemble of props in an installation that probes question about his chameleon character. Graham constructs a visual analogy about identity politics using the idea that clothing both covers up and yet reveals a truth. Analogies are a basic form of abstract representation that help viewers *translate* meaning by being exposed to something that is recognised – in this case 'transparency' – which is used as a means to come to understand something that may be obscure – the reinvention of identity and self. In this sense, Graham is using her art practice to bring a new understanding into play using a collection of related forms that are part of the store of Twain's artefactual history, but they may not have been represented in quite this fashion before.

Brett Alexander does a different kind of theorising – he takes aim at some illusions and comfortable complacencies that are part of the nostalgia for a past of much simpler times. It's hard to escape the rapid-fire clutches of his installation because it encloses the wall and floor spaces and enwarps the mindspace as memories of the past are remade from the questions cropping up in front of you. Alexander reminds us that Twain's stories get burnished with affection in their retelling and take on the warmth of old work clothes – like jeans and boots dragged on each day in anticipation of an honest day's work. Here the rhetorical strategy is visual metaphor and the theoretical reference is 'resemblance'

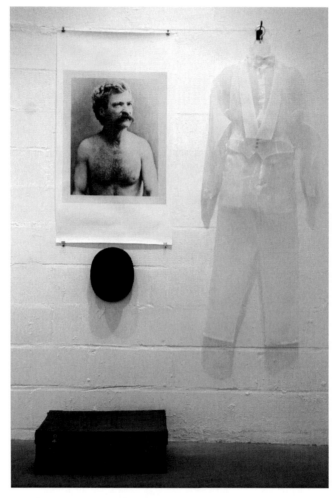

Figure 2.2 Anne Graham. Mark Twain's New Clothes. *The Suit: 'I prefer to be clean in the matter of raiment – clean in a dirty world.' The Hat. The Photograph. The Suitcase.*

as forms serve as evidence of claims made about social crises. For the viewer, visual metaphors help *transform* meanings by illustrating similarities and helping make connections. In this case, woven into the surface of clothing that is both comfortable but conjoined, are embroidered racial epithets and gender slurs that mask uncomfortable truths. By taking aim at these issues in metaphoric form and in literal, if playful, terms using toy guns, Alexander creates an echo of social disquiet that for him remains as woven into the fabric of society today as much as it was in Twain's time.

For Kris Smith (Figure 2.4) and Philip Schofield (Figure 2.5) the encounter with Mark Twain has a conceptual appeal as ideas take on form through media

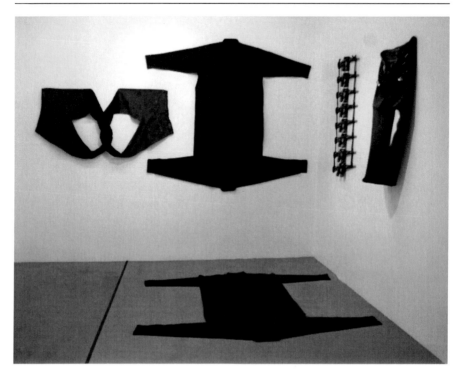

Figure 2.3 Brett Alexander. *Tomfoolery: Land of the free (to bear arms)* (wall mounted) and *Crime Scene: Hate Crime – Road Kill* (floor mounted).

Figure 2.4 Kris Smith. *The Lighthouse Keeper Sleeps.* 59 cm × 88 cm. Digital photograph.

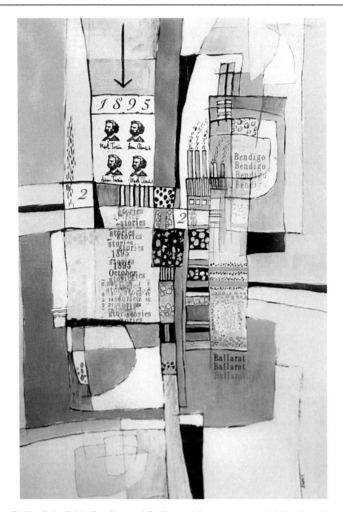

Figure 2.5 Philip Schofield. *Bendigo and Ballarat: 'the great nuggets'*. Mixed media on paper.

explorations that themselves reveal how fragments are often all that is used to give structure to meaning. Kris Smith's digital photographs of the headstone of James Johnson, a survivor of a calamity chronicled by Twain in one of his Australian stories, chart a time of day that also marks a time of life. The incident in history that was retold by Twain is revisited by Smith and unfolds in the most curious of coincidences. What we see is a mere fragment of an image, a visual index that represents much more. The weathered gravestones, fiercely shadowed in the daylight glare, look different in the soft cobwebs of dusk. Much in the manner of story fragments from the past, image bits may smooth over tragedy and triumph in the retelling, but can reveal other tales as well.

The concepts of place, time and travel are tracked in Philip Schofield's

visual essays. His aerial surveys of the landscape echo indigenous views of the land when seen from above and chart Twain's treks across southeast Australia. But there is a sense of distance evident in the images that also echo Twain's tendency to remain the perpetual visitor – the astute observer who also bears witness. The late 1800s was about the time that local artists realised that they could only begin to see what was around them if they shed the vestiges of accumulated knowledge, and this also often meant travelling abroad in order to look back with fresh eyes. Schofield creates local histories that could be readily captioned by excerpts from Twain's travelogue, for they serve as autobiographical traces through a muted landscape of snippets, signposts and snapshots.

The work of Miranda Lawry (Figure 2.6), Trevor Weekes (Figure 2.7) and

Figure 2.6 Miranda Lawry. *Excursion 2: 'with spacious views of stream and lake'*. Archival digital print.

Figure 2.7 Trevor Weekes. *Twain Spotting. Panels 1–5* (detail). Pen and ink on Stonehenge paper.

Patricia Wilson-Adams (Figure 2.8) open up a dialogue by connecting viewers with experiences that can be made their own. Anyone who has taken the train trip north from Sydney along the Hawkesbury River will immediately be transported into the textual narrative of Miranda Lawry's image series. This is the view Mark Twain saw:

> There was other scenery on the trip. That of the Hawksbury [*sic*] river in the National Park region, fine – extraordinarily fine, with spacious views of stream and lake imposingly framed in woody hills; and every now and then the noblest groupings of mountains, and the most enchanting rearrangements of the water effects. (1897/1899: 343)

The limits of peering out a window, where what is seen is formed by what is known, freeze-frames reality in Lawry's glimpses as the world speeds by. We feel this stretch of images rather than look at them because they are partly blurred and partly in focus, and in the mix we see through the spaces to places

Figure 2.8 Patricia Wilson-Adams. *Grave Markers for the Silent VI*. 2007. Lead, intaglio, silkscreen and emu feathers on Somerset Velvet paper.

we think we know but may have never seen. Miranda Lawry takes delight in a narrative game of compressing clues found in the wake of Mark Twain's journeys into a rhythmic visual language that transports us along the Mississippi as much as it does the Hawkesbury.

For Trevor Weekes subtle meaning making is not found in pushing pigments around, but in the sub-texts of stark pen and ink sequences in his Huck Finn and Tom Sawyer lookalike story. Here the message is the medium as Twain's imagined Newcastle nightmare rolls out in graphic detail. As Gionni Di Gravio (2007) acknowledges in his 'mythological explanation' of Twain's journey through Newcastle, local folklore arises from curious circumstances that often have nothing to do with fact but nevertheless serve to anchor a sense of identity, often through self-deprecating humour. Drawn in the best

Australian black-and-white cartoon tradition where de-fanging authority is a daily sport, the local legend of Mark Twain's legacy of half truths is given similar treatment by Weekes.

For Patricia Wilson-Adams, growing up in isolation amid the sparseness of Australia's interior landscapes meant that detail of particular places and things became silent markers of identity. Sites and settings take on narrative meaning that signal what it means to be part of a place and this can offer transient relief or remain rock solid. Her series, *Grave Markers for the Silent*, refer to those whose history has not been recorded and whose identity is unknown – a legacy faced by many from the past who, for Wilson-Adams, 'had no voice and remain silent' (2007: 32). Transposed into materials as fleeting as feathers or as tough as lead, Wilson-Adams' grave markers are emblematic of putting down roots and claiming a sense of ownership and agency while at the same time keeping on the move – incongruities that Mark Twain never resolved.

The art practice of Elizabeth Ashburn (Figure 2.9) and Pam Sinnott (Figure 2.10) capture contexts that are used to unsettle complacencies and reveal cracks and different tracks in constructions of public and personal histories. Myths masked as fact made by those in the know are also messages that bear false witness. Elizabeth Ashburn invites us into a world where fiction and falsity tease and tempt with disastrous consequences. Embellished with the decorative trim necessary to make a lie seem like the truth, her series of brightly colored miniature myths, rendered with the irony of exacting detail, take on new proportions when seen within a history of political lies. Cutout forms traced from illustrations in Twain's books (some of which he may have even drawn himself) echo the mischevious if ever present tendency of political expediency – a world in which faction and fiction mix with dire consequences and a reminder that, although the past has gone, history continues to repeat itself.

Pam Sinnott's cast of characters is beautifully held in centre frame in photo album black and white. Yet there is a tinge of nervous nostalgia amid the backyard patios, shrubbery and lawns and the visual clip of a Hills hoist. The backyard of the 1950s that was the playground for Aussie adventures of Huckleberry Finn and Tom Sawyer and other Saturday afternoon movie machos is a memory with a twinge. Although identity can now be enacted with comfortable ease, for the women who put themselves in Sinnott's scenes there remains an ill fit reminiscent of a past discomfort in who played the goodies or the baddies when growing up. Past times are mostly shown in images made by others, and for young girls this meant photos of them wearing their best party dress rather than snapshots of them as 'tomboys'. Sinnott's critique revisits these times and resituates them in ways that embody new meanings in the best traditions of a critical art practice.

Figure 2.9 Elizabeth Ashburn. *Lie Three: A yellow peril from Asia threatens to overwhelm Australia*. Watercolour and gouache.

Mark Twain's quip that Australian history reads like the most beautiful lies was not a put down. He went on to say that the 'lies' are 'all of a fresh sort, no moldy old stale ones' (1897/1899: 170). This is an especially apt description of the surprises found in the work exhibited in *The New Adventures of Mark Twain*. In his catalogue essay, Peter Hill finds fresh surprises in the way artworks 'rhyme' in time and place. He draws attention to the changing rhythms of influence that shape contemporary art. For many Australian artists in the past, rhymes were mostly heard and seen as echoes of events that happened first on other shores. Those who believed art happened somewhere else were always eager to embrace cultural stylists from afar.

Figure 2.10 Pam Sinnott. *Cowboy*. Digital photograph.

However, this was not the attitude of the 'new breed of creative academics' (2007: 35) that Hill writes about who participated in this exhibition. Rather, they opened up ideas to allow us to look in new ways at art, culture, history and research, among other things. For some viewers of this exhibition in New York there was an element of unease as past notions were unsettled and prodded, and the comfortable knowledge of Mark Twain and his stories was jolted by the images on display. Others were able to arrive at a conclusion similar to Mark Twain's response to his Australian surroundings, where there was a sense of comfort knowing that past truths are 'full of surprises and adventures, and incongruities, and contradictions, and incredibilities' (1897/1899: 170).

CONCLUSION

A central claim made in this chapter is that practice-led researchers share the goal that research involves the quest to create new knowledge, but do so by making use of a series of inquiry practices that are theoretically rich, conceptually robust and provoke individuals and communities into seeing and understanding things in new ways. Figure 2.1 presented earlier in this chapter describes various practices, forms and outcomes encompassed by practice-led researchers. The illustrations from the *New Adventures of Mark Twain* exhibition provide more concrete examples of artist-researchers in action.

But how is new knowledge created in practice-led research? First, there is an unequivocal creative impulse that is a critical starting point in looking beyond what is known. Irrespective of whether the origin of knowledge is stable or shaky, there is a need to move beyond prevailing attitudes, assumptions and assurances. As Benjamin Genocchio reminds us with his reflection on Australian indigenous history, 'absence of evidence is not evidence of absence' (2001: 28), therefore there is a continual need to reassess interpretations of past histories. Second, there is acceptance that traditional systems for knowledge that rely on probable outcomes or plausible interpretations cannot fully respond to the challenge of new interpretive possibilities.

This is where artist-researchers take us – to where we've never been, to see what we've never seen. And then they bring us back and help us look again at what we thought we knew. Facing the unknown and disrupting the known is precisely what artist-researchers achieve as they delve into theoretical, conceptual, dialectical and contextual practices through artmaking. As described in this chapter, practice-led research variously emphasises insights revealed by the artist-practitioner, the creative product or the critical process. To fully consider the impact this quest for new knowledge has on the self, others and communities requires a new responsibility on the part of artist-researchers to take up the challenge of theorising their practice, for 'in academe, the artist-researcher cannot hide behind the robe of the mute artist' (Mäkelä and Routarinne 2006b: 25). To meet these demands it is no longer viable for advocates of practice-led research to merely borrow methods from other fields of inquiry for this denies the intellectual maturity of arts practice as a plausible basis for raising significant theoretical questions and as a viable site for undertaking important artistic, cultural and educational inquiries. If a measure of the utility of research is seen to be the capacity to create new knowledge that is individually and culturally transformative then the potential of practice-led research to open up new realms of possibility is now in full view.

NOTES

1. Cézanne quote in letter to Emile Bernard, 1905 (cited 25 May 2008). Available from: http://constable.net/arthistory/glo-cezanne.html.
2. Policies pursued at the time were contained in *Creative Nation: Commonwealth Cultural Policy*: October, 1994 (cited 31 May 2008). Available from: http://www.nla.gov.au/creative.nation/contents.html. The enthusiasm for creativity as a central focus of cultural policy continues, as evidenced in the report *Towards a Creative Australia: The Future of the Arts, Film and Design* (cited 31 May 2008). Available from http://www.australia2020.gov.au/topics/creative.cfm. This was part of the *Australia 2020 Summit* held on 19 and 20 April 2008 (cited 31 May 2008). Available from http://www.australia2020.gov.au.
3. There are several government-sponsored reports and conference papers that track the political changes and legislated frameworks put in place during the 1980s and 1990s as the visual arts came under close scrutiny in higher education. Those undertaken in the UK, such as Frayling and colleagues (Frayling 1997; Green 2001), were reference points that informed the Australasian context.
4. See, for instance, the online journal *Working Papers in Art and Design, vols 1, 2, 3, and 4* (cited 4 June 2008), available from: http://sitem.herts.ac.uk/artdes_research/papers/wpades/index.html; and the Conference Proceedings *Speculation and Innovation: Applying Practice Led Research in the Creative Industries*, Queensland University of Technology (cited 3 June 2008), available from: http://www.speculation2005.net.
5. The Arts and Humanities Council in the UK was established in April 2003 and replaced the Arts and Humanities Board that was originally set up in 1998. See http://www.ahrc.ac.uk.
6. *New Adventures of Mark Twain: From Metropolis to Coalopolis* (cited 1 June 2008), available from: http://www.newcastle.edu.au/service/archives/marktwain/venues.html. For images from the Pearl Street Gallery exhibition of New Adventures of Mark Twain see http://picasaweb.google.com/Samuel.Clemens.Mark.Twain/TwainPearlStreetGalleryNY (cited 4 June 2008).

REFERENCES

Alvesson, M. and K. Sköldberg (2000), *Reflexive Methodology: New Vistas for Qualitative Research*, London: Sage.

Arts and Humanities Research Board (2003), *The Arts and Humanities:*

Understanding the Research Landscape, Arts and Humanities Research Council (UK) (cited 4 June 2008), available from: http://www.ahrc.ac.uk.

Barrett, E. and B. Bolt (eds) (2007), *Practice as Research: Context, Method, Knowledge*, London: I. B. Tauris.

Bowden, E. M., M. Jung-Beeman, J. Fleck, and J. Kounios (2005), 'New approaches to demystifying insight', *Trends in Cognitive Sciences*, 9, 322–8.

Brown, N. C. M. (2003), 'Art as a practice of research', *Proceedings of the 31st InSEA World Congress, August, 2002. InSEA Member Presentations: Papers and Workshops CD-ROM*, New York: Center for International Art Education, Teachers College, Columbia University.

Cahnmann-Taylor, M. and R. Siegesmund (eds) (2008), *Arts-based Research in Education: Foundations for Practice*, New York: Routledge.

Di Gravio, G. (2007), 'Why Mark Twain lost a tooth in Newcastle: a mythological explanation', in *New Adventures of Mark Twain: Coalopolis to Metropolis*, Newcastle, NSW: University of Newcastle, pp. 62–72.

Frayling, C. (1997), *Practice-Based Doctorates in the Creative and Performing Arts and Design*, Lichfield: UK Council for Graduate Education (cited 6 February 2009), available from: http://www.ukcge.ac.uk/publications/reports.htm.

Genocchio, B. (2001), *Fiona Foley: Solitaire*, Annandale, NSW: Piper Press.

Green, H. (2001), *Research Training in the Creative and Performing Arts and Design*, Lichfield: UK Council for Graduate Education (cited 6 February 2009), available from: http://www.ukcge.ac.uk/publications/reports.htm.

Hill, P. (2007), 'The dentist, the lighthouse keeper, the storyteller and his thirteen white suits', in *New Adventures of Mark Twain: Coalopolis to Metropolis*, Newcastle, NSW: University of Newcastle, pp. 34–51.

Knowles, J. G. and A. L. Cole (eds) (2008), *Handbook of the Arts in Qualitative Research: Perspectives, Methodologies, Examples, and Issues*, London: Sage.

Kounios, J., J. L. Frymiare, E. M. Bowden, J. I. Fleck, K. Subramaniam, T. B. Parrish and M. Jung-Beeman (2006), 'The prepared mind: neural activity prior to problem presentation predicts subsequent solution by sudden insight', *Psychological Science*, 17, 882–90.

Macleod, K. and L. Holdridge (eds) (2006), *Thinking Through Art: Reflections on Art as Research*, New York: Routledge.

Mäkelä, M. and S. Routarinne (eds) (2006a), *The Art of Research: Practice in Research of Art and Design*, Helsinki: University of Art and Design Helsinki.

Mäkelä, M. and S. Routarinne (2006b), 'Connecting different practices', in M. Mäkelä and S. Routarinne (eds), *The Art of Research: Practice in Research of Art and Design*, Helsinki: University of Art and Design Helsinki, pp. 10–39.

Organisation for Economic Cooperation and Development (OECD) (2002), *Frascati Manual: Proposed Standard Practice for Surveys on Research and Experimental Development*, Paris: OECD Publication Service (cited 1 June 2008), available from: http://www.oecd.org/document/6/0,3343,en_2649 _34451_33828550_1_1_1_1,00.html.

Strand, D. (ed.) (1998), *Research in the Creative Arts, 98/6*, Department of Employment, Education, Training and Youth Affairs, Canberra: Commonwealth of Australia.

Sullivan, G. (2005), *Art Practice as Research: Inquiry in the Visual Arts*, Thousand Oaks, CA: Sage.

Taylor, M. C. (2001), *The Moment of Complexity: The Emergence of Network Culture*, Chicago: University of Chicago Press.

Twain, M. (1897/1899), *Following the Equator: A Journey around the World*, Volume I, Author's National Edition, New York: Harper & Bros.

Wilson, S. (2002), *Information Arts: Intersections of Art, Science and Technology*, Cambridge, MA: MIT Press.

New Media: The 'First Word' in Art?

Simon Biggs

There has been a significant increase in academic research within the creative arts. There are a number of drivers behind this which have been documented in an increasing number of books (Candy and Edmonds 2002; Sullivan 2005; Gilman 2006), journals and conference proceedings.[1] Many practitioners working at this cutting edge are new media artists. The question arises whether the characteristics of new media art encourage its practice as research?

Before addressing this it would be useful to clarify what is meant by 'new media art' and 'research'.

TERMS

New media art can be defined as creative arts practice that involves the development and/or application of emergent mediating tools and systems. New media art necessarily researches novel means and reflects upon them in its outcomes. The processes and outcomes of new media art may suggest that it be regarded as qualitatively distinct from conventional artistic practices as the artwork embodies novelty within an expanded set of criteria.

If new media artists develop and/or employ emergent and novel media in the production and dissemination of their artwork then they will, as a matter of course, be required to undertake research into the media systems they employ. This leads to the question: what is research and how might artists do it?

Research can be defined as original investigation seeking to create new knowledge. However, there is no single definition of what methods or subjects might be valid as research. Different disciplines conceive research differently. Conventionally research has been defined as 'basic', 'scholarly' or 'applied' and comprised of varying quantitative and qualitative methodologies.

In practice research cannot be so clearly defined. Various knowledge

domains employ distinct combinations of fundamental forms of research and associated methodologies. New research modalities are constantly emerging as new problems demand novel solutions. Thus 'translational', 'strategic', 'clinical' and other forms of research exist in the literature. A recent form of research is 'practice-led'. This has emerged as a research category due, in part, to the demands of a higher education sector where creative arts subjects now offer research degrees and are thus subject to a rigour similar to the sciences.

Practice-led research has developed within a number of academic contexts, including the creative arts. However, other established subject areas have been instrumental in defining practice-led research, notably the health-related sciences. As its name suggests, practice-led research employs professional and creative practice methodologies and evaluative criteria. As an evolving area practice-led research is still developing its methodologies. They are often characterised by hybridity, appropriating methods from other research domains.

The UK's Research Assessment Exercise (RAE) guidelines define research as follows:

> 'Research' for the purpose of the RAE is to be understood as original
> investigation undertaken in order to gain knowledge and understanding.
> It includes work of direct relevance to the needs of commerce and
> industry, as well as to the public and voluntary sectors; scholarship; the
> invention and generation of ideas, images, performances and artefacts,
> including design, where these lead to new or substantially improved
> insights; and the use of existing knowledge in experimental development
> to produce new or substantially improved materials, devices, products
> and processes, including design and construction. (RAE 2001)

What is clear from this definition is that artworks can be valid research outcomes, whatever their form or media, so long as they are regarded as embodying new knowledge or improved insights. Thus it is accepted that artists can undertake the production of art and, at the same time, be undertaking research that will ultimately be embodied in the final artwork.

Stephen Scrivener has observed that the idea of the artwork embodying research can be problematic:

> The visual arts community places great significance on the art object
> and the art making process. Consequently, many visual artists wish to
> see a form of research in which art and art making are central: that is to
> say, the art making process is understood as a form of research and the
> art object as a form of knowledge. If one takes this position and accepts
> the common understanding of research then one must be able to explain
> how visual art contributes to knowledge. (Scrivener 2002)

Scrivener asserts that the 'proper goal of visual arts research is visual art' and observes that understanding the art making process as yielding new knowledge, independent of the art object, may risk relegating the artwork to the status of a by-product. To expect the artwork to primarily embody knowledge would, in the eyes of many, lead to a utilitarian view of what art can be.

In Scrivener's view the generous ambit of the RAE's definition of research is not sustainable. He proposes a problematic of how research and creative practice might operate together and seeks to redefine what research can be, proposing 'that we should not attempt to justify the art object as a form of knowledge and should instead focus on defining the goals and norms of the activity that we choose to call arts research.' Although he is not seeking a definitive answer to this problem Scrivener has opened the door to an alternate view of what research can be for and proposes this might include, along with knowledge, other outcomes. He argues that apprehension can be considered the objective of art and that this can be a research outcome, and thus a justification of research, if the '. . . researcher intends to generate novel apprehensions (by novel I mean culturally novel, not just novel to the creator or individual observers of an artefact) by undertaking original creation, and it is this that separates the researcher from the practitioner.'

Scrivener's argument echoes the earlier observation concerning new media artists and the research they are obliged to undertake to produce artworks that employ emergent media. In this respect new media artists are engaged in research that appears, in many ways, to resemble research as it is undertaken in other fields. New media artists almost routinely undertake applied research, seeking to develop novel mediating systems or new applications for existing media. As artists they also have to satisfy the conventional demands for novelty associated with creative practice. They may seek to do this in terms that Scrivener would recognise as compliant with his definition of creative arts research, or they may seek to satisfy only the conventional art world's expectations. However, the new media artist is free to do either and still be considered to have satisfied demanding definitions of what research is. In this we begin to see a possible answer to our question: why do new media artists seem to have been successful in adapting to working with research?

RESEARCH ENVIRONMENTS

Research is undertaken within a research environment. It might prove useful to look at how some new media arts research environments have emerged.

Although there are earlier initiatives,[2] an early example of artists' engagement with formal research environments was the 1967 to 1971 Art and Technology Program of the Los Angeles County Museum of Art (Tuchman

1971) involving, at that time, emerging artists Robert Irwin, James Lee Byars and James Turrell. This project has since served as something of a model for other initiatives, such as the Australia Council and Commonwealth Scientific and Industrial Research Organisation's (CSIRO) Artists Fellowship programme[3] of the 1980s and the more recent UK Arts and Humanities Research Council's (AHRC) and Arts Council England's (ACE) Art and Science Research Fellowships initiative.[4]

The Los Angeles County Museum's programme was focused on facilitating artists' access to the resources and working methods available in corporate research environments. The Australia Council and AHRC's initiatives were distinct in that the first placed artists within the purely scientific research context of the CSIRO while the AHRC programme placed artists within academic research contexts. In this respect the AHRC programme most closely matches the focus of this essay. Other initiatives, such as Xerox PARC (Harris 1999) and the Interval Research programme[5] were also important and distinctive examples of artists being engaged in research within corporate research environments.

What is notable about these examples is that they involved artists undertaking their work in what were, for them, alien environments. In more recent years (in the UK since 1996, when the AHRC – then AHRB – was created) there has been a move to a model where the research environments artists work within are determined and staffed by artists who are also researchers. We have seen emerge and gain credence the idea that creative arts practice is itself a research domain involving research criteria and methods that derive from the characteristics of creative arts practice.

ARTISTS' EXPERIENCES

The objective here is to inquire into new media artists' practice as research and the diverse forms this can take, asking whether new media artists are especially well placed to integrate creative practice with formal research. This task has been informed by primary research surveying new media arts practitioners working in research environments. The practitioner/researchers involved come from varying demographic contexts covering a number of countries and cultures, stages of career progression, gender and diverse social circumstances. The data has been evaluated in order to help determine whether new media art practices do promote ways of working that afford a particularly amenable relationship to formal research methods and objectives. The highly internationalised field of new media arts practice and related research activity is contextualised within the varying characteristics of the geographic, political and social circumstances in which such work is undertaken.

Questions include: how the relationship between practice and research

can evolve during a professional career; how artists with primarily practice-led careers differ from those pursuing more academic roles; whether certain creative practices are better pursued within formal research contexts; what research methods seem to be most commonly employed in new media arts practice; and how the relationship between practice and research functions in a number of different contexts.

One issue to emerge among the respondents concerned is whether they perceive themselves as artists. Most appeared happy to be defined as artists but a number were clear that they saw themselves as having hybrid professional identities and, in some cases, questioned whether being identified as an artist accurately reflected what they did.

Mexican artist Eugenio Tisselli articulated this when he stated:

At one point in my life I realised that some of the creative work I was doing could be seen as being artistic in quality . . . I landed on the artistic world by mere convenience. I have also abandoned this world just as easily.[6]

Although Tisselli has worked in higher education he has most recently been working within the industrial research environment of Sony's Paris-based Computer Science Laboratory. A number of well known new media artists have worked at this facility. Like many of the artists discussed here, Tisselli actively engages in the development of the technologies underpinning his work, researching and developing new applications and systems. As he observes:

My creative work is largely based on programming, the discipline which I have followed since I was ten years old. Programming creatively is a highly experimental activity and is always tightly linked to research, whether formal or informal. So, for me, research has been a significant aspect of my work from the very beginning.

UK artist/writer John Cayley articulates ambivalence about his professional identity when he states:

I started working full-time in academia only six months ago (Brown University, Rhode Island, USA). I am trained in another field – Chinese language and civilisation – and was a curator (1986–89) in the British Library, Chinese Section. My 'career' in writing digital media has run parallel and unsupported, until now, to my academic involvement.

Although ambivalent, it should be noted that Cayley's artwork explicitly reflects the hybridity of his professional interests, engaging as it does with

generative poetics, polysemic writing and multimedia combinations of text, image and sound.

The artists engaged in this survey present from a wide range of media practices. This diversity is a characteristic of new media arts practice, where the novelty and motility of media is more a concern than media specificity. These artists work across many media and approaches. Nearly all are familiar with and regularly work within collaborative contexts, working with artists and non-artists in teams engaging a range of technologies.

Nevertheless, while a particular artist may work across a wide range of media, they might identify themselves very clearly in disciplinary terms, as Johannes Birringer exemplifies when he states 'I am a choreographer', continuing:

> I work in theatre, dance, moving (and still) images, site-specific installations, exhibitions, digital works, telematic works (online performance), interactive design, screen-based installations, poetry/ music. My work has been shown in theatres, concert halls, museums, galleries, at festivals, outdoors and site specifically, at film festivals, art exhibitions, photography exhibitions and online.

What is clear here is that while Birringer considers himself a choreographer, the forms his work takes and the contexts it might be encountered in engage many arts. Birringer's comments evidence ease in working with hybrid practices which derives from the strength he acquires from a clearly defined disciplinary foundation in his practice.

This hybridity and ambiguity in forms of practice is reflected in the diverse contexts in which many of these artists undertake their practice and research. These range from the academic to the industrial, engaging the physical and social sciences and involving collaborations across numerous disciplines. This complicates what forms knowledge might take in different circumstances and how value accrues to it. Atau Tanaka observes:

> I have worked in various contexts – as an independent artist, in an industry-sponsored lab and in academia. Knowledge is available everywhere, especially in today's era of democratised knowledge. Resources differ in each context, but it is not simply a question of magnitude – it is also a question of process and procedure to obtain resources, and the politics of compromise inherent therein that shifts from context to context. This determines the liberty and freedom of research, and alongside that the criteria and rigours of evaluation.

Further reflecting such pragmatics Maria Mencia states:

I have pursued the production of my artwork and research within an academic environment as this provides me with the production, network and dissemination platforms needed for the development of the work. I don't think this is the only environment which would allow me to develop my work as there are many other avenues in the art world but it has been my choice to select the academic as opposed to the art world.

Mencia contextualises this and the value derived from this approach when she says 'I am interested in the art scene when exhibitions expand into other dialogues such as seminars, talks and workshops; otherwise I find the art gallery a bit sterile and contained.'

Miguel Santos amplifies Mencia's observations on the value of expanded creative environments when he states:

The (art)work is developed within an academic/research environment. The reasons (for this) are wider than accessibility to resources and knowledge but accessibility is a crucial element. The academic/research environment demands a specific form of rigour and freedom, a sort of frame for the artwork, that I do not find within an art environment.

Johannes Birringer observes that seeking to undertake creative practice and research in an academic environment can be a mixed experience. He notes:

Most institutions are not equipped to do sustained experimental multimedia work. I would require a lab and laboratory conditions as they exist in the sciences but most art or humanities programs do not understand this and expect me to set up (a lab) and strike it every night, set up again the next week, for 3 hours, strike the 'set', beg for open network connections, and bring my own laptops.

On the other hand he also identifies the benefits of:

. . . using university theatres with lighting and bringing performance students and art students together with computing science, design and engineering, connecting dance and music technology, allowing ourselves the luxury of using a new motion capture system installed in an advanced computer centre, making friends in biology and life sciences, learning new things, meeting other scientists, hearing the new discourse, attending lectures and conferences.

This suggests he finds the hybrid and expanded nature of interdisciplinary work more rewarding than the contexts afforded by conventional artistic practices.

Birringer's experience evidences that the creative arts as a research area within academia is an emergent phenomenon that is not entirely comfortable within an institution that often does not understand the particularities of creative practice as research. Anne Sarah Le Meur observes that:

> In France art departments in universities rarely have money or computer laboratories. So my practice is made outside the university. I have to work on my own, with my own materials or find and pay other people to work for me. The theoretical part of my research gains more advantage from my academic position.

This suggests that in some contexts the idea of the creative arts as research is not yet established and the artist can only expect support when it resembles conventional research. Kai Syng Tan, within the context of Fine Arts education in Singapore, observes:

> Since the environment for my professional work as a teacher does not sufficiently support my artistic work I separate the two. I conduct research for my artworks on my own, outside and independent of my teaching in college. Sometimes I do bring into the classroom what I have investigated to share with the students, but I consciously try to separate the two.

Kirk Woolford echoes this when he states '. . . my relationship to academia has always been secondary to the creation of (art)works themselves.'

Michael Naimark has worked as an artist and researcher in diverse contexts: academic, corporate, industrial, non-profit and freelance. He notes that the perception of the artist in these varying contexts can function problematically, for both parties. 'If you are a good artist in a commercial environment then people worry that you will waste money. If you are a good producer in an arts research environment people think you can get things done.' Naimark is observing that such perceptions function to ingrain the misapprehension that artists only work in research environments so as to gain access to resources and, the obverse, that artists are poor managers of their own and others resources.

Kirk Woolford observes, tellingly, that 'I had better access to people and resources through my own (private production) company than I do through the university', suggesting that, on the one hand, the university might not always present the opportunity it appears to from outside and, on the other, that artists can be very capable managers.

Sustaining Woolford's observation that the university might not offer the sort of support that the artist hopes for, Garth Paine notes that:

The university sector in Australia does not recognise practice-driven research in terms of research workload – this is calculated using a science model, accounting for competitive research income, books and journal articles only. Therefore if one is to maintain a research practice within the institution it needs to address these criteria.

It is clear that experiences in the UK, USA, France, Singapore and Australia are distinct. However, it is also evident that within a single country's higher education sector (the UK) there are also big differences (Birringer and Woolford) and even within a single institution and department (Birringer). These differences are possibly due to variations in how successful departments have been in attracting research funding and how they have negotiated the relationship between research and teaching.

Whatever the challenges working contexts present, all of the respondents agreed that research and practice inform one another. Tanaka simply stated 'My practice emerges from research' while Le Meur observed 'both are completely melded.' Miguel Santos noted that 'My working methods require research and practice and I only find problems when I start to make a distinction.' Florian Cramer responded with the nuanced comment that 'My research attempts to be led by artistic practice' while Mencia problematised the relationship between practice and research by observing that 'My working methods are both practice-led and research-led but I would argue this distinction is understood differently by artist/researchers and academics', illustrating the discomfort academe feels in accommodating creative practice as research.

Given this evidence of how research-active artists interface with their immediate working environment, it is also useful to seek an overview of how they engage a broader creative research community. The experience of Stuart Jones may echo that of most creative arts professionals employed in higher education when he states that 'the community of my practice is largely different from the community of my research.' Jones is reflecting upon how distinct pedagogy and research are from practice, and how exclusive professional communities are formed around each area of activity. While some of the survey respondents differ what emerges is that many have encountered difficulties in reconciling their roles in their research environment and their professional practice, even when they find them methodologically complementary and mutually dependent.

Reflecting the problems that can emerge if cultures collide, when the art academy and the university meet, Anne Sarah Le Meur responds:

Most of the time, colleagues discuss or work together because they are already friends; they studied together or met outside the university.

You don't generally speak to colleagues about research. Academe is reserved and this is a way to avoid conflict.

Maria Mencia observes:

There is not a place for me in my institution as a researcher. Although my research is acknowledged, there is not a research culture or centre recognised as part of the RAE where my work can be placed. Therefore, it makes things difficult in terms of getting time and funding for research.

However, other respondents had a different view of their environment and community. Michael Naimark observed that 'new media arts is a larger territory than we know and most of it has not yet been explored. There is a lot of space between the different media involved and many different cultures associated with this.' Naimark is identifying not only the diverse contexts and interests that constitute interdisciplinary art practices but also the space between disciplines where opportunities for novel work are most profitably pursued. He notes '. . . those artists who can move between these research communities will discover new areas of practice. Thus much of the (artist's) time is spent on bridge building and learning new disciplinary languages. The challenge is to move beyond your comfort zone.'

Eugenio Tisselli similarly states: 'I see myself as part of a dispersed community. It is a community that draws its potential from its fragmentation and that communicates across digital networks.' Tisselli goes so far as to suggest that 'this fragmented community is some sort of global mind that transcends space and time.' Tisselli is commenting upon the global nature of contemporary culture, and its associated research communities and the instrumentality that underpins it – the emergence of a networked communications system that is not based on hierarchies or structures predicated on the centre serving and controlling the margins. The key here is the Internet and, not surprisingly, new media artists find themselves well placed to employ the technologies involved.

We have looked at the contexts research-active new media artists work in, the media and resources they work with, the environments that facilitate such work and how these factors impact upon both research and creative practice. We have inquired into how such artists perceive the relationship between research and practice, what the implications of working in one mode are for the other and whether they can balance them in a productive tension. Diverse experiences have been exposed, depending on context and the nature of the work the artists undertake. Perhaps it is now useful to turn our attention to how they go about doing their work in each of these domains.

The question, in terms of how it informs our hypothesis, is whether there

are any common characteristics in how new media artists undertake practice-led research or whether heterogeneity is the default. Do they employ the same means in their practice as they do in their research? Do they distinguish between these two modalities? An artist/researcher such as Paul Sermon might appear to confirm our expectations of what appropriate research methods in the creative arts are when he describes his approach as 'practice-led, action research, ethnographic research'. However, is this expectation supported by the evidence of our inquiry?

What emerges from the respondents is how many see practice as both the justification for the research and as a means for evaluating it. Michael Hohl observed that research 'begins with an idea for a project and an investigation of the tools, resources and skills necessary to realise it. Practice and research inform each other.' Naimark suggests he employs 'practice and research in an iterative' relationship. He notes that by these means you 'surprise yourself' and move towards a paradigm shift in the work, this being the measure of novelty and value. Kai Syng Tan sought to include the art audience in a discursive relationship, as active partners in the research and creative process, stating 'creative outcomes are but means through which the artist and audience engage in collective reflection, contemplation, dialogue and perhaps reconciliation.'

Many of the artists admitted they are opportunistic regarding methodologies, adapting and employing methods from diverse disciplines as a function of the demands of project objectives. They also observed that they employed strategies that artists have long used, such as intuition, arbitrary constraints and contrariness, alongside more conventional and rigorous methods recognisable from academia. Maria Mencia noted:

> I pick and use approaches according to the issues, enquiries or concepts I am pursuing in my research. In some projects the methodology is more specific, and sometimes I use an ethnographic approach; but I wasn't aware I was using this methodology before I set out to do my work,

Mencia continued, 'Intuition is not considered a research methodology but, as I mentioned above, the unknowable does take a part in my process of investigating'. Mencia articulates the potential for conflict when she states:

> . . . having to link (creative practice) to academia we have to find a way to describe research methodologies but I wonder if it would be more appropriate to call it processes of research and creative practice.

Stuart Jones similarly reflected upon how he employs a combination of artistic and academic methodologies, stating:

I tend to do a lot of contextual research, whether this may be about
the particularity of a place, the subject matter I am working with, a
particular art-historical context I am referencing: sometimes a particular
project will involve technical or scientific research. Much of my practice
methodology derives from musical practice, which thrives on practical
constraints. I like constraints and experience them as stimuli; I will
sometimes deliberately impose them in situations where they are not
strictly necessary.

This is significant as it evidences an artist's use of what could be considered
arbitrary processes as essential in their practice. One might ask whether this
contrariness is common in formal research contexts?

Miguel Santos articulated quite a different position, stating that:

My practice and research methodologies are the same. My
methodologies are developed from an ontological perspective in which
the use and the relations developed between objects, subjects and
systems are as important as the objects, subjects and systems of those
same relations.

Santos is in the process of completing a doctorate and he may feel more acutely
the need to reconcile practice and research. Michael Hohl, who recently com-
pleted his doctorate, firmly situates practice as instrumental to research:

Practice could be described as a research instrument (a method) and
part of the methodology. I have a theory, idea or hypothesis – and make
the tool to investigate it. The result is my practice.

When asked for a description of his research methods Paul Sermon
responded:

Embedded methods in practiced-led research – monitoring user
interaction and perceptions through software systems in interactive
artworks. Site-specific residency projects, action research used to
monitor self-progress in the creative process. Participating in online
communities, 'going native' in order to obtain informed ethnographic
records of responses and reactions.

Chris Meigh Andrews described his methods as the complete integration of
practice and research, clearly stating 'action research, practice-led' and further
articulating this as 'historical, philosophical, phenomenological'.

The respondents employ a diversity of formal research methods, including

contextual reviews, case studies, interviews, practical experiments, scenario building, action research, user monitoring and evaluation, external assessment through structured audience engagement, version control systems and ethnographic observation/analysis, among others.

To a large extent it was clear that most respondents were comfortable with employing such formal research methods and they regarded these as aspects not only of research but of their practice. However, serendipity was identified by several as central. Anne Sarah Le Meur stated that 'poetic writing can help/reveal as much as analytical (writing)', suggesting that methods familiar from the creative arts can be profitably employed alongside formal academic methods without concern that this might compromise rigour.

Nevertheless, Garth Paine noted that research and practice can be divergent:

> In my creative work I am always exploring. This is often a more experiential exploration, not focusing on a formal hypothesis but seeking new qualities in the materials I am working with. This subconscious approach to engaging with materials is critical to creative practice, is very difficult to quantify or qualify and is, I think, one of the main reasons that practice-driven research is so poorly respected as research.

The artists involved in this inquiry appear comfortable with working in research environments and subsuming related methods into their practice. However, a tension clearly exists between creative practice and research, and to seek to avoid or eradicate this tension could be counterproductive to both practice and research. Stuart Jones notes that 'I have a background in mathematics and physics (and) the lack of rigour often found in arts research, both in terms of method and language, appals me.'

Following on from this, a number of respondents echoed what have been frequent calls in the new media arts community for a greater quantity and better quality of critical writing. It is commonplace to hear that new media art remains under-theorised. Johannes Birringer notes that there is a need for

> more good writing on our artistic practices and thought (concepts and ideas articulated in works and in different ways of working). It is incredibly important to develop a more acute critical and historical awareness of the frameworks of art practices (performance, art, media) of the last 100 years. It is very important to think through the history of technology and the political history of science, technology and art.

If one of the objectives of research is to ensure that we are not constantly reinventing the wheel then Birringer's observation that 'students repeat the

same stuff and some of the bad experiments and practices I thought we had already abandoned fifteen years ago' is a sobering reminder of the lack of rigour in the sector and evidence of why it is important in both research and practice.

As Miguel Santos observes, echoing Stephen Scrivener's arguments about the problematic relationship of creative practice to research:

> Research within the creative arts suffers from an inferiority complex in relation to other established academic areas of knowledge. That inferiority complex is not the result of a less valuable knowledge or the novelty of creative arts research but the result of a constant need to justify that research/practice through aims, methods and outcomes that are external to the creative arts.

While creative practitioners are evidently comfortable with addressing the problems that pervade notions such as novelty and rigour they are in no better position to reconcile and resolve them than professionals in any other field, including academic, scientific or industrial researchers.

Michael Naimark usefully differentiates the concepts of 'first-word' and 'last-word' art. He notes that:

> With first-word art, rules and terms are not defined while last-word art is where you work within established traditions and known terms. First-word art is difficult to compare or theorise. Haydn was a first-word artist in developing the symphony. Beethoven's much later Ninth blew people away. Paik said if it has been done before he is not interested. Some artists think novelty and art are mutually required. Others that art does not really start to get going until an area of practice is established (for example, Beethoven). Nevertheless, people who work with new media are, by definition, first-word artists.

He concludes this argument:

> In the age of Google there is no excuse for not knowing what has gone before. Being ignorant of other's prior practice is not good enough. It is OK not to be totally innovative but if you make work and then claim it is novel that is not OK. However, in research this is not permissible. In industry you need to know that what you are doing is original or, at least, not know that there might be precursor technology. You need to be able to look a patent judge in the eye and say you had no knowledge of the prior work.

CONCLUSION

This text has asked whether the character of new media arts allows its creative practitioners to better engage formal research. Essential concepts were defined. Novelty in new media art and how this might relate to research was questioned. The emergence of practice-led research was described to enable us to see how new media artists, as creative practitioners, are contextualised relative to formal research paradigms.

The contexts within which new media artists are likely to find themselves engaging with research were reviewed so that an understanding of the working challenges they face could be developed. A range of environments were discussed with a particular focus on the academic research environment. As was observed, there is an increasing number of research centres being established which are led and staffed by creative practitioners, their research focus being, and their research methods deriving from, practice.

A survey of new media artists' experiences of a number of questions concerning creative practice and research was employed in order to gain insight into how artists work in research environments and apply research methodologies. Insights were gained that informed our inquiry.

It was observed that new media artists are able to satisfy quite demanding definitions of research being assimilated within their practice through two routes: firstly, through the demands of their discipline, that in order to satisfy the demand for novelty and critical reflection in their technical means such practitioners are obliged to undertake applied research to produce their work; secondly, in order to satisfy the conventional demands of the artist/researcher, that their outputs embody originality determined according to values and methods associated with formal research (as defined by Scrivener). It was proposed that the new media artist is doubly obliged to engage in research and is free to do either and still be considered to have satisfied demanding definitions of what research is. This argument was supported by the opinions of the surveyed artists, where they articulated how they employ methods associated with formal research as part of their creative work and apply academic and scientific criteria in the evaluation of the outcomes.

We can answer our question: yes, new media artists do seem to be well placed to engage in formal research. However, from the evidence presented here, this remains problematic. In some instances individual artists have articulated discomfort with and resistance to certain of the methods and values associated with formal research. Given that the advent of artist-led research within academic environments employing practice-led methodologies is relatively recent we are not yet able to determine conclusively what the outcome

of this development will be nor what its implications may be for professional academics and creative practitioners.

It may have been valuable, in this context, to address the modalities of diffusion that artists who engage in research contexts employ and how these differ from conventional strategies in the creative arts. The modalities of exhibition, performance and broadcast function to define the characteristics of art disciplines, but this has not been the focus of this inquiry. The key question remains as to what distinguishes a research output from an artwork. This distinction between artwork and output is important (even if it is artificial) as it is an expression of a commonly perceived distrust among creative practitioners of research. Why do some artists fear research?

Many artists working within academia do not wish to be perceived as researchers. They argue that to be identified as such dilutes their artistic identity, a social role evolved over centuries with an entire apparatus of expectation constructed around it. Central to this is the value attached to the uniqueness of the artist's 'voice', where novelty is regarded as a function of the self-differentiating individual rather than the collective dynamics of rigorous peer review. The art world replicates and promotes this 'myth of the artist' as it seeks to satisfy a market demand for artefacts which embody this mythic individual. If the artist is seen to be a researcher, subject to a system of peer review and the transparency of methods and criteria this demands, they risk seriously compromising this model of the artist, with profound effect on the reception of their art in its traditional domain, the art world. The practical difficulties associated with this likely justify many artists' discomfort with research.

Is it contradictory to employ artists within an institution that then requires them to submit their creative practice for assessment as research? As Scrivener observes, this may render their art practice utilitarian. However, we need to look beyond this if we are to find a solution which will ensure creative practitioners remain at the heart of art and design education and are facilitated through their institutional role, beyond drawing a salary, as practising artists and mentors of the next generation. The question here, therefore, asks what value artist-led research contributes to art and, indeed, whether it might function to compromise those things we esteem most in artistic practice and its artefacts? The answer to this question will become apparent through further study of the emerging practices and actual outcomes of research-active creative practitioners.

Many thanks to the artists who participated in the interviews essential to the development of this essay.

NOTES

1. The website 'Working Papers in Art and Design' extensively documents UK practice-led research: http://sitem.herts.ac.uk/artdes_research/papers/wpades/index.html (cited 8 April 2008).
2. In 1956 at Bell Laboratories Billy Kluver founded Experiments in Art and Technology, involving artists Robert Rauschenberg, John Cage and Jasper Johns and culminating in the historic Nine Evenings: Theatre and Engineering event at the Armoury, New York. Other artists included Lucinda Childs, Yvonne Rainer, Deborah Hay, Robert Whitman and David Tudor.
3. The Australia Council funded and placed artists at the CSIRO's National Measurement Laboratories in Sydney for periods of several months, allowing them to pursue defined research agendas with specific research scientists.
4. Information on this programme can be found at: http://www.ahrc.ac.uk/apply/research/arts_science_research_fellowships.asp (cited 8 April 2008). A report on the first round of awards was published in *Leonardo*, 39 (5) 2006.
5. Michael Naimark, a respondent for this essay, was a key researcher at Interval in the 1990s, a long-term laboratory, funded by Microsoft co-founder Paul Allen, which emphasised the importance of the role of artists in research environments. The title of this chapter refers to Naimark's essay 'First word art/last word art', *Fine Art Forum*, 15 (8), 2001 (cited 9 April 2008), available at http://www.naimark.net/writing/firstword.html. Naimark describes first-word art as predicated on creating novel form and last-word art as exploiting known form in pursuit of excellence within the form. Wisely he does not seek to assign value.
6. This and following quotes derive from research carried out by the author during early 2008, when artist/researchers were asked to reply to a questionnaire. Seventeen artists from the USA, UK, Australia, Germany, France and Singapore responded.

REFERENCES

Candy, L. and E. Edmonds (eds) (2002), *Explorations in Art and Technology*, New York: Springer.
Gilman, C. (ed.) (2006), *Research – The Itemisation of Creative Knowledge*, Liverpool: Foundation for Art and Creative Technology and Liverpool University Press.

Harris, C. (ed.) (1999), *Art and Innovation: The Xerox PARC Artist-in-Residence Program*, Boston: MIT Press.

RAE 2001 (2001), *Panel Criteria and Working Methods Guide*, Higher Education Funding Council for England (cited 9 April 2008), available from: http://l95.194.167.103/Pubs/2_99/.

Scrivener, S. (2002), 'The art object does not embody a form of knowledge', *Working Papers in Art and Design*, 2 (cited 13 May 2008), available from: http://www.herts.ac.uk/artdes/research/papers/wpades/vol2/scriven-erfull.html.

Sullivan, G. (2005), *Art Practice as Research: Inquiry in the Visual Arts*, Thousand Oaks, CA: Sage.

Tuchman, M. (1971), A Report of the Art and Technology Program of the Los Angeles County Museum of Art, New York: Viking.

Knowledge Unspoken: Contemporary Dance and the Cycle of Practice-led Research, Basic and Applied Research, and Research-led Practice

Shirley McKechnie and Catherine Stevens

Contemporary dance is most often created through bodily explorations in the medium of movement. It is expressive, ephemeral and unspoken. Dance epitomises the challenge for the temporal arts in documenting, describing, quantifying and explaining unspoken knowledge. In this chapter, we argue that the qualities of dance that challenge traditional research methods and documentation are informative in disciplines such as cognitive science. We will describe the way dance encapsulates embodied cognition and the potency of that unspoken knowledge. Drawing on our own experiences in multidisciplinary research in, about and for contemporary dance we discuss the application of extant qualitative and quantitative methods to creative, perceptual and cognitive processes in choreographers, dancers and observers.

Our industry-funded collaborative research began with observation and documentation of choreographers and dancers who were working collaboratively in the studio to create new works of art. These choreographers and dancers were immersed in *practice-led research* defined by Haseman (2006) as intrinsically experiential, coming to the fore when the researcher creates new artistic forms for performance and exhibition. The artwork constituted the outcome and knowledge for the artists. Subsequent analysis of documentation of the dynamic studio process drew on both qualitative and quantitative methods. Later still, we conducted basic research about dance with multiple live performances of dance works serving as stimuli for the investigation of observer response. From this and other basic and applied research we draw implications for the artform. While our own studies are only now beginning to complete the practice–research–practice cycle, we foreshadow new

investigations that arise from basic research outcomes and the opportunities for artists to implement, explore, augment or refute these research findings for dance in their research-led practice. It is concluded that universities working closely with community and industry groups present an ideal context, as well as the essential ingredient of time, for growing and communicating knowledge gained from practice-led research and research-led practice.

FORMS OF KNOWLEDGE IN CHOREOGRAPHY AND CONTEMPORARY DANCE

The choreographer is not in the studio. She is sitting at a desk at the end of a day wondering what she will write in her journal. The researchers with whom she is working have asked that she make a daily record of her studio practice. She writes: 'I go into the studio each day wondering what I will find there' (Smith 1999). How to describe in words the complexities and subtleties of movement, emotion and reflection that have characterised that particular day?

Complex dance vocabularies challenge the view of human memory as a storehouse of linguistic propositions. Creating and performing dance involves knowledge that is procedural (implicit knowledge or knowing how to perform various tasks) and declarative (explicit knowledge or knowing about states of affairs such as dance and phrases of dance). The inspiration for phrases of dance material may be a concept, feeling(s), a space, texture, rhythm, lilt or sound. Contemporary dance declares thoughts and ideas not in words but expressed kinesthetically and emotionally through movement. This is achieved through movement subtleties and qualities, contrasts between tension and relaxation, and contrasts between high degrees of physicality and absolute stillness.

Most often, communication in the studio is also through movement – 'Show me what you just did!' (Grove 2005). In the absence of skilled notation or multi-dimensional, multi-modal recordings and archives of dance works, dancers' bodies are the repositories of dance works that they have performed. The dancer's language, to Grove (McKechnie and Grove 2000), is a kind of utterance of the body or the body *being* uttered by a language it doesn't entirely know. Verbal language, he says, is full of these unexpected 'knowledges', these potentialities and pressures, and it may be that dance-language is the same.

Verbal encoding, said to be the first stage in the acquisition of expert skills (Anderson 1983), is not a necessary condition in contemporary dance. Verbal labels such as 'D's wrists', 'K's shoulders', 'hangs' may be used in the studio where dancers and choreographers name phrases or sections to cue and communicate in words (Stevens et al. 2003; Stevens 2005). Comparing the dance of

children and adults, the first author has noted an apparent lack of 'movement intelligence' among adults who came late to the dance experience. According to Damasio (1999), once language is learned it is impossible to not use it, as everything is named and this tends to take over. The children's superior ability in being able to 'look and do' supports the notion that kinaesthetic perception and knowledge precedes verbal coding. Kinaesthetic perception appears to be a skill retained by those who dance.

In a second 'associative' stage of skill acquisition (Anderson 1983) procedural knowledge may replace declarative knowledge or the two may coexist. Such proceduralisation is familiar to all in the experience of a new task becoming automatic with practice. The knowledge of a new dance work of which a dancer may be consciously aware will, with deliberate practice, become automated with retrieval fast and largely unconscious. The knowledge manifested in composing and performing contemporary dance fluctuates between procedural and declarative forms.

BASIC RESEARCH INTO THE UNSPOKEN KNOWLEDGE OF DANCE

In recent decades, writings on dance (Banes 1994; Carter 1998) have come largely from the perspective of postmodern cultural theorists and historians influenced by the dominance of poststructuralist theory. However, the field is now changing rapidly. In 2007 Alexandra Carter wrote,

> The activity of 'practice' has historically been seen as a binary opposite to that of 'writing' with the hierarchical values which binaries entail. In the dance profession words have been viewed with great suspicion; contrarily, in academia, practice has been a second-class activity. Recently, however, there has been an acceptance of practice as legitimate research.

This recognition has been slow in coming even though dance artists and scholars as well as their counterparts in the other arts have been writing and speaking about these issues for over a decade (McAuley 1996; McKechnie 1996; Smalley 1996; Strand 1998). Other theoretical perspectives are emanating from the neurological and cognitive sciences (Brown et al. 2006; Calvo-Merino et al. 2005), consciousness studies (Hagendoorn 2004) and a wide range of theoretical perspectives from the social sciences including anthropology and psychology (Grau 2007; Hanna 1979, 1988; McCarthy et al. 2006; Stevens and McKechnie 2005). Dance in all its cultural variations is complex human behaviour, its intricate physicality perhaps its most striking aspect.

The very qualities that make dance difficult to document and record – its kinaesthetic, non-verbal and embodied nature – make it relevant to neuroscientists and psychologists interested in complex visual, spatial, motor and temporal processes. As the subject of basic research, dance is recognised increasingly as fascinating and informative human behaviour with dancers leaping across chasms that have previously separated disciplines and epistemologies.

To date, the flow of information and knowledge has tended to be one-way with advances made in, say, our understanding of the mechanisms of action observation (e.g. through a motor mirroring or motor simulation system: Calvo-Merino et al. 2005) but with few if any explicit implications for development of the artform. However, with greater understanding of the forms of knowledge involved in creating and performing dance, particularly from cross-disciplinary inquiry, we anticipate flow-on effects for the artform and for artists. One spin-off comes from basic research into audience response and intention-reception. The second arises from the development of new technologies for the documentation of contemporary dance. We will discuss these two methods in turn.

KNOWLEDGE COMMUNICATED THROUGH DANCE – STUDIES OF INTENTION–RECEPTION

Dance is one of the ways in which a society communicates with itself and with other societies. Australian dance presents images of national identity, some direct and consciously local, others indirect, metaphoric, abstracted. In a collaboration involving industry partners, dance academics and cognitive psychologists, we gauged the effect of pre-performance information sessions on response to live contemporary dance (Glass 2005, 2006). The outcomes of this project have implications for the artform and dance industry in Australia.

Our experimental investigation of audience response involved the systematic manipulation of three variables or factors: choreographic intention (representational versus abstract), audience member expertise (experts (ten years' training) versus novices) and pre-performance information (generic information session, specific information session, no information session – control group). Four-hundred and seventy-two audience members formed the sample for the experiment with sessions conducted over a period of six months. Two new Australian works were used as stimulus material with data collected from audiences attending one of seven live performances in city and regional centres in the Australian Capital Territory (Canberra), New South Wales (Sydney), Tasmania (Launceston) and Victoria (Melbourne and Geelong). Approximately half of each audience arrived early to receive either a generic or

Table 4.1 Cues used to form an interpretation (Glass 2006)

Cue	Red Rain (%)	Fine Line Terrain (%)
Visual elements	40.5	35.9
Aural elements	31.4	35.9
Movement	31.4	< 10
Use of space	< 10	63.1

specific information session concerning the work they were about to see. The sessions were presented by dance writers and artists McKechnie, Grove and Healey, and included examples of movement performed by dancers live or on video. The remainder of each audience arrived just before the performance, forming a control group for the information variable (i.e. the control group received no information other than the title of the work and brief programme notes). The two dance works were *Red Rain* choreographed by Anna Smith and *Fine Line Terrain* choreographed by Sue Healey.

An example of *action research*, the implementation of different kinds of information sessions necessitated some means for evaluation of session effectiveness. This gave rise to the development of the Audience Response Tool (ART) – a new psychometric instrument for gathering psychological reactions to live or recorded performance (Glass 2005, 2006). The ART consists of three broad sections: a qualitative section that explores cognitive, emotional and affective reactions; a quantitative section that includes a series of rating scales that assess cognitive, emotional, visceral and affective responses; and a demographic and background information section (e.g. age, gender, dance or music experience, etc.).

Exhaustive qualitative and quantitative analyses of open-ended responses demonstrated that approximately 90 per cent of participants formed an interpretation of the dance work that they saw (Glass 2006). For the observer, contemporary dance can be viewed as non-representational or representational and various cognitive strategies may be called upon to extract representational content including (1) thematic analysis, (2) metaphor, (3) imagery, (4) narrative-searching and (5) personal memory. Some of the cues used to form an interpretation included visual elements, aural elements, movement and the use of space; Table 4.1 shows that the relative contribution of these elements in the two works differed (Glass 2005, 2006). Information sessions did not impact on the tendency to engage with the piece but *specific* information sessions did impact on the *content* of interpreted responses.

Almost 90 per cent of participants reported that they felt an emotional response, and almost 95 per cent of participants reported that they enjoyed at least one aspect of the dance-work. The results indicated that contemporary

Table 4.2 Reasons for enjoyment (Glass 2006)

Cue	Red Rain (%)	Fine Line Terrain (%)
Visual	32.4	51.3
Aural	28.4	28.3
Dancer characteristics	28.0	39.5
Movement	25.6	36.8
Choreography	10.0	18.4
Interpretation	7.6	25.0
Emotional recognition	3.6	6.6
Novelty	15.2	11.2
Spatial/dynamic	14.4	26.3
Intellectual stimulation	14.4	7.9
Piece generally	5.6	3.9
Emotional stimulation	7.6	9.2

dance is a multi-layered event with numerous avenues for emotional and affective communication. Some of the reasons for the experience of emotion and enjoyment, as stated by participants, included visual and aural cues, dancer characteristics, movement, choreography, novelty, spatial/dynamic elements, emotional recognition, intellectual stimulation, the piece generally and emotional stimulation (see Table 4.2). Audience members also noted higher-order relations between cues as being important for their enjoyment. For example, relations between dancer movement and music were mentioned; movement and music appear to embody motion expressed through structural variables such as dynamics and time (Glass 2006). Some of the processes that we had observed during practice-led research in creating a dance work (Stevens et al. 2003) are active as audience members watch contemporary dance – processes such as association, analogical transfer, synthesis and functional inference. Creative thinking was evident not only in the context of observers watching Smith's *Red Rain* (the dance work that we had studied from the perspective of creative choreographic cognition) but also in the context of a more abstract piece, Healey's *Fine Line Terrain*.

Information sessions did not impact on the tendency to respond emotionally or the tendency to enjoy the piece. Differing levels of dance expertise and experience among audience members did not appear to affect verbal responses gathered using the ART. Implications of the study include the value of a period of reflection after a performance suggested by the enthusiasm with which people entered into completing the questionnaire, the need for new methods that record involuntary responses (e.g. eye movements: Stevens et al. 2007) and continuous rather than retrospective reactions, and the role of pre-performance sessions offering a variety of ways to approach a live performance.

Other forms of pre-performance information

Recent findings in cognitive neuroscience point to other forms of pre-performance sessions that might enhance response to contemporary dance. Psychologists have long speculated that perception and action are intimately linked – that observing an action involves the same repertoire of motor representations that are used to produce the action (Castiello 2003). One implication of this view is that the capacity to understand another's behaviour and to attribute intention or beliefs to others is rooted in a neural execution/observation mechanism (Grèzes and Decety 2001). Using fMRI, Calvo-Merino et al. (2005) demonstrated neural mirroring and an effect of specialist expertise when dancers observed dance movement that they had learned to do (either classical ballet or capoeira) compared with movement that they had not learned to do (either classical ballet or capoeira). The results show an effect of acquired motor skills on brain activity during action observation – brain activity was affected by whether observers could do the action or not. Experts had greater activation when observing the specific movement style that they could perform; the same areas of activation in non-expert control subjects were insensitive to stimulus type (Calvo-Merino et al. 2005: 1245).

An implication for practice from this basic research is that an alternative to verbal pre-performance information might consist of action observation. Laboratory investigations of eye movement patterns of expert and novice observers of dance indicate that even after just one viewing of a short dance film, novice observers have acquired expectations about the dance and begin to anticipate trajectories and phrases (Stevens et al. 2007). For the active and more adventurous audience member, especially those with some dance experience, efforts to enact and embody some phrases of an unfamiliar dance work should heighten recognition of that movement in subsequent viewings of the dance. Enhanced response to the work will likely flow from increased perceptual fluency (Szpunar et al. 2004; Zajonc 1968). For example, a dance piece, like a musical one, can be constructed systematically so that there are novel movements or themes with repetition used to develop perceptual fluency as the piece proceeds, thereby constructing effective semiotic fields which would be expected to be viewer-specific as well as piece-specific.

NEW TECHNOLOGIES FOR DOCUMENTING CONTEMPORARY DANCE

The difficulties in documenting and archiving works from a temporal artform such as dance can also become a focus of research-led practice. As words fall

short of capturing the breadth and depth of knowledge in dance, the customisation of digital media in the reporting of graduate research helps communicate temporal and corporeal material (e.g. Adams 2006; Ellis 2005; Schippers 2007).

Virtual reality presents a glimpse of future documentation possibilities. With the rendering of immersive 3D worlds, one hopes that the capturing and archiving of the four dimensions of a dance, complete with multiple vantage points and soundscape, is not too far away. Merce Cunningham anticipated the complementary process, rendering dancers and dance in software, in Life Forms in the late 1980s, and there are myriad possibilities in both Dance Forms and Second Life.

Ready access to high-speed motion capture equipment enables not only real-time digital performance but the means to document and analyse new or 'classic' pieces. For example, we are working with mature artists in their reconstruction of dance works created in Australia in the 1960s. What at first glance might appear to be a project of purely historical interest becomes forward-looking and of educational import for the artform when new methods of documentation are introduced. Working with Ruth Osborne at QL2 Centre for Youth Dance, Jenny Kinder at the Victorian College of the Arts and Kim Vincs at Deakin University, dancers who originally performed the material will be filmed as they recall the movement material under various conditions (e.g. in silence and in the presence of powerful cues to long-term memory such as music and/or other dancers from that time). One goal is to transfer knowledge of the work to the bodies of newer dancers. The motion of the original and newer dancers will be recorded using state-of-the-art motion capture. The motion capture data in its various forms may then be used in new works in isolation or in tandem with dancers, as stimulus material for the investigation of psychological processes that mediate dance perception and recognition of lineages and legacies in Australian contemporary dance, and as a source for algorithmic choreographic variation. *Algorithmic synaesthesia* (Dean et al. 2006), meaning data and algorithms simultaneously driving sound and image (c.f. Monro and Pressing 1998), may manifest from algorithms driving choreography and other components such as sound. The cognitive load imposed by such intermodal relations or *relational complexity* (Stevens and Gallagher 2004) will be a basic pertinent research question.

Significant advantages will flow from high fidelity documentation of dance. We might ask where are the dances that have been so ahead of their time that they have been stored in an attic or dusty drawer waiting for a more comprehending and empathic era? The answer is that there are no attics or dusty drawers for dances. Only the dancers themselves retain fleeting traces of the movement images. For audiences, artists and researchers of the future, many dances are gone forever. Both artists and audiences are the losers when a fine

work cannot easily be recreated in other times and different places. Many Australian dances, including those of our most admired choreographers of the past, are among those losses. This perishability has both positive and negative effects. In the absence of many treasured dance 'texts' from even the recent past, it ensures the constant creation of new work, but it also leaves little by which to measure the stature of the work so endlessly created. Documentation enables peer review beyond the ephemeral live performance, and detailed analysis, re-visiting and refinement. Another essential ingredient for dance is the *time* to reflect, develop and revise.

TIME, DISCOVERY AND CREATIVITY IN A UNIVERSITY SETTING

In 1992, Graeme Murphy, one of Australia's most acclaimed choreographers, was commissioned to produce a full-length work (Grove 2001). Murphy was given just twenty-three working days in which to achieve it.

> Compared to a novelist, how little a choreographer is expected to explore or revise! We don't say to a composer, 'Here's the orchestra; take them next door and start whistling your symphony to them,' but that's just about what we require choreographers to do. Even at the top professional level, their job is seen as a matter of putting steps together, not (like other arts) as a form of thought. (Grove 2001: 1)

Australian choreographers are seldom given time to explore, test or revise their work. A few renowned choreographers, less constrained by the terms of their commission, often take a year or more to complete a work, but the results are there for all to see. The work of Pina Bausch, Maguy Marin, William Forsythe and other such independent artists lasts for years, touring internationally and seeding new creations in other environments as well. By contrast, the Australian dance industry suffers a perpetual shortage of highly evolved new work. Universities that contain departments of dance-study are uniquely positioned to work with industry to advance the kind of knowledge that will enrich and extend choreographic practice. If we consider the creation of new work as a process of evolution, then time becomes an essential ingredient.

A theory of the dance ensemble as an evolving dynamical system

Drawing on contemporary writings (e.g. Clark 1997; Heylighen 2001; Kauffman 1995; Thelen 1995) and extensive studio investigations, we contend that

collaboration in creative activities is something to be pondered to advantage. One perspective is that the dance ensemble is a microcosm of world structure, related in important ways to the larger concerns of societies and cultures. We theorise too that a collaborative ensemble is a dynamical system. The work of twentieth century physicists and biologists has revealed a universe that end-lessly generates novelty where complex systems evolve by accumulation of successive useful (and at the time useless) variations (Kauffman 1995). We have observed this kind of complex system in the dance ensemble, revealed as vital and energising for the artists involved (McKechnie 2005, 2007; Stevens et al. 2001, 2003). The studio process can be characterised as a 'community of creative minds' where cooperation and teamwork are essential elements of discovery and innovation.

The creative process in dance making – the editing, modification, creation and re-creation – appears to be a kind of evolution. For example, a movement subtlety seen in one dancer appears in the body of another, changed, often extended or transformed by the individual length of an arm or leg, a subtle shift of focus, a sudden stillness, an inclination of the head, perhaps a radical recasting of the rhythmic tensions. As a specific example, the processes involved in creating *Red Rain* consisted of a cycle of generative and explora-tory actions (Finke et al. 1996; Stevens et al. 2003). Initial generative phases consisted of pre-inventive structures with properties that promoted discov-ery. Examples from *Red Rain* include retrieval (red images: tomatoes, blood, red earth, red wax, red kidney beans), association (the concept of blood led to associated concepts of life, veins, arteries, spine, death, ritual), synthesis (blending of concepts of breathing and blood with red/blue paper), analogi-cal transfer (consideration of a paper sculpture as spine or personal history; pattern of helix movement as analogue of DNA structure). Pre-inventive properties in creative cognition included: novelty, ambiguity, meaningful-ness, emergence, incongruity and divergence. Exploratory phases included attribute finding (red/blue paper → womb, nest), conceptual interpreta-tion (beans as bloodflow or aurally as rainfall), functional inference (book/spine paper sculpture) and hypothesis testing (helix pattern problem and solution).

Processes involving both thought and action unfold in time. Substantial achievement is the result of the blossoming of ideas, the selective success and further evolution of some of these and the dying away or editing out of others. Charles Darwin's 'dangerous idea' (Dennett 1995) about the evolu-tion of species can also illuminate the evolution of ideas in a creative process. Dawkins (1989) coined the word 'meme' as a cultural analogue of the gene. He proposed that our ideas, beliefs, values, actions and patterns of doing things are conceived and evolved in mind processes, just as genes are conceived and evolved in biological processes. But the meme, in this theory, is replicated,

not in biologically defined cells, but in the minds of individuals and groups. Memes, he said, are also subject to variation, and to selection and replication, according to adaptive pressures. The nexus between memetic evolution and the concepts inherent in theories of self-organising dynamical systems can provide new ways of thinking about how dances are made within a collaborative framework.

These, then, are the two basic elements that form the basis of such a theory. First, the idea of a meme: a unit of culture, a pattern, a poem, a way of building a canoe, spinning a thread or a yarn, making a dance, or embellishing a particular style – the phenotype or distinctive expression of genotype in a given environment.[1] The meme is an idea nurtured in minds and passed from one to another by a process of selection, elimination or adaptation, and Barrett has suggested that the exegesis is a meme or cultural replicator (Barrett 2007). Second, the idea of the dance ensemble as a complex dynamical system adapting through time to the day-to-day changes inherent in any creative process. Such a system is sustained or not by its ability to adapt, to cooperate, to deal with ideas that are generated by group processes.

A third factor characteristic of evolutionary ideas is the need to preserve diversity. Biological evolution requires counterbalancing mechanisms that operate on both genotypes and phenotypes which preserve reservoirs of diversity, some of which may be counterproductive in the immediate environment, that ensure immediate and long-term adaptability. That is, any genotype should have multiple possible expressions in multiple phenotypes which can vary with time in response to the environment. Barrett (2007) emphasises the importance of infidelity in evolution, meaning a departure from customary ways of thinking and doing things. Such departures that occur within an individual's arts practice may of course constitute major breakthroughs or revolutions for an entire artistic style (Martindale 1990).

These theoretical frameworks provide powerful tools for thinking about how dances are made and communicated. While contemporary choreographers increasingly view the interchange between themselves and the dancers as a necessary part of 'evolveability' and, indeed, speak about these processes as natural and productive, it is seldom in terms of a self-organising dynamical system or that of evolutionary theory. To think in these terms would enable them to comprehend their creative processes within theoretical frameworks that can be applied to all natural systems, such as minds, groups, societies, cultures, weather patterns and economies. Time allows the emergence of greater complexity, and with it a much greater potential for finding the much sought for and often elusive pattern of structure and meaning.

COMPLETING THE CYCLE: BASIC AND APPLIED RESEARCH TAKEN INTO CHOREOGRAPHY AND PERFORMANCE

In research-led practice, new frameworks for thinking about dance now include the physical, biological, all the social sciences and many combinations of these disciplines (e.g. Bachner-Melman et al. 2005; Bond and Stinson 2000; Brown et al. 2006; Cross et al. 2006; Fensham and Gardner 2005). 'These sciences must themselves increasingly deal with culture and cognition all at once: questions about pleasure in movement, habit and skill, and kinaesthetic memory, for example, require neuroscientific, physiological, psychological, sociological, and anthropological investigation simultaneously' (Sutton 2005).

Our interdisciplinary collaboration began with a psychologist on the team observing and learning about the subject matter and processes of contemporary dance. In the first stages, quantitative and qualitative methods adapted from experimental psychology and the social sciences were applied to elicit and scrutinise the psychological processes integral in creating, performing and responding to contemporary dance (e.g. Stevens et al. 2003). The flow of information was predominantly one way. Dance practice generated a number of new works of art but was also in the service of psychological research.

With the acquisition of knowledge about contemporary dance, research-led practice becomes possible, concomitant with a flow of knowledge within and across disciplines involved in the collaboration. Ideas, knowledge and discoveries flow from basic research into practice, into the artform. Here are just a few illustrative examples and, in Figure 4.1, we illustrate our own practice–research–practice cycle across three different research projects over nine consecutive years.

Methods honed in examining audience response may be re-focused on students who are learning the craft of contemporary dance. Vincs et al. (2007) set out to address the question of how students learn to choreograph by looking at the underlying issue of how they view and construct meaning in dance. Rather than seeking to decipher the 'meaning' of students' responses to dance works through qualitative means such as description and intertextual analysis, they measured students' real-time responses to dance performances. The extent of agreement between observers' levels of engagement with the dance was higher than would be expected if those levels were solely based on intertextual factors. There was consistency in responses. While each observer brings their own experience, assumptions and expectations to any situation, there was remarkable similarity in peak responses across the group. In addition to intertextual meanings, older ideas of structural meaning in choreography – such as those of Langer (1953) and Humphrey (1959) – are far more prevalent and embedded in students' understanding of dance than might have been anticipated. Vincs et al. conclude that while the question remains whether students are

1. **Multidisciplinary team:** accrues a range of experiences, approaches and methods. Team members familiarise themselves with different discipline approaches, questions and language.

2. **Practice-led research (research in dance):** choreographers and dancers work collaboratively creating new works. Outcomes: (a) exegeses and theses that document practice, process, problems, solutions in the form of text, recordings, diaries, analyses, e-portfolios, reviews; (b) new works that are performed, subjected to further analysis inside and outside the research team, and that raise questions necessitating new basic research.

3. **Basic and applied research (research about dance):** building on collaboration in (1) and (2) turns investigative focus from choreographers and artists to audiences. Uses artworks developed in (2) as stimulus for experiments investigating audience response and effects of expertise, information session, and type of dance work. Experiments are conducted during live performances of *Red Rain* and *Fine Line Terrain* – art meets science, and audiences and dancers are both observers and the observed.

 Audience experiments raise questions about the best method for capturing unspoken knowledge of dance experts. These questions lead to new basic research and the development of the portable Audience Response Facility (pARF) to measure continuous responses; eye movement methods to record involuntary indices of attention and cognition; and motion capture to aid interpretation of continuous ratings of emotion from audience. New technology and methods are implemented initially in the laboratory, then in the dance studio with dance students as participants, and finally during live performance with the simultaneous recording of dancer motion and continuous audience ratings of engagement or emotion (see also Calvo-Merino et al.2005; McCarthy et al. 2006).

4. **Communication:** of (2) and (3) in many different formats – academic journal articles and book chapters, conference papers for academics and artists, community feedback forums, websites, blogs, magazines, newsletters and the popular press.

5. **Research-led practice (research for dance):** artists, industry, students begin to implement, explore, validate or refute experimental findings in the studio or in performance, for example pre-performance information, action observation, mere exposure and perceptual fluency, and conducting experiments that involve audience and artists as part of a performance.

Figure 4.1 Retrospective description outlining the stages in our nine-year multidisciplinary practice–research–practice cycle.

being taught to see dance in this way or the tendency is related to more general cultural norms and tropes regarding narrative in other media, the students see dance in surprisingly coherent and, it seems, schematic terms.

Respecting the aesthetic of a dance piece, techniques such as motion capture and continuous recording of response to live dance with PDAs (Stevens et al. 2008) enable the interlacing of experiment and performance. Pre-performance enactment is one example of the theatre as laboratory. In another example, we have simultaneously recorded the motion of a dancer while twenty audience members used the portable Audience Response Facility (pARF) to rate

emotion expressed during the dance performance. The performance consisted of three conditions – movement only, music only and movement plus music. We are currently analysing the effects of the absence and presence of music on dancer motion and continuous audience response. Informal reactions from audience members involved in this study suggested that they enjoyed the combination of performance and experiment and the tangible nexus of art and science.

Choreographer Wayne McGregor is working closely with cognitive scientists in the UK – software tools for recording and communicating dance gestures have been developed as well as conceptual and practical explorations of movement, brain and mind (McCarthy et al. 2006). With this research-led practice inspired perhaps by the 'decade of the brain', McGregor draws on new basic research to maximise innovation and relevance.

A 'virtual heritage ' (Haseman 2006) or digital archive of Siobhan Davies' dance works is in development incorporating innovative techniques for archiving, searching, retrieving and describing choreographic material (http://www.siobhandavies.com/index.php/parent/67/item/481). The content and organisation of material is being designed to convey an understanding of the process and practice of Davies' work. It will contain filmed performances, stills, reviews, academic writing, analytic commentaries and newly commissioned writing. This enterprise draws on research in information retrieval, next generation search technology, digital media and design; Davies' works become available for analysis from many perspectives including sonics, dance analysis and cultural theory.

In Australia, Sue Healey's latest work *The Curiosities* (2008) has palpable influences from science, medicine and technology. Adams (2006) introduced a counselling psychologist to his studio collaborations to facilitate and provoke a new ensemble dance piece. Problems presented by technology and the tension between hiding and revealing technology wizardry also pose research questions. For example, Quartet (http://www.quartetproject.net/space/start) is a real-time dance, music and new media performance that explores how the science of movement can be translated through four performers – a dancer, a musician, a motion-controlled robotic camera and a 3D virtual dancer – to an audience. Questions raised by this complex, hybrid ensemble include how much to explain or expose the technology and how best to work with and extend the capacity of observers' (and performers') perceptual and cognitive limits.

CONCLUSION

These are just a handful of examples of basic research outcomes flowing back to the artform of dance. Neuroscience, cognitive science and the social sciences

are richer for the questions and challenges for theory and method posed by the unspoken knowledge of contemporary dance. With the right combination of time, resources, personnel, energy and vision there are exciting possibilities for findings from the natural and behavioural sciences stimulating new ideas and outcomes in practice. The kind of research discussed here can rarely be done within a dance company short of funds or time, or where the commercial context depends on box-office returns. Universities can provide the appropriate time for deep investigation, impetus for the training and development of new research leaders in dance and performing arts, and facilities for the creation and evolution of new works of art and significant research discoveries. Practice leading research that in turn leads to basic research and subsequently informs the artform provides stimulating and conceptually – and methodologically – rich contexts for interdisciplinary training. The practice–research–practice cycle also engages universities with communities and cultural, creative and knowledge industries of the twenty-first Century.

ACKNOWLEDGEMENTS

This research was supported by the Australian Research Council through its Strategic Partnerships with Industry Research & Training (SPIRT) and Linkage Project (C59930500, LP0211991, LP0562687) and Infrastructure (LE0347784, LE0668448) schemes, the School of Dance at the Victorian College of the Arts, and industry partners the Australia Council for the Arts Dance Board, Australian Dance Council – Ausdance, QL2 Centre for Youth Dance (formerly the Australian Choreographic Centre), and the ACT Cultural Facilities Corporation. For discussions that helped clarify these ideas, we thank Scott deLaHunta, Margie Medlin, Sue Healey, Ruth Osborne, Garth Paine, Kim Vincs, Mark Gordon, Roger Dean and Hazel Smith. Further information may be obtained from Kate Stevens, e-mail: kj.stevens@uws.edu.au, websites: http://www.ausdance.org.au/unspoken; http://www.ausdance.org.au/connections; http://marcs.uws.edu.au and search 'intention'.

NOTE

1. Phenotype refers to the observable physical or biochemical characteristics of an organism resulting from the combined action of genotype (i.e. genetic make-up or genome) and environmental influences.

BIBLIOGRAPHY

Adams, N. (2006), 'INCARNA: Investigating Spatial Realization in Choreography'. Unpublished doctoral dissertation and DVD, Victorian College of the Arts, University of Melbourne.

Anderson, J. R. (1983), *The Architecture of Cognition*, Cambridge, MA: Harvard University Press.

Bachner-Melman, R., C. Dina, A. H. Zohar, N. Constantini, E. Lerer, S. Hoch, S. Sella, L. Nemanov, I. Gritsenko, P. Lichtenberg, R. Granot and R. P. Ebstein (2005), 'AVPR1a and SLC6A4 gene polymorphisms are associated with creative dance performance', *PLoS Genet*, 1 (3), e42.

Banes, S. (1994), *Writing Dancing in the Age of Postmodernism*, Hanover, NH and London: Wesleyan University Press.

Barrett, E. (2007), 'The exegesis as meme', in E. Barrett and B. Bolt (eds), *Practice as Research: Approaches to Creative Arts Enquiry*, London: I. B. Tauris, pp. 159–63.

Bond, K. E. and S. W. Stinson (2000/1), 'I feel like I'm going to take off: young people's experiences of the superordinary in dance', *Dance Research Journal*, 32, 52–87.

Brown, S., M. J. Martinez and L. M. Parsons (2006), 'The neural basis of human dance', *Cerebral Cortex*, 16, 1157–67.

Calvo-Merino, B., D. E. Glaser, J. Grezes, R. W. Passingham and P. Haggard (2005), 'Action observation and acquired motor skills: an fMRI study with expert dancers', *Cerebral Cortex*, 15, 1243–9.

Carter, A. (ed.) (1998), *The Routledge Dance Studies Reader*, London: Routledge.

Carter, A. (2007), 'Practicing dance history: reflections on the shared processes of dance historians and dance makers', *Proceedings: Re-Thinking Practice and Theory*, International Symposium on Dance Research, Society of Dance History Scholars, Thirtieth Annual Conference, pp. 126–30.

Castiello, U. (2003), 'Understanding other people's actions: intention and attention', *Journal of Experimental Psychology: Human Perception and Performance*, 29, 416–30.

Clark, A. (1997), *Being There: Putting Brain, Body, and World Together Again*, Cambridge, MA: MIT Press.

Cohen, S. J. (ed.) (1965), *The Modern Dance: Seven Statements of Belief*, New York: Wesleyan University Press.

Cross, E. S., A. F.de C. Hamilton and S. T. Grafton (2006), 'Building a motor simulation de novo: observation of dance by dancers', *NeuroImage*, 31, 1257–67.

Damasio, A. R. (1999), *The Feeling of What Happens: Body and Emotion in the Making of Consciousness*, London: Heinemann.

Dawkins, R. (1989), *The Selfish Gene*, London: Oxford Paperbacks.

Dean, R. T., M. Whitelaw, H. Smith and D. Worrall (2006), 'The mirage of real-time algorithmic synaesthesia: some compositional mechanisms and research agendas in computer music and sonification', *Contemporary Music Review*, 25, 311–26.

Dennett, D. C. (1995), *Darwin's Dangerous Idea: Evolution and the Meaning of Life*, New York: Simon & Schuster.

Ellis, S. K. (2005), 'Indelible: A Movement Based Practice Led Inquiry into Memory, Remembering and Representation'. Unpublished doctoral dissertation and DVD, Victorian College of the Arts, University of Melbourne.

Fensham, R. and S. Gardner (2005), 'Dance classes, youth cultures and public health', *Youth Studies Australia*, 24, 14–20.

Finke, R. A., T. B. Ward and S. M. Smith (1996), *Creative Cognition: Theory, Research, and Applications*, Cambridge, MA: MIT Press.

Glass, R. (2005), 'Observer response to contemporary dance', in R. Grove, C. Stevens and S. McKechnie (eds), *Thinking in Four Dimensions: Creativity and Cognition in Contemporary Dance*, Carlton: Melbourne University Press, pp. 107–21.

Glass, R. (2006), 'The Audience Response Tool (ART): The Impact of Choreographic Intention, Information, and Dance Expertise on Psychological Reactions to Contemporary Dance'. Unpublished doctoral dissertation, MARCS Auditory Laboratories, University of Western Sydney.

Grau, A. (2007), 'Dance, anthropology and research through practice', *Proceedings*, Society of Dance History Scholars, Thirtieth Annual Conference, pp. 87–92.

Grèzes, J. and J. Decety (2001), 'Functional anatomy of execution, mental simulation, observation, and verb generation of actions: a meta-analysis', *Human Brain Mapping*, 12, 1–19.

Grove, R. (2001), 'Unspoken knowledges', *Critical Review*, 41, 1–10.

Grove, R. (2005), 'Show me what you just did', in R. Grove, C. Stevens and S. McKechnie (eds), *Thinking in Four Dimensions: Creativity and Cognition in Contemporary Dance*, Carlton: Melbourne University Press, pp. 37–49.

Hagendoorn, I. (2004), 'Some speculative hypotheses about the nature and perception of dance and choreography', *Journal of Consciousness Studies*, 11, 79–110.

Hanna, J. L. (1979), *To Dance is Human: A Theory of Nonverbal Communication*, Chicago: University of Chicago Press.

Hanna, J. L. (1988), *Dance, Sex and Gender: Signs of Identity, Dominance, Defiance*, Chicago: University of Chicago Press.

Haseman, B. (2006), 'A manifesto for performative research', *Media International Australia incorporating Culture and Policy*, 118, 98–106.

Healey, S. (Choreographer/Director) (2008), *The Curiosities*, performance, installation, dance and film with Lisa Griffiths, Rachelle Hickson and Nalina Wait; composer Darrin Verhagen; digital animator Adnan Lalani; digital artist Adam Synnott; designer Paul Matthews. iO Myers Studio, Kensington, August.

Heylighen, F. (2001), 'The science of self-organization and adaptivity', *Encyclopedia of Life Support Systems*, Oxford: EOLSS Publishers.

Humphrey, D. (1959), *The Art of Making Dances*, Princeton, NJ: Princeton Book Company.

Kauffman, S. (1995), 'Order for free', in J. Brockman (ed.), *The Third Culture*, New York: Simon & Schuster, pp. 334–43.

Langer, S. K. (1953), *Feeling and Form*, London: Routledge & Kegan Paul.

McAuley, G. (1996), 'Drama, theatre, performance: the changing research paradigm', in M. M. Stoljar (ed.), *Creative Investigations*, Canberra: Australian Academy of the Humanities, pp. 47–61.

McCarthy, R., A. Blackwell, S. deLahunta, A. Wing, K. Hollands, P. Barnard, I. Nimmo-Smith and A. Marcel (2006), 'Bodies meet minds: choreography and cognition', *Leonardo*, 39, 475–8.

McKechnie, S. (1996), 'Choreography as research', in M. M. Stoljar (ed.), *Creative Investigations*, Canberra: Australian Academy of the Humanities, pp. 31–45.

McKechnie, S. (2005), 'Dancing memes, minds and designs', in R. Grove, C. Stevens and S. McKechnie (eds), *Thinking in Four Dimensions: Creativity and Cognition in Contemporary Dance*, Carlton: Melbourne University Press, pp. 81–94.

McKechnie, S. (2007), 'Thinking bodies, dancing minds', *Brolga: An Australian Journal about Dance*, 27, 38–46.

McKechnie, S. and R. Grove (2000), 'Thinking bodies', *Brolga: An Australian Journal about Dance*, 12, 7–14.

Martindale, C. (1990), *The Clockwork Muse: The Predictability of Artistic Change*, New York: Basic Books.

Monro, G. and J. Pressing (1998), 'Sound visualization using embedding: the art and science of auditory autocorrelation', *Computer Music Journal*, 22, 20–34.

Schippers, H. (2007), 'The marriage of art and academia – challenges and opportunities for music research in practice-based environments', *Dutch Journal for Music Theory*, 12, 34–40.

Smalley, R. (1996), 'The art and science of musical performance and its implications for research', in M. M. Stoljar (ed.), *Creative Investigations*, Canberra: Australian Academy of the Humanities, pp. 23–30.

Smith, A. (1999), 'Daily journal, 22 July 1999', Unspoken Knowledges Research Project (cited September 2008), available from: http://www.ausdance.org.au/unspoken/.

Stevens, C. (2005), 'Trans-disciplinary approaches to research into creation, performance, and appreciation of contemporary dance', in R. Grove, C. Stevens and S. McKechnie (eds), *Thinking in Four Dimensions: Creativity and Cognition in Contemporary Dance*, Carlton: Melbourne University Press, pp. 156–70.

Stevens, C. and M. J. Gallagher (2004), 'The development of mental models for auditory events: relational complexity and discrimination of pitch and duration', *British Journal of Developmental Psychology*, 22, 569–83.

Stevens, C., C. Kroos, S. Halovic, J. Chen, E. Schubert, S. Wang, K. Vincs, J. Tardieu and G. Paine (2008), 'Analysis of contemporary dance movement in the presence and absence of a musical soundscape', in *Proceedings of the 10th International Conference on Music Perception and Cognition* (ICMPC10), Adelaide, SA: Causal Productions.

Stevens, C. and S. McKechnie (2005), 'Thinking in action: thought made visible in contemporary dance', *Cognitive Processing*, 6, 243–52.

Stevens, C., S. Malloch and S. McKechnie (2001), 'Moving mind: the cognitive psychology of contemporary dance', *Brolga: An Australian Journal about Dance*, 15, 55–67.

Stevens, C., S. Malloch, S. McKechnie and N. Steven (2003), 'Choreographic cognition: the time-course and phenomenology of creating a dance', *Pragmatics and Cognition*, 11, 299–329.

Stevens, C., H. Winskel, S. Healey, C. Howell, L.-M. Vidal, C. Latimer, and J. Milne-Home (2007), 'The dancing brain: the effect of expertise on visual attention while viewing Australian contemporary dance', in R. Solomon and J. Solomon (eds), *Proceedings of the 17th Annual Meeting of the International Association for Dance Medicine and Science*, Canberra, pp. 309–14.

Strand, D. (1998), *Research in the Creative Arts*, Canberra: Department of Employment, Education, Training and Youth Affairs (cited September 2008), available from: http://dest.gov.au/archive/highered/eippubs/eip98-6/eip98-6.pdf.

Sutton, J. (2005), 'Moving and thinking together in dance', in R. Grove, C. Stevens and S. McKechnie (eds), *Thinking in Four Dimensions: Creativity and Cognition in Contemporary Dance*, Carlton: Melbourne University Press, pp. 50–6.

Szpunar, K. K., E. G. Schellenberg and P. Pliner (2004), 'Liking and memory for musical stimuli as a function of exposure', *Journal of Experimental Psychology: Learning, Memory, and Cognition*, 30, 370–81.

Thelen, E. (1995), 'Time-scale dynamics and the development of an embodied cognition', in R. F. Port and T. van Gelder (eds), *Mind as Motion: Explorations of the Dynamics of Cognition*, Cambridge, MA: MIT Press, pp. 69–100.

Vincs, K., E. Schubert and C. Stevens (2007), 'Engagement and the "gem"

moment: how do dance students view and respond to dance in real time?', in R. Solomon and J. Solomon (eds), *Proceedings of the 17th Annual Meeting of the International Association for Dance Medicine & Science*, Canberra, pp. 230–4.

Zajonc, R. B. (1968), 'Attitudinal effects of mere exposure', *Journal of Personality and Social Psychology Monograph Supplement*, 9: Part 2.

Practice as Research through Performance

Baz Kershaw

I. PRELUDE

Ludwig Wittgenstein dreamt up the foundational idea of his philosophical masterpiece, the *Tractatus*, while reading in a First World War trench. A sketch in a newspaper showed a sequence of events leading to a car accident, triggering the sudden thought that language was a picture of the world. But less than a decade later the philosopher dramatically lost his faith in the imagistic power of words. A memoir by a Cambridge don describes the occasion:

> Wittgenstein and P. Sraffa . . . argued together a great deal over the ideas of the *Tractatus*. One day (they were riding, I think, on a train), when Wittgenstein was insisting that a proposition and that which it describes must have the same 'logical form' . . . Sraffa made a gesture, familiar to Neapolitans as meaning something like dislike or contempt, of brushing the underneath of his chin with an outward sweep of the fingertips of one hand. And he asked: 'What is the logical form of that?' . . . This broke the hold [over Wittgenstein] of the conception that a proposition must literally be a 'picture' of the reality it describes. (Malcolm 1958, quoted in Mehta 1965: 85)

The brush of Sraffa's dismissive gesture is the moment of performance as research. One kind of knowledge – language, theory, philosophy, books, libraries, archives – is challenged profoundly by another. The performing body bites back at the thinking mind in a prospective quintessential practice-as-research experiment.

The example of Sraffa's 'contempt' of course raises many issues about the nature of knowledge in the long history of modernism. The issues are prodigious, yet a single question can serve to indicate their extent. In the

instant of the brush off where was the knowledge it produced located? Was it in the moving hand, in the philosopher's body, between the two minds of the protagonists, in the published memoirs, in this analysis, or in some relationship between all these and more? In other words, once live performance is introduced directly into the equations of knowing, conventional views of how knowledge is best produced, accumulated, stored and transmitted may be called deeply into question. This is because the most crucial effect of performance practice as research is to *dis-locate* knowledge in the manner indicated by the example of Sraffa's gesture. Such performed moments can unravel all established forms of representation, becoming irresistibly viral to any assumed stability of thought. The source of that power is paradoxical, as it makes the commonplace extraordinary. It can even, perhaps, call into question Samuel Butler's famous observation that: 'Nothing is so unthinkable as thought, unless it be the entire absence of thought' (Butler 1951: 154).

2. INTRODUCTION

Towards the end of the 2000s 'practice as research' became a well-established approach to using creative performance as a method of inquiry in universities in the UK, Australia, Canada, Scandinavia, South Africa and elsewhere. In less than two decades creative processes had been established as providing crucial new approaches to research in theatre, dance, film, video, digital-media and performance studies, complementing and in some ways profoundly challenging traditional methodologies. Placing creativity at the heart of research implied a paradigm shift, through which established ontologies and epistemologies of research in arts-related disciplines, potentially, could be radically undone. Hence, as early as 2006, Swedish theatre scholar Ylva Gislén could confidently present an international word map of 'research in the artistic realm', which included rough estimations of dates for its emergence, (see Figure 5.1). The bigger the font the greater the volume as well as range of variety in practice. What linked these practices across countries together, argued Gislén, was 'research in relation to . . . higher education in the arts'. However, there was a telling tension in her formulations, as the differences between research 'in' *and* 'in relation to' the arts suggest fundamentally contrasting procedural modes, the first treating creativity as a means of investigation, the second implying it and its products as constituting a field to be studied by some other means. Her observation that a current concern in university systems welcoming these developments was the generic titles of research degrees reflected this tension: 'Should they be called PhDs or Doctors of Arts or PhD by project or PhD by publication?' (Gislén 2006: 132).

Here was a strange irony, given the diversity of the fast-growing community

Figure 5.1 Gislén's international world map of 'research in the artistic realm'.

of practitioner-academics using theatre, dance, live art, inter-medial perform-
ance, video, film and so on that was radically stretching the bounds of research
in the academy. But as the doctorate most commonly is the highest-ranked
university diploma awarded for original research internationally, it was clear
that practice-based research in the performing and media arts was coming
of age – though not without some definitional confusions and significantly
strong resistance. When the challenge of 'artistic research' meets established
hierarchies of knowledge, the result might match that mythical moment in
physics when an irresistible force meets an immovable object: an inconceivable
disturbance.

To assess the sources of such seismic controversies, this chapter will analyse
fundamental issues of 'knowledge production' in the creative arts when they
are generated by live and mediated performance practice as research. The 'as'
in the phrase functions to problematise conventional notions of theatre and
performance practice, which if they reference research at all – rather than,
say, entertainment or other cultural forms – tend to link it to the preparatory

work that leads into a production or an event. The actors research their role in, or directors the 'background' of, a play. But the 'as' makes a claim that the performance or theatre event itself may be a form of research. What exactly might make this difference is a key point at which the complications and debates about practice as research begin, with radical practitioners contesting that time-based cultural events – productions, installations, films, live art and so on – may be research 'in themselves', while their moderate colleagues would expect some supplementary material – articles, journals, interpretive accounts of various kinds – for the 'research' to become manifest.

This is to address the issues of practice as research mainly from the angle of its presentational protocols. But these issues also touch on notions of 'research method' *per se*, ideas about the nature of human 'knowledge' and the purposes of innovative creative arts beyond university campuses and precincts. Fundamental to practice as research, whether in or beyond universities, is the radical dis-location of ways of knowing exemplified by Wittgenstein's sudden revelation: a process that turns all notions of stable criteria that aim to 'finally' define it into a fool's illusion. To partly circumvent this problem, my focus in this chapter will be on specific examples of practice as research that may be representative in their potential to trigger radical challenges to established research paradigms. Yet I think this potential is not especially unusual, as it aligns with a widespread 'turn to practice' in the late-twentieth century that emanated from many loci, including poststructural theory, postmodern capitalism and perhaps even post-ecological activism (Schatzki et al. 2000; Ingold 2000; Thrift 2004). The main emphasis of this turn was away from abstract theorising and scientific rationality in favour of action-based investigations oriented toward practical engagement in the world. Hence anthropologist Tim Ingold crisply characterises this radical shift, arguing that 'it is necessary that . . . we descend from the imaginary heights of abstract reason and resituate ourselves in an active and ongoing interaction with our environment' (Ingold 2000: 16). From Althusser to Wittgenstein through Bourdieu and de Certeau, practice became crucial to new economies of knowledge in many domains.

I will focus on crucial areas of performance as practice as research under the headings of Starting Points, Aesthetics and Documentation, and as a means eventually to draw out some speculative implications for global futures of its key generic challenges. I will aim for this result through applying an analytical method based on what I call the 'paradoxology of performance' (Kershaw 2007: 101). This has evolved in light of my creative practice as research projects undertaken since the 1970s, but latterly informed by my investigations into theatre and performance ecologies. This treats theatre and performance as operating in a continuum with natural phenomena, such as seashores and forest perimeters, so that the same principles of ecology can be seen to shape both cultural and natural processes. Two broader research projects have also

influenced my arguments. First and most recent, the IFTR (International Federation of Theatre Research) Performance as Research working group, with a roster of members from twelve or so countries, has met annually since 2005 to investigate international practices ranging from environmental time-lapse video installations through extended voice performance to theatre in telematic space as part of a detailed exploration of key methodological questions (International Federation of Theatre Research: Call for Papers 2008). Second, between 2000 and 2006 I directed PARIP (Practice as Research in Performance), a project that involved over 600 practitioner-researchers in an inquiry which included three conferences, the meetings of six UK regional working groups, the compilation of eighteen representative case studies, the production of four interactive DVDs exploring live-performance practices, and more (Practice as Research in Performance 2008). One of these DVDs, *The Suchness of Heni and Eddie,* provides the last of the three case studies that inform this chapter's analysis. The second case study draws on one of my own projects, *Being in Between,* while the first discusses a pioneering PhD production, *Slightly Cloudy, Chance of Rain.* The UK bias here reflects my conviction that while performance practice as research is always especially rooted in particular environments – including even its most abstracted digital experiments – it also works through practices which are often highly representative with regard to the research issues they raise. Moreover, the successful growth of the practice-as-research movement internationally attests to the frequent power of its inquiries in addressing much broader dilemmas of the human animal in the twenty-first century.

3. STARTING POINTS

The voice on the audiotape cassette *Self-Hypnosis for Motorists,* slotted into my car's sound system, quietly and calmly speaks as in 2002 I drive north on the motorway to examine a practice-as-research PhD presentation.

> They were travelling on the southbound M6 which, due to roadworks, had been reduced to a single carriage-way, and a fifty mile an hour speed limit. They remained within the speed limit, whereas the car in front on them, a five series BMW, was exceeding it, greatly. At approximately eighty-five or ninety miles an hour the BMW suffered a blow-out. It veered to the left, to the right, to the left and to the right again, before careering into the coned off area where the road works were continuing. As the car left the road it ploughed into a portable toilet, provided by BorderLoos of Carlisle. The force of the car sent the lavatory in an upward trajectory, at the top-most point of which the

door swung open, and out fell a man, wearing a hard hat, his trousers round his ankles, and a bemused expression on his face.

He struck the bonnet of their car and was pronounced dead at the scene.

Arriving at the Sandbach Roadchef Service Station (between J16 and J17 on the M6) I am greeted by the two internal examiners as the other external examiner joins us, and we joke about wearing our smart suits and ties for the examination performance by the two joint candidates, Bob and Lee. A corner of the café has been cordoned off and we sit on each side of an aisle surrounded by their families – parents, aunts, uncles, cousins and half-cousins spanning three generations – facing a makeshift altar with silver vases full of flowers. All is as it formally should be for a reaffirmation of the candidates' wedding vows by the priest who married them, which is done with solemnity tinged by humorous light irony, but also made surreal because the café is 'open as usual' and the public behind us stand watching amazed, amused, bemused by this obviously authentic but highly out-of-place ceremony. As the confetti and the bride's bouquet are thrown to whoops of joy, celebratory music plays through the service station sound system and the congregation divides into two groups to be taken separately by the happy bride and groom on tailor-made narrated tours of the site, here and there catching glimpses of the ten duplicate wedding couples, in full formal attire, also treating this as the best ever place to be for such a happy event. All finally regroup on the newly mown grass between the café and motorway where the serried wedding pairs dance a graceful waltz and the passing trucks loudly honk their klaxon horns and within minutes the traffic in all three lanes is slowed to a crawl as the driving public eyeballs this extraordinary scene (Whalley and Miller 2005).

Fifteen months later I'm up the motorway again to complete the examination process, having read the standard-length thesis jointly written – with no indications of separate authorship – by Lee and Bob. The four examiners have agreed, as approved by the university, a rigorous sequence of joint and single *viva voce* meetings with the two candidates, designed to ensure that each has contributed equally to the impressive qualities of the analysis and that no advantage has been gained over other PhD awards through the non-standard examination process. The examiners agree on some areas where the written part of the submission – the thesis accompanying the performance as research – could be improved, and six months later Bob and Lee are formally informed that they have successfully met the standards required for the award of doctorates by the university. A few months on and Dr Joanne 'Bob' Whalley and Dr Lee Miller are each in possession of their own separate doctoral scrolls. The first ever fully collaborative UK performance practice-as-research PhD was successfully concluded. Back near the lawn where the waltzing wedding

Figure 5.2 *Slightly Cloudy, Chance of Rain*, at M5 Sandbach Roadchef Service Station, Cheshire, UK, 2002. Devised by: Joanne 'Bob' Whalley and Lee Miller. Photographer: Martin Nealon. Reproduced with permission.

couples almost brought the motorway to a halt a new wooden garden bench bears a small brass plaque. It informs the many travellers who use it that this was the site of the first collaboration between a motorway service station and a university, which just happened to have the performed reaffirmation of a successful marriage at its heart.

My starting point here is that this project's complexity, especially given its highly public but intimate collaborative ethos, suggests many different possible starting points for practice as research in performing arts. Yet despite the strongly unconventional match of venue and aesthetics for *Slightly Cloudy, Chance of Rain*, the written thesis was unexceptional in beginning with a single, carefully framed question. In fact, in this context, the singularity and form of the question is more important than what it asked when set against the obvious paradoxes of the performance: a private ceremony in public space, an artwork as formal examination, and so on. This contrast between a highly focused discursive inquiry and a creative event that was wonderfully multifaceted – in, for example, predictably producing several accidental audiences and unpredictably bringing a busy motorway almost to a standstill without accident – serves to illustrate some deep and highly challenging tensions of method in performance practice as research. Try to figure out, for example, what its starting point (or points) might have been and you should quickly gain a sense of why the process of judging its research value had to be complexly structured. Yet even a much simpler practice-based project would produce a

similar problematic. That, of course, has profound implications for research funding agencies' judgements of projects before they start, as well as for examiners (whether or not they choose the way they arrive) at their end.

The recent history of 'official' *starting points* set by UK research councils can serve to prise open the Pandora's box of practice as research for its international relevance, as similar terms of reference were evolved in Canada, Australia and elsewhere. The current national system for evaluating then funding practice as research in British universities began in the late-1980s. Evaluation led the way, in the form of the Research Assessment Exercise (RAE), a four to five yearly peer-review-based process that judged the 'outputs' of every university researcher in the land. The performing arts were first included as a separate subject in 1992 with the creation of a peer-panel for Drama, Dance and Performing Arts. However, practice was not explicitly part of its criteria until 1996, when practice-as-researchers were asked for a 'succinct statement of research content' together with 'supporting documentation' (HERO RAE 1996). In 2001 the criteria also advised that practical research should 'interrogate itself' and 'be located in a research context', but above all it should be 'driven by a research imperative', perhaps a default phrase for 'starting point' (HERO RAE 2001). In 2008 'research imperative' appears again, potentially clarified by an accompanying 'descriptive complement', but potential starting points are reduced to 'questions addressed' (RAE 2006). This evolution of phrasing is politically interesting as it begins by allowing individual practitioner researchers to decide how best to present the nature and methods of their projects but ends by becoming pretty prescriptive in its requirements. The assessment system shifts from a relatively liberal and democratic framework for evaluating practice as research to one that was much less open to the inbuilt diversity of creative research as it was, and is, actually practised. And this was a uniform pattern for both PhD scholarships and post-doctoral grant schemes, effecting a kind of flattening out or, more critically, a dumbing down of the research base of practical creative research in UK universities.

It is ironic, then, that the newly emergent funding regime for arts and humanities in the UK moved in the opposite direction to the RAE, though only slightly. Founded in 1998, the Arts and Humanities Research Board (AHRB) from the outset followed the RAE by including practical research in the performing arts as eligible for funding, even offering 'Small Grants in the Performing and Creative Arts' in its inaugural portfolio and, from 2001, Fellowships in the Creative and Performing Arts for professional artists (AHRC: Arts and Humanities Research Council 2008). But from the start, for virtually all of its grants schemes, the AHRB required applicants at all levels of experience to formulate a 'research question or questions' that their projects would address. This clearly was a hedging of bets against possible criticism of a lack of 'rigour' in its operational framework, as the rule surely reflected

the traditional requirement that doctoral researchers start by framing a question – a move that, of course, significantly restricts the exploratory quality of research as all questions imply a limit to their potential answers. Yet, ironically, the AHRC requirement fell short of starting-point liberalism for *post-doctoral* researchers in the sciences, who generally were simply asked to state *project aims* or *objectives* in applications to their Research Councils (EPSRC: Engineering and Physical Sciences Research Council 2008). However, the upgrading of the AHRB to Council status in 2005 seemed to produce a new confidence – plus a new logo – and a modicum of greater choice in research starting points. In 2006 the Small Grants scheme was replaced by 'Research Grants – practice-led and applied routes', which had a more liberal rubric. If questions had been too narrow a launch pad, then researchers were invited to provide 'questions, issues or problems' in their practice-as-research applications (AHRC 2008).

So the shift from 'research imperatives' to 'questions' and 'questions' to 'problems' may be seen to represent highly ambivalent 'progress' regarding required starting points for performance-practice-as-research projects in UK official funding systems. But how does that square up against the gap between the written-discursive and practical-creative components of projects such as *Slightly Cloudy, Chance of Rain*? Is there a clue to solving *that* conundrum in the differences between 'questions' and 'problems'? The main objection to 'questions' aired in the UK practice as research community has been that even the most open and carefully expressed queries inevitably imply a more or less predictable range of responses, which flatly contradicts the qualities of radical openness and excess that the creativity of performance practice at its best can produce. That is not to suggest that questions are necessarily poor opening gambits for practice as research, but including them *as a rule* does imply that, say, the equivalent of – admittedly increasingly rare – 'blue skies' research in the sciences will tend to be ruled out of court. The AHRC's addition of 'problems' was no doubt intended to assuage such concerns. But the dominant modernist traditions of definition had tended to stress uses of 'problem' in logic, mathematics and chess, which since the seventeenth century had linked it closely to 'questions'. However, the word's obsolete uses might provide an etymological chink that throws light beyond the problems of 'problem' for performance practice as research. Its main meanings in the late medieval period had centred on 'puzzles' and 'riddles', which resonates with the paradoxical qualities that are fundamental to most performance practices in the twenty-first century (*Shorter Oxford English Dictionary* 2002: 2353)

I drew attention to derivatives of key general paradoxes of contemporary performance in Bob and Lee's doctoral project: a private ceremony in public space, an artwork as formal examination. These and cognate paradoxes – a carbon emission-reducing dance, a seamless pairing of bodies united in

a text – operated across *both* its main practices of academic writing and crea-
tive production. So paradoxes are very suggestive of further starting points
that might be especially appropriate to this new style of research. Of course
puzzles and riddles can be 'solved' by analysis, but equally – like paradoxes –
they can require intuition, insight and maybe even instinct to determine their
potential as creative springboards for performance research. These alterna-
tives could be triggers that launch new creative research processes, but what
might best trigger those triggers because it matches the radical potential of
those processes? Could it be that the august institutions charged with sup-
porting advanced research in universities worldwide should adopt 'hunch' as a
dynamic addition to the practice-as-research lexicon of starting-point terms?

4. AESTHETICS

As visitors enter the zoo they face a large glass-fronted enclosure housing a
single male spider monkey. Inside the transparent cube hang ropes and nets
between big branches, suspended spars and fixed wooden platforms. The
spider monkey has a prehensile tail and hands and feet that grip like power-
ful hydraulic clamps. Hanging from a vertical rope some three metres back
from the glass he swings in a long elliptical arc back and forth to close in
on two dancing human figures on the outside of the enclosure whose agile
movements are brightly reflected in the transparent shield. They wear khaki
bush-trousers and tight pinkish tops with lacy frills like delicate flaps of skin
that undulate in the wake of their reactions to the flying primate. Arms swirl
and bodies arc backwards and return as weight shifts from foot to foot in a
ground-bound to-and-fro traverse that answers the monkey's aerial circling
with precisely relaxed syncopation. No imitation but a dance-like analogue of
its fabulous antigravity skills (see Fig. 5.3, p. 114) that so far has lasted for over
seven minutes, long enough for two clusters of exiting visitors to be stopped
in their tracks, long enough for a small child to detach from its family on the
bench beneath the beech tree and prance across the sunny space with his own
version of the monkey's acrobatic feats, long enough to reward the tight-knit
group of animal keepers and zoo gardeners gathered to watch at the end of a
hot busy day with proof that the cross-species divide has been significantly
shrunk again. Again the dancing had entered an in-between place where a trio
of primates could seemingly share something in common through the glass
wall, beyond the horrors of quarantine and incarceration.

This was the second of three days for *Being in Between* in Bristol Zoo, a
durational performance that aimed to engage the paradoxes of the species
divide. I worked collaboratively with highly experienced environmental move-
ment artist Sandra Reeve, plus a professional team: the two performers, a

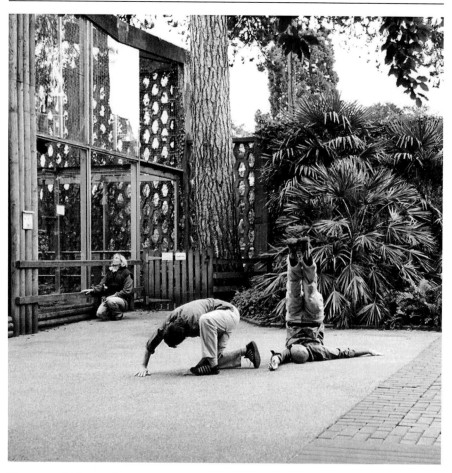

Figure 5.3 Spider monkey and dancers upside down (his head in top left-hand corner of lower pane). *Being in Between*, at Bristol Zoological Gardens, 2005. Performers: Maya Cockburn and Alistair Ganley, with co-director Sandra Reeve. Photographer: Drew Yapp. Reproduced with permission.

costume designer, two documenters, a research assistant and various zoo staff, most crucially the keepers and gardeners. The performances ran from 10 a.m. to 5 p.m., developing through two main styles. First, performer 'walkabouts' through all of the zoo's public areas, introducing playful forms of disruption into its daily routine. Second, regular 'dances' between 10 and 40 minutes long, spread throughout the day at four primate enclosures: Madagassy mongoose lemurs, owl-eyed monkeys and Madagassy ayes-ayes, African lowland gorillas and the lone South American spider monkey. Four 'identities' were evolved with the performers, marked by different costumes: zoo visitors, zoo-keepers, primatologists, feral animals. For the paying visitors these occupied a performance spectrum from invisible to highly visible. We had thought the

performers might become 'naked humans' once a day on the gorillas' island while the latter were feeding in their indoor enclosure, but health and safety and ethical considerations demanded protective blankets, making them look more like 'misplaced refugees'. A rigorously flexible system of movement afforded continuous improvisation by the performers as they searched for creative spaces in-between four ever-present groups across the zoo's many environments: non-human animals, visitors, keepers, gardeners. The performance's research imperative was to transform those spaces into places of cross-species creative encounter, responding interactively and *equally* with all four groups. To gain funding from the AHRC our stated main aims included: to investigate the aesthetics of body-based interactive small-scale spectacle and to enhance the zoo's conservation messages.

The aesthetics of performance practice as research are highly sensitive as they automatically spark off major issues regarding, for example, standards and virtuosity, rigorous protocols and creative unpredictability, inadequate resources and the nature of appropriate infrastructures. The underlying dynamic producing these issues aligns with the 'questions or hunches' conundrum outlined above. Because 'hunches' – or, more conventionally, 'intuitions' – problematise the well-worn modernist oppositions between mind and body, spirituality and materiality, creativity and rationality, arts and sciences, and so on, and can issue in aesthetic forms that confound those distinctions – whether through the raw economics of 'production finish' or even in hopes to prove a thing of beauty is a truth forever. Hence contemporary performance practice as research generally may patently fail to conform to the schemas of modernism through its principal defining feature: a radical diversity of approaches producing an incongruous field. So general agreement among practitioners about aesthetics as a catalytic factor in creative research is likely to prove as elusive as the Loch Ness monster or the Himalayan yeti – as indeed is the case in, say, mathematics and the sciences, where issues of elegance or stylishness, for example, are by no means ignored. Not surprisingly, then, a common tactic to avoid accusations of chasing after arty chimeras through practice as research, especially as it emerged in the UK, has been for practitioners to devise transparent methods of inquiry in the form of explicitly stated protocols or procedures that include both artwork and its documentation – and sometimes to test them to breaking point. At its most recursive this last approach uses procedures that severely challenge the aesthetics of even the best-designed projects. These could do worse for a motto than adapt a paradox – What are husbands for, but to keep our mistresses? – that misquotes novelist George Moore (Moore 1998): What are methods for, but to ruin our experiments?

Body-based interactive aesthetics were indispensable to *Being in Between*, so the biggest threats to its durational ambitions would come from research

methods – including the creation of documentation – that dealt with time and participation in entirely routine ways. Hence the project produced forms of documentation that are now exceedingly common in practice as research, but which could also be detrimental to its aesthetic research agenda. A continuous two-camera video recording of the event was made on all three days of performances. So how did the process of the video production promise to totally ruin the aesthetic strategies that the research crucially depended on for its success?

The two aesthetic qualities most relevant to this issue were, first, the potential invisibility of the performers for the visitors and, second, the styles of movement developed with the performers to create what Reeve calls the 'ecological body' (Reeve 2006: 8). She characterises this with admirable specificity as dependent on

> . . . altering the movement patterns which seem to be leading us into
> ecological turmoil [by devising] somatic skills which refuse to ignore
> this somatic approach . . . By working *with* the elements/environment
> in different conditions and at different times of day, for example
> walking on sand, on the rocks, in the sea . . . I am required to investigate
> . . . and to adopt an attitude of adaptability and flexibility in order to
> discover what is possible . . . (10, my emphasis)

Of course, this is what she trained the performers to do through responding to the non-human primates as wholly equivalent to sand, rocks and sea in her description. This established an interdependence between research aims and aesthetics that was designed to work as follows. The spectra of invisibility–visibility created by the costumes and movement styles – from 'visitor' to 'bare human' – were evolved to provide high degrees of semiotic and somatic flexibility for the performers. At best this afforded them highly responsive integration into any 'scene' as they responded and adapted interactively to the energy flows between animals, visitors, keepers and gardeners, for example in visitors' efforts to gain good animal 'views'. Then, by continuously exploring the opportunities for improvisation that the movement styles afforded them, they could work to open up channels of communication that might stretch the bounds of conventional zoo behaviour and reception, as happened, for example, when the young boy joined in the 'dance' with the spider monkey, a sight that stopped some exiting punters in their tracks.

Our research interest in this 'ecological' manner of inhabiting the zoo demanded the two-camera video shoot so that we could study it retrospectively in detail. The decision led to some wonderfully farcical encounters, because the closer the camera operators got to the actors the more they had to find ways to make their highly visible cameras (and themselves) invisible so as not

to reduce the performers' scope for invisibility. The spectacle of an intensely concentrated film-maker, camera clamped to eye-socket, walking carefully backwards into a thick clump of rose bushes was reminiscent of *Monty Python* at its absurdist best. Gradually, though, the documenters reduced this potential to destroy our research objectives by themselves developing skills for moving in and out of visibility that matched those of the performers; in effect, they became a 'shadow' aspect of the movement aesthetics. So these side effects of our research methods, even at their most absurd, were incorporated into creating the invisibility–visibility spectra. This increased the power of the project's aesthetics. For example, it destabilised the routines of perception of many zoo visitors who, as the keepers often pointed out, often seemed to be looking at the animals without ever really seeing them. As the performers and primates 'danced' together, *Being in Between* offered a radically subtle challenge to such unintended blindness.

The fundamental point here is that the cameras worked through performative paradoxes *within* the research process, thus possibly creating homologous synergies with the inevitable paradoxes that the zoo *qua* zoo itself could not help but be performing all the time. For example, the camera operators' presence served to refine the techniques the performers evolved to make themselves invisible, hence *exposure enhanced invisibility*. Also, the zoo created high conservation profiles for animals under greatest threat of extinction (such as the lowland gorillas) that were intended to make a difference beyond its walls, hence *visibility protects endangered species*. Such structural homologies, in this case between patterns of perception shaping human/animal interactions, are a key factor in my 'paradoxology of performance'. Through this, even relatively incidental reinforcements of the key aesthetic strategies of *Being in Between*, such as the effects of the presence of the cameras, may be seen as significantly improving the project's potential for successfully delivering on the objectives of its practice-as-research promise, which (as mentioned above) included exploring ways to strengthen the zoo's conservation programmes. Formal feedback from keepers, gardeners, artist and academic observers (from experimental theatre and circus, philosophy and archaeology), as well as a variety of visitors, indicates that this was partly achieved, especially through the sessions with the primates.

So from the perspective of this theoretical territory, the more rigorously consistent the research design the *greater* may be the chances of missing out on producing reflexive results. Unexpected, accidental or improvisatory events – such as the young boy joining in the 'dance' or the cat-and-mouse interactions that evolved between the performers and the cameramen – opened up new perspectives on the purposes of the project. A fly in the ointment *can* raise its game. And this method for identifying potentially useful homologies between arts and environments can extend to more everyday performances,

and perhaps even permanently bridge the gaps between sites that seem ethically incommensurate: such as zoos and indigenous animal habitats. Hence people who avoid zoos on principle might do worse than reflect positively on Ambrose Bierce's wicked dictum: Abstainer – a weak person who yields to the temptation of denying himself a pleasure.

5. DOCUMENTATION

My strongest memory of using the DVD *The Suchness of Heni and Eddie* is of the two dancers, male and female, standing side by side but not touching. They are dressed simply in t-shirts and loose tracksuit bottoms and both wear ordinary trainers. They have their eyes closed and in complete silence the woman reaches her left hand towards the man below shoulder height where she stills and cups it palm up, then he moves his head towards her and is clearly searching for the hand through their eyes-shut darkness which can't be seen but maybe we sense it somatically. Following the head as it lowers towards the floor the man's body arches sideways into a difficult balance until it rests into the stillness of her hand. The finely found poise is held a few moments and they slowly return to standing to then run the sequence several

Figure 5.4 Head finding a nest in *The Suchness of Heni and Eddie*, at ResCen Nightwalking Conference, Greenwich Dance Agency, 2002. Performers: Henrietta Hale and Eddie Nixon. Choreographer: Rosemary Lee. Writer: Niki Pollard. Photographer: Vipul Sangoi, Raindesign. Reproduced with permission.

times again, each move of head to hand becoming more demanding as they explore the limits of extension and balance, perhaps testing the edges of an extraordinary comfort zone. The sensitivity and accuracy of this blind collaboration is remarkable in demonstrating the graciously awkward meetings of everyday body-minds. Each time a head finally rests in a hand like an oversize egg in a fragile nest a poignant collaborative poise is born.

Click on 'menu' on the screen and the image of the two dancers shrinks to become a sub-screen but the scene continues to run alongside a same-size black and white photograph of them doing the same exercise. Move the cursor over the photo and a red frame appears around it. Click there to view a full-screen gallery sequence showing several pages of a written 'score' listing actions that precede the hand-head routine with a title that tells you Eddie Nixon and Henrietta Hale first worked with choreographer Rosemary Lee on *Passage*, premiered at London's South Bank Centre in 2001. Two colour images of this show appear in sequence followed by a title screen announcing: '. . . the first showing of *the Suchness of Heni and Eddie* at *Nightwalking – Navigating the Unknown* . . . September, 2002: a 3-day artist-led conference event bringing into view processes of artistic creation' plus more photographs of them dancing at that event, ending back at the two-picture starting point of the gallery. Clicking on 'main' jumps you to four sub-screens side by side, all showing moving images with titles below: 'the performance' (Heni and Eddie dancing), 'performers' (the hand-head sequence), 'process' (cameraman filming the dancers), post-performance (woman in a loose grey shift talking to . . .). What am I looking for? Click on 'process'. Two sub-screens: 'the filming process' and 'rehearsal to performance'. Choose the first and another two sub-screens display 'multiscreen view 1' and 'multiscreen view 2' both taking you to simultaneous two-camera views of the rehearsal process at different stages on the same day, including shots of the head-hand exercise, with the choreographer – *that's* Rosemary Lee – giving brief instructions to the dancers. You're in a digital maze, so fast forward to >> 'main' and the four side-by-side sub-screens to choose >> 'performance' because you really want to see head-hand as it finished up in the show.

But – oh no – *another* sub-screen choice 'multiscreen view' and 'full performance Nottdance 06', the latter being five years on from your DVD starting point. Go for it >>, to get Lee in that grey shift introducing the piece, so fast forward to 'head-hand' and there it is as Heni and Eddie search each other out in their blindness always finding a balance as Lee speaks quietly from her notes

they don't know who's going to put the ledge out, they don't know where the hand is, they can't see, we're not trying to fake anything . . . paring it down to the simplest things, because the simplest things

you can see the complexity more easily [*sic*] . . . Dilemmas of day one. Am I doing what I said I'd do? How do I see their suchness without structures, and how do structures make me see their suchness? . . . Dilemmas four years later, day one. Am I doing what I said I'd do? Set or improvised? . . . How do I refine a structure or a task without the dancers getting better at it, and then the excitement goes, the struggle goes, the learning in action goes, the more they do it the more they learn, is it possible not to know, can you unlearn? (Lee 2007)

As I re-run the sequence in my head and feel an aching shimmer as her head finally finds its nestling place in his waist-level outstretched hand, [there's] an egg-head forever poised in past time but also right here alive in my mind's eye *now*.

I never saw any of this practice as research live, nor ever meet Eddie and Heni face to face, though I did see Lee twice during production of the DVD and I viewed its alpha-version to advise on structure and navigation tags. It was the last of four that PARIP produced/funded, which together created some methodological and political disquiet and controversy in the UK practice-as-research community. Wouldn't these high-tech (for then) and relatively high-cost items issued by a high-profile project set expectations against which other, cheaper forms of documentation would be found badly lacking? Wasn't this yet another move by an already privileged research university to consolidate its 'lead position', thus inevitably overshadowing the excellent work being done elsewhere? Little in advanced areas of creative arts research is not ambivalent, so 'no' and/but 'yes'. Though PARIP took care to always underline 'the need to respect the diversity in approaches in PAR', there was always a powerful undertow running through the community of researchers in the UK and elsewhere that was extremely wary of *any* kind of documentation: 'If . . . artefact-based outcomes [alone] are seen to "embody" the research as the "serious" output, we might suggest that that reproduces the systems of commodity exchange . . .' (Piccini and Kershaw 2003: 122).

A key source of this wariness of documentation was Peggy Phelan's insistence on ephemerality as *the* essential quality of performance, but an even more thoroughgoing vision of time-slipping identities had been bombshelled in by Judith Butler's performativity theories and a fast-mustering host of like-minded advocates (Phelan 1993: 146; Parker and Sedgwick 1995). From this perspective, the 'documentation' of practice as research in live performance easily could seem tainted by technology and teleology. If the high-ground of advanced technical mastery was a key component in any 'proof' that *ephemeral* performance could produce *lasting* 'knowledge' as an *ultimate* goal, then the devil of commodification through documentation always already would be dancing rings around the conflagration of radical hopes, political or otherwise,

in performance practice as research. Never mind that such documentary digital derring-do might create new aesthetic qualities to establish emergent synergies with the events that egged it on – much as the advent of the quill pen did for spoken poetry, perhaps – in this game the double bind of collusion with capital in the name of 'capturing' art was a dead cert. But what is lost in this line of thought is an appreciation of how memory may newly play through various mnemonic systems, such as, say, texts, still images, DVD interactivity with moving images, links from these to the growing richness of Internet resources, and so on.

Nonetheless, from the perspective of the doctrine of ephemerality, despite being a total of five years in development, the process of creating interactive analogues between *The Suchness of Heni and Eddie* as live event and digital document was a lost cause. The authoring of synergies between super-tight choreographic and onscreen visual tropes *and* body-based and finger-clicking improvisatory freedom was doomed when the first move in making the digital quill was made. Even the most super-sophisticated representation could not reactivate a quality or condition that *by definition* was absent from the event in the first place. Moreover, in this performance theology 'suchness' was for certain an automatic loser. This is because 'suchness' indicates an *essential quality* that is total anathema to the postmodern relativism on which, ironically, the doctrine of ephemerality as an essential quality of 'live' performance is founded.

It also automatically follows that the dream I have just evoked, of somehow reviving the liveness of Eddie and Heni's virtuoso display of improvised precision through interactivity with a precisely calibrated digital object, is a fool's foregone – i.e. logically certain – illusion. And of course the circularity of *that* formulation, especially in proximity to a political double bind, would conventionally signal a classic logical quietus. But then what sense might one make of resonant notions such as Picasso's 'Art lies in concealing art' or Dubuffet's '[Art's] best moments are when it forgets what it is called'? As Rosemary Lee's choreography was in practice deceptively simple, in the sense that its constant imperative was the impossible injunction to Heni and Eddie to 'be spontaneous', why should that process *not* find a homology in the practice of an interactive DVD that *structurally* reproduces its choreographic principles?

In the live event those principles were created as between a simple but highly rigorous formal system – the choreographic 'rules' – and a complex but finely tuned simplicity of improvisatory response *within* that system – the dancing of Heni and Eddie. In any one screen-space on the DVD the viewer can see *that* under construction in the creative process and/or 'completed' in the 'final' performance. But *also* in the live event Lee provided mediating material – in her spoken commentary and through interpretive postcards handed to the audience, for example – thus opening further reflexive channels

that provided spectators with overt choices in how they might engage with the dance/dancers. Such channels are reproduced technologically *as between* the DVD itself as fixed-but-flexible system (= structure/choreography) *and* how the choreographer/dancers may be variously represented by the choices of the DVD user (= improvisation/creative freedom). Hence, *both* sets of relationships together create a doubled injunction for users to 'be spontaneous' in their interactions with the screen and its materials. Of course, there is no guarantee that either the live-event spectators or the DVD-event users will engage that process, but the structural and thematic homologies between live- and DVD-events are the basis of its possibility in *both* processes. How can you tell the dancers from the dance? How can you tell the moving images dancing from the dance?

As with the paradoxical processes analysed in *Slightly Cloudy, Chance of Rain* and *Being in Between*, it takes a paradoxology of performance to recognise how documentation of a live event might reactivate in the present of its user a sense of performance life from the past. In this sense the homologies between document and event work as multi-channel reflexive opportunities for recreating qualities of the processes of the latter in the former. Hence the vicious circles produced by the doctrine of ephemerality in live performance may be transmuted into *virtuous circles* that challenge the assumptions of the theology of 'liveness'. Paradoxes are crucial to such transmutations because they *both* incorporate the contradictions on which the theology rests *and* indicate 'truths' that potentially override them. In the case of *The Suchness of Heni and Eddie* both as live and DVD event the operative paradox was: be spontaneous! And the effect of its operation for live-event spectator and DVD-event user was, as it were, through interactivity to share out a sense of the live as existing between the two. Hence the operations of a paradoxology of performance in response to absolutism in the doctrine/theology of the ephemeral/'liveness' open up what I call 'degrees of ephemerality' between a live event and its documents. Such degrees, I suggest, afford a prospecting for performance ecologies that can become more sustainable through the live in both events and documents. So I fondly like to think that recognition of this potential in performance practice as research could introduce a little more eco-sanity into the world.

CONCLUSIONS

I trust these tightly focused reflections give a modest indication of the expansiveness of creative performance practice as a research methodology – or methodologies – in the twenty-first century. Such expansiveness arises from two main sources. Firstly, the powers of practice as research to create methods that *dis-locate* knowledge (or its equivalents) in the multiple dimensions of

performance events. Secondly, the flexibility of practice as research as a methodology that can encompass many (if not all) disciplines through the paradoxical rigour of its specific procedures and protocols. Together, these indicate something of the radical challenge that practice-based research may offer to established methods of knowledge production. And though such challenges are perhaps becoming increasingly familiar, they remain quintessentially important to the efficacy of practice as research in the arts and humanities disciplines and, of course, in others beyond them. The widespread 'turn to practice' in many disciplines in the late twentieth century was clear indication of a major shift away from logocentric and modernist paradigms. Likewise, the widely recognised spread of 'performance' and 'performativity' as key concepts for process-oriented systems of knowing underlines the potential of research that fundamentally incorporates the creative protocols of innovative performing arts (McKenzie 2001). It is hardly surprising, then, that performance practice as research typically generates generic research issues relevant to an especially broad church of research methodologies. This is because it inherently challenges binary formulations – such as conventional polarities between, say, theory and practice, rationality and creativity, process and product, artistic and academic – through the degrees to which it successfully evolves methods that are holistic in conception and operation. Which is to imply that it does not eschew binary modalities, any more than the complex system that is this computer on which I am working does, but rather incorporates them into the specific ecologies of particular performative/performance research processes. My invocation of this general tactic produces the 'paradoxology of performance' explored in this chapter as a means to explication of what is ultimately inexplicable. Which is just another way of saying that the 'findings' of performance practice as research are likely to be always already provisional. Want something finished? Never say never!

Hence, I chose my case studies as examples, in part, for the oblique approaches they might afford to some emergent contradictions and conundrums of the twenty-first century, in order by indirection to find direction out. Motorways, zoos and dance studios may seem collectively random in their relevance to, say, environmental devastation, fundamentalist wars, global capitalist exploitation, but a performance practice as research that fully embraces their constitutive paradoxes might, just, gather in a little unusual illumination for a future that looks increasingly dark. Thus, on a rising scale of improbabilities: a widening range of options for research *starting points* might be more likely to produce projects that imaginatively reduce carbon emissions; more extravagantly, establishing the indispensability of *aesthetics* to the reformation of perception could conceivably increase diplomacy by revisioning intra- as well as inter-species divides and conflicts; and moving into the realms of pathological hope, modelling new technologies of *documentation* to reactivate

the economies of past energy exchange just conceivably might help to generate more sustainable equities of common wealth. Of course, such high-flung speculations are a sure-fire target for scepticism, even ridicule, so I advance them simply as piquantly absurd aperçus. Yet if one were looking for the key qualities of research inquiries that could actually begin to address such stupendous impossibilities, then the prodigious creative compass potentially available to performance practice as research could well become one of them. Or as the poet Louis Aragon once so wisely said, *without* brushing fingers under his chin: 'Your imagination, my dear reader, is worth more than you imagine.'

REFERENCES

Arts and Humanities Research Council (AHRC) (2008), *Funding Opportunities* (cited 15 June 2008), available from: http://www.ahrc.ac.uk/FundingOpportunities/Documents/Research%20Funding%20G.

Butler, S. (1951), *Samuel Butler's Notebooks*, eds G. Keynes and B. Hill, London: E. P. Button.

Engineering and Physical Sciences Research Council (EPSRC) (2008), *Funding Guide* (cited 15 June 2008), available from: http://www.epsrc.ac.uk/CMSWeb/Downloads/Publications/Other/FundingGuideApril2008.pdf.

Gislén, Y. (2006), 'Research: notions and complications', in L. Elkjaer (ed.), *Re.Searching – Om Praksisbaseret Forskning i Scenekunst*, NordScen: Nordisk center for Scenekunst, pp. 125–40.

Higher Education and Research Opportunities (HERO RAE) (1996), *Criteria for Assessment* (cited 15 June 2008), available from: http://www.hero.ac.uk/rae/rae96/66.html.

Higher Education and Research Opportunities (HERO RAE) (2001), *Section III: Panel's Criteria and Working Methods* (cited 15 June 2008), available from: http://www.hero.ac.uk/rae/Pubs/5_99/ByUoA/crit66.htm.

Ingold, T. (2000), *The Perception of the Environment: Essays on Livelihood, Dwelling and Skill*, London and New York: Routledge.

International Federation of Theatre Research, Working Groups 2008 (cited 15 June 2008), available from: http://www.firt-iftr.org/firt/site/working-groupinfo.jsp?pGroupID=17.

Kershaw, B. (2006), 'Performance studies and Po-chang's ox: steps to a paradoxology of performance', *New Theatre Quarterly*, XXII (1), 30–53.

Kershaw, B. (2007), *Theatre Ecology: Environments and Performance Events*, Cambridge: Cambridge University Press.

Lee, R. (2007), *The Suchness of Heni and Eddie: An Interactive Document and Investigative Research Resource* [DVD], PARIP/University of Bristol/ResCen.

McKay, G. (ed.) (1998), *DiY Protest: Party and Protest in Nineties Britain*, London: Verso.

McKenzie, J. (2001), *Perform or Else: From Discipline to Performance*, London and New York: Routledge.

Malcolm, N. (1958), *Ludwig Wittgenstein: A Memoir*, Oxford: Oxford University Press.

Mehta, V. (1965), *Fly and the Fly Bottle*, Harmondsworth: Pelican Books.

Moore, G. (1998) [originally published 1898], *Evelyn Innes*, London: Unwin Hyman.

Parker, A. and E. K. Sedgwick (eds) (1995), *Performativity and Performance*, London and New York: Routledge.

Phelan, P. (1993), *Unmarked: The Politics of Performance*, London and New York: Routledge.

Piccini, A. and B. Kershaw (2003), 'Practice as research in performance: from epistemology to evaluation', *Journal of Media Practice*, 4 (2), 113–23.

Practice as Research in Performance 2000–2006. PARIP (cited 15 June 2008), available from http://www.bristol.ac.uk/PARIP/.

Reeve, S. (2006), *The Next Step: Eco-somatics and Performance*, paper presented at the Changing Body, University of Exeter (cited 5 October 2008), available from: http://www.moveintolife.co.ulc/reeve.pdf.

Research Assessment Exercise (RAE) (2006), *Dance, Drama and Performing Arts* (cited 15 June 2008), available from: http://www.rae.ac.uk/pubs/2006/01/docs/065.pdf.

Schatzki, T. K., K. K. Cetina and E. von Savigny (eds) (2001), *The Practice Turn in Contemporary Theory*, London and New York: Routledge.

Shorter Oxford English Dictionary (1970/2002), Third and Fifth Editions, Oxford: Oxford University Press.

Thrift, N. (2004), *Knowing Capitalism*, London: Sage.

Whalley, J. 'B'. and L. Miller (2005), 'A dwelling in the screen, at least for a little time', *Performance Research*, 10 (4), 138–47.

Beachcombing: A Fossicker's Guide to Whiteness and Indigenous Sovereignty

Anne Brewster

> We walk along the beach. The gaze slides along and between strands of seaweed, lines of shells and pebbles, jumping over small items of detritus – all washed up along the tidelines. We sift the beach with our eyes, our fingers, our toes. What shall we do with this abundance of cast-off things? To beachcomb is to become entangled with things incidentally, to become curious, to recollect.

Two models of scholarly research dominate the academy, quantitative and qualitative research. Traditionally, both have naturalised the perspective of the researcher. Similarly, research, as a process, has conventionally been taken as self-evident. Quantitative and qualitative research use different paradigms to report their results. Quantitative research uses measurement: numbers, graphs or formulas. Qualitative research, on the other hand, deals mainly with texts. It emphases 'written outcomes' and disseminates research results in 'discursive prose' (Haseman 2006: 99), specifically the author-evacuated analytical prose of the Anglo-American scholarly tradition.

Brad Haseman (2006) argues for a third category, 'performative research', which has been gathering momentum with the proliferation of new media and the entry of other creative practices into the academy. This third category, as he conceives it, largely constitutes a renovation of qualitative research. Performative research (a term he uses interchangeably with 'practice-led research') is distinguished by privileging practice in the research process and by arguing for the status of practice as a research outcome.

It uses the 'symbolic language and forms' (2006: 100) of the media in which the research is undertaken to report research results. Haseman defends the concept of performative research by arguing for the 'primacy' of the medium in which the practice takes place (computer code, audio data, video, theatrical

performance, dance or graphic arts) and suggests that the research output should be assessed according to the rubric of these media. 'Claims to knowing', he argues, are made through 'the symbolic language and forms' of the practice (2006: 100–1). In other words, they do not need to be translated into written outcomes in order to be recognised as research outcomes. In this chapter I focus on one trajectory within qualitative research which could be characterised as performative research, namely experiential and personally-situated writing, in order to examine what research outcomes these innovative writing practices produce. I argue that the research outcomes of new writing practices in turn require new reading practices.

The last two decades in qualitative research in the social sciences in North America have seen a reconfiguration of the role of practice in research and the emergence of a range of alternative research practices, including personally-situated writing.[1] This latter innovation was in part a response to critiques, for example as made by people of colour in the 1980s, of disembodied, putatively 'objective' and 'neutral' speaking positions. These speaking positions, it has been argued, are based on assumptions of universalism that mask white privilege and entitlement. Many renovated qualitative methodologies have privileged the 'experiential'[2] and expanded the range of scholarly enunciative and generic modes thereby introducing new constituencies into the field of scholarly research (for example, women, the working class, raced and ethnic groups, queers, disabled people, sex workers, refugees and immigrants). One of the key figures in the renovation of qualitative research in the social sciences is Laurel Richardson who has championed a range of what she calls 'creative analytic' research and writing practices (2000: 929). She argues that orthodox methods of qualitative research have suffered from an 'acute and chronic passivity' which made qualitative research boring and irrelevant to people's lived experience (2000: 924). She suggests that because the subjects of social science research are essentially 'the world, ourselves, and others' (2000: 924–5), the scholarly writing of this field should itself become more demotic; the proper function of scholarly work is to close the gap between our experience of the world and the languages of research (2000: 925). Scholarly writing should directly address demotic constituencies and not just a congregation of scholars. In her own work she focuses in particular on women as both a community of researchers and a general audience. She identifies a central shift in feminist scholarly writing towards understanding 'theory [as] story' and, concomitantly, turning research into 'narrative'. She advocates innovative feminist research practices in which

> women talking about their experience, narrativising their lives,
> telling individual and collective stories became understood as women
> theorising their lives. (2000: 927)

If the goal of this self-reflexive research is for women to 'understand [them] selves' and their specificities, this in turn allows them to recognise themselves as the product of the interplay between 'language, subjectivity, social organiza-tion, and power' (2000: 928–9).

> Taking ideas and rolling them between your palms like a stone until they become warm. Putting theory to work in everyday life, in the immediacy and temporalities of the body, the living tissue of social relations: desires, sensations, convictions, doubts, puzzlements, curiosities, anxieties, hopes. The allure of theory. The incidental pleasures of bricolage.
> Theory and creative writing re-enchanting each other through reverie, through strolling. Reading is an act of reception, of invitation. We open ourselves to change.

Much of the restyled scholarly work in qualitative research over the last two decades is interdisciplinary, drawing on both literary textual strategies (from poetry, for example) and a miscellany of generic modes from outside the academy, such as memoirs, letters, journals, anecdotes, etc. Richardson suggests that literary devices 're-create lived experience and evoke emotional responses': such writing 'touches us where we live, in our bodies' (2000: 931). It opens up ways of incorporating into scholarly writing the affect and bodily experience that it has traditionally elided.

This period of innovation and invention in North American qualitative research impacted upon scholarly work in Australia, largely in the social sci-ences. More recently, it resonates with the theory and principles of Haseman's performative research. Haseman acknowledges that qualitative research in recent decades has foregrounded its research methodologies and their 'situ-ations of practice' (2006: 99). However, he argues that even this innovation works to position research practice as 'an object of study' (2006: 99), rather than radically changing the parameters of research practice by according rec-ognition to the primacy of practice. Although it has a 'strong alignment' with some of these renovated qualitative research strategies, performative research has its own distinctive methods arising from the 'primacy' of its practice (2007: 6). In this chapter I examine how Haseman's concept of performative research might contribute to a better understanding of contemporary interdisciplinary text-based research practices in the social sciences and the humanities. I am specifically interested in how contemporary interdisciplinary writing reconfig-ures the nexus between practice and research.

In textual studies the term 'practice' yoked to the term 'research' usually signifies the inclusion of bodily experience in writing. The body's material-ity is a 'pure force and potential' (Colebrook 2002: 694). It is also the locus of affect and sensation. In Western analytical discourse bodily experience

has commonly been assimilated to cognitive models (Connerton 1989). However, recent cultural theories of the body insist that bodily experience is not reducible to an intentional subjectivity or assimilable to cognition; it remains other to them. Bodily practices complement and inform thinking in contrapuntal ways. To incorporate bodily practice and experience into writing is to acknowledge the subject's relationality to other subjects and the world of things. It is to discard orthodox paradigms in which the object of the research is inert and passive and the researcher masterful and controlling. Weiss, for example, uses the term 'embodied ethics' to characterise research which incorporates the temporality and the affective consequences of bodily experience. Drawing on philosophers as diverse as Aristotle and Hume she argues that ethical agency is not achieved solely through cognition but that 'sentiments' and bodily imperatives play a crucial, motivating role (1999).

In this chapter I investigate the embodied ethics of the recently convened interdisciplinary field of personalised critical whiteness studies. This field emerged within Australian humanities and social sciences in the 1990s following the global renovation of qualitative research. My interest in this field is shaped both by my research, as a white middle-class Anglo Celtic-Australian, in Australian indigenous literature, and by my experience as a creative writing teacher. Personalised whiteness writing is a mode of performative research that is simultaneously grounded in theory and the experiential. I suggest that the experiential has entered into academic discourse in response to urgent social and political imperatives. Performative research in this field enables the academy to engage directly with emergent intercultural imaginaries. It seeks to accommodate the volatile affective dispositions, uncertainty and equivocation which accompany social change.

In his taxonomy of practice-led research Haseman uses creative writing as an example of performative research in textual studies. In discussing the writing of research outcomes he makes a distinction between discursive (analytical) and non-discursive (creative) writing. The former he positions within qualitative research, the latter, performative research (2007: 9–11). According to Haseman the research output for creative writing is the novel. But is creative writing the only textual mode in which performative research can be undertaken? In its deployment of my own personalised whiteness writing, this chapter demonstrates that analytical discourse can become performative research by incorporating the 'symbolic language and forms' of creative writing and other extra-literary modes. In its use of first-person narrative, anecdote and poetic strategies and its borrowings from non-literary genres, personalised scholarly whiteness writing brings research directly into proximity with *practices* of self- and national-fashioning. It engages with a range of affective dispositions and non-cognitive bodily experience that is normally

excluded from the scholarly enterprise. Hence, although personalised whiteness writing is grounded in theory, it shares many methodological aspects of practice-led research.

In this chapter I explore the nexus between theory and practice by complicating the relationship between the two key terms: research and practice. Haseman, quoting Carole Gray, defines practice-led research as being 'initiated in practice . . . [and] carried out through practice' (2007: 3). I demonstrate, through a dialogue of creative and theoretical writing, that performative research does not necessarily proceed along a linear trajectory or chronology – that is, with research being 'initiated' and 'carried out' through practice. I suggest, rather, that a contrapuntal movement where the inverse action – (experiential) practice being initiated by (theoretical) research – may occur.[3] Accordingly, this chapter expands the category of textual practice-led research to accommodate its mirror image, research-led practice.

Personalised critical whiteness studies is a sub-category of critical whiteness studies, a body of theory which aims to open up the cultural reproduction of whiteness and the white subject to scrutiny.[4] It argues that whiteness has traditionally been resistant to questioning, occupying the norm to which racialised identities are compared (and found wanting). Whiteness, it is argued, has been resistant to analysis precisely because its reproduction maintains a system of authority, privilege and entitlement, in which white subjects and power structures are heavily invested. Australian critical whiteness studies have adopted a bricolage of scholarly styles. These include anecdotal and personally-situated writing, largely by white women.[5] I have argued elsewhere that the adoption of personally-situated narrative has been in response to several decades of first-person writing by indigenous women (Brewster 2005a; see also Whitlock 2000). It has also been influenced in Australia by fictocriticism, a hybridising practice which developed in the academies in the 1980s at an interdisciplinary convergence of creative writing and disciplines such as literary studies and cultural and media studies.[6] Fictocriticism combines theoretical work with modes of writing from a range of literary and extra-literary genres many of which are first-person modes (e.g. memoir, anecdote). This chapter tracks the legacy of fictocriticism in recent innovative methodologies of personalised Australian scholarly writing about whiteness. Both these fields undertake performative research, most commonly research-led practice. My particular interest in these categories derives from the work they perform in investigating contemporary Australian intercultural relations between indigenous and non-indigenous people.

To walk along the beach is to fossick, to write. You don't know what is coming next. You anticipate the discovery of minor yet engaging

objects, a special shell among the banks of shells. You meander onwards, occasionally pausing or turning to retrace a few steps.

You make a mental note to take a plastic shopping bag with you next time to pick up the junk – a broken water pistol, the section of a snorkel, plastic bottles and part of a bathing suit.

You move at the pace that the sand, tugging at your ankles, will allow. You feel your toes splaying as they mould themselves to the sand. You plough it with your heavy feet, eyes down, thinking of the bullocks and horses that were used in the region for the timber industry. They dragged logs the size of a house to the sawmills. There were photos of them in Karl's book on Bateman's Bay. There were up to eight horses in a team and they pulled the cart laden with logs along a railway track. The author of the local history described how the horses were selected for the 'right step'. You ponder this and conclude that it means a pace that allowed them to step comfortably between the railway sleepers. You love the photos of the old Clydesdales, huge, shaggy and meek-natured.

Water is the emissary of commerce, bringing colonisers to this shore and later carrying the logs down the Clyde River to the coast at Bateman's Bay where they were shipped to Sydney. Walking along Pebbly Beach, it's hard to imagine that this was once a bustling little town gathered around the sawmill. Now there is almost nothing left. A trace of a history of allure, of struggle and frustration, remains in the place names: Mt Agony Road, Pretty Beach, Dark Beach. Now a generation of holidaymakers is settling the area. You think about first contact stories. Looking out over the sea you imagine the navigators, cartographers and botanists: their curious, acquisitive gaze. Karl's book said that Cook first sighted indigenous people – here on Koorbrua beach at Murramarang – on 22nd April 1770.[7] Cook and Banks observed five 'enormously black' Aboriginal men.[8] Cook attempted to anchor but the seas were too rough.[9]

The horizon seems to stretch forever. It is the same horizon on which those ships first appeared, breaking the smooth, shimmering line dividing water from sky, and drawing inexorably closer. In 1832, sixty years after Cook's first sighting, there was a massacre here, according to historical records. Three years after the massacre, on 10th October 1835, the NSW Governor, Sir Richard Bourke, proclaimed the Colony *terra nullius*.

Barbara Bolt characterises the process of creative arts research as one of 'handling' materials (a term she borrows from Heidegger). Heidegger argued that we do not come to 'know' the world primarily through contemplative cognition and theoretical reflection but through our 'handling' of its materials (2007: 30). She adapts Heidegger's concept of 'handling' to qualify and extend Paul Carter's notion of creative research as 'material thinking'. She uses it to highlight the important role of the body in creative research, and to emphasise that it is not only through 'talk' that 'material thinking' occurs (2007: 30). She argues that it is primarily in bodily response to and conjunction with its *materials* that creative arts research emerges (2007: 30).

Unpacking Bolt's argument further, I suggest that the metaphor of 'handling', in privileging the hand, can instrumentalise the body and its sensations. The concept of 'handling' implies that our interaction with our research materials is always mediated by the hand, and that the relationship is, thereby, one principally determined by work: the hand transforms dull, obdurate matter, through labour, into something useful. Indeed the hand often functions as a metonym of the labouring body ('all hands on deck'). I want to contrast the hand with the foot. No doubt the latter has historically also been a tool of labour (most obviously through ambulation). However, I suggest that it does not evoke so readily and immediately the labour often associated with the hand, such as the practice of writing, for example. (Another example of the hand as the exemplar of transformative labour can be seen in the opposable thumb. This feature has been used anthropologically to differentiate significant stages in the evolution of primates, stages that are marked by the manual use of tools. In this paradigm the evolution of *homo sapiens* is facilitated through the labouring body, of which the hand is metonymic.) So if the hand is a cipher of work, the foot, by contrast, evades work (which, for the purposes of this argument, I define as habitualised labour). The flaneuse, for example, is engaged in an altogether different kind of bodily activity.

I take the foot (in the idle act of strolling along the beach) as a metaphor for embarking upon a different kind of productivity, an apparently footloose and aimless wandering which leads the researcher into unexpected and aleatory encounters. The strolling body is drawn forward by curiosity. Curiosity is not merely a cognitive facility; it has visceral and affective dimensions. It initiates contact and generates knowledge. The term 'contact' recalls Merleau-Ponty's notion of 'flesh', the name he gives to the interface between body and world (1968), but it also alludes to other cultural encounters at the border between self and other, for example the 'first contact' of colonising Europeans with their indigenous others. The moment of intercultural contact is an embodied encounter between different and often incommensurable knowledge systems. What new ways of thinking and being does such a troubling encounter produce? If we shift the focus from knowing the other to knowing whiteness

– as critical whiteness studies recommends – how does a researcher, located within a white knowledge system, come to know themselves (as an index of whiteness) and their history differently through revisiting the decussations of the border?

Indigenous Sovereignty

The European colonisers of the eighteenth and nineteenth centuries drew on the writings of international jurists in order to formalise legally their acquisition of lands in the 'new world'. Clark's A Summary of Colonial Law (1834) was an important international handbook for jurists at the time of the colonisation of Australia. This book defines the various means by which lands could be annexed and British sovereignty extended to them.

It states that there were three ways in which colonies could be established. They were:

1, by conquest; 2, by cession under treaty; or 3, by occupancy, viz. where an uninhabited country is discovered by British subjects, and is upon such discovery adopted or recognised by the crown as part of its possessions (Clark, quoted by Reynolds 1996: 91).

The British proclaimed that Australia was acquired by the third means, that is, through occupancy, or 'settlement'. In other words this 'settlement' was essentially a peaceful rather than a warfaring procedure. This idea was enabled by the promulgation of the legal doctrine of terra nullius: land inhabited by no one.[10]

In 1889, one hundred years after the arrival of the first fleet, the Privy Council's Lord Watson confirmed that when Cook declared British sovereignty over NSW in 1788, Australia was 'a tract of territory practically unoccupied without settled inhabitants or settled law' (Watson, quoted by Reynolds 1996: 19).

According to British jurisprudence, then, there was no formal 'war' with or defeat of the indigenous peoples of Australia. Neither was there a negotiation (by way of treaty) in which indigenous peoples ceded their lands to the British.

Lord Watson's 1889 description is puzzling. Cook himself had many dealings with indigenous peoples in Australia during his voyages around

the continent. And historians documented at length the first decades of white settlement in which there was frequent contact between settlers and indigenous peoples. During this time settlers recorded numerous observations of indigenous culture, including indigenous people's overt attachment to and identification with their country.

Moreover, during the hundred years that followed the establishment of British sovereignty, indigenous people's wish to retain occupancy of their lands and their defence of them is apparent throughout a large archive of historical records. The statement in 1889 by the British Privy Council – one hundred years after the arrival of the First Fleet – that the land was 'practically unoccupied' was clearly indefensible. The persistence of this denial of indigenous occupation in recent times underlines a deeply repressed anxiety surrounding the legality of British sovereignty in Australia.

It is clear that indigenous people had a system of law and governance equivalent to the Western term 'sovereignty' before the arrival of the British. Indigenous sovereignty is a term that points to indigenous people's prior and ongoing cosmological relationship – which is the basis of their cultural traditions and identity – with their homelands, and their continuing inalienable rights of access to them. Indigenous lawyer Michael Mansell, for example, describes sovereignty as 'the exclusive rights exercised by a distinct group of people over a particular piece of territory' (1994: 1012). In the face of ongoing claims for the legitimacy of white Australian sovereignty, Falk and Martin suggest that 'the question of how and when indigenous sovereignty was lost needs to be answered at Law' (2007: 38). Indigenous legal scholar Behrendt observes that 'the notion of [indigenous] sovereignty goes to the heart of the restructuring of the relationship between indigenous and non-indigenous Australia' (2003: 96).

'Mabo' is a term that refers to the 1992 landmark court case in which the Australian High Court recognised the existence of native title.[11] This decision dispelled the myth of *terra nullius* and affirmed that indigenous native title survived the establishment of white sovereignty. It did not, however, recognise indigenous sovereignty because, it was argued, white sovereignty was an Act of the Crown. This meant that no challenge to it was justiciable in Australian courts. This chapter, in its investigation of post-Mabo white liberalism, is poised at this legal and cultural hiatus between (1) white recognition of indigenous prior occupation and native title and (2) a stalled recognition of indigenous sovereignty.

Performative research brings whiteness into a new proximity to the past. It is a part of a huge, slow wave rolling us over, tumbling us around so that we are back at the meeting place of black and white: two sovereignties, two nations. The term 'contact' functions atavistically; it returns me to the encounter of coloniser and indigene figured by classical anthropology and ethnography. The bodily 'recollection' of Cook's anxious colonial encounter is superimposed upon the belated postcolonial[12] recognition of the sovereignty of the indigenous body. One of the methodologies of whiteness studies is defamiliarising whiteness (Brewster 2007, 2008) and in this chapter I aim specifically to defamiliarise white sovereignty. This chapter performs an interdisciplinary convergence of literary studies, history, archival material, critical whiteness and race theory, tourist brochures and creative writing. It accommodates a fossicking and recollection within numerous disciplinary fields and within everyday life that allow me to imagine what recognising indigenous sovereignty might entail. It stages an encounter – with history, with a body in reverie, with the Murramarang National Park.[13] It generates a knowledge that is informed by reading, thinking, writing, feeling, dreaming, yearning for political change and by the body walking along the beach. It does not assume that the researcher is detached from her materials. She is not an inert, passive observer but one who is embedded in the fraught standoff between white and indigenous sovereignties that subtends the white nation. Performative research can move into this space, the liminal strip of beach on which colonisers first set foot and encountered the other, on which they planted the British flag and proclaimed ownership of the new south land. It allows access to the moment in which we recognise the sublated disavowal of indigenous sovereignty and the precariousness of white Australian authority.

Two Australians who have produced a sizeable body of innovative scholarship on the subject of contemporary cross-racial relationality are Stephen Muecke and Margaret Somerville. Neither of these writers draws directly on critical whiteness studies; however, both work from a white point of view to address relations between indigenous and white Australians. Both draw on a range of fictocritical strategies such as storytelling and the use of the first person. Three of Muecke's books, *No Road* (1997), *Ancient and Modern* (2004) and *Joe in the Andamans* (2008), situate themselves within a fictocritical rubric. They combine theory – drawn largely from Bruno Latour (1993, 2004) – with anecdotes and autobiographical snippets, what Muecke calls 'self portraits' (2008: 13). Fictocriticism, he says, 'tells a story and makes an argument at the same time' (2008: 113). It is 'inspired by the materials and situation at hand' (2008: 15), and is situated in familial and demotic (that is, mundane, everyday) contexts. The 'stories' he constructs are often minimal in terms of narrative plot or suspense; they relate incidents and events in a non-closural way.[14] What

'closure' there is emerges from the juxtapositioning of a range of people, places and events in such a way that they resonate to produce an intensity of connection and correspondence.

 Muecke's 'arguments' are also often a loose coalescence of ideas rather than a neatly delineated trajectory. Heavily influenced by Deleuze, Muecke argues against critical and 'conceptual' philosophy, expressing a preference for the percept which Deleuze defines as a function of fiction. According to Deleuze, percepts in fiction describe the relationship between a character and landscape and, more broadly, between mind and the world. The term 'percept' designates 'the dissolution of the ego in art' (Marks 2005: 199). It figures how we 'become with the world', how we are 'part of the compounds of sensation' (Marks 2005: 199). It thus challenges the traditional notion of character. Muecke is centrally interested in the relationship between the self/subject and their 'situations' and the world; he contrasts the richness of the work that the percept does in 're-enchanting the world' (2008: 19) with the arid abstraction of philosophical concepts. His anecdotal narratives favour a sensual, experiential relation with the world and its objects rather than conceptual argument. Writing about trams, for example, he recommends that instead of

> pointing our bony finger at the world, from the outside as it were, judging it, we [write] from the inside of things, from our necessary assembly or convocation with those non-human things that have always helped us think. (2008: 113–14)

Because of its eschewal of the critical 'concept' in favour of the percept it is sometimes difficult to engage with and respond to Muecke's work 'critically'. Whereas philosophical concepts are 'taken up and used by others', Muecke argues, percepts are 'just *there*' and 'stand alone' (2008: 19, his emphasis). Its privileging of percepts (and eschewal of explication) gives his fictocriticism a minimalist quiddity which resists exegesis. There is often uncertainty among readers as to whether the fictocriticism should be read as literature or as 'critical' work. I would suggest that this ambiguity is one of the unsettling effects of fictocriticism which, as a hybrid genre, requires readings and responses which are different to orthodox forms of assessing research output. We respond to it as literature – i.e. it's not easy to engage argumentatively with his ideas.

 Three of Margaret Somerville's books, *Ingelba and the Five Black Matriarchs* (with Patsy Cohen) (1990), *The Sun Dancin'* (1994) and *Body/Landscape Journals* (1999), deploy the journal and fragmented life history in collaborative work with indigenous women. Another, *Wildflowering* (2004), is a fictocritical biography of the white conservationist, Kathleen McArthur, and explores Somerville's own relationship with the land. While Somerville does not overtly characterise her writing as fictocritical, it shares many of its features: it

is grounded in a wide range of cultural theory and, like Muecke, she turns to storytelling as a means to negotiate cross-cultural relationality. The personal turn, central to her work, is common to many women fictocritical writers and to the sub-category of personalised whiteness writing that I identity above. Somerville uses performativity theory to foster a writing that is 'open, unfinished, decentred, liminal' (1999: 16) and that focuses on bodily sensation and experiential transformation.

Like Muecke, Somerville is interested in the relationship between body and landscape. At the centre of much of her work is the question through which she interrogates whiteness: 'how can I have a sense of belonging in the Australian landscape?' (1999: 128). Her work searches for new forms of white identification and cross-cultural intersubjectivity. The vernacular is the dominant mode of Somerville's writing: it enables her to integrate her emotional and intellectual life. In documenting her embeddedness in cross-cultural relations she explores feelings of grief and sorrow, her love of the Australian bush and her own struggles which often manifest as illness, in living through painful experience. Illness, like affect, is an index of change, a liminal phase in which occurs 'a movement from one state of being to another' (1999: 80). Like Muecke she wants her writing to negotiate change or shift, bodily and subjectively. The journal is a mode that allows her to document how stories can produce new identities both in bodily and personal contexts but also in public discourse about nationhood and belonging. It enables a recognition of indigenous sovereignty and a reconfiguring of whiteness.

Like Muecke, she's interested in white people's relationship with the Australian landscape, a landscape filled with glimpses of indigenous occupation and the post-memory of colonial invasion. In *Wildflowering*, her fictocritical biography of Kathleen McArthur, an elderly conservationist, she searches for a way to describe her own relationship, as a middle-aged white woman, with the coastal sand dunes of Cooloola. This area has significance in geological discourse as 'the largest continuous series of sand dunes in the world, and the oldest system of parabolic dunes so far described on earth' (134). Her guide, Kris, tells Somerville that 'Captain Cook used the Cooloola sand patch as a marker . . . It would have been very significant for Aboriginal people. From the sand patch you can see for miles around and you can also see it from a great distance' (153). Somerville thinks of 'the landscape as a subject, an active being that reaches out to me' (142). In her meditations on the land as an old continent with a long indigenous history, and on her own and Kathleen's relationship with it, she concludes that 'Cooloola is about learning to grow old in the landscape' (146). She describes Kathleen thus:

> I think about Kathleen, with the mottled skin of her arms like the
> lichen-lace on the trunk of the tuckeroo outside her window. I love her

weatherbeaten skin and have often longed to photograph her arm lying
on the table. But, deterred by shyness and the difficulty, I photograph
the tuckeroo instead. Kathleen is growing old and so am I. Aging is a
difficult subject. What are the effects of representing our land as an aged
landscape? An aged female landscape? (147–8, 149)

Muecke, like Somerville, investigates various models for white people's rela-
tionships with indigenous people and the land. He champions an 'attitude of
respectful visiting' (2008: 91) as a model of white relationality. This model
addresses the political issue of indigenous sovereignty:

> Speaking as myself, and as an Australian, there is something of
> a dilemma in visiting others within my own country. Aboriginal
> people have been playing host to a lot of visitors over the years,
> going backwards and forwards with changing stories about what they
> experience in Aboriginal country. The paradox of 'visiting Aboriginal
> Australia' concerns the unresolved political question of 'them' and 'us.'
> At what level are we the same people within a nation? (Muecke 2008: 86)

Like Somerville, Muecke fashions a writing that draws on the performa-
tive process of making stories; visitors, he says, are 'traders in stories' (2008:
84). He defines visitors as categorically different to scholars: 'Seeing oneself
as a visitor on the lookout for stories is quite a different thing from being a
researcher equipped with theories' (2008: 84). Despite the fact that Muecke
wants to maintain the separation of 'visiting' on the one hand and 'research'
and 'theory' on the other, his weaving of various theorists into his writing
indicates that theory does indeed inform his interaction with 'Aboriginal
Australia'. Like Somerville's writing, his work shares much with the category
of research-led practice. Both Muecke and Somerville write about the rela-
tionality of Australian whiteness to indigeneity in approaches informed both
by contemporary theory and an insistence on embodied ethics. Both draw on
the 'primacy' (to use Haseman's term) of embodied experience in negotiating
the contemporary aftermath of colonial invasion and the brutal dispossession
of indigenous people.

If I were to define two 'research problems' in my embodied research on post-
Mabo liberalism they would be: how can non-indigenous academics write
ethically about the 'other' (i.e. without fetishising them) and how can we
recognise indigenous sovereignty in our work? A critical whiteness studies'
response to these questions, as I suggest above, would recommend that white-
ness be located within the purview of our research topics and methodologies.
In writing about everyday life we introduce the white body and its affective

relationality to indigenous people into scholarly research. The beach is a performative site of bodily encounter with things, people, landscape, history and memory. In placing the body in the context of the everyday (a walk along the beach) I bring my ruminations on whiteness into proximity with a field of theory which figures everyday life as a zone where qualitative change takes place at the visceral level of the body. This allows me to think of the body as simultaneously an index of the reproduction of whiteness and of the volatility of its affects. Affect, by its very nature, informs social relations. Postcolonial affects (including grief, melancholy and guilt) are the legacy of the trauma and violence of colonisation. Accommodating and examining affect in our writing allows us to rethink and rewrite the category of the subject in the aftermath of critiques of the Enlightenment concepts of rationalism and liberalism.

Many intercultural and post/colonial theorists have argued for the primacy of relationality. It is productive to remind ourselves that white subjectivity is predicated upon an elided *inter*subjectivity. To rephrase Sara Ahmed, the *encounter* of indigenous and non-indigenous peoples is ontologically prior to the notion of the *subject* who encounters. Ahmed reminds us of the priority of encounter over identity. The subject, she argues, only comes into being through its encounters with others and its identity cannot be separated from its psychic and social interactions with them. Relationality, moreover, registers on the body materially and affectively before it registers cognitively or consciously. *Participation* (in the dynamics of interrelationality) precedes cognitive understanding. Massumi analyses the catalytic role of feeling and affect in triggering change. In his theorisation of the body Massumi mounts a critique of constructivism. He argues that production is not always reproduction – in other words there is always the possibility of change. He contrasts the slightness of qualitative change with the rupture of periodic change, for example that figured by historical discourse. In evoking the bodily dimension of cross-racial encounter the beach scene evokes the sensations and postcolonial (post) memories[15] where slippery and volatile affects slide into each other (anxiety, fear, sadness, curiosity, aggression, desire).

Return to the beach

I look around at the bush. Here it comes tumbling right down to the beach and seems wild: beguiling but resistant. There are shadows within shadows, space coiling within space. Sunlight and shade flicker; there are small movements everywhere.

It must have been obvious to early colonists that indigenous people lived here. They met them face to face. Was it the strangeness of the bush that lead the English to conclude that this land was not a habitat,

that it was not 'occupied' by the indigenous people? Perhaps the weird vegetation and the absence of what they recognised as agriculture lead them to believe this place was entirely inhospitable to human kind and therefore 'empty'.

As I walk along the beach I arrive again. I imagine the curiosity, the anxiety and stormy weather, the trepidation, thirst, aggression and greed. I fossick among things that have been tumbling in waves and finally washed up. I am looking for things buried in the huge mound of history.

It is known that Murramarang was an important meeting and trading place for Walbunga tribes from all over the region. The huge middens which are 12,000 years old are evidence of this. They point to a long history of indigenous occupation.

I look down at my feet. When I lift a foot the print fills up with water. I can see that the footsteps behind me have been reduced to dimples. Each minute the waves ravel and unravel the beach in an immense labour of reiteration.

In the second-hand bookshop I had bought a book of Aboriginal place names. The rather dubious miscellany explains that the name of Bondi Beach in Sydney, where I live, is derived from the word Boondi, meaning the sound of the waves on the beach.

I try it out here. *Boondi*, I say, attempting to match the word with the sound of the waves.

In this chapter I am drawing on the notion of contact or encounter as a central metaphor for social relations and for the process of two different knowledge systems coming into proximity. I'm staging this scene of contact on the beach, the liminal zone between land and sea that is the originary locale of invasion, the founding moment of occupation. The beach has been an iconic topic in Australian cultural studies (Fiske et al. 1987). It has been discussed as a locus for the staging of white patriarchal sovereignty, for example in performances of surfing, ANZACS,[16] surf lifesavers and, more ominously, white supremacy (in the 2005 Cronulla race riots – see, for example, Johns 2008). My purpose in revisiting the beach is to stage a further engagement with white Australia, namely a recognition of indigenous sovereignty. The metaphor of contact, a key term in traditional anthropology, has been critiqued for characterising culture as autonomous and separate, with discrete, impermeable, sealed boundaries (Byrne 1996). Nicholas Thomas (1991) introduced the alternative

term 'entanglement' to describe the mutuality and interdependency of colo-
niser and colonised. In returning to the term 'contact' I reinvest the interracial
encounter with a sense of bewilderment and the volatility of affect. I want to
emphasise the bodily difference that indigenous sovereignty represents. The
encounter with the indigenous bodies is also an encounter of indigenous sover-
eignty; as indigenous scholar Aileen Moreton-Robinson has said, 'indigenous
people . . . carry title to the land through and on their bodies' (2007b: 115).
As I suggest above, indigenous bodies have a specific relationship to land and
this relationship is an aspect of their sovereignty. Moreton-Robinson explains
further:

> Our sovereignty is embodied, it is ontological (our being) and
> epistemological (our way of knowing), and it is grounded within
> complex relations derived from the intersubstantiation of ancestral
> beings, humans and land. In this sense, our sovereignty is carried by
> the body and differs for Western constructions of sovereignty, which
> are predicated on the social contract model, the idea of a supreme
> authority, territorial integrity and individual rights. (2007a: 2)

Performative research is an effective antidote to the epistemological legacies
of coloniality, those objectifying systems which keep the other at a distance,
reifying them as objects of study, while preserving the authority and entitle-
ments of the white investigating subject in atemporal author-evacuated schol-
arship and in the fiction of what we might call *doctrina nullius* – a nomadic,
universalising and naturalising body of theory whose cultural origins are not
acknowledged. Interrogating the disavowed and misrecognised relationality
that subtends colonial knowledge and returning whiteness to its encounter
with the indigene problematises the subject–object relation that is central to
the tradition of Anglo-American analytical scholarship.

I embarked upon this chapter with a substantial grounding in critical white-
ness theory and a familiarity with a tradition of personalised whiteness writing
by Australian women. The 'creative' writing both impinges upon and is
prompted by the theory, changing the direction and nature of the argument.
Neither mode precedes or supersedes the other. The creative writing gener-
ates commentary which is, from this point of view, derived from it. However,
this process is circular as it was my theoretical research which prompted the
creative writing (and perhaps, in the Foucauldian sense, identified this realm
of experience as a worthy subject for writing). In other words creative research
does not subordinate the poetics of the creative writing to the authority of the-
oretical argument or vice versa. Each is dependent on the other. The process is
interruptive and dialogic, not fusile; each mode retains its generic specificity.

Similarly cognition is dependent upon affect and sensory forms of perception and knowing. To adapt Brad Haseman's formulation, as a performative researcher I do not merely 'think' my way through a problem or issue, but immerse myself in its bodily and affective dimensions (2007: 147). Haseman invokes Denzin's adage that creative research moves 'beyond the purely representational and towards the presentational' (quoted by Haseman 2007: 149). In the creative writing aspect of this chapter I aim to 'present' the beachcombing post-Mabo white liberal body in a face-to-face encounter with its colonial other. Bodily affect and experience is by definition performative and physically traceless. However, discursive genres such as the journal, anecdote, poetry and the novel, evoke bodily experience in their vernacular styles, points of view and description. They recreate textually bodily reciprocity and the contact between bodies and their environments.

The nature of both embodied, performative research and its outcomes is clearly different to orthodox qualitative research. As Haseman suggests, performative research is experiential in that the researchers 'tend to "dive in," to commence practising to see what emerges' (2006: 100). If the practice of performative research cannot be entirely assimilated to cognitive processes then its outcomes cannot be formulated *wholly* in terms of an 'answer' or conclusion. What emerges from the ambiguous textuality of much discursive research-led practice from fictocriticism onwards are reading practices which accommodate conversations with the academy's others.

Coda

The waves are calling

I hear so many things[17]

The beach is a meeting place. The waves tumble. They are saying
something but it is in a language we never knew. Behind, our footsteps
fill with water. Around us the waves remake the beach. At the mouth of
the river stand five black men, watching.[18]

NOTES

1. See Denzin and Lincoln (2000, 2003a, 2003b, and 2003c).
2. Haseman also uses this term to characterise practice-led research (2007: 5).
3. This reciprocal contrapuntal relationship, I might add, is not limited to the humanities; Brian Massumi (2000), for example, tracks the role of bodily experience such as surprise in scientific research.

4. Critical whiteness studies have been established for over a decade in North America where they proliferated across a wide range of fields, notably studies of labour history and histories of slavery. In Australia critical whiteness studies have developed along a different trajectory. Whereas in the US, whiteness has been defined culturally mainly in relation to African and Hispanic Americans, in Australia it has historically been defined largely in relation to indigenous people. Concomitantly, the emergent field of critical whiteness studies in Australia has been visibly shaped by a number of indigenous scholars, including Aileen Moreton-Robinson, Lillian Holt and Wendy Brady. For anthologies of Australian critical whiteness studies articles see McKay (1999), Moreton-Robinson (2004), Riggs (2007), Schech and Wadham (2004), and special issues of e-journals *Australian Humanities Review* (4, Aug.–Oct. 2007) and *borderlands* (3 (2), 2004).

5. For whiteness writing in Australia that adopts personalised modes of narration or commentary see Brewster (2004), Fergie (1998), Ferrell (2003), Garbutt (2004), Prosser (2002), Riggs (2002), Schlunke (2005), Slater (2007) and Wojecki (2007). See also Westcott (2007) and Brewster (2005a) for analyses of autobiographical, confessional and testimonial modes of whiteness writing.

6. For fictocritical writings and essays on fictocriticism see Brewster (1996a, 1996b, 1996c, 2003, 2005b), Brewster and Smith (2003), Costello (2005), Davis (2005), Dean et al. (2003), Kerr (2003), Muecke (1997, 2004, 2008), Kerr and Nettelbeck (1998), Robb (2003), Smith (2005) and Stern (1999).

7. Harmon (1994). Harmon quotes R. F. Pleadon (1990: 8–9).

8. Beaglehole (1962: 50).

9. NSW National Parks and Wildlife Service (1998: 8).

10. Legally the term *terra nullius* describes a method 'of acquiring sovereignty over . . . a territory belonging to no-one at the time of the act alleged to constitute the "occupation"' (Parry et al. 1986: 391). In this chapter I also refer to its vernacular meanings such as empty or uninhabited land.

11. The case addressed an action led by Eddie Mabo to determine the legal rights of the Meriam people to land on the islands of Mer in Queensland. The Mabo judgement defined native title thus: 'Native title has its origin in and is given its content by the traditional laws acknowledged by and the traditional customs observed by the indigenous inhabitants of a territory' (quoted by Webber 2000: 62). As Webber notes, however, 'the law of indigenous title recognises not just a set of rights and obligations with respect to land, but the continued relevance of autonomous indigenous legal traditions' (2000: 62). Native title is thus an integral aspect of indigenous sovereignty.

12. I use the term in this chapter in a periodist sense to suggest the post-Federation Australian world – which is both distant to and embedded within the colonial moment.

13. This is a large national park 250 km south of Sydney. It is part of the coastline mapped by Captain James Cook on his first voyage to Australia in 1770. Within a few decades of the first Australian colony being established in Sydney in 1788 the area was invaded by 'settlers' and is therefore one of the earliest colonised regions in Australia. Now it is considered an important site with a significant record of indigenous occupation, culture and history. It has had a long history of non-indigenous scientific investigation and has been described as 'the most studied Aboriginal site in Australia' (National Parks and Wildlife Service 1998: 1). For these reasons I take the park as an exemplary site of 'contact' between white and indigenous bodies.

14. See, for example, the two stories 'Gulaga Story' and 'A Chance to Hear Nyigina Song' in Muecke (2008).

15. I use the term deployed in trauma studies to indicate that memories of events outside a person's lifetime may still be incorporated within that person as their own memories.

16. The acronym refers to the Australian and New Zealand Army Corps who fought against the Turks in the Battle of Gallipoli in the First World War. This battle is commemorated annually.

17. Barbara Stammner, 'Just Beach Land' in Brewster, O'Neill and van den Berg (2001).

18. This chapter is dedicated to Latin scholar Helen White. I would like to thank Karl and Elizabeth Lisners for their hospitality, Mandy Swann for her research assistance, John Gascoigne for his advice and Ben Miller, Hazel Smith and Roger Dean for their feedback on earlier drafts.

REFERENCES

Ahmed, S. (2000), *Strange Encounters: Embodied Others in Post-Coloniality*, London: Routledge.

Anderson, W. (2002), *The Cultivation of Whiteness: Science, Health and Racial Destiny in Australia*, Melbourne: University of Melbourne Press.

Australian Humanities Review (2004) 4 (August–October), available at: http://www.australianhumanitiesreview.org/.

Beaglehole, J. C. (ed.) (1962), *The Endeavour Journals of Joseph Banks 1768–1771*, Vol. II, Sydney: Angus & Robertson.

Behrendt, L. (2003), *Achieving Social Justice*, Annandale, NSW: Federation Press.

Birch, T. (2007), '"The invisible fire": indigenous sovereignty, history and responsibility', in A. Moreton-Robinson (ed.), *Sovereign Subjects: Indigenous Sovereignty Matters*, Crows Nest, NSW: Allen & Unwin, pp. 105–17.

Bolt, B. (2007), 'The magic is in the handling', in E. Barrett and B. Bolt (eds), *Practice as Research: Approaches to Creative Arts Enquiry*, London: I. B. Tauris, pp. 27–34.

borderlands (2004) 3 (2), Special Issue, available at: http://www.borderlands. net.au.

Brewster, A. (1996a), 'Fictocritical sequence, "hauntings": a road poem (stories of forgetting and unknowing)', in G. Turcotte (ed.), *Masks, Tapestries, Journeys*, Wollongong: University of Wollongong, pp. 133–41.

Brewster, A. (1996b), 'Fictocriticism: undisciplined writing', in J. Hutchinson and G. Williams (eds), *Writing-Teaching: Teaching Writing*, Sydney: University of Technology, pp. 29–32.

Brewster, A. (1996c), 'Fictocriticism: pedagogy and practice', in C. Guerin, P. Butterss and A. Nettlebeck (eds), *Crossing Lines: Formations of Australian Culture*, Adelaide, SA: Association for the Study of Australian Literature, pp. 89–92.

Brewster, A. (2003), 'Strangeness, magic and writing', *Cultural Studies Review*, 9 (2), 157–63.

Brewster, A. (2004), 'Revisiting the idea of home', in J. Muk-Muk Burke and M. Langford (eds), *Ngara: Living in This Place Now. Poems, Essays and Meditations*, Wollongong, NSW: Five Islands Press, pp. 71–5.

Brewster, A. (2005a), 'Writing whiteness: the personal turn', *Australian Humanities Review*, 35 (June), available at: http://www.lib.latrobe.edu.au/ AHR/archive/Issue-June-2005/brewster.html.

Brewster, A. (2005b), 'The poetics of memory', *Continuum*, 19 (3), 397–402.

Brewster, A. (2007), 'Brokering cross-racial feminism: reading indigenous Australian Poet Lisa Bellear', *Feminist Theory*, 8 (2), 209–22.

Brewster, A. (2008), 'Engaging the public intimacy of whiteness: the indigenous protest poetry of Romaine Moreton', *Journal of the Association for the Study of Australian Literature*, Special Issue: The Colonial Present, pp. 6–76.

Brewster, A. and H. Smith (2003b), 'AFFECTions: friendship, community, bodies', *TEXT*, 7 (2), available at: http://www.gu.edu.au/school/art/ text/octo3/brewstersmith.htm.

Brewster, A., A. O'Neill and R. van den Berg (eds) (2001), *Those Who Remain Will Always Remember: An Anthology of Aboriginal Writing*, Fremantle: Fremantle Arts Centre Press.

Byrne, D. (1996), 'Deep nation: Australia's acquisition of an indigenous past', *Aboriginal History*, 20, 82–107.

Cohen, P. and M. Somerville (1990), *Ingelba and the Five Black Matriarchs*, Sydney: Allen & Unwin.

Colebrook, C. (2002), 'The politics and potential of everyday life', *New Literary History*, 33, 687–706.

Connerton, P. (1989), 'Social memory', in *How Societies Remember*, Cambridge: Cambridge University Press, pp. 6–109.

Costello, M. (2005), '"Irrigorous uncertainties": writing, politics and pedagogy', *TEXT*, 9 (1), available at: http://www.griffith.edu.au/school/art/text/.

Davis, K. (2005), 'Thin air', *Continuum: Journal of Media and Cultural Studies*, 19 (3), 421–6.

Dean, R. T., A. Brewster and H. Smith (2004), 'SoundAFFECTs', *TEXT*, 8 (2), available at: http://www.gu.edu.au/school/art/text/oct04/smith2.mov; also on the CD-Rom in Smith (2008).

Denzin, N. K. and Y. S. Lincoln (2000), *Handbook of Qualitative Research*, 2nd edn, Thousand Oaks, CA: Sage.

Denzin, N. K. and Y. S. Lincoln (2003a), *The Landscape of Qualitative Research: Theories and Issues*, 2nd edn, Thousand Oaks, CA: Sage.

Denzin, N. K. and Y. S. Lincoln (2003b), *Strategies of Inquiry*, 2nd edn, Thousand Oaks, CA: Sage.

Denzin, N. K. and Y. S. Lincoln (2003c), *Collecting and Interpreting Qualitative Research*, 2nd edn, Thousand Oaks, CA: Sage.

Falk, P. and G. Martin (2007), 'Misconstruing indigenous sovereignty: maintaining the fabric of Australian law', in A. Moreton-Robinson (ed.), *Sovereign Subjects*, Sydney: Allen & Unwin, pp. 33–46.

Fergie, D. (1998), 'Unsettled', in *The Space Between: Australian Women Writing Fictocriticism*, Perth: University of Western Australia Press, pp. 173–200.

Ferrell, R. (2003), 'Pinjarra 1970: shame and the country town', *Cultural Studies Review*, 9 (1), 23–34.

Fiske, J., B. Hodge and G. Turner (1987), *Myths of Oz: Reading Australian Popular Culture*, Sydney: Allen & Unwin.

Garbutt R. (2004), 'White on white: surveying the boundaries of local whiteness', in S. Schech and B. Wadham (eds), *Placing Race and Localising Whiteness*, Bedford Park, SA: Flinders Press, pp. 104–22.

Harmon, B.V. (1994), *They Came to Murramarang*, Canberra: Australian National University, Centre for Resources and Environmental Studies and Edith and Joy London Foundation.

Haseman, B. (2006), 'A manifesto for performative research', *Media International Australia Incorporating Culture and Policy*, 118, 98–102.

Haseman, B. (2007), 'Tightrope writing: creative writing programs in the RQF environment', *TEXT*, 11 (1), 1–14, available at: http://www.text-journal.com.au/april07/haseman.htm.

Human Rights and Equal Opportunity Commission (1997), *Bringing Them Home, Report of the National Inquiry into the Separation of Aboriginal and*

Torres Strait Islander Children from their Families, Australia, Canberra: Commonwealth of Australia.

Johns, A. (2008), 'White tribe: echoes of the Anzac myth in Cronulla', *Continuum*, 22 (1), 3–16.

Kerr, H. (2003), 'Fictocritical empathy and the work of mourning', *Cultural Studies Review*, 9 (1), 180–200.

Kerr, H. and A. Nettlebeck (eds) (1998), *The Space Between: Australian Women Writing Fictocriticism*, Perth: University of Western Australia Press, pp. 209–16.

Lake, M. and H. Reynolds (2008), *Drawing the Global Colour Line*, Carlton: Melbourne University Press.

Latour, B. (1993), *We Have Never Been Modern*, Cambridge, MA: Harvard University Press.

Latour, B. (2004), *Politics of Nature: How to Bring the Sciences into Democracy*, trans. Catherine Porter, Cambridge, MA: Harvard University Press.

McKay, B. (ed.) (1999), *Unmasking Whiteness: Race Relations and Reconciliation*, Brisbane: Queensland Studies Centre, Griffith University.

Mansell, M. (1994), 'Sovereignty', in D. Horton (ed.), *The Encyclopaedia of Aboriginal Australia*, Vol. 2, Canberra: Aboriginal Studies Press, p. 1012.

Marks, J. (2005), 'Percept + Literature', in A. Parr (ed.), *The Deleuze Dictionary*, Edinburgh: Edinburgh University Press, pp. 199–200.

Massumi, B. (2000), 'Too blue: colour-patch for an expanded empiricism', *Cultural Studies*, 14 (2), 177–226.

Massumi, B. (2002), *Parables for the Virtual*, London: Duke University Press.

Merleau-Ponty, M. (1968), 'The intertwining – the chiasm', in C. Lefort (ed.), *The Visible and the Invisible: Followed by Working Notes*, trans. A. Lingis, Evanston, IL: Northwestern University Press, pp. 130–55.

Moreton-Robinson, A. (ed.) (2004), *Whitening Race*, Canberra, ACT: Aboriginal Studies Press.

Moreton-Robinson, A. (2007a), 'Introduction', in A. Moreton-Robinson (ed.), *Sovereign Subjects: Indigenous Sovereignty Matters*, Sydney: Allen & Unwin, pp. 1–14.

Moreton-Robinson, A. (2007b), 'The possessive logic of patriarchal white sovereignty: the High Court and the Yorta Yorta decision', in D. Riggs (ed.), *Taking Up the Challenge*, Adelaide, SA: Crawford House, pp. 109–24.

Morrison, T. (1992), *Playing in the Dark: Whiteness and the Literary Imagination*, Cambridge, MA: Cambridge University Press.

Muecke, S. (1997), *No Road (Bitumen All the Way)*, South Fremantle, WA: Fremantle Arts Centre Press.

Muecke, S. (2004), *Ancient and Modern: Time, Culture and Indigenous Philosophy*, Sydney: University of New South Wales Press.

Muecke, S. (2008), *Joe in the Andamans and Other Fictocritical Stories*, Sydney, NSW: Local Consumption Publications.

New South Wales Parks and Wildlife Service (1988), *Murrumarang Aboriginal Area*, March, Plan of Management, p. 8.

Parry, C. et al. (eds) (1986), *Parry and Grant Encyclopaedic Dictionary of International Law*, New York: Oceana.

Pleadon, R. F. (1990), *Coastal Explorers*, Milton, NSW: Milton/Ulladulla District History Society, pp. 8–9.

Probyn-Rapsey, F. (2007), 'Playing chicken at the intersection: the white critic of whiteness', in D. Riggs (ed.), *Taking Up the Challenge: Critical Race and Whiteness Studies in a Postcolonising Nation*, Belair, SA: Crawford House, pp. 322–46.

Prosser, R. (2002), 'Writing + memory = memory writing', *Salt*, Special Issue on Memory Writing, 16, 157–73.

Reynolds, H. (1996), *Aboriginal Sovereignty*, Sydney: Allen & Unwin.

Richardson, L. (2000), 'Writing: A method of inquiry', in N. K. Denzin and Y. S. Lincoln (eds), *Handbook of Qualitative Research*, London: Sage, pp. 923–48.

Riggs, D. W. (2002), 'As if it were real: writing experiential multiplicity as epistemology', paper presented at *Conference Proceedings of the First Australian Postgraduate Students, Critical Psychology Conference*, Sydney: University of Western Sydney Press.

Riggs, D. W. (ed.) (2007), *Taking Up the Challenge: Critical Race and Whiteness Studies in a Postcolonising Nation*, Belair, SA: Crawford House.

Robb, S. (2003), *The Hulk*, Bulahdelah, NSW: Post Taste Media and Publishing.

Schech, S. and B. Wadham (eds) (2004), *Placing Race and Localising Whiteness*, Conference Proceedings for the 'Placing Race and Localising Whiteness' Conference, Bedford Park, SA: Flinders Press.

Schlunke, K. (2005), *Bluff Rock: Autobiography of a Massacre*, Fremantle, WA: Fremantle Arts Centre Press.

Slater, L. (2007), 'No place like home: staying well in a too sovereign country', *m/c journal*, 10 (4), available at: http://www.media-culture.org.au.

Smith, H. (2005), 'The erotics of gossip: fictocriticism, performativity, technology', *Continuum: Journal of Media and Cultural Studies*, 19 (3), 403–12.

Smith, H. (2008), *The Erotics of Geography*, Kane'ohe, HI: TinFish.

Somerville, M. (1994), *The Sun Dancin'*, Canberra: Aboriginal Studies Press.

Somerville, M. (1999), *Body/Landscape Journals*, Melbourne: Spinifex.

Somerville, M. (2004), *Wildflowering. The Life and Places of Kathleen McArthur*, St Lucia: University of Queensland Press.

Stapleton, P. (2006), 'Documentation in performance-led research', *Media International Australia*, 118, 77–85.

Stern, L. (1999), *The Smoking Book*, Chicago: University of Chicago Press.

Thomas, N. (1991), *Entangled Objects: Exchange, Material Culture, and Colonialism in the Pacific*, Cambridge, MA: Harvard University Press.

Webber, J. (2000), 'Beyond regret: Mabo's implications for Australian constitutionalism', in D. Ivison, P. Patton and W. Sanders (eds), *Political Theory and the Rights of Indigenous Peoples*, Cambridge: Cambridge University Press, pp. 60–88.

Weiss, G. (1999), *Body Images: Embodiment as Intercorporeality*, London: Routledge.

Westcott, R. (2007), 'Witnessing whiteness: articulating race and the "politics of style"', in D. W. Riggs (ed.), *Taking Up the Challenge: Critical Race and Whiteness Studies in a Postcolonising Nation*, Adelaide, SA: Crawford House, pp. 287–306.

Whitlock, G. (2000), *The Intimate Empire: Reading Women's Autobiography*, London: Cassell.

Wojecki, A. (2007), 'Learning "race": personal narrative as pedagogy in critical whiteness studies – pitfall or potential?', in D. W. Riggs (ed.), *Taking Up the Challenge: Critical Race and Whiteness Studies in a Postcolonising Nation*, Belair, SA: Crawford House.

Case Histories

Integrating Creative Practice and Research in the Digital Media Arts

Andrew R. Brown and Andrew Sorensen

INTRODUCTION

Research is often characterised as the search for new ideas and understanding. The language of this view privileges the cognitive and intellectual aspects of discovery. However, in the research process theoretical claims are usually evaluated in practice and, indeed, the observations and experiences of practical circumstances often lead to new research questions. This feedback loop between speculation and experimentation is fundamental to research in many disciplines, and is also appropriate for research in the creative arts. In this chapter we will examine how our creative desire for artistic expressivity results in interplay between actions and ideas that direct the development of techniques and approaches for our audio/visual live-coding activities.

There is a definitional hurdle that we believe needs to be exposed at the outset of discussions about practice-led research concerning the term 'research' itself. There is a general way in which research is a part of many activities. In this general way, research refers to the act of finding out about something and is involved in learning about a topic, extending a skill, solving a problem and so on. In particular, almost all creative practice involves this general type of research, and often lots of it. In contrast, there is a more limited use of the word research prevalent in academia and about which this article is concerned, where the term refers to uncovering evidence that builds or elaborates upon a theory. Our more limited academic definition also requires that research should be coherent and situated within a broader theoretical framework. In other words, academic research should be situated within a body of extant knowledge, regardless of whether the research supports or challenges existing theory or existing practices.

The distinction we make about general and academic research has parallels to different modes or levels of creativity, what Margaret Boden (1990) refers

to as psychological and historical creativity. In a similar way, general research uncovers knowledge that was previously unknown to the individual but known to the field, while academic research aims at uncovering/creating knowledge that was previously unknown to the field. Given that creative practice is often individualistic, the opportunity for tension between individual and collective understanding through artistic expression and experience is unsurprising. Having outlined what we mean by research for the purposes of this discussion we will proceed to a more detailed discussion about digital media practice.

In our digital media work, knowledge is created and expressed through a conversation between research and practice. The nature of this conversation may vary with different types of practice, but we believe there are consistencies that comprise the character and style of this type of research. The research and practice with which the authors have been most involved is the algorithmic generation of digital content, creatively expressed as audio and visual media art works, and in this chapter we will reflect on our practice of live-coding in particular. But first we will discuss the characteristics of digital media practice more broadly and the opportunities it presents for research.

DIGITAL PRACTICE

Digital computing systems have a fluidity and constructability that has made them ubiquitous since arriving on the scene in the middle of the twentieth century. Digital systems are fluid, in that bits can be recycled for use almost indefinitely, and constructible because while their organisation is variable and provisional it is definable by coding in computer programming languages. The fluidity of digital media means that there can be digital representations of various other media including text, image and sound along with processes for the manipulation of them. Like their mathematical cousins, digital systems can represent ideas as formal expressions in code, and this is an important feature for their use in research. The different ways in which media practice exploits digital systems can be simply characterised as *using* or *building* digital systems. By far the greatest use of digital media by creative practitioners is for media simulation where computers are used for drawing, video editing, music production and the like.

Despite media simulation being so popular, we believe that the greatest research potential of digital systems is to combine these with building media by defining processes through the formal expression of ideas in code. The same fluidity that makes digital systems effective for media editing makes them valuable for idea exploration. This is not to say that ideas are not being explored during editing processes, but rather that even greater leverage can be gained by digitising the representation of ideas as code as well as their effect in

media art works. This leverage is present in creative practices that incorporate tool building as meta-creation to exploit the computer as an idea amplifier (Kay and Goldberg 1977), while still making use of its efficient simulation of physical media processes. This combination of tool building and using in practice-led research continues to reflect observations about optimal environments for interactive art by Edmonds (2004: 83):

> Our experience suggests that even today, with all the advances in software, the degree of programming and systems expertise is critical to having more artistic control over the developing process.

The desire for expressive control in artistic work correlates well with the need to be able to express unique and novel ideas in research contexts. The ability for digital systems to enable the articulation of generative processes as a form of meta-creation allows interaction between the expression and exploration of ideas that is fruitful for both creative practice and research endeavours.

APPROACHES TO RESEARCH

There are numerous approaches to research. In particular we see two long-standing traditions that feed into practice-led research: experimental and conceptual research. At the risk of oversimplification, we will use caricatures of different research approaches to highlight contrasts and make our points.

Experimental or ethnographic approaches are based on observation in the world. The sciences have largely conducted research in this way since the Renaissance. There is, of course, variety in this approach, including direct observation often featured in disciplines such as biology and anthropology, through to the measuring of designed interventions in disciplines including engineering, agriculture and social or political activism.

A conceptual or philosophical research approach is based on logic and argument. It relies on measures of internal consistency, resonances with lived experience and, to a lesser extent, popularity for its merit. While this style of research is aligned with the humanities through its use in disciplines such as philosophy, sociology and literature, it also has a strong home in science disciplines including mathematics, cosmology and theoretical physics where empirical measures may be impractical.

Both experimental and conceptual researchers can make significant use of digital systems to aid their thinking and experimenting. Mostly this involves the exploration of hypotheses using computer simulations of their domains. Some obvious examples include aircraft design, weather forecasting, economic modelling and game theory. While this research may use many of the same

tools and skills required by our research in media art, it differs in that, for them, the digital system acts only as a model and the 'hard' evidence is found in behaviours of the real systems they simulate; on the other hand, for us, the computer system is directly in play and its behaviour and outputs are the objects of inquiry. While it can also be argued that for us the 'hard' evidence is also found outside the digital system in the behaviours and opinions of people who experience the music and art produced by our digital systems, it is not our primary concern (but may reasonably be for others) to model the cognitive systems that lead to people's experience of media art.

Our practice-led research draws on elements of both experimental and conceptual traditions. Like the experimental traditions our research creates hypothesis, builds trials and judges their success by evaluating the outcomes 'in the wild' through practice. Like conceptual research our digital systems and aesthetic fitness measures are constructs of the collective imagination, with all the inherent recursiveness and provisionality that characterise dynamic cultural contexts. Not surprisingly, practice-led research approaches like ours seem to best fit the disciplines of creative arts, design and information technology where there is interplay between human culture and physical materiality. The experimental and conceptual dimensions of practice-led research are considered by Richard Vella to be windows onto the creative imagination that produce two layers of metaphorical output, 'the work of art and all its symbolic representations' and 'the theoretical model' (Vella 2003: 4). We are sympathetic to this argument that there are multiple metaphors of understanding, although we differ from Vella's view that the symbolic metaphorical representation precedes the theoretical; rather we believe they are interdependent.

The interdependent nature of experimental and conceptual aspects of research highlights a pronounced difficulty for practice-led research. It requires that the investigator be both a practitioner of some experience and a researcher of some significance. This appears to cause some confusion for arts practitioners who, incorrectly in our opinion, are often of the view that being a practitioner is in some way equivalent to being a researcher. We feel this confusion is rooted in the confusion between general and academic research we outlined above. We are equally suspicious of researchers who believe that they are practitioners. This often leads to unconvincing creative outputs where it is difficult to differentiate between a failure of conception or expression. We see two different tasks. It is possible, and useful, to combine these tasks, but this requires capability in both domains. If the researcher is a poor practitioner then any findings of the outcomes may be of questionable cultural value. If the practitioner is a poor researcher then there is unlikely to be any significant elaboration of existing theory. Research partnerships can often provide complementary skills to bridge this gap. Within aa-cell (see below) we believe we have collectively, and perhaps individually, both researcher and practitioner expertise.

AA–CELL'S LIVE–CODING PRACTICE

As a case study we will discuss our creative practice. We perform music and audio-visual live-coding performances under the name aa-cell, and use the techniques developed through this activity for various media art exhibitions and as input to other research activities using generative media. We have creative backgrounds as instrumental music performers and composers, and have in more recent years established a practice around visual and audio-visual exhibitions. We have experience at creating computer music development platforms and building software tools for making music. Our live-coding performance practice has evolved alongside the development of the Impromptu software which makes this new performance practice possible.

In mid-2005 Andrew Sorensen began developing the Impromptu live-coding environment (Sorensen 2005). At first this work was conceived at a nexus of extant projects authored by Sorensen but soon grew into a self-contained and directed project. The original inspiration for Impromptu was an article authored by Alex McLean entitled 'Hacking Perl in Nightclubs' (McLean 2004). This article outlined a performance practice called live-coding which placed the real-time development of computational algorithms as a central and integral aspect of live computer music production.

Inspired by the notion of real-time music programming, Impromptu was conceived as a tool designed to assist in the construction of musical algorithms in live performance. In the early stages of the development, questions and aesthetic considerations concerning the project could be loosely banded into two separate groups: practical considerations which generally impacted upon engineering-related issues such as scheduling models, signal processing architectures, garbage collection strategies and the like; and more philosophical investigations such as the aesthetic nature of computation, broad notions of time, symmetry and order as well as various other ontological issues. Conspicuously, what was not considered in this early development was any specific musical outcome or stylistic intent. In other words, defined artistic outcomes were not an early focus of the project and tool development started with undefined aesthetic goals. Indeed, the primary motivation of Impromptu's development was a belief that new aesthetic opportunities would arise directly as a result of tool innovation.

This is not to say that there were no creative practice goals established for the project. In fact the opposite was true. Impromptu's early development was marked by rapid progress made necessary by a fixed performance date. In June of 2005, only three months after Impromptu's initial conception, we performed using Impromptu at the Australasian Computer Music Conference in Brisbane, Australia. This hard deadline provided the motivation to realise a significant amount of work in a very short period of time. Another result

of such a short time frame was a clarity and focus for the project, born of necessity.

The importance of such fixed performance dates cannot be overstated. They provide an invaluable force in directing and constraining the project. Further, these performances provide excellent project milestones and are a primary mechanism for measuring the successes and failures of the project at a given point in time. In quite a direct manner it is the artistic practice that frames the successes and failures of the various approaches being followed by the project. These successes and failures then feed back into the iterative project cycle, informing new research directions and opportunities for public dissemination.

As the tool development and usage patterns matured, and in light of the results of early performances, it became clear that our research would encompass issues around both effective tool construction and new ways of representing generative media processes suitable for live-coding. This investigative path involved explorations of effective data and coding structures and theoretical investigations into the computational notation of artistic methods and structures. Outcomes of our explorations are captured as code libraries and performance files, recorded performances and academic publications.

The availability of outputs in multiple forms is a valuable feature of practice-led research. It allows for a diverse approach to the transmission of the ideas developed during the research without having to rely overtly on the preparation of presentational media, such as video documentaries, to reach audiences beyond academia.

REFLECTIONS ON LIVE-CODING RESEARCH

While, as we have discussed, research approaches can be differentiated by their emphasis on the concrete or the abstract, they also vary according to how open-ended or tightly constrained their investigations are. Some research has clearly articulated goals, procedures and measures for success, but our creative practice and research rarely does. Rather the value of our approach is in its agility, enabling us to respond quickly to new insights or changes in context, and in its robust findings that result from having worked through issues of implementation and application as part of the process of discovery.

Research projects typically have a number of stages with, potentially, different degrees of specificity at each. A prototypical experimental research project might devise a hypothesis for testing, set up experiments that control for all variables and measure results statistically. By contrast an ethnographic study may begin by seeking to understand the reasons for a social situation then, after starting, select subjects or a site, record all activities in case they might be significant and analyse data by comparing a series of manual summaries. Our

practice-led research is often closer to the depicted ethnographic approach in that investigations are often loosely formed at the outset, although the context of the study – our creative practice – is usually well defined.

In our digital media investigations the aesthetic criteria for judging success are, like all aesthetic criteria, negotiable within the bounds of established cultural conventions. Projects involve a series of iterations of small-scale tests until a likely candidate for more extensive exploration is arrived at. Often these early iterations result in the development of small software libraries which are leveraged when working on a larger-scale work. The number of such iterations is quite variable and a skill for the practice-led researcher is learning to judge whether an investigative path shows promise or not. A single project often involves several extensive explorations. This iterative hierarchy proceeds until success is clear, failure seems inevitable or time runs out. At the end of this process there are numerous materials for discussion and dissemination including code libraries that can be used for future projects, outputs from small- and larger-scale tests and completed creative works. These data provide a rich resource for discussion, further work, or verification and validation by peers. How general findings can be derived from such data is dependent on a number of factors. In most cases the multiple tests and small-scale works provide sufficient evidence that the processes or ideas developed can have a life beyond one work or context. But it is likely that more work is required to extract from the project those learnings which are specific and those which are more generally applicable. The issue of generalisation, and thus reuse, is important not only for making contributions to society at large through effective knowledge transfer but also to empower the researcher/practitioner in their future work.

In this way our research is highly iterative, not unlike current trends in software design where the exalted status of 'specification' has been somewhat eroded by a realisation that specification is an inherently flawed activity and that development agility with regular reference to outcome requirements is more efficient. Some research design strategies that require upfront specification have similarly been accused of being potentially restricting. A traditional view of scientific research envisions a clearly defined research goal with an orderly implementation plan that results in an outcome clearly demonstrating the success or failure of an initial hypothesis. The problem with this view is its risk adversity and tendency to drift to the centre. As Peter Downton states: 'An often-made criticism of this expectation is that it is a convergent view of research whereas the truly inventive demands a divergent view – a seeking of the unknown and unexpected' (Downton 2003).

In our practice we seek to balance the competing interests of specifiable targets and playful exploration by attempting to rapidly develop, deploy and reflect. By iterating over shorter periods and forcing critique and reflection through regular exposition of our research to both public and academic debate, we feel better able

to explore more novel approaches while still maintaining the healthy pragmatism that performance practice dictates. To quote Steve Jobs, 'real artists ship.'

For us practice-led research is a journey, with an emergent set of stops along the way at points of interest. The journey may take a lifetime, while the individual 'projects' are the paths between points of interest. Snapshots from these points of interest manifest themselves as performances, exhibitions, recordings, websites, presentations, papers and books.

AESTHETICS AND RESEARCH

One of the key points about our creative practice and our research is that aesthetic criteria, understood as subjective human preference based on direct experience (Dewey 1934), are central to the undertaking. The role of aesthetics in creative practice is well established, but not so well established is the role of aesthetics in research. Aesthetics does play a role in many research fields where elegance, simplicity and the like are valued. However, in media art research it generally has a more critical role. In our research the effectiveness of various computational media processes in improving creative output is the most substantial measure of their value. Other criteria for us include the generalisability of a process across many situations, novelty or innovation in the process and the simplicity or parsimonious representation of a process. While it is possible for practice-led researchers to consider their own aesthetic judgement sufficient validation of success or failure, we prefer to use our own judgement for incremental steps but to subject larger-scale works and theoretical advances to peer and public review. Employing collective wisdom as a measure of quality is deeply rooted in both research and arts cultures, particularly in the form of peer review of academic papers or curatorial judgements around art and design. Collective wisdom is also a significant measure in other domains that resist quantitative testing, such as theories about the origins of the universe which are also subject to aesthetic criteria.

Aesthetic judgement is an imprecise measure, it has tendencies toward normative outcomes and expert opinions can be quite divergent. To account for this in our practice-led research we seek peer review regularly and widely, especially when we are unsure about direction, but we also hold fast to a vision for innovation when we are confident about our direction. In the end the results of such practice-led research, like all other research, will stand or fall in the long term by the respect the work commands from others in the field and its impact in the world.

Aesthetic judgement also makes an important contribution to the pragmatism of our research. By focusing on the media outcomes of the research we keep our eye on improving our practice and activity in the world, which keeps

in check the potential for us to obsess overly about interesting technical, theo-
retical, political or philosophical threads. As well, this perspective leads us to
make public a large amount of the practical work resulting from our research.
Feedback from these disseminations varies significantly. Performances provide
immediate feedback, then a trickle of more considered comment over time and
occasionally a formal review in the press. Web-based information and distribu-
tion has a qualitative aspect with regard to the frequency and number of visi-
tors and where they are from. We have also found that when work is released in
this way we can scan the web for blog posts and other commentary not directed
to us but that we can access and accumulate to paint a picture of how the work
is received. We welcome controlled testing of our works, which would typi-
cally be through statistical tests of algorithms or as reception studies of people
engaging with our work, but have so far made limited use of these approaches.

We also regularly engage in the formal academic dissemination processes
which are largely text based and see that they have a place in articulating
our ideas and representing our work in established academic discourse. We
feel that the exposure of our media outcomes offsets the limitation of textual
descriptions to some extent and communicates our research findings more
clearly than in text alone. As a corollary of this we often present code as part
of performances and exhibitions and as libraries that provide another perspec-
tive, insight and description of our work.

CONNECTING PERSONAL AND COLLECTIVE UNDERSTANDING

One of the great affordances of creative practice as a research method is the
rich opportunity for public dissemination of information. As discussed briefly
above in relation to the role of aesthetics, our performance practice offers
us the ability to disseminate information as recorded audio/visual media, as
software and code, as printed musical score, in written research papers, as
presentations to academic and trade conferences and, most importantly, in
performance. Performance has proven to be particularly valuable as this is for
many people the initial point of contact with our research. We feel that there
really is little better way to prove the value of a new musical algorithm than
to have someone appreciating it, for example by dancing to it. We believe that
the impact of this rich diversity of output is significant as it allows us to reach
audiences outside traditional academic forums, to engage with a broader range
of disciplines and to evoke greater public scrutiny and comment.

aa-cell have been performing regularly over the past three years throughout
Asia and Europe. During this time we have published regularly on a range
of topics related to our practice and reciprocally our research has resulted in

new tools for use in our live performances (Brown 2006; Brown and Sorensen 2007; Sorensen and Brown 2008). These performances continue to provide opportunities for reflection and critical audience feedback. Performances also provide the motivation for exploration and discovery as we strive to innovate and provide exciting outcomes for our audiences.

However, it is not for audiences alone that we search for novel approaches, nor is our research based on aesthetic considerations alone. Indeed, while we value highly the role of aesthetic judgement in practice-led research we question the appropriateness of assigning research outcomes only to results based on aesthetics. Rather, the value of our research is in the knowledge embedded in the practice and, by extension, in the computational processes and techniques we use to make it. This is not to say that the quality of the music and visuals is immaterial – indeed we believe it is integral; however, we are interested in the understanding and insights that can arise through the development of new methods for creative expression. We constantly strive to discover new artistic knowledge – be that compositional, cultural, creative or computational – and are interested in how what we learn here might be useful for other artists and applied more widely, especially to other applications of computational systems. We also feel that it is our responsibility to report on that knowledge and to transfer our findings to the broader community, which we accomplish using the full range of media at our disposal.

While it is certainly true that research needs to extend and challenge social norms and cultural practice through innovation, we find that the reality check of actually taking our research into the world is revealing and challenging with regard to the relevance of any innovation we may pursue.

FROM REFLECTION TO THEORY

A critical element of the iterative nature of our creative practice and research is reflection on results. Our experience confirms the findings of Donald Schön that reflection in action is a critical element in developing understanding (Schön 1987). Interestingly Schön's work also grew out of exploring how technologies precipitate innovations and in trying to understand how people accommodate these (Schön 1967).

In general, artistic knowledge is often intuitive and reflection may not occur naturally. Or, perhaps it would be more accurate to say, practical knowledge is inherent in doing and is often considered implicit and as such may not be identified or valued without explicit attention paid to it. It is common for arts practitioners to have significant knowledge without necessarily being able to adequately describe that knowledge. In other words, knowledge embedded in practice is often personal and ineffable. In order to make this personal

knowledge more generally useful a process of reflection and contextualisation is often required. Reflection can help to find patterns that make this personal knowledge more generally applicable and contextualisation helps to place those findings within a broader history of accumulated knowledge. These processes are important because they are essential to transforming personal knowledge into communal knowledge. This knowledge can be accessed through the various presentations of the work – as art works, code libraries, algorithms, written descriptions, critical analysis and commentaries and so on. An integral part of research is this transmission of personal knowledge and understanding that has some novel and general application into communal knowledge.

Shareable knowledge is often expressed as a method, process or theory. The production and dissemination of theory is a distinguishing differentiation between our practice-led research and conventional artistic practice. In our research, theories are frequently associated with patterns of usage, that is with techniques or practices we use regularly. These regular patterns of usage often indicate areas of particular interest in our work and it is through introspection that these patterns may develop into a more general theory or into new techniques and habits. These generalisations, or theories, invariably find their way back into our practice. We feel that this iterative process between expression and reflection is essential to all research and is integral to arts practice.

Experience of the creative output or artefact is also of great importance to understanding the knowledge generated by the research. Firstly, the artefact provides evidence of the knowledge discovered. It stands as a demonstration of the theory and is available as a reference for further investigation and verification. The artefact helps to make the ideas explicit. Secondly, the artefact provides a stimulus for engagement with the knowledge gained. The artefact is integral in communicating the ideas of the research in all its richness and in making the theory available to a wider audience who might otherwise not engage with knowledge in the abstract. In a very real sense practice makes an excellent partner to research, because the benefits of practice-led research flow in both directions.

CONCLUSION

In this chapter we have outlined our approach to research using our live-coding performance practice as a case study. We have argued, based on our experience, that while research and creative practice are not the same activity, there is significant intellectual and cultural benefit to be gained through the integration of research and practice.

Our practice of live-coding has involved both the building and using of digital tools and the development of new representations of musical processes.

We have argued that this provides a way of exploring both the possibilities of established processes and innovation through the construction of new processes. The ease of controlling digital systems through programming software makes this a particularly attractive option for digital media practitioners. The demands of the live-coding performances we undertake provide hard constraints that serve to propel our work forward and add rigour to the results. In addition, the ability to build new software tools enables an agile approach where avenues for investigation can be explored or discarded with minimal effort.

Practice-led research, as we conduct it, is hierarchically iterative with each large step encompassing numerous smaller steps. Progress and direction are guided by aesthetic judgements, enabled by efforts to engage in a healthy dialogue between our own assessments, the opinions of others in our field and those of the broader public. This critical dialogue is facilitated by making our work available in a variety of formats and forums, including recordings of creative work, code examples, academic and informal writing and, especially, live performance. The documentation of our work in these many forms facilitates reflections on the work that lead to the observations of patterns and theories, as well as highlighting opportunities that lead to new work.

So what drives our work? In the end it is our creative desire for artistic expressivity that results in an interplay between actions and ideas. And it is our desire for a productive dialogue with others around this expressivity that leads us to the extensive documentation, reflection and dialogue that positions our practice within a research framework.

The feedback loop between reflection and action, between speculation and experimentation, is fundamental to research in many disciplines and it is an important feature of our work. We suggest that a deliberate and public interplay between imagining and expressing is generally productive as a method for practice and research in the digital media arts.

ACKNOWLEDGEMENTS

This research was conducted with support from the Australasian CRC for Interaction Design (ACID), which is established and supported under the Australian Government's Cooperative Research Centre programme.

REFERENCES

Boden, M. (1990), *The Creative Mind*, London: Cardinal.
Brown, A. R. (2006), 'Code jamming', *M/C Journal*, 9 (6), available at: http://journal.media-culture.org.au/0612/03-brown.php.

Brown, A. R. and A. Sorensen (2007), 'Dynamic media arts programming in Impromptu', *Proceedings of Creativity and Cognition 2007*, Washington, DC: ACM Press, pp. 245–6.

Brün, H. (1989), 'Composer's input outputs music', in R. J. Heifetz (ed.), *On the Wires of Our Nerves: The Art of Electroacoustic Music*, Caranbury, NJ: Associated University Presses, pp. 133–47.

Dewey, J. (1934), *Art as Experience*, New York: Putman.

Downton, P. (2003), *Design Research*, Melbourne: RMIT University Press.

Edmonds, E. (2004), 'Interactive media: on modes of interaction in art systems', in R. Wissler, B. Haseman, S.-A. Wallace and M. Keane (eds), *Innovation in Australian Arts, Media, Design: Fresh Challenges for the Tertiary Sector*, Flaxton, QLD: Post Pressed, pp. 73–86.

Kay, A. and A. Goldberg (1977), 'Personal dynamic media', *Computer*, 10 (3), 31–41.

McLean, A. (2004), *Hacking Perl in Nightclubs*, O'Reilly perl.com (cited 1 May 2005), available at: http://www.perl.com/pub/a/2004/08/31/livecode.html.

Schön, D. A. (1967), *Technology and Change*, Oxford: Pergamon Press.

Schön, D. A. (1987), *Educating the Reflective Practitioner*, San Francisco: Jossey-Bass.

Sorensen, A. (2005), 'Impromptu: an interactive programming environment for composition and performance', *Proceedings of the Australasian Computer Music Conference 2005*, Brisbane, QLD: ACMA, pp. 149–53.

Sorensen, A. and A. R. Brown (2007), 'aa-cell in practice: an approach to musical live-coding', *Proceedings of the International Computer Music Conference*, Copenhagen: ICMA, pp. 292–9.

Sorensen, A. and A. R. Brown (2008), 'A computational model for the generation of orchestral music in the Germanic symphonic tradition: a progress report', *Proceedings of the Australasian Computer Music Conference 2008*, Sydney: ACMA, pp. 78–84.

Vella, R. (2003), 'Artistic practice as research', *Proceedings of the AARME XXVth Annual Conference*, Brisbane, QLD: Australian Association for Research in Music Education, pp. 1–14.

Mariposa: The Story of New Work of Research/Creation, Taking Shape, Taking Flight

Kathleen Vaughan

1. ANNUNCIATION: MONTREAL, CANADA, MARCH 2008

I had been waiting for new work to begin. In and among the busy times and travels of this past year, I had taken moments to turn my attention inwards, to focus, to listen for the first murmurings of the artwork that I would be prompted to make next. After the big productive push of creating the inter-twined visual and textual work of my PhD dissertation (Vaughan 2006), I knew that I needed some time fallow, a slow germination. But I had been waiting. I had become eager. And so I was relieved to feel that familiar inner, dancing, quickening as I was caught by an idea for art.

It happened as I was walking along St Catherine Street, a main thorough-fare of downtown Montreal, midday on Saturday, 1 March 2008. March in Montreal is still very much winter. In fact, until that morning, the city had been in the grip of a cold snap, sending temperatures shivering down to minus 30 degrees Celsius and keeping all sane beings off the streets. But overnight the weather front had shifted, and as the morning sun rose in the sky, the temperature nudged upwards and people were tempted out of doors. Strolling shoppers, buskers, mimes crowded the wide sidewalks of the city centre. Through their relieved, leisurely promenade I strode purposefully, on my way to meet up with the taxi that would take me to the airport and my flight home to Toronto, an hour away.

But suddenly I was stopped, literally, by a large poster in a bus shelter, its vivid oranges a brilliant, tropical contrast to the city's winter greys. More than the visual, the French caption caught my eye: 'Papillons en liberté'. In English, 'Butterflies go free'. I paused, mid-step.

All at once, an image rose in my mind's eye: the irregular flutter of a flying butterfly, in slow motion – or more accurately, a partial image, full frame, of

a portion of the butterfly's moving wings, its characteristic jitter slowed to a stately, balletic gesture. My mind's eye saw the image large, projected to eight feet tall, more. And unlike the vivid, crisp rendering of the yellow and black butterfly in the transit ad, my imaginary creature was murky, grainy, pearlescent, all dull dove greys and bluish-mauves, shading into velvet blacks. To my surprise, since I've done very little artwork in time-based media, the image that presented itself to me – the image that seemed to be asking to be externalised and created in the real world – was moving.

Stopped in my tracks, I was reminded of Jeanette Winterson's remarks, on having been halted on her walk through Amsterdam by 'a painting that had more power to stop me than I had to walk on' (1995: 3). In my case, I was stopped by the mental image of art that I might make, arrested mid-stride. But with a plane to catch, I resumed my route, after noting the specifics of the butterfly exhibition advertised, at Montreal's Botanical Gardens until 27 April 2008.

Since then, I've been nudging my understanding of that image forward and considering what the new work sparked by it might turn out to be (see a sketch of the image in Figure 8.1). I've learned, over the years in the studio, to recognise that characteristic inner quickening – which I actually feel as a kind of stomach pang – as an indication that there is depth and density of creative potential in the idea or image that has come. I have learned to respect and respond to this feeling, as to a summons. Indeed, I have come to understand that (so far, at least) my creative practice is one of response, either to a visual image that grabs me and hurtles me forward into unexpected imaginings, or to a deeply felt inner experience, one that links emotional and body-based realities, and percolates into an external aesthetic expression. Such a summons does not come just once, to kick start a body of work, but can recur throughout the entire process of making, as I am faced with decisions and directions to take up or not.

And so how does research fit into and support this nascent work of mine, on butterflies?

Perhaps here is the place to describe what I mean by 'research' (leaving the broader category of art strategically unaddressed). Institutionally, within the Canadian academic community, research is construed as 'sustained' inquiry, since that is the description set out by our major national funding body, the Social Sciences and Humanities Research Council (SSHRC 2008). In fact, SSHRC provides no specific definition of research, wishing the term to be interpreted in light of each funding programme's objectives (M. Ravignat, personal communications, 29 May 2008). Etymologically, research is – as poet and scholar Rishma Dunlop reminds us – a *re*-search, a re-cherche, a looking again *at* and *for* fundamental elements (Barone et al. 1999). With respect to the arts, research is, perfunctorily, a basic level of fact finding and information

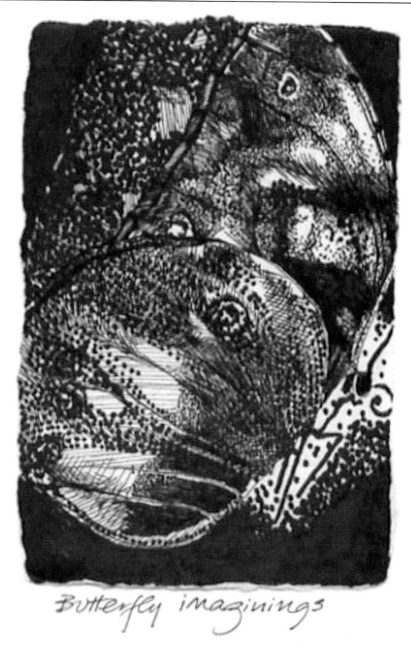

Figure 8.1 Kathleen Vaughan, butterfly sketch, 2008. Marker on Japanese paper, approx. 6 in H × 4 in W.

culling that enables many artists' practice, comprising the various steps of activity and the technical and conceptual investigations that many of us engage in as we prepare and plan new artwork. In this sense, an artist can undertake, for example, 'documentary research, visual and sound research, mockups, sketches, work plans, demos, etc.' – a list of the ways that research and creation can intersect suggested by sociologist and digital arts theorist Jean-Pierre Fourmentraux (2007).[1] In this same vein of preliminary fact-finding but with a psychological, even hermeneutic orientation, research can consist of an individual's careful review and articulation of experience and feeling in the manner described by psychologist Donald A. Schön (1983) as 'reflection-on-action' and 'reflection-in-action' – an approach that allows those operating in a practice-based field to move tacit knowledge to explicit understanding.[2] Indeed, throughout this chapter, I use the word 'research' to describe all these externally oriented and internally directed forms of trail-following as I begin to understand my work with butterflies.

But more and more, what interests me in the connection between art and research is the philosophical, even the methodological link. Along those lines, I have an understanding, perhaps even a belief, about the role of research in art that goes beyond the basic descriptors above. Indeed, I consider that embedded and embodied within a work of art, almost holographically, is a reservoir of knowledge and understanding, the 'research' of the work as conducted by the artist. This conception of research is perhaps similar to Walter Benjamin's concept of aura (1955/1968) as something that pertains irreducibly to the artistic object, performance or event, a quality we can feel although not always decode. (Of course, such art-embedded 'research' is subject to the pleasures and problematics of interpretation by those who engage with it.) To my mind, the presence of this kind of research is dependent upon the artist's intentionality – it does not occur by accident – and may consist of any combination of personal, historical, technical or cultural thematics, explored deliberately and in response to a research query, either within the field of fine arts practice or interdisciplinarily.

This larger question of the interconnections between art and research is one that I work to understand and articulate in all my work, and represents a process of inquiry in the sense that John Dewey proposed: beginning in an indeterminate situation, with, initially, tentative understandings, through a series of steps whose particularities become known as they are undertaken (1991). Anthropologist Paul Rabinow has recently reframed Dewey's notion of inquiry in a way that I believe makes particular sense for artists working as researchers, suggesting that:

> The giving of form (whether discursive, logical, artistic, scientific, political, and the like) is . . . an essential goal of 'describing' a problem

and of shaping an inquiry. Description rather than explanation is the goal, but description is not a naïve act but one that can arise only within a process of inquiry that is engaged in one or another type of form making. (2008: 9)

In this way, I see the role of art as research and research as art *less* as creating new knowledge and *more* as calling forth, pulling together and arranging the multiplicities of knowledges embedded within. However, because art as research and research as art can be transformative in the way that Graeme Sullivan describes (2006: 22) – being a profound engagement that changes both the researcher and the researched – the process can evoke something new. In my case, with this butterfly work at least, I do not see myself as creating new denotative knowledge or as following in the footsteps of artist and ardent lepidopterist Vladimir Nabokov, whose entomological work did make real contributions to scientific knowledge of butterflies (Boyd 2000). That is to say, using the words of educational theorist and arts connoisseur Elliot Eisner, 'the products of this research are closer in function to deep conversation and insightful dialogue than they are to error-free conclusions' (2008: 7).

And so to return to the question of how research fits into and supports my work on butterflies, what I can offer here are the following: this latter articulation of my orientation to art as research and research as art, a discussion of the context in which I explore these concerns and an itemising of some of the actual beginnings of this new work – the annunciation, the call and its consequent activities.

2. RESEARCH: ONLINE, ONGOING

As is often my first act of information gathering, in exploring the topic of butterflies I went online, consulting the website for the Montreal Botanical Gardens (Jardin botanique de Montréal 2008b). There, I found that although I had never before heard of an exhibition that allowed people to walk among free-flying butterflies, the Insectarium at the Botanical Gardens had been hosting such presentations for eleven years. In that time, more than a million people had taken in the butterfly presentations (S. Le Tirant, personal communication, 2 June 2008). Clearly, I was not the only person who found the prospect of walking amid fluttering butterflies absolutely enchanting – particularly towards the end of a long, hard, exceptionally snowy winter. Clicking through the site's pages, through the abundant information for teachers and students, the slide shows of images, I discovered that exhibitions of live butterflies can – through purchases from certified butterfly farms – promote sustainable elevation of these insects in Africa, Central America and Asia, benefiting humans,

insects and a region's whole biodiversity (Jardin botanique de Montréal 2008a). In fact, butterflies are native to all continents but Antarctica; butterfly sanctuaries and gardens have been established all around the world (Mikula Web Solutions 1993–2008).

In Indonesian, butterfly is *kupukupu*; in Danish, *summerfugl*; in Hebrew, *parpar*; and in ancient Greek, of course, *psyche*.

As I read, I realised that by working through the metaphors, imagery and practicalities of butterfly exhibitions, I could move towards a number of related objectives. Methodologically and philosophically, I could deepen my understanding of the interconnections between art and research that I articulate above and further my explorations of art as a mode of knowing. The latter were the context of my doctoral work in an interdisciplinary faculty of education, where, as companion to my own work of making, I considered theories of visual modalities of representing knowledge – theories from studio arts and art history (Gray and Malins 2004; Rose 2001; Sullivan 2005), philosophy (Langer 1953, 1979), anthropology (Taylor 1994) or education, via multiliteracies theories (Cazden et al. 1996), research methods investigations (Barone and Eisner 1997; Bresler 2006; Eisner 2002), or the pragmatic, arts-oriented philosophy of John Dewey, mentioned above (1934) and epistemologies of Michael Polanyi (1958).

Beyond these considerations of philosophy and method, I began to understand that work on this polyvalent 'butterfly' thematic could bring together a number of ethical questions that had been preoccupying me. I was and am concerned to explore how, as a Western artist and scholar in a position of great privilege, I might create work that through content and form addresses our ethical obligations to each other as humans, to other species and to our living planet as a whole at this time of globalisation and increasing inequity between individuals and cultures. I have been wondering what kind of art to next make within this context, knowing that my studio practice would as always trigger subsequent art education initiatives for children in schools and communities, engaging young imaginations in considerations parallel to my own.

The butterfly seemed a propitious way into this research/creation exploration of interdependence, responsibility and care, especially given the pop culture notion of the 'butterfly effect' – the idea that a small change, such as a butterfly flapping its wings in Central America, can have a significant, unexpected impact in a distant context, changing weather patterns in Montreal, for example. I began to discern interdisciplinary possibilities, touching on entomology, ecology, cultural anthropology, aesthetics, ethics and education. I felt a door opening to a rich, dimensional world of creative practice, scholarship and ultimately teaching, and I was excited. I could sense possibilities, but not yet see their specifics.

3. COINCIDENCE: CHICAGO, USA, MARCH 2008

After Montreal, my next trip was to Chicago, mid-March, where I noticed another exhibition of live butterflies (Peggy Notebaert Nature Museum n.d.) As it happens, my short voyages to Montreal and Chicago were both for job interviews, the extensive, full-day performance-cum-interrogation preliminaries for tenure-stream positions at North American universities. These job interviews reflected my ambition, as an artist, scholar and teacher, to find a full-time position that would allow me to work between the arts, education and other disciplines.

Indeed, I see my visual and scholarly practices as fully integrated and interwoven. I work in what is known as 'research/creation', the term used by Canada's Social Sciences and Humanities Research Council (SSHRC) to describe research

> . . . that forms an essential part of a creative process or artistic discipline and that directly fosters the creation of literary/artistic works. The research must address clear research questions, offer theoretical contextualization within the relevant field or fields of literary/artistic inquiry, and present a well-considered methodological approach. Both the research and the resulting literary/artistic works must meet peer standards of excellence and be suitable for publication, public performance or viewing. (SSHRC 2005)

SSHRC construes research/creation as a stream of activity distinct from 'standard research' of an exclusively academic kind, and in 2003 established a three-year pilot programme of funding for research projects by artist-researchers within university settings. The Research/Creation Program in Fine Arts was put in place to help 'bridge the gap between the creative and interpretive disciplines and link the humanities more closely with the arts communities', a response to the important role artist-researchers were and are playing in interdisciplinary inquiry, and to remedy the lack of appropriate federal funding for research by university-based artists (SSHRC 2008).

Since then, three research/creation competitions have been held (in 2003, 2005 and 2006) with funding awarded to eighty-four projects by individuals or teams of artist-researchers, for the creation of research that is embodied in dance, creative writing, electronic music, photography, textile arts and architecture – just to pick a few of the forms of representation used (M. Ravignat, personal communication, 29 May 2008).[3] Evaluated by a jury of peers, a project may be awarded up to three years of funding, to a maximum of $250,000.

A 2006–7 formative evaluation of the Research/Creation Program judged it to be a success, that is relevant to the work of university-based artist-researchers

as well as an important means of enhancing quality research/creation, of promoting the dissemination of research/creation results within academia and beyond and of training a new generation of artist/scholars (SSHRC 2007). The evaluation recommended that the programme be continued for at least two more competitions and more data gathered on its impact and effectiveness. Indeed, a 2008 competition has been launched; however, no public statement has been made about activities beyond that.

While the Research/Creation Program – with its recognition that research may be embodied in professional-calibre creative forms – may put Canadian artist-researchers in an enviable position compared to our peers in other countries, it is also worth noting that the programme has a relatively low success rate – 19 per cent for the first three competitions. Other SSHRC programmes (from 2005 to 2007) have an average success rate of just about double that, or 37 per cent, and programmes for funding of arts projects (with no research dimension) through the Canada Council for the Arts, our federal arts funding body, have an overall success rate of 22 per cent (1990–8) (SSHRC 2007). These comparative success rates suggest that, if the Research/Creation programme is a work in progress, so is the ability of university-affiliated artist-researchers to frame our work in grant-winning terms.

I've had a little bit of practice in this regard, having successfully won SSHRC funding for my doctoral work framed as research/creation. And so with respect to my butterfly work-to-come, I had grant applications in mind and was fumbling towards a formulation of my research questions as I elaborated the aesthetic and ethical concerns that motivate this work. Initial research would help this process and provide the work's theoretical contextualisation, some of which begins to be articulated in this chapter. And while an explicit articulation of my methodology will come later, I knew and know I will build on my earlier work elaborating collage as an artist's method for interdisciplinary research (Vaughan 2005, 2006).

Why collage? Because it is a point of principle with me to use a fine arts-originated trope as the basis for a research/creation method, to work within the updated and re-contextualised traditions of fine arts while integrating approaches from other qualitative research practices. I should specify that by 'collage' I am referring not to the familiar cut-paper-and-glue art forms of Picasso and Braque (Poggi 1992), but to a contemporary artistic practice that resides in the juxtaposition of elements – whether appropriated or purpose-made – that otherwise would have been independent. And so the term 'collage' can work across disciplines to encompass montage, assemblage and its modern digital adaptations of mash-up or re-mix. Indeed, 'The principle of collage is the central principle of all art in the 20th century in all media,' as stated by writer Donald Barthelme (1997: 58). In this twenty-first century, novelist Michael Ondaatje proclaimed, 'Everything is collage' (2007: 16).

The familiarity and ubiquity of collage have made the art form a useful metaphor for thinking about all manner of human imaginative engagement, including educational research (Butler-Kisber, 2008), critical pedagogy (Garoian and Gaudelius 2008), feminist epistemologies of science (Harding 1996) and postmodernism itself (Brockelman 2001). Social scientist Joe L. Kincheloe and his associates have been working to articulate a qualitative research method that is based in a variation of collage, specifically in *the brico-lage*, or the approach proposed by anthropologist Claude Lévi-Strauss for conducting effective fieldwork by piecing together whatever is at hand (Kincheloe and Berry 2004; Lévi-Strauss 1966).

Collage's critical potential makes it well-suited to my own theoretical frameworks, which are based in feminist, postcolonial and environmental thought as much as postpostmodern yearnings. Since my mind tends to engage with and respond to the concrete – my own embodied visual/textual/digital works – I know that my self-reflective work on my butterfly project will enable me to more fully articulate my concept of a collage method – work that is new to me as well as others, and perhaps useful to all of us. With the relative newness to the academy of concepts of art as research and research as art, it seems to me that the more fully fleshed articulations of method we can discuss together, the better. That is to say, as Ann Douglas and her colleagues in practice-led research in the United Kingdom have phrased it:

> The aim and outcome of the research process, in all its manifestations, is not to reach consensus on a single 'correct' model of research – but to raise informed debates by locating and communicating research activities. The proposing and evaluating of different interpretations of the practice/research relationship becomes a vital characteristic of our research culture. (Douglas et al. 2000: 2)

But in the early stages of work on the butterfly that I articulate here, I was and am simply exploring, seeking information, ideas, images that would produce that familiar stomach pang that confirms for me that I am on the right track.

Butterfly in Cantonese is *woo deep*; in Vietnamese, *buom buom*. In Maori, butterfly is *pepeké*; in Italian *farfalla*.

4. EXPERIENCE: NEW YORK, USA, MARCH 2008

Two weeks after the Chicago trip, during the last week of March 2008, I visited New York for the annual meeting of the American Educational Research Association (AERA). This trip, I had time to enjoy local attractions so when I

saw advertised *The Butterfly Conservancy: Tropical Butterflies Alive in Winter* at the American Museum of Natural History (AMNH n.d. (a)), I went. I had no camera and so no means of recording images of the butterflies I would see – no means of attempting to create the image I had envisioned in my mind's eye. But I was determined to experience the show regardless and see what it offered my creative and scholarly mind.

I should admit here that I have no specialised or even extended knowledge of butterflies. I can identify a Monarch when I see one – and indeed a Monarch figured prominently in the AMNH advertising, probably because there are many people with a comparable level of knowledge (or ignorance!) to mine. I like butterflies in a generalised 'oooh, pretty!' kind of way, but I have no special fascination with them, no great love, at least as yet. (I expect that will change as I delve into the scholarly work of others – scientists, anthropologists, cultural geographers – and get excited by their own passion.) But the impulse upon which I was acting – the longing to see beauty alive, moving, quicksilver – is more widespread than I first thought, and has prompted the exhibition of live butterflies in North American cities in winter. Indeed, for the duration of the show, the American Museum of Natural History's website even offered live streaming of webcam images from the Conservancy (AMNH n.d.(b)). But better still was the opportunity to see butterflies live, as I was about to.

At the exhibit's entry, a security guard watched over the airlocked door, eking out slow access. He finally ushered me across the threshold into warm moist air, thick with people, plants and – yes! – fluttering butterflies. A pathway snaked through the lush green potted plants and an awestruck huddle of adults and children shuffled its slow way forward, marvelling. All around shimmered a miraculous abundance of butterflies and moths. Large and small, they posed on plants, congregated at feeding stations, fluttered fearlessly among us and, very occasionally, landed on a visitor, a butterfly blessing. A lovely little specimen stopped on one man's shoulder, perhaps attracted by the robin's egg blue of his shirt, and slowly fanned its wings open and shut. Seeing this, a fearful child shrieked, 'Don't let them land on me! Don't let them land on me!' Even beauty can be a monster, it seems.

But for the most part, we were entranced – and intent on capturing images of these creatures. Most of us were armed with video and still cameras, some with cell phones. Children seized photos of favourites – 'Oooh! Look at that one!' – and then conferred, heads together over the viewfinder, to ensure that the photo met with approval. How long does the lustre of these images last, I wonder? What do the children do with their digital inventory when they get the photos home? We have such a voracious appetite for the creation of these images; are we equally ardent in our contemplation of them? We make them; do we use them? How? This consideration of questions about our image-making

experiences within the conservancy formed part of my initial stocktaking as I determined what I wished to explore on this subject of butterflies.

5. IMAGE-MAKING: MONTREAL, CANADA, APRIL 2008

Having won the plum job at Concordia University, I went to Montreal to find a place to live. While that was the pretext for my visit, mostly I wanted to see the butterflies during their final weekend of the Botanical Garden's exhibition, and to try my hand at capturing a video image akin to the idea that 'stopped' me seven weeks before. I borrowed a video camera and set off.

Within the Insectarium I found some aspects familiar from New York: the warmth, the humidity, the feeding stations, the imprecations not to touch the insects. However, in this location, unlike at the confined quarters of the Museum of Natural History's midtown site, we had space. With room to move and breathe, the butterflies appeared to take longer flights among us. We seemed less confronted by the inescapability of their beauty and so perhaps better able to bring more reflective engagement to our encounters. But we still took pictures.

I fumbled with the video camera, inserting the tape cartridge, removing the lens cap, making ready. Power on, I pressed various buttons, waiting for the technology to respond. Was I recording? No. Could I figure out how to do so? No. And since I had not had time to consult the online user's manual (as suggested by the technicians from whom I'd borrowed the equipment), I had no recourse. I was stuck without the capacity to make video, at least on this particular visit.

Around me, though, others compensated for my deficiency by adeptly using all manner of photographic apparatuses. A couple of very serious photographers worked their long lenses slowly along the exhibition's oval pathway, up and down its various levels, clicking and whirring as their cameras stopped the butterflies' movements, in pixels recording the iridescent gleams of colour, the exuberance of display.

And all of a sudden, I didn't any longer want to create a moving image of a butterfly. Imagining what these other photographers' cameras captured – the predictably glorious colours, the inevitably exquisite symmetry of forms – I resisted. I didn't want an image of a butterfly, as such. And I don't think that this was just a retaliation tantrum from someone whose plans had been thwarted. Instead, I was 'stopped', again, this time by the complexity of working with images of familiar, almost stereotypical, beauty in – as Walter Benjamin (1955/1968) put it – our age of mechanical [digital!] reproduction, now that our imaginations have been supersaturated by mass media photographs of butterflies, leaving us little that can be imaged or seen afresh. No

accident, perhaps, that the first image I was offered, back on 1 March, was almost an 'anti'-butterfly, its colours cloaked by shadow, the wings' double-lobed shape cropped out of frame.

But still, prudent researcher that I am, I pulled my trusty pocket digital Nikon from my satchel and wandered the exhibition, snapping images of butterflies in flight and their human observers. These photos, I thought, might be the basis of some later sketches. They could be something to think with as I endeavoured to move closer to my understanding of this burgeoning new work and its meanings for me. I would collect some image specimens for potential later use rather than foreclose the possibility of working with photos I'd generated myself, which is what putting aside the camera would have meant. I was implicated.

In 2008, the Insectarium's special focus was African butterflies such as the *Papilio demodocus*, familiarly known as the Christmas butterfly, Orange dog or Citrus Swallowtail – the vivid black and yellow creature with blue and red highlights featured in the ad that had 'stopped' me. Seen for the first time in Canada in the Insectarium's exhibition, this exotic beauty is evidently so common in sub-Saharan African open forests and gardens that it can be considered a 'pest' (Neubauer n.d.; Laakkonen and Laakkonen 1996). Other celebrity butterflies could be spotted throughout the display and are named in promotional material: *Cethosia biblis* or Red lacewing; *Ideopsis juventa*, the wood nymph; *Attacus atlas* or Cobra moth; *Heliconius melpomene*, the Postman (MuseumsNatureMontreal 2008a, 2008b).

The Montreal exhibit also showcased butterflies and moths imported from Central America and Asia, meaning that the Insectarium offered a kind of world tour of butterflies from twenty-five countries on all butterfly-inhabited continents (S. Le Tirant, personal communication, 2 June 2008), a microcosmic Eden where the insects' only danger is human. Along those lines, I noticed that some of the exhibit's brilliant blue South American *Morpho helenor* butterflies were a little ragged around the edges. The wing contours showed the effects of making contact with other beings – perhaps the over-eager hands of Insectarium visitors – and the injury to delicacy that can ensue.

6. RESEARCH: AESTHETIC CONTEXT, ONGOING

Doing due diligence – the kind of ordinary research an artist may do in the course of preparing a body of work – I sought out work by other visual artists concerned with the butterfly or insects in general. Both Jennifer Angus, who in projects such as *A Terrible Beauty* builds elaborate installations of actual insect carcasses (Beaudry and Quinton 2008; Angus 2008), and Kristi Malakoff, whose *Swarm* and *Resting Swarm* use facsimile butterflies and bees in meticulously rendered paper cutouts (Malakoff 2008), use insect/butterfly images to

explore questions of wonder and dread within the familiar tropes of contemporary creative practice.

I found two artists who collaborated with scientists on interdisciplinary projects with more of a research component, although neither frames their project as research/creation. *Blue Morph* is an installation by Los Angeles artist Victoria Vesna and scientist James Gimzewski, with Gil Kuno and Sarah Cross (Vesna n.d.). Based on the species *Morpho peleides*, the interactive work uses nanoscale images and sounds derived from cell-level activity of the metamorphosis of a caterpillar into a butterfly. The visuals were created by atomic force microscopy from a single scale of a butterfly's wing, whose lamellate structure creates such exceptional iridescence that some Morphos can reportedly be seen up to a kilometre away (Wikipedia 2008). The sound on the website hints at what I imagine to be the extraordinary acoustical experience in the actual presence of the *Blue Morph* installation, which amplifies the cell-level sounds of a butterfly's emergence from its cocoon. Who would have anticipated butterfly sounds with the gravitas and grace of whale songs, the powerful surges of eight pumps or 'hearts' providing rhythmic accompaniment to stertorous, lurching noises of the process of emergence? By highlighting this reality, *Blue Morpho* offers astonishing counterpoint to the common wisdom that butterflies are silent. Even seen in low-res facsimile on the website, *Blue Morph* seems a marvellous analogue for the living creative process: surprising, possibly violent and overwhelming, but of glittering beauty and resonant of human hope.

Here in Canada, *Resonating Bodies – Bumble Domicile* offers an interdisciplinary exploration of bees and what their endangerment as pollinators means to southern Ontario, using electronic arts in a visual installation created by project leader Sarah Peebles with artists Rob Kind, Anne Barros and Rob Cruikshank, and scientists Lawrence Packer, Jessamun Manson, Peter Hallett and Stephen Buckman (Peebles n.d.). *Resonating Bodies – Bumble Domicile* is a series of mixed-media installations and community outreach projects that focus on the biodiversity of pollinators indigenous to the natural and urban ecosystems of the Greater Toronto area – an environmental orientation to which I can relate.

Like these works, my *Mariposa* will aim for public display in professional venues (art galleries and natural history museums); its written component will be oriented to publication in peer-reviewed and trade publications. I hold my work to the four Research/Creation programme objectives established by SSHRC:

1. to support high-quality research/creation in projects that advance knowledge in the fine arts and enhance the overall quality of artistic production in Canadian postsecondary institutions;
2. to develop the research skills of graduate and undergraduate students who

are working in artistic and related disciplines through their participation in programmes of research that involve artistic practice;

3. to facilitate the dissemination and presentation of high quality work to a broad public through a diversity of scholarly and artistic means; and,

4. to foster opportunities for collaboration, whenever appropriate, among university- and college-based artist-researchers, other university and college researchers, and professional artists. (SSHRC 2008)

I share the values that frame these objectives and expect to continue to, no matter whether SSHRC renews this particular granting programme.

I also look to a work of research/creation to exhibit the highest possible standards of contemporary creative and scholarly practice, which means that I seek the following characteristics: a kind of congruence between intention and effect; technical facility, that is to say a confidence of expression that suggests no rupture of form between intention and output/outcome; surprise, something unexpected, original; a sense of play or delight in the making, even if the subject matter is very dark and so temperamentally perhaps anti-play; knowledge of cultural context and contemporary practice, a nod to the broader worlds of 'making' and writing and the ideas that inform them; and, if appropriate to the form the work takes, evidence of some movement of thought, that is working beyond a first idea to a better, more differentiated idea, through dialogue with texts, images, other makers, etc. I apply these standards to my own work and to that of others. And I am fortunate in the location from which I do so, since I now have a full-time tenure-stream position in art education in the Faculty of Fine Arts at Concordia University. This institution not only supports but also expects research work, most obviously research/creation, from its artist-researchers on faculty, and has been successful in procuring such SSHRC grants to date (SSHRC 2007: 19–20).[4] In other words, I have institutional support to back me up – as well as external and internal funding opportunities, colleagues who share my orientation to research/creation, and a ready cohort of graduate students, themselves artist-researchers, to hire as assistants.

Over eighty species of Morpho butterflies are known, including *M. adonis, M. diana, M. hercules, M. menelaus and M. theseus* – these all named after characters from Greek mythology.

7. RESEARCH: CULTURAL ANTHROPOLOGY, ONGOING

Seventy years before Vesna and Gimzewski used nanotechnology to complicate our understanding of the butterfly's metamorphosis, the children of Poland's Majdanek concentration camp seemed to have intuited similar

meanings in the insect's image. According to Dr Elizabeth Kübler-Ross's recollection of her visit to the children's barracks at this Nazi camp, these murdered youngsters had used their fingernails, stones and anything else at hand to carve hundreds of butterflies into the wooden walls. Later, after a quarter century of work with the dying, Kübler-Ross came to believe that these images were the responses of the imprisoned children to the knowledge that they were going to be killed, a gesture of defiance and hope for the future (as cited in Manos-Jones 2000: 71).

Images of butterflies have compelled us through human history, but I wonder what it is about *this* moment that these presentations of *live* butterflies entrance us? What is it that prompted the 1978 inauguration of the first lepidopterum at Compton House, England? What need did that first initiative so successfully fulfil that it was copied again and again worldwide, to the extent that live butterfly cultivation and export has now become an international industry worth a billion dollars a year (Manos-Jones 2003: 137–8)?

At this point, extrapolating from my own experiences, I have hunches rather than facts. Butterflies' fragility seems to appeal to us, as, I suspect, does their relative benignity: they prey upon no other animal, although some become pests in their consumption of plants. But primarily, I believe that we are seduced by the perpetual *surprise* of butterflies, that is by their extraordinary and various design – so over the top and almost unnecessarily generous.

This brings us of course to the problem and pleasure of beauty. As people, as artists, we yearn for beauty and fear its power to move us: millennially cynical, we are afraid of being duped. Working with horror is easy, familiar, expected; taking on beauty without irony is much more complicated, or so it seems to me now. Through this butterfly project, I intend to explore questions of beauty, irony and indeed cliché, as I work in the gap between the more critical engagement with these concerns present in contemporary Western art communities, and what appears to be the relatively unproblematised engagement with butterfly complexities among conservancy visitors or even the general public. And I intend to add other voices to the mix: those of workers at butterfly farms in countries such as Kenya, Tanzania and Costa Rica, where sustainable farms of butterfly pupae maintain local biodiversity and provide important employment for local residents (see, for example, the websites of El Bosque Neuvo – http://www.elbosqueneuvo.org – and Spirogyra Butterfly Gardens – http://www.infocostarica.com/butterfly/spiro1.htm). My plan is to find a way to integrate their perspectives, images, words in a way that makes a meaningful contribution to them as much as they will undoubtedly enrich the project.

Butterfly in Dutch is *vlinder*; in Cherokee; *kamama*; in Yoruba, *labalaba*; in Farsi, *parvaneh*; and in Spanish, *mariposa*.

8. ARTICULATING: GRANT WRITING, SUMMER/FALL 2008. MONTREAL, CANADA

Hired into my position as of 1 July 2008, I spent the summer establishing an institutional presence at Concordia, writing grant applications (which dug me deeper into my understanding of my project), and planning the fall semester's new teaching: an undergraduate class in photography for artist-educators in the making; a graduate class in art-as-research and research-as-art, a course of my own design that links theory and practice and explores method. I feel very fortunate, since the thematics and practicalities of my teaching dovetail well with my research interests, meaning that I am working forward in an integrated way.

So far, the research of my butterfly project has taken the form of preliminaries, supported by a recent small grant from Concordia that will allow me to hire a graduate student to begin sourcing scholarly literature in cultural anthropology, entomology and ethnoentomology, environmental ethics, and post-postmodern aesthetics. This money will also pay for materials for technical texts, specifically printing digital image files (JPEGs) onto specially prepared cloth – wool and silk, I'm thinking – that I believe may constitute my butterflies' wings. As a Concordia faculty member, I have access to this specialised technology through Hexagram (http://www.hexagram.concordia.ca), a state-of-the-art media arts research facility jointly operated by the Université de Montréal, the Université du Québec à Montréal and Concordia, and located within our Faculty of Fine Arts. With the particular possibilities of the fabric printing studio orienting my imagination, I began to visualise some specific aspects to my work.

I plan an installation in mixed media: three to five large-scale sculptures that incorporate photography, handmade Japanese paper (washi), textiles, bamboo and wood in kinetic, suspended sculptures, akin to kites and mobiles. I expect that my butterflies will be larger than the typical adult human, with the biggest about 10 feet high by about 15 feet across an open wingspan. At this kind of scale, my butterflies will engage the viewer's own physicality and felt experience of smallness next to an imposing but fragile paper and cloth structure. The surfaces of the sculptures will consist of found, appropriated and purpose-made photos and drawings – some, I hope, created by butterfly farmers, some by visitors to butterfly conservancies – reproduced onto pieces of washi and cloth and worked together into a collage composite, each image analogous to one of many microscopic scales that creates a living butterfly's wings.

At this point, I long to have my hands in materials, to supplement my text- and interview-based beginnings with the mess-making of creating embodied artifacts. I know that these early hands-on stages of practice will then lead my research, just as my research has been led by and will continue to direct my practice. A reciprocal dance.

I have begun to call this project *Mariposa*, Spanish for butterfly, recognising the mother tongue of the butterfly farmers in Costa Rica, whom I hope to visit, and suggesting both strangeness and humour. It usually raises a smile to learn that 'Mariposa' is the name for a long-standing southern Ontario folk music festival, whose residual hippie sensibility seems to go hand-in-glove with the uncritical countercultural status attributed to the butterfly image – the kind of easy iconicity that my *Mariposa* will take on. 'Take on' in a non-confrontational way, that is, since I see my work as adding to the conversation in which Malakoff, Vesna, Peebles and others already participate. I listen, with respect, and offer my own interpretive version of research/creation in turn.

Two nights ago, as I lay in bed, I heard a skittering rustle between my curtains and the window. When I got up to investigate, I was startled to find a butterfly – or perhaps it was a moth – trying to frail its way through the wooden frame. Surprisingly large to be indoors at about three inches across by two inches high, this lovely creature was a warm brown, with a few sparse dots of blue on the tops of its wings. I don't know where it had come from or how long it had struggled for its freedom. I opened the sash and pulled back the screen; released, this winged wonder flickered out of view. Before I let it go, I probably should have run for my camera and taken shots with which I could have identified this butterfly/moth, but I didn't want to make it wait for its liberty any longer. I just let it go. And I wish it well. This surprise visit seemed synchronistic, a message meant for me, a gentle kick in the diaphragm urging me to continue my research/creation, flicker onwards myself with the making of *Mariposa* and the building of my new professional life at Concordia, and see what happens.

And so I do, metaphorical butterflies in my stomach.

I extend special thanks to Stéphane Le Tirant, Collections Manager of the Insectarium de Montréal, originator of the Papillons en liberté *initiative in Montreal and consultant to butterfly conservatories in Canada and elsewhere. I very much appreciate his generosity with information and expertise in response to my preliminary questions, facilitating this initial work. I am also grateful to Marielle Aylen for her company during my visit to Montreal's* Butterflies Go Free *event, and for her astute observations on the challenges of creating artwork based on such a familiar and beautiful image.*

NOTES

1. Fourmentraux also suggests that research can occur after the creation of the object, specifically in the outcomes beyond an artwork, in 'externalities' such as 'scientific knowledge, technological processes, methods, inventions,

tools, patents, etc. that may be part of an ambition towards social usefulness or commercial or industrial applicability' (see Fourmentraux 2007: 490).

2. Concepts of tacit knowledge as expressed by Michael Polanyi in his ground-breaking 1958 work, *Personal Knowledge: Towards a Post-critical Philosophy* (London: Routledge) have been important to many of us working on connections between art and knowledge. For specific applications to this field, see work such as Michael Jarvis's 2007 article, 'Articulating the tacit dimension in artmaking', *Journal of Visual Arts Practice*, 6 (3), 201–13.

3. A full list of funded research/creation projects is available on the SSHRC website, by consulting the SSHRC Awards Search Engine at: http://www.outil.ost.uqam.ca/CRSH/RechProj.aspx?vLangue=Anglais and selecting 'Research/Creation Grants in Fine Arts' from the pull-down tab for Program Clusters and Programs.

4. In addition to research/creation funding available through SSHRC, grants are also available to full-time faculty members who are Quebec residents from the Province of Quebec. These have been available since 2000 in advance of the SSHRC programme – they are smaller purses more oriented to new researchers. Additional information is available on the programme's website, http://www.fqrsc.gouv.qc.ca.

REFERENCES

American Museum of Natural History (n.d.(a)), 'The Butterfly Conservatory: Tropical Butterflies Alive in Winter', 6 October 2007 – 26 May 2008 (cited 13 June 2008), available at: http://www.amnh.org/exhibitions/butterflies.

American Museum of Natural History (n.d.(b)), 'The Butterfly Conservatory: Butterfly Cams' (cited 13 June 2008), available at: http://www.amnh.org/exhibitions/butterflies/.

Angus, J. (2008), Jennifer Angus website (cited 12 October 2008), available from http://www.jenniferangus.com.

Barone, T. and E. W. Eisner (1997), 'Arts-based educational research', in R. M. Jaeger (ed.), *Complementary Methods for Research in Education*, 2nd edn, Washington, DC: American Educational Research Association, pp. 73–116.

Barone, T., C. Crissman, R. Dunlop, E. Eisner and H. Gardner (1999), *Shaking the Ivory Tower: Reading, Writing and Critiquing the Postmodern Dissertation*, Panel presentation at the Annual Meeting of the American Educational Researcher's Association, April, Montreal (cassette recording), Richmond Hill, ON: Audio Archives and Duplicators.

Barthelme, D. (1997), *Not-Knowing: The Essays and Interviews of Donald Barthelme*, ed. K. Harzinger, New York: Random House.

Beaudry, E.-L. and S. Quinton (2008), *A Terrible Beauty*, Textile Museum of Canada, Musée d'art de Joliette, Dennos Museum Center (Jennifer Angus exhibition catalogue).

Benjamin, W. ([1955] 1968), 'The work of art in the age of mechanical reproduction', in *Illuminations*, trans. H. Zohn, ed. H. Arendt, New York: Schocken Books, pp. 217–51.

Boyd, B. (2000), 'Nabokov, literature, lepidoptera', in B. Boyd and R. M. Pyle (eds), *Nabokov's Butterflies: Unpublished and Uncollected Writings*, Boston: Beacon Press, pp. 1–31.

Bresler, L. (2006), 'Toward connectedness: aesthetically based research', *Studies in Art Education: A Journal of Issues and Research*, 48 (1), 52–69.

Brockelman, T. P. (2001), *The Frame and the Mirror: On Collage and the Postmodern*. Evanston, IL: Northwestern University Press.

Butler-Kisber, L. (2008), 'Collage in qualitative inquiry', in G. Knowles and A. Cole (eds), *Handbook of the Arts in Qualitative Research: Perspectives, Methodologies, Examples and Issues*, Thousand Oaks, CA: Sage, pp. 265–76.

Cazden, C., B. Cope, N. Fairclough, J. Gee et al. (1996), 'A pedagogy of multiliteracies: designing social futures', *Harvard Educational Review*, 66 (1), 60–92.

Dewey, J. (1934), *Art as Experience*, New York: Minton, Balch & Co.

Dewey, J. (1991), *Logic: The Theory of Inquiry*. Vol. 12: *The Later Works, 1925–38*, Carbondale, IL: Southern Illinois Press.

Douglas, A. with K. Scopa and C. Gray (2000), *Research through Practice: Positioning the Practitioner as Researcher* (cited 12 October 2008), available from: sitem.herts.ac.uk/artdes_research/papers/wpades/vol1/douglas2.html.

Eisner, E. (2002), *The Arts and the Creation of Mind*, New Haven, CT: Yale University Press.

Eisner, E. (2008), 'Art and knowledge', in J. G. Knowles and A .L. Cole (eds), *Handbook of the Arts in Qualitative Research: Perspectives, Methodologies, Examples, and Issues*, Thousand Oaks, CA: Sage, pp. 3–12.

Fourmentraux, J.-P. (2007), 'Governing artistic innovation: an interface among art, science, industry', *Leonardo*, 40 (5), 489–92.

Garoian, C. R. and Y. M. Gaudelius (2008), 'Curriculum and pedagogy as collage narrative', in C. R. Garoian and Y. M. Gaudelius (eds), *Spectacle Pedagogy: Art, Politics, and Visual Culture*, Albany, NY: State University of New York Press, pp. 89–97.

Gray, C. and J. Malins (2004), *Visualising Research: A Guide to the Research Process in Art and Design*, Aldershot: Ashgate.

Harding, S. (1996), 'Science is "good to think with": thinking science, thinking society', *Social Text*, 46/47, 14 (1&2), 15–26.

Jardin botanique de Montréal (2008a), *Butterflies Go Free: Students at Work!* (cited 30 May 2008), available at: http://www2.ville.montreal.qc.ca/insectarium/en/index.php?section=actpap_c.htm.

Jardin botanique de Montréal (2008b), *If an African butterfly beats its wings . . . A unique exhibition at the Montreal Botanical Garden from February 21 to April 27, 2008* (cited 29 May 2008), available at: http://www2.ville.montreal.qc.ca/jardin/en/propos/papillon.htm.

Jarvis, M. (2007), 'Articulating the tacit dimension of artmaking', *Journal of Visual Arts Practice*, 6 (3), 201–13.

Kincheloe, J. L. and K. S. Berry (2004), *Rigour and Complexity in Educational Research: Conceptualizing the Bricolage*, Milton Keynes: Open University Press.

Laakkonen, M. and R. Laakkonen (n.d.), 'Citrus butterfly/African lime butterfly/Christmas butterfly/Orange dog: *Papilio demodocus*' (cited 11 June 2008), available from: http://www.onime.com/Butterflies/African/papiliodemodocus.html.

Langer, S. (1953), *Feeling and Form*, New York: Charles Scribner's Sons.

Langer, S. (1979), *Philosophy in a New Key: A Study in the Symbolism of Reason, Rite, and Art*, Cambridge, MA: Harvard University Press.

Lévi-Strauss, C. (1966), *The Savage Mind*, 2nd edn, Chicago: University of Chicago Press.

Malakoff, K. (2008), Kristi Malakoff website (cited 12 October 2008), available at: http://www.kristimalakoff.com.

Manos-Jones, M. (2000), *The Spirit of Butterflies: Myth, Magic and Art*, New York: Harry N. Abrams.

Mikula Web Solutions (1993–2008), 'Butterfly gardens and exhibits', *The Butterfly Website* (cited 15 June 2008), available at: http://butterflywebsite.com/gardens/index.cfm.

MuseumsNatureMontreal (2008a), 'If an African butterfly beats its wings . . .', press release, 18 February. Montreal, QC: Author.

MuseumsNatureMontreal (2008b), *Butterflies Go Free 2008* (brochure), Montreal, QC: Author.

Neubauer, I. T. (n.d.), '*Papilio demodocus* (Citrus butterfly, Orange Dog, Christmas Butterfly)' (cited 11 June 2008), available at: http://en.butterflycorner.net/Papilio-demodocus-Citrus-butterfly-Orang-Dog-Christmas-Butterfly.491.0.html.

Ondaatje, M. (2007), *Divisadero*, Toronto: McClelland & Stewart.

Peebles, S. (n.d.), *Resonating Bodies* (cited 10 October 2008), available at: http://sarahpeebles.net/resonating_2.html.

Peggy Notebaert Nature Museum (n.d.), Judy Istock Butterfly Haven (cited 13 June 2008), available at: http://www.naturemuseum.org/index.php?id=l14.

Poggi, C. (1992), *In Defiance of Painting: Cubism, Futurism, and the Invention of Collage*, New Haven, CT: Yale University Press.

Polanyi, M. (1958), *Personal Knowledge: Towards a Post-critical Philosophy*, London: Routledge.

Rabinow, P. (2008), *Marking Time: On the Anthropology of the Contemporary*, Princeton, NJ: Princeton University Press.

Rose, G. (2001), *Visual Methodologies: An Introduction to the Interpretation of Visual Materials*, Thousand Oaks, CA: Sage.

Schön, D. (1983), *The Reflective Practitioner: How Professionals Think in Action*, Aldershot: Ashgate.

Social Sciences and Humanities Research Council (SSHRC) (2005), 'Definitions' (cited 14 June 2008), available at: http://www.sshrc-crsh.gc.ca.

Social Sciences and Humanities Research Council (SSHRC) (2007), 'Formative evaluation of SSHRC's Research/Creation in Fine Arts Program: Final report', 8 October (cited 3 October 2008), available at: http://www.sshrc-crsh.gc.ca.

Social Sciences and Humanities Research Council (SSHRC) (2008), 'Research/creation grants in fine arts for artist-researchers affiliated with Canadian postsecondary institutions' (cited 4 October 2008), available at: http://www.sshrc-crsh.gc.ca.

Sullivan, G. (2005), *Art Practice as Research: Inquiry in the Visual Arts*, Thousand Oaks, CA: Sage.

Sullivan, G. (2006), 'Research acts in art practice', *Studies in Art Education: A Journal of Issues and Research*, 48 (1), 19–35.

Taylor, L. (1994), 'Foreword', in L. Taylor (ed.), *Visualizing Theory: Selected Essays from V.A.R. 1990–1994*, New York: Routledge, pp. xi–xviii.

Vaughan, K. (2005), 'Pieced together: collage as an artist's method for interdisciplinary research', *International Journal of Qualitative Methods*, 4 (1), article 4 (cited 14 June 2008), available at: http://ejournals.library.ualberta.ca/index.php/IJQM/index.

Vaughan, K. (2006), 'Finding Home: Knowledge, Collage, and the Local Environments', unpublished doctoral dissertation, York University, Toronto, Canada; available online at http://www.akaredhanded.com/kv-dissertation.html.

Vesna, V. (n.d.), *Blue Morph* (cited 12 June 2008), available at: http://artsci.ucla.edu/BlueMorph/concept.html.

Wikipedia (2008), 'Morpho (butterfly)', 9 June (cited 12 June 2008), available at: http://en.wikipedia.org/wiki/Morpho_%28butterfly%29.

Winterson, J. (1995), *Art Objects: Essays on Ecstasy and Effrontery*, Toronto: Alfred A. Knopf.

Sustaining the Sustainable? Developing a Practice and Problem-led New Media Praxis

Keith Armstrong

INTRODUCTION

In this chapter I introduce an ecological-philosophical approach to artmaking that has guided my work over the past sixteen years. I call this 'ecosophical praxis.' To illustrate how this infuses and directs my research methodologies, I draw upon a case study called *Knowmore (House of Commons)*, an emerging interactive installation due for first showings in 2009. This allows me to tease out the complex interrelationships between research and practice within my work, and describe how they comment upon and model these eco-cultural theories. I conclude with my intentions and hopes for the continued emergence of a contemporary eco-political modality of new media praxis that self-reflexively questions how we might re-focus future practices upon 'sustaining the sustainable'.

A CONTEXT FOR MY RESEARCH

Over the past sixteen years of active practice I have produced and collaborated upon numerous artworks of all scales. I am best known for large-scale, multidisciplinary projects that are presented internationally under the banner of 'media arts'. (For full project details, images and videos see http://www. embodiedmedia.com.) Many of these works experiment with a range of non-traditional human–computer interfaces that implicate the participants' bodies within their emergent forms. The majority of these works are interactive experiences that become realised through individual and group interactions of participating audiences. Rather than creating 'detached objects' for critical scrutiny these artworks privilege process over product by fostering interactions both between participants and the work's technologies *and* between participants via these technologies.

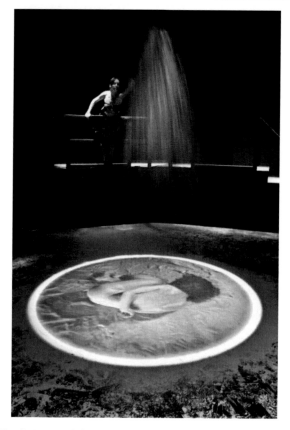

Figure 9.1 *Shifting Intimacies*, Cairns, Australia: Image: David Campbell.

My media artworks are grounded in the assumption that our collective ability to sustain is as much a cultural problematic as it is an economic or technological one. Each work emerges from thinking and writing grounded upon a philosophical basis within 'ecosophy'. 'Ecosophy' is derived from the Greek words *oikos* (meaning house or dwelling) and *sophia* (meaning wisdom). This suggests a need to act with care and respect for everything else that is also dependent upon that which is shared in common. This idea is stressed in the artists' statement that accompanied a recent showing of *Intimate Transactions* (Armstrong et al. 2005) in the 2008 Olympics Cultural Festival Event, *Synthetic Times: Media Art China*.

> Each of us is dependent on our fellow humans. Despite our
> obvious differences we rely on each other culturally, physically
> and spiritually. Every act we make needs to be considered in
> relationship to all the others that it affects. This requires us to act with

compassion, forgiveness and tolerance of others, however difficult this might seem.

Intimate Transactions examines these ideas through the metaphor of a dual-site virtual world, which you, the other person and a family of virtual creatures inhabit. It is your choice how you interact, but whatever you choose to do, others will always suffer or prosper. In turn their experience will always directly impact upon your own.

An ecosophy is a philosophical position or form of self-realisation that a subject (i.e. you or I) might embody over time. Norwegian philosopher Arne Naess (Naess 1995) describes how he employed theories of Deep Ecology to form his own ecosophy, something he calls 'Ecosophy-T.' For Naess 'Ecosophy-T' was not some comprehensive or all knowing knowledge, but rather a self-realisation born both out of his development of and identification with the philosophy he is credited with birthing, 'Deep Ecology', as well as his evolving engagements with the world. Seen from this perspective, solutions to our ecological crisis require dramatic ontological/cultural shifts in how we understand ourselves in relation to the world and each other. These new understandings must form the subjective basis upon which realistic, practical scientific, political and major structural changes are based.

In an essay about the work *Intimate Transactions* (Fry 2008) Tony Fry wrote of its ecosophical basis,

> The problem is circular – *we* cause ecological/environmental problems that threaten, but these problems are inherent in the world that contributes to forming the way we are. Ecosophy names a way to break into, and maybe out of, this vicious circle. As Felix Guattari (Guattari 1995) put it – 'The ecological crisis can be traced to a more general crisis of the social, political and existential.' He then went on to point out that dealing with this crisis 'involves a type of revolution of mentalities.' In turn, he believed this required *the development of new kinds of socio-environmental subjects* (new kinds of people) rather than increased productivism (the means of exchange by which existing social subjects are replicated and their world extended).

In 2003 I completed a doctorate that laid out a series of 'ecosophical questions' directed towards praxis to frame and develop works. For example, one of these 'ecosophical questions' asked whether 'energy transfers' inherent within the work might be made 'consistent with scientific ecological principles' that considers 'energy transfers and exchanges within the work' as 'woven into systems of flow', travelling from 'sources to sinks, or being recycled and re-utilised' (Armstrong 2003).

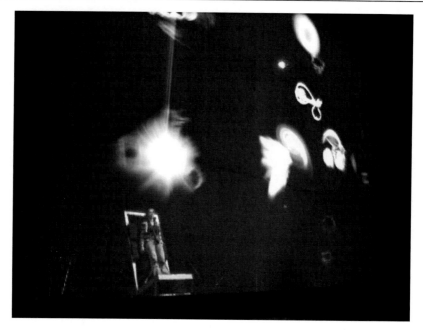

Figure 9.2 *Intimate Transactions*, shown in Beijing, China. Photo: Peter Cullen.

At this stage these questions simply remain objects of challenge and of potential utility for my praxis and by extension others. This approach therefore forms one part of my 'ecosophy' that is underpinned by a desire to discover and become the 'new socio-environmental subject' that Guattari and Fry describe.

All of my works begin with the assumption that we exist within a series of four interconnected ecologies. The first three are: the biophysical ecology of the natural world, the ecology of all that is artificial and that which we create, and the social ecologies that ensure we cannot exist without others. The fourth ecology is what Tony Fry (2003) calls the 'ecology of the image' and it strongly mediates the other three. He describes how we dwell, see and act via the way images in this ecology (literary and pictorial) mediate all other ecologies (i.e. we 'see' nothing without this pre-layering). Everything in this ecology of the image (like all other ecologies) is relational because no domain of the visual is discrete. Everything we perceive is therefore refracted by images gained from historic and contemporary literary and visual sources, and so the rethinking and reworking of what those 'images' are and how they are created becomes the central project of ecosophical practice.

This in turn calls for the development of new forms of hybridised practice that engender the experience of our being relationally connected. Just as knowing emerges from doing, then so the experiencing of ecosophical works

foments the possibility that participants will move beyond simple subjective responses (i.e. did I like it, how did it all work?) towards embodied forms of learning (i.e. what have I just been experiencing and what have I therefore learnt as reflection becomes transformed into conscious knowledge?). Achieving this nascent possibility is the deepest goal for my entire practice. This means that I must continually challenge my own subject position as 'artist' and collaborator in order that I can myself become part of a 'change community' via the small but vital contribution that my works can lend to this cultural project. Tony Fry calls this modality of working 're-directive practice'. In a parallel vein Davey (Macleod and Holdridge 2006: 23) writes that such practices offer 'the possibility of recognising in other traditions and practices the otherness of ourselves'.

SUSTAINABLE ECOSOPHICAL PRAXIS?

As a technology-based artist who is regularly lumped under the 'innovation' banner it is important that I am not simply contributing to the unsustainable productivist cycle that Fry suggests is even written into the mainstream discourses of 'sustainability' (Fry 2003). Such praxis is always a work in progress, particularly when it operates within the rapidly changing world of art and technology that rarely pays attention to its unsustaining basis. All technological practice is grossly wasteful in terms of the rapid obsolescence and the hidden costs of its production. Of course this is not a problem only germane to this discipline, but more generally endemic within today's 'design for landfill' mentality. If I were to refuse to struggle with these questions then I would become a part of the problem of the unsustainable. As part of my ecosophical commitment I must continually wrestle with this dilemma.

The ability of new media forms to foster interactive, media-rich experiences allows them to be employed, in concert with ecosophical principles, to create works that are dialogic and conversational. In these cases engagement with them has the possibility to be eventful and transformative in the same way that conversations can lead to unexpected insights or bring attention to the overlooked. Davey (Macleod and Holdridge 2006: 24) writes that conversations 'are endless in that while they may break off they are never completed and in that sense they can never stand as a final statement.' He goes onto to say of dialogic works that 'far from being an inadequacy, the incompleteness of a work's subject matter poses a creative challenge: to think on and uncover what has yet to be said' (Macleod and Holdridge 2006: 22).

PRAXIS-LED RESEARCH

I have adopted the term 'praxis-led' to describe my approach to art making that melds ecosophical theory through every aspect of my practice. This approach should be understood in the context that ecosophies remain personal and social philosophical positions based upon a series of metaphysical beliefs that ultimately are not possible to demonstrate empirically. This complex mixture of practice-led and problem-led methodologies concurs with the Aristotelian conception of praxis, which concerns the thoughts and actions that comprise our ethical and political life and ultimately focuses upon furthering human well-being and, by extension, non-human well-being. Each new project is conceived under the general aegis of my ecosophy and is part of a broader thinking-through and writing-about process that is central to my life as a practitioner. I use theory as a series of iterative stepping stones in order to generate increasingly or sufficiently appropriate artistic propositions. The development of my works involve a continual looping between practice and writing such that 'writing would belong to such work as a part of its unfolding, a continuation of the conditions of its appearing' (Macleod and Holdridge 2006: 4). The praxis-led methodologies that I use need to be appropriate to ecosophical practice and therefore grounded within the ecosophical pointers.

KNOWMORE (HOUSE OF COMMONS) A CASE STUDY

So to what degree does this theory flow into praxis? At the time of writing (mid-2008) I am in the early stages of developing of a new interactive artwork work called *Knowmore (House of Commons)* (Armstrong et al. 2009) – to be premiered at the State Library of Queensland, Brisbane, Australia – opening in early 2009. I will use this work to discuss a praxis-led way of working and therefore how I make that open for scrutiny. My approaches to a large-scale project such as this can be broken down into a series of general steps.

Firstly I begin with a series of theoretical starting points, often encompassed in one or more discussion papers. This locates field of inquiry and conceptual terrain and is used to clarify assumptions about 'the world'. The subject matter accords with some aspect of ecology that I am investigating. For *Knowmore* a key contextualising statement was:

> In an age that has come to celebrate cultural difference *Knowmore (House of Commons)* considers the urgent need for us to celebrate what we have in common – the needs of all that sustain us at the most fundamental level. This requires us each to envision new ways that

Figure 9.3 *Knowmore (House of Commons)*, test setup. Image: Keith Armstrong.

connect our everyday life choices with a duty of care over that which is shared by all: The Commons.

Having settled upon this broad idea I then begin to think through a more detailed treatment. At this early stage I often work alone or in small groups in advance of securing funding for a full creative team. For *Knowmore* I began to develop a rich dialogue with fellow artist-researcher Chris Barker. This led us to synthesise two differing but sympathetic worldviews, leading to a project statement of intent.

> *Knowmore* centres on the core assumption that ecological connections between things are present at all times, but they are not always apparent or evident to us. The work speaks to this idea through requiring participants to engage with the work through embodied, perceptive processes that allow them to see/hear/feel imagery that is omnipresent, but at most times invisible. The work therefore asks – what do we 'need to know' before being able to embody and live with better regard to this critical inter-connectivity? To achieve this *Knowmore* avoids rigid structures, repetitive tasks or directly representational forms common to conventional gaming to instead allow participants generous room to experiment and reflect – through deep engagement in embodied,

kinetic, audio-visual and collaborative 'play' that links participants and work into an ever-closer ecological synthesis.

This approach dovetailed with a range of granting proposal and funding applications. The initial host venue – the State Library of Queensland (SLQ) – was focused upon how its collection, as a knowledge store, might best facilitate the public in undertaking processes of active, socialised learning. We therefore resolved to focus not on what we each might 'know' about a personal ecosophy, but rather how that might manifest in how we each separately and conjointly act upon that knowledge. I therefore wrote:

> Libraries allow us to 'know more' in many ways. They seek to foster community connection and social development. The new library, as epitomized by SLQ, is our commonly shared resource. Through its extraordinary collection it is evolving into a place not only for us to 'know more' but also an environment within which we can go on to 'learn' more. In that spirit this artwork draws attention to where a contemporary library's 'collection' might be evolving and therefore what kind of resource for us all it might ultimately become.

ESTABLISHING AN ECOSOPHICAL RESEARCH PROCESS

From this point onwards collaborations and discussion with hired artists began in earnest. In many of my projects collaborators work outside of the academy and may or may not have had recent contact with practice-led research methodologies. I typically prefer to work with full-time professional artists for the relevance, experience and commitment that they share to placing the final works within the international art exhibition context in which I operate.

As an ecosophical director I consider forceful, teleological, directive approaches (commonly referred to as an artistic director's 'strong vision') antithetical to the work's philosophical bases as separating theoretical bases from a consequent way of working would deeply undermine the ecological, sustaining intent of the work. I therefore seek to create a supportive, respectful place to work that finds a common ground between the entire team. This requires a generosity of approach, a letting go of attachment to specific design approaches and a continued re-remembering of that which we are attempting to achieve – despite the pressure cooker that is artistic expectation. In these ways I intend that each artist remains committed to the project and also challenged and satisfied that their own practice is being advanced. This moves away from the notion of my contracting others on an in-service basis towards developing a contract between us that sustains long-term collaboration.

Figure 9.4 *Knowmore (House of Commons)*, test screen. Image: Keith Armstrong.

To establish this appropriate process I spend time over numerous early meetings contextualising the work and the process to confirm that the team's commitment to documentation, dissemination, publication and academic scrutiny is assured. Over time I have learnt to place deep trust in these collaborative, creative, processes. What drives this research process is more than what Brad Haseman (Haseman 2006) calls 'an enthusiasm of practice', although the need for enthusiasm to push the project through difficult times shouldn't be underestimated. The goal becomes what Haseman calls an 'improvement of practice', in the sense that its processes are increasingly aligned to the stated ecological and embodied frameworks.

FINDING AN APPROPRIATE INTERACTIVE APPROACH

The next step is to discover an interactive structure around which to best progress the work. Unlike some other artforms that can be tackled at the outset through open experimentation and play, complex interactives – in my experience – require particular software and hardware which necessitates a well-developed seeding structure around which experimentation can subsequently occur. The overall form of *Knowmore* emerged slowly in a series of iterations.

As we began to understand the fit between the project's ecosophical roots and interactive experience, artistic collaborator Chris Barker (2008) wrote in a personal e-mail:

> Like architecture without embellishments, the work is constructed as a scaffold, upon which certain types of interaction or characteristics are mapped. These are the physical constraints, it is this high, it is this dark, it is this long, etc. These mappings then, become the syntax upon which an argument is constructed. A bit like making a philosophical machine – an object, which becomes the scaffold for a self-reflexive intellectual layering.
>
> This is where interactivity shines – it is a rare opportunity to build such objects. Using the principles of interaction (user input/change in state), we are essentially building a sculpture, which can 'look into' itself and change form. We can take then, the essential characteristics of the form (big, skinny, rotating, projected, etc.) and the simulation (motion descriptions, dynamics, representations, animations – eg: particle mass, viewing position, illusion, etc.) and we can 'think into these things' in order to generate the content.

This allowed us to conjointly establish a base interactive strategy for the work, which we summarised as follows:

> The work's form and primary interface is a circular, 1.5m-diameter tabletop set at an average person's hip height. This 'table' spins on a smooth, central bearing, which is easily hand manipulated – allowing it to be spun (like a wheel) or positioned (like a selector knob). A computer-controlled video down projection falls directly onto it, re-configuring it in real time in response to sensed rotational speed and modalities, creating an uncanny blend of physical object and virtual media. This revolving table sits within a curtained space, both to protect it against light and to increase the intensity/privacy of the experience. Participants enter singly or in groups and their changing presence around the table, as well as how they touch it is registered by sensors. A 5:1 sound system also envelops this circular space with each speaker focussing upon one of five active table zones. A subsonic speaker also provides bodily-resonant components. This innovative format allows up to five people to 'play' the work together in a technically simple, but intensely affective collaboration.

This description outlines a broad structure rather than the specifics of what exactly will be seen, heard or embodied, as these are future decisions

that will only emerge from the practice-led process that at the time of writing had only just begun. In these ways we will privilege practice and problem-led approaches as co-dependent and equally important. This also acknowledges that the deeply multidimensional, reciprocal and iterative journeys of making work involve a broad swathe of forces that include intuition, budget, brief, career stage and sustainability of materials, processes and showing contexts. However, ultimately the final outcome will emerge from experimentation in close collaboration with theory, including the possibility of chance outcomes arising from parallel and serial open-ended investigations.

Only now, with all this groundwork in place, do we 'push off from the side' and begin to develop a practical model of departure. As the work unfolds we engage in deep reflection in action (why this way, why not that way, what are the performative and political implications of this decision), foregrounded by ongoing documentation, review and reflection. This eventually leads us to the development of a series of proof of concept sketches involving public or semi-public showings, allowing us to further think into and reflect towards subsequent developments. From then on in we commit to our first major proof of concept presentation, which involves peer-reviewed feedback, audience feedback, structured interviews and live documentation integrated into these outcomes. This is achieved by a series of invited showings where audiences attend on the proviso that they will discuss their experience with us both after their session and several days later. In recent years as bigger galleries and festivals have shown my works the base of the audiences has moved well beyond just those already in tune with my work. Based upon the transcription and analysis of these interviews and discussions I then engage in reflective, analytical writing, drawing upon themes cemented by quotations. This process involves developing aims for the subsequent stages of the work and then re-examining how these outcomes relate back to the grounding theories and decisions as to whether the new relationship is still consistent with the aims originally set for the work. This also leads us to decide how the next phases of the project will be pursued based upon an identification of the cultural impacts. Later stages of the research process involve full documentation compilations prepared for online and offline dissemination and archiving purposes.

CONCLUSIONS

Praxis led, ecosophical works both suggest the 'problem of ecology' and also simultaneously offer audiences images suggestive of transformation, imprinted through the power of physically active experience. This avoids simplistic

over-reliance on the promotion of fear and guilt, particularly for audiences who may well be already inured to warnings about our deepening ecological crisis.

It would be easy and wrong to suggest that participating within these works might somehow lead to changes in future behaviour or action through some transcendental or 'ahah' moment. However, I am repeatedly drawn to my own experiences in the early 1990s of reading Suzi Gablik's book of interviews, *Conversations Before the End of Time* (Gablik 1995) in which she spoke with numerous artworkers and philosophers about how they were personally dealing with the ecological crisis. The realisations that I gained from that book were just the right ideas for me at that time – spurring me to then develop the ecosophical project that I have pursued now for many years. It is that possibility of catalytic action, inspired by the experience of a creative work in the context of all other experience, that as both an artist and a social activist inspires me to continue this journey.

This approach, I hope, lessens the risk that the real problem of ecology will remain concealed – the problem of us.

REFERENCES

Armstrong, K. (2003), *Towards an Ecosophical Praxis of New Media Space Design*, PhD, Creative Industries Faculty, Queensland University of Technology, Brisbane.

Armstrong, K., C. Barker, D. Pack, S. Lawson and L. Lickfold (2009), *Knowmore (House of Commons)*, Brisbane, QLD.

Armstrong, K., L. O'Neill and G. Webster (2005), *Intimate Transactions*, Brisbane, QLD: Transmute Collective.

Barker, C. (2008), *Knowmore Project Briefing Notes*, 11 March.

Fry, T. (2003), 'The voice of sustainment: an introduction', *Design Philosophy Papers*, Issue 1.

Fry, T. (2008), *Intimate Transactions: Close Encounters of Another Kind*, Geo website, at: http://www.geoproject.org.au/geo/_dbase_upl/IT%20 Critical%20Writing.pdf.

Gablik, S. (1995), *Conversations Before the End of Time*, New York: Thames & Hudson.

Guattari, F. (1995), 'The ecosophic object', in *Chaosmosis: An Ethic-Aesthetic Paradigm*, Sydney: Power Publications.

Haseman, B. (2006), 'A manifesto for performative research', *Media International Australia incorporating Culture and Policy: Practice-led Research*, 118, 98–106.

Macleod, K. and L. Holdridge (2006), *Thinking Through Art: Reflections on Art as Research, Innovations in Art and Design*, London and New York: Routledge.

Naess, A. (1995), 'The deep ecology "eight points" revisited', in G. Sessions (ed.), *Deep Ecology for the 21st Century*, Boston: Shambhala.

Nightmares in the Engine Room

Jane Goodall

'Research' is something of a buzzword among writers of popular novels. It is a topic often brought up at literary festivals among panels of authors who are concerned about being taken seriously. Specialist knowledge of certain kinds has a high value in the book-selling stakes: any fiction writer who has flown an aircraft or conducted brain surgery, who has a background in foreign affairs or espionage, or who has travelled in extreme environments is seen to have 'done their research' and is respected accordingly. In other words, research is assumed to be practice-led and understood to be the factual dimension of a fictional work; the writer's job is to make that dimension intriguing or adventurous.

To someone coming from a background in the academy, and especially from the Humanities, research means something rather more. It is an investigative process designed to reveal new knowledge or new modes of understanding. What it means to engage in 'a research-led practice' in the area of popular fiction is not something I've heard discussed outside the academy, and within the academy the question tends to steer towards theoretical issues about genre. In theory, it should be possible to exploit a sophisticated awareness of generic elements by treating them as ingredients in a recipe for success in the market. Of course it doesn't work like that. Giving the formulaic components to even the shrewdest critical intelligence rarely leads to the composition of anything that will work as a narrative. If practice is to be led by research in this area, the process is more intuitive and less easily defined, and is best considered after an exploration of what happens as practice generates research.

When I began to write fiction, as something of an under-the-counter activity, I felt a sense of liberation from the constraints of professional research. I could assemble historical facts quite promiscuously, in a fashion determined entirely by the requirements of a storyline, feeling accountable to no one for attributions, omissions and distortions, or even for shamelessly making things up,

provided the overall narrative line was convincing. My training as an academic researcher perhaps helped to fine-tune my intuition as to where you could make it up and where you needed to adhere to a framework of authenticated fact and detail, but I found myself enjoying the freedoms of 'research lite'.

This is not to say that the process lacked rigour, but what was rigorous about it had changed, and I discovered more about that as I went further into the fictional world. My academic research might be broadly described as cultural history, which is typically conducted through the study of documents. For example, some work on late Renaissance science led me to ferret out the original writings of key figures: John Dee, William Gilbert, Walter Raleigh and other members of the 'School of Night'. When you are looking for new angles on existing knowledge, you have to be thorough and comprehensive in your searches, so there are always anxieties about whether you have missed something, whether you can fully document the connections you are making, whether your ideas are backed up by enough evidence to be convincing. Much time is spent in the archives, carefully separating the pages of ancient and fragile books, puzzling over archaic letterings.

While I was doing this, it would occasionally occur to me that there was something potentially sinister about the activity of trawling through old writings. What if one of those figures lurking at the edges of the scene of knowledge turned out to be a really ugly customer? What if some of the better known characters revealed a murky undercurrent of thought and behaviour? Or indeed, what if there was something weird about the motives of the scholar ferreting through all this in the library? Such questions have been the starting point for many of the stories I like: especially the musty academic ghost stories of M. R. James, Peter Ackroyd's *The House of Doctor Dee* and his strangely evil novel *Hawksmoor*. As any scholar knows, all manner of thoughts will come to distract you in the library, but the distraction here was oddly insistent, and I began to invent as well as to search.

Eventually, some of these inventions found their way into the background of my first thriller, *The Walker*, which is set in London in 1971, but features a type of villainy that carries a deep history. There are hints of an alchemical experiment gone wrong somewhere a few centuries back, and the documentary trail from this leads to the identification of a killer at work in the twentieth century. It was easy to invent a seventeenth-century alchemist and to concoct the details of an experiment involving mercury and cinnabar, some bird symbolism and a homunculus. For me, though, the fascination of all this was in the way it was written about in the documents I'd studied. The challenge was to get the tone right, the sense of a voiced human consciousness with intentionality. Here research and creative process came very close together. I was aware that replicating period style in modern fiction is a technical *tour de force* and I wasn't trying to achieve that, but I needed a convincing vignette.

At a late stage in the story, the case turns on the discovery of two written messages, dating back to 1728. The first is a warning against attempting a particular experimental process in this phase of the lunar cycle, and it's evident that the writer, for all his rather convoluted language, is seriously rattled. A week later he is found dead in his bed, with both eyes neatly removed and placed in a silver dish on the table beside him. This is itself the answering message, but is accompanied by a brief written text, left propped against the silver dish:

That you may see the business that is done. (Goodall 2004: 317)

From a writer's point of view, this is harmless play (the *homage* to Ackroyd will be evident to anyone who has read *Hawksmoor*) and far from the most difficult aspect of what you have to do to get a novel to work.

The process of discovering and laying out the parameters of a fictional world, I found, was a task of a different order from the intricate but mainly pleasurable fixing of details. How many times did I literally write myself into a corner? Sometimes by putting a character into a situation I couldn't see the way out of, sometimes by setting off tension lines that refused to merge as I had originally envisaged, sometimes by trapping the action line into a logical impossibility. Sometimes the momentum just ran out. Research alone cannot rescue you from such predicaments. Like a person trapped in an impenetrable enclosure – a good staple ingredient in a thriller – you have to just try everything: reinvestigate what you have about you and push your invention in every possible direction till you can find something that will work to release the free-running energies that every reader takes for granted and requires as an incentive for continuing to turn the pages.

Research alone cannot rescue you, but it may still be of some help, since research is involved in most workable inventions. One of the murders in *The Walker* happens in an old church and the victim is the rector. My plot design required that the church door be locked when the body was discovered, because the killer was exhibiting an almost supernatural propensity for getting in and out of places. The lock on the door, then, had to be something special: an ancient and over-ingenious device, with a key the size of a soup spoon that is kept on a chain around the rector's waist, and is still there when his body is discovered, carefully arranged in the pulpit. How to account for the relocking of the door and the killer's means of exit? Anything the police might trace by normal investigative work on the site had to be excluded. Remembering that my hairdresser is married to a locksmith, I asked tentatively if he might be up for a bit of expert advice regarding the lock on the church door. Absolutely not, was the answer. Locksmiths do not divulge the secrets of the trade, least of all to people who are likely to broadcast them in a work of commercial fiction. So I went back to the library and ordered up some historical works on lock and

key design and, by combining what I found with a certain amount of embellishment, came up with what I felt was a viable option. It had to be a possibility the police would explicitly discount, and this is where history can help, since people think differently across the centuries.

The locked room scenario is a classic exercise in improvisation and, having done some time in the drama studio as a teacher, I was aware of the creative symbolism involved here. How do you release invention itself, make it so free that it can resolve structural dilemmas that seem to defeat a reasoned approach? Improvisation is a fascinating activity in itself, leading people to come out with ideas and connections quite outside their normal thinking patterns. From a thriller writer's point of view, there is a shock value in the way things sometimes just happen. Two people break into a shouting match in a shopping centre; there's a traffic accident; someone collapses in a department store. Even the simple act of breaking into a run on a crowded street will cause the whole dynamic of the scene to change. Other people stop in their tracks. Some turn and stare. Expressions change, remarks are made and the person making a dash becomes for a moment the very embodiment of unpredictability.

A storyline driven by action requires improvised moves from the characters, so that the writer has to be aware of how people improvise in the real world. Children do this habitually, and so do certain kinds of criminals. In my second novel, *The Visitor*, I introduced twin boys who trigger some of the twists in the action through the kinds of random imaginings that will occur between children at play, and I had a killer whose jumping mind intersected with theirs. There was a risk, though, in taking the improvisation too far and losing the logic and shape that are integral to an effective plot, so research can help to anchor the inventive dimensions of the story.

The art of plotting has to do with bringing together event and context in unexpected yet entirely logical ways. Here location research is of the essence: getting to know the context as intimately as possible, in its social dimensions and its qualities of place or location. For the setting of *The Visitor*, I found myself led – by the nose, so to speak – to a landscape so drenched in story you'd have to be what's quaintly called 'foolhardy' to start cooking another one there. I was foolhardy. Or, as I prefer to think, the place is so primordially greedy for stories you can't walk through it without finding them birthing in your head and growing with every step.

The landscape around the Avebury Stone Circle is a concentrated arrangement of ancient sacred sites. A few kilometres away, and visible from the outer edges of the Circle, is the strange little pyramid of Silbury Hill, constructed some 4,500 years ago. From Silbury Hill, you can look across to West Kennet Long Barrow, one of the most ancient man-made structures in Europe. Near here is also the starting point of the Ridgeway, the oldest road in England, which runs east across the country for nearly 140 kilometres. Only short parts

of it have ever been linked up with the driving routes through that part of the country, but walkers have never stopped using it for long-distance expeditions. A two-day walk from Avebury will take you to the White Horse Hill outside Uffington, where there is a prehistoric fort. Almost within sight of the White Horse is Wayland's Smith long barrow, with its surrounding wood.

About all this there is much to learn from existing research, and much to find out from personal exploration. I visited the area and combed the local libraries and museums; I collected maps of many different kinds, including hand-drawn diagrams by the eighteenth-century Avebury enthusiast William Stukeley. Out in the landscape, these led me up across the remote stretch of high ground between the village of Ogbourne St George (where there was a warm inn and a chatty, well informed proprietor) and the Uffington Fort. I drove through a gathering mist up the precipitous road to the top of the White Horse hill and got out of the car to find I could hardly see a hand in front of my face. The place seemed fearsomely potent and strange, and I balked at walking on that occasion. They have their own weathers and moods, those places, and a stronger psychic presence than any normal human being. I was learning how practice-led research can dig deep into the imaginative process. A kind of knowledge-based dreaming can take over and researched elements start to lead the way, but I also discovered that it is a mistake to allow them to distract from the exigencies of the moment.

Towards the end of my last visit to Avebury, which I'd timed to coincide with the Winter Solstice, I was making my way back to my car after a fairly arduous walk, thinking I'd call it a day, seeing this one was supposed to be short. The light was fading fast and the cold was stepping up. But looking across towards the slope leading up to West Kennet long barrow, I saw a line of people, silhouetted against the after-glow of the sun, making their way down towards the road. I was curious, naturally, and also rather annoyed with myself. There must have been some ceremony up there and I'd missed the opportunity to witness it. A background in academic research doesn't necessarily help you to be a good sleuth, which is what you need to be as a fiction researcher. Sometimes you need a quick, sharp pick-up on what's happening here and now, and in spite of being in the right place at the right time, I'd failed to register the vital signals. By way of penance, I drove the car to the foot of the hill and walked up the slope, against the stream of black-clad figures on their way down. By the time I reached the barrow, it was fully dark and there was no one else around, but I could see light coming from the barrow mouth. Inside, there were literally hundreds of candles, placed around the edges of the caved space, and at the farthest end of the enclosure some kind of shrine had been constructed. Here, one figure still stood vigil, wearing a hooded cloak. So I stood there as well. I have no idea for how long, because there is, I swear, a natural time-warp in that extraordinary place. It speaks a kind of quietness I've experienced nowhere else.

That episode didn't belong in the novel. My instinct was that West Kennet long barrow didn't belong in anyone's fiction, though I drew on that scene for a climactic scene in the novel. It was the other ancient barrow in the area – Wayland's Smithy – that belonged in stories. Over the centuries, it has been the wellspring of an endless stream of legends, so I tapped into them and adopted it as a myth-drenched locus.

During the months of work on the first draft of the story, though, it wasn't the dark myths of its setting that gave me nightmares. It was the sheer technical demands of bringing several improvised action lines into a coordinated design. The trouble was in the engine room. One response to this was to research the technical precedents: to re-reread some of the best designed thrillers I knew, and try to identify the secret formulae of a successfully engineered suspense novel. But that would be an explicitly research-driven approach, and I had my doubts about it, generated largely by reading Norman Mailer's *The Spooky Art*, one of the best books I know about fiction writing. In it, Mailer gives a compelling account of a novel gone wrong. Some three years after commencing work on *The Deer Park*, he says, he came to a realisation: 'I had been strangling the life of my novel' (Mailer 2003: 35). Influenced by his wide reading of literary works, he had tried to emulate them, putting into practice all he had learned about style and structure in narrative. He had been allowing his research to lead his practice in terms of craft and composition, and the process had misfired. In popular fiction, the equivalent of this error is to allow studied models in the genre to steer the approach to narrative composition.

No matter how acute your theoretical knowledge of what makes a plot work, you cannot activate the mainspring of dramatic tension through a sequence of decided processes. That is rather like trying to design a computer program to play chess. There are just too many variables, the most significant of which is the immediacy of live human interaction: between writer and reader, between the characters who generate the action and, in some bizarre way, between the author and the novel. It is this last relationship that is most likely to be sabotaged by a research-led approach to the process of composition. Even among the most hard-headed novelists there are those who accord some kind of uncanny autonomy to the book in the making, as if an unwritten novel is a determining entity that takes possession of the writer, generating nightmares of technical impossibility from which the only way out is ever deep resignation to the work as daemon. Mailer broke the deadlock over *The Deer Park* by dismantling all the consciously crafted elements he had imposed upon it. This is the *via negativa* of authorial control, and as he pursued it, Mailer says, vitality spilled back onto the pages. 'The book had come alive and was invading my brain' (Mailer 2003: 36). I can't claim to have had this experience, but if research has taught me anything about the creative process itself (and in this sense, I count reading and re-reading *The Spooky Art* as a form of research),

it is that fiction writing requires a finely calibrated balance between conscious planning and improvisatory caprice.

My third novel, *The Calling*, had to be written on a tight contractual timeline. It was to be set in 1976, with action lines riding on the first surge of the punk movement in the appropriately named World's End of London. After a few months' work, the story was starting to shape up. I had a runaway schoolgirl paired with a punk insider, an edgy young woman called Zig, given to wearing rubber gear and making all the decisions. I had a feral rock group called Sudden Deff who appeared on stage in leather Cambridge rapist masks (items sold in Vivienne Westwood's shop at 430 Kings Road). I had a body part washed up on the Thames embankment near the Lots Road Power Station, a red brick building of cathedral proportions that towers over the residential part of the World's End. For a while, all these lines of narrative seemed to be humming along, then I reached a point where the engine just seemed to have died. Maybe the power station was the wrong metaphor. I was tempting fate to deliver me a supply failure.

Dealing with this predicament when the calendar on your wall shows that there aren't many of its pages left to turn before the crunch comes is not much fun. This is when you have to harden your head and call on experience. And speaking of calling, I didn't have a title yet. I'd written pages and pages of scattergun ideas for titles, but none of them were right. Somehow, the key to the lost momentum, the master switch in the engine room, had to be the title, but the more I was fussing with it, the less it was responding. I tried another approach, taking a notebook on a café crawl and scribbling down random trains of thought about what made me want to write this story in the first place. It was a question of motive.

Writers, like killers, must have motive, and as I spun out the automatic writing, it became clear that motivation was at the heart of the narrative and amounted to much more than the conventional plot device of a motive for murder. It was do with how the relatively smooth surface of everyday life gets ruptured every so often when the motivating energies that normally run in channels – work, sport, family, sexual relationships – suddenly surge up and burst their containment. Someone decides they want more than can be delivered through the patterns of achievement and gratification laid out through social consensus. Adolescents, typically, will manifest this kind of determination, often in a quite unfocused way. There are some individuals who are charged up with a sustained hyper-motivation, which is like a life force, though it can be violent in its impact.

The punk movement is an example of a collective surge of this kind, but its key identities – Johnny Rotten, Vivienne Westwood, Sid Vicious, Nancy, Siouxsie, Malcolm McLaren – drove on crash courses across each other's paths. Although their declared mission was destruction, they generated

creative energies that are still working their way through mainstream culture thirty years later. My story didn't need one hyper-motivated person, it needed a force field in which everyone caught up in the events found themselves spun on some new axis.

With such a chaotic milieu, some counterbalance was required. A crime novel, classically, counterbalances the chaotic underworld of violence with the structural world of policing. This is an almost archaic dualism, but it needs some stirring up if it's to produce a good story. Once I'd decided that my title was *The Calling*, I found a centre of gravity around which the chaos could be spun. My detective was the one with the calling, a sense of destined lifetime commitment which, as a woman in her early thirties, she was still trying to come to terms with. Amid the feral shouting energies of the punks, the calling was working its way with a different kind of potency.

Nightmares in the engine room are, of course, a recurring affliction, and analysing them doesn't make them go away or diminish their terrors. Analysis cannot produce a story. What it can do is help in cutting through to the place where the story is breaking, where the running edge of tension is released.

With some help from my guides, then, I've been learning that the spooky art of fiction writing involves a commitment to improvisation and randomness, a submission to the erasure of authorial design, a readiness to be mesmerised by place and possessed by psychological energies from competing directions. I'd also been learning the hard way that you have to come back from the zones of chance, dreaming and impulse to the hard-core business of engineering, and that you must not leave it too late to make that return. Research in the context of the creative arts can actually serve to calibrate awareness of the psychological displacements required to keep the work alive and manage its energies. In the practice of any art form, there's a need to know about the work of others and to build up a density of such knowledge. This, too, is research and its pursuit may assist in finding the alchemical point at which consciousness needs to resign its controls, and the equally vital point at which it must resume them again.

REFERENCES

Ackroyd, P. (1991), *Hawksmoor*, London: Abacus.
Ackroyd, P. (1994), *The House of Doctor Dee*, London: Penguin.
Goodall, J. (2004), *The Walker*, Sydney: Hodder.
Goodall, J. (2005), *The Visitor*, Sydney: Hodder.
Goodall, J. (2007), *The Calling*, Sydney: Hachette.
James, M. R. ([1904] 1971), *Ghost Stories of an Antiquary*, London: Dover.
Mailer, N. (2003), *The Spooky Art*, New York: Random House.

Creative Practice and Research in Education and Politics

Acquiring Know-How: Research Training for Practice-led Researchers

Brad Haseman and Daniel Mafe

INTRODUCTION

Over the past decade opportunities have increased for artists and creative practitioners to undertake higher research degrees and so bring the benefits of research to their practice and discipline. However, in Australia this move into research has seldom been easy, for traditional research approaches are made up of protocols and conventions which are hardly congenial to the working practices and methods favoured by artists and practitioners. These newcomers to the world of research feel deep and unresolved tensions, for traditional research approaches seem too linear, too predictable and too ordered to capture the messiness and dynamism of the process of inquiry which lies at the heart of their creative production. Nonetheless, they recognise that research is valuable and feel they need to conform, and frequently want to conform, to the established and authoritative research paradigms.

The central problem is one of research methodology. Traditional research methodologies, from both the quantitative and qualitative research paradigms are characterised by well established and widely shared procedures and protocols, using research strategies and methods which afford a high level of methodological 'hygiene' (Law 2004: 9). For these approaches naming the research problem, controlling variables, disciplining data and specifying findings are fundamental quality assurance measures. The same methodological assumptions dominate the research industry as understood by the regulations and expectations of research funding bodies and the rules commonly imposed on PhD and Masters candidates. Both operate with clear and unambiguous requirements for researchers to meet if they are to be successful and credible.

Invariably, and at the very beginning of the research process, they require researchers to outline the background, significance and purpose of the study, state the research problem and related research questions, and outline the

research approach and methodology with methods appropriate to the aims of the proposal. Typically a full research plan and proposed timeline is required. None of this is strange to researchers schooled in and researching within the well established paradigms of qualitative or quantitative research. However, for artists and creative practitioners seeking to join the community of researchers this environment can seem unsympathetic and dismissive of their contribution.

The potential for anxiety is not surprising for most established research strategies are carefully structured to exclude the researcher, based on the belief that researcher subjectivity stands to infect the objective 'truth' and universal applicability of research findings. Of course the authority of objectivity to account for all human experience has been battered by developments in science and poststructural thought. Quantum physics led the charge over a century ago with revolutionary notions of relativity and uncertainty, and the challenge continues today from fields as diverse as cosmology and bioinfomatics. It is no longer the case that a united research world rejects the notion that the ambiguities which confront us are merely problems waiting to be solved, to be collapsed into hierarchies or unitary solutions. Many researchers across the sciences, humanities, social sciences and the creative arts believe this absolutely, agreeing with Deutscher that it is objectivism

> . . . that would have us forget that it is a view; the objectivist is a subject who would forget and have others forget that he is a subject. There is only what is viewed; the viewing of it is passed over. (Deutscher 1983: 29)

But for all this the research industry and universities continue to insist that researchers conform to traditional approaches and research practices with their guarantee of methodological 'hygiene'.

Recently into this unsettled and shifting research environment arrived the artists and creative practitioners who wish to undertake research into their practice by placing it at the heart of the research process, and in ways which go beyond the conventional research strategies favoured by traditional quantitative and qualitative research. As candidates for higher research degrees many struggle to understand exactly how the regulations and procedures imposed by the research industry can include their particular processes of creation and knowledge production.

After nearly two decades of trying to adapt to these demands artist researchers have been able to borrow certain research strategies and methods from the qualitative tradition. They have found, for example, that reflective practice, action research, grounded theory and participant-observation can meet some of their needs. Finally, though, it has been necessary to devise and refine a distinctive research strategy with its own methods which are drawn from the

long-standing and accepted working methods and practices of the creative disciplines. Such an approach is known by a number of terms including creative practice as research, practice-based research, studio research and performance as research. For the purposes of this chapter we will use the term practice-led research for we believe it is the most appropriate term to capture the dynamics of a powerful and distinctive research strategy which meets the needs of both the artist/researcher and the expectations of the research industry.

This methodological innovation is crucial for the integration of artists and creative practitioners into the research community but it must be accompanied by new regimes of research training which address the specifics of practice-led research. The final section of this chapter seeks to do just this: to discuss what effective research training may be for these researchers. However, first it is necessary to be clear about what practice-led research actually is and the specific challenges and demands it makes of the researcher, the matters being researched and the way findings are reported. It sets out how practice-led research may be understood and how the researcher is challenged at every turn to employ researcher-reflexivity to deal with emergence in the research process. Only when these conditions of practice-led research are made explicit will it be possible to consider how appropriate research training may best be undertaken.

THE SIX CONDITIONS OF PRACTICE-LED RESEARCH

What is it about practice-led research and its distinctive approach which makes it so serviceable for artists and creative practitioners? Two crucial aspects are captured in Carole Gray's original and enabling definition for practice-led research first articulated in 1996. She sets out these two aspects as:

> . . . firstly research which is initiated in practice, where questions, problems, challenges are identified and formed by the needs of practice and practitioners; and secondly, that the research strategy is carried out through practice, using predominantly methodologies and specific methods familiar to us as practitioners. (Gray 1996: 3)

It is important to acknowledge from the outset that by insisting that practice leads the research process Gray is aligning researchers who insist on the primacy of their creative practice in research with those philosophers and epistemologists who are intent on theorising practice. Practice-led researchers join a bold tradition of practice theorists such as Bourdieu, Dewey and Schön whose central core '. . . conceives of practices as embodied, materially mediated arrays of human activity centrally organised around shared practical

understanding' (Schatzki 2001: 2). Gray stands in the tradition of those practitioners and theorists who seek to build epistemologies of practice which serve to improve both the practice itself and our theoretical understandings of that practice.

In this context, practice can be understood primarily as the knowledge, tacit or otherwise, of how something is done within the context of a professional and cultural framework, a contingent activity that makes or establishes meaning or significance, although not through the application of thought alone. Practice needs to be understood in its wider sense as *all* the activity an artist/creative practitioner undertakes. Practitioners think, read and write as well as look, listen and make.

Perhaps most significantly, Gray points us to the conditions under which all practice-led researchers are bound to operate, namely within dynamic systems of complexity and emergence. While Gray offers two fundamental aspects of this research strategy it is now clear that practice-led researchers deal with greater complexity than those of problem definition and methods of practice alone. At this point in the history and development of practice-led research it is clear that the practice-led research process is characterised by six conditions.

Resolving the 'problem' of the research problem

Gray's first defining characteristic '. . . where questions, problems, challenges are identified and formed by the needs of practice and practitioners' (1996: 3) seems simple enough and yet it poses a fundamental challenge for traditional research approaches which hold to the belief that a clear and early articulation of the research question is essential for all convincing research. One consequence of this is that PhD candidates the world over are required to state their research question often within months of beginning their long and strenuous research degree. While this may be an essential quality check for conventional researchers it often becomes an impediment for creative practitioner/researchers.

Gray's point is that for practice-led researchers problem formation does not happen in that neat and predictable way. Instead the problem, or many problems, emerge over time according to the needs of the practice and practitioners' evolving purposes. Practice-led researchers therefore have consistently argued that their need to delay identifying the research question is both defensible and necessary and, in fact, not unknown in much traditional research. However, unlike traditional researchers, even those whose research questions do mutate and change, the practice-led researcher may find problem definition is unstable for as long as practice is ongoing and it is only when the practice is done, and possibly in the final phases of candidature, that the final research problem will be decided.

Repurposing methods and languages of practice into the methods and language of research

Almost without exception higher degree research students are required to enrol in a research method subject early in their candidature. Invariably these subjects proclaim the proven and reliable methods acceptable to the quantitative and qualitative research traditions. By the end of the subject students are required to select methods which best fit their research question and design. However, these methods, even those arising from the qualitative tradition which are designed to research practice, do not serve the creative researcher's purposes well. For example, while a research strategy such as grounded theory may seem promising for researching creative production, it is unable to map onto the processes and techniques of the artist in ways which capture and report on the emerging nuances and directions possible in the work. It is not surprising then that creative researchers are left feeling somewhat awkward after such a research methods course as they struggle to find a legitimate place within academic research, and it can be particularly distressing and confronting for some who feel they have little sense of entitlement within the language and procedures of research.

Gray's bold solution to this tension is to proclaim that practitioner/researchers need instead to take the terms and the technique of their practice and repurpose them into the language and methods of research. For example, many artists use journals and sketch books to develop their work. Such a specific method, familiar to the visual art practitioner, can be repurposed to serve as a research method for documenting and recording discoveries. Repurposing in this case may include regularly and formally reviewing and re-reading the journal to identify key markers of the creative journey as it shifts over time. Such a repurposing or conversion for use in a new setting is required, as the context for both the practice and the work expands to meet the requirements of research. Inevitably this represents something of a quantum shift in the creative researcher's thinking. Now the art making and the artwork itself are no longer to be thought of as existing solely within their disciplinary field. They become, instead, part of a research process that requires methodological scrutiny and research outputs. This expansion of 'use' is one way creative researchers can become more practised and familiar with the protocols of research and participate more firmly in the research culture. As the research culture becomes a more familiar habitat for practice-led researchers, the sense of belonging and entitlement grows.

Identifying and deploying emerging critical contexts which are networked out of his or her practice

In his essay '*In defence of overinterpretation*', Jonathan Culler (1992: 120) reflects on the statement that 'meaning is context bound'. For the practice-led

researcher this is an inescapable reality, the ramifications of which must be actively and thoughtfully negotiated. This negotiation is characterised and complicated by the fact that even though meaning is limited or specified by the defined context, contexts themselves are potentially limitless. This means that before a critical meaning or significance for a practice-led research project can be identified, a range of pertinent critical contexts must be clearly named *and* claimed. It is only when the practical is located within critical contexts that findings can begin to be established.

Identifying and engaging with the 'professional' frames within which practice is pursued

A parallel situation faces creative practitioner/researchers in the way they claim or relate to the professional frames that name or define the creative practice itself. As shared practical understandings grow, their full impact and value is necessarily marked by the professional protocols and regulations that contain or delimit them. These professional frames play a crucial role in knowledge definition and procedural application and can be seen, for example, in the way entrepreneurial exchange and ownership issues frame what is valued, contemporary and 'legitimate'. Often these arbiters of the professional are conservative in nature, and research must find ways of influencing these professional dictates.

Anticipating and deciding on possible forms of reporting

Practice-led research outcomes are essentially reported in two forms – the creative work and the exegetical, linguistic accompaniment to that work. This goes to the very heart of practice-led research because for many researchers the question 'How can the findings of a practice be best represented?' is a question that establishes just what it is which can make a finding significant or worthwhile. The materiality of a creative work impacts on both the content and the reading of that content. This is further complicated by the relationship of that 'expression' with the necessary exegetical accompaniment, which is typically linguistic. Issues of translation of meaning from one medium to another are immediately encountered. How to speak in a way that complements that work? What is it to speak of the work? Are we explaining it? Defining it, amplifying it? Finally, where exactly do research findings lie? Specific answers to these questions vary from study to study and are only found by paying ongoing and ever present attention to matters of documentation and reporting.

Deliberating on the emerging aspirations, benefits and consequences which may flow from the demands and contingencies of practice

Much has been written about the crisis of legitimation in contemporary research. Reviewing the last fifty years of qualitative research in particular we can see 'patterns and interpretive theories, as opposed to causal, linear theories, were now more common, as writers continued to challenge older models of truth and meaning' (Denzin and Lincoln 2005: 18). If truth then no longer sets the standard for all quality research, what other aspirations and potential benefits can researchers have for their research projects? John Law (2004) suggests there are other 'goods' to be embraced and in fact a research project may realise a number of different goods or benefits during its life. This is especially so for those practice-led researchers who find that a multiplicity of goods emerges during various stages of research. The research may have truth aspirations, or see benefits around justice or politics or aesthetics or possibly even the spiritual. For the practice-led researcher, just as the research problem emerges and evolves during the study, so the benefits of the research are likely to evolve and transform over time.

Accepting that these six conditions frame this particular research environment, practice-led research is a process of inquiry driven by the opportunities, challenges and needs afforded by the creative practitioner/researcher. It is a research strategy specifically designed to investigate the contingencies of practice by seeking to discipline, throughout the duration of the study, the ongoing emergence of problem formulation, methods selection, professional and critical contexts, expressive forms of knowledge representation and finally the benefit of the research to stakeholders.

Unlike many of the traditional research methods taught to higher research degree students which promise clear pathways of discovery and reliable outcomes, practice-led researchers uniquely struggle with this evolving state of emergence. At all times the practice-led researcher is making decisions and moving forwards and backwards and across the six conditions outlined above. To cope with the 'messy' research project in such a way requires practice-led researchers to have an understanding of not only emergence but its constituting condition of complexity.

EMERGENCE AND REFLEXIVITY IN PRACTICE-LED RESEARCH

From the six conditions of practice-led research it is clearly a research strategy characterised by emergence and complexity and it is out of this complexity that

the outcomes or findings of practice-led research are generated. To understand this further we need to look at complexity itself.

Defining complexity is not a simple task. Peter A. Corning of the Institute for the Study of Complex Systems, for example, feels that instead of holding to a single definition of complexity it is better to articulate defining attributes.

> . . . complexity often (not always) implies the following attributes:
> (1) a complex phenomenon consists of many parts (or items, or units, or individuals); (2) there are many relationships/interactions among the parts; and (3) the parts produce combined effects (synergies) that are not easily predicted and may often be novel, unexpected, even surprising. (Corning 1998)

These attributes are certainly consistent with practice-led research and the six conditions which inform it. For example, from the outset practice-led research is multidisciplinary. It is built, at times uneasily, from contrasting registers of professional activity, creative practice and academic research. Underpinning this tension is the additional complication that accompanies the interpretation of the creative work itself. Graeme Sullivan has observed that:

> The linguistic turn of postmodernism has done much to disrupt the easy equation that presumes an artwork and its 'reading' by viewers is a simple matter of encoding and decoding visual forms. Interpretive acts open up the space among the artist, artwork, and the setting as different interests and perspectives are embraced. (Sullivan 2006a: 30)

This interpretive complication is played out in the space demarcated between the material and immediate qualities of any media/substance worked with, and its connection with the particular genre and creative discipline to which it belongs. The very establishment of its meaning and critical significance is constituted by a tension between critical understanding and affect.

While emergence and complexity are pivotal for understanding and managing practice-led research it should be noted that these dynamics are not completely absent from other research approaches. The difference, however, lies in the degree of intensity of these forces in unsettling and shaping the research project as a whole. For the creative practitioner emergence and reflexivity are much more than distracting variables in the research which need controlling. Instead they are both foundational and constituting, operating at practically every level of the research, and it is this which makes it a difficult, messy and at times a frustrating endeavour for the creative researcher.

The ensemble of tensions generated within and by the various component parts of the research can only be successfully managed if the researcher

develops a heightened sense of reflexivity. The reflexive defines a position where the researcher can refer to and reflect upon themselves and so be able to give an account of their own position of enunciation. This is clearly parallel to those social constructionist approaches to research where there is a growing 'awareness that doing research must be expanded to include those artist-like processes that are already there, but filtered out of ordinary research writing' (Steier 1991: 4).

Reflexivity is one of those 'artist-like processes' which occurs when a creative practitioner acts upon the requisite research material to generate new material which immediately acts back upon the practitioner who is in turn stimulated to make a subsequent response. Within this looping process authorial control can be fragmented, raising doubts about purpose, efficacy and control. A kind of chaos results and it is from within this chaos and complexity that the results of the creative research will begin to emerge and be worked through. For Sullivan reflexivity is central to negotiating complexity, seeing it as

> . . . a messy process that requires a capacity to appreciate and negotiate between complex and simple realities, often at the same time. There may not be an elegant or parsimonious resolution to this – there rarely is. In all likelihood the shock of recognition that comes from new insight is mostly particular rather than general, singular rather than plural, for this is a more realistic description of how experience is enlivened and knowledge is accrued. (Sullivan 2006b)

It is this 'shock of recognition' that marks a key step in the way practice-led researchers find their way through the ongoing state of emergence which characterises their research studies. Joseph Goldstein remarks that emergence has been increasingly used

> . . . as a description for the way creative ideas, images, and insights can arise unexpectedly and radically distinct from whatever inputs that may have served as a groundwork for the created product. (Goldstein 2005: 3)

The emphasis on the 'unexpectedly and the radically distinct' closely mirrors Corning's third attribute of complexity where 'the parts produce combined effects (synergies) that are not easily predicted and may often be novel, unexpected, even surprising.'

Emergent novel outcomes occur as processual logics and methods are followed as well as contradicted or undermined. This pattern is necessary so there is sufficient similarity or continuity with past contexts for the novelty to be observed. Goldstein, speaking of the creative act, remarks:

> In other words they mix things up so much so that unpredictable,
> non-deducible and irreducible novelty results through a paradoxical-
> simultaneous continuing and undermining of extant rules, routines, and
> procedures. (Goldstein 2005: 7)

This begins to articulate how practice-led research is an emergent method.
It is worth remembering that research findings are held not only in the art
or creative work alone. The creative work is one research output but crea-
tive research itself is something that works with the creative component to
establish something other, some critical or technological finding for example.
So while there are emergent outcomes within creative practice, it is when this
potent and somewhat unruly discipline is co-joined with research that creative
practice-led research becomes truly emergent in its outcomes. What was a cre-
ative work becomes part of some other order of understanding that is research.
The research is also changed by this interaction. Research outcomes have to
be thought of differently given that the 'findings' are an amalgam of contrast-
ing documentation and media forms. This begins to shift what we consider
knowledge to actually be and has epistemological implications for each study
and the field. Affect is now actively brought into the equation and with it the
indeterminacy of interpretation.

Practice-led research, particularly for the creative practice-led researcher,
is unruly, ambiguous and marked by extremes of interpretive anxiety for the
reflexive researcher. It is this way *because* it is deeply emergent in nature and
the need to tolerate the ambiguity and make it sensible through heightened
reflexivity is a part of what it is to be a successful practice-led researcher in the
creative arts.

RESEARCH TRAINING TO MANAGE EMERGENCE THROUGH REFLEXIVITY

The above discussion shapes the contours of the uncertain and ambiguous
landscape within which practice-led research takes place and so any discussion
of what is required to become a practice-led researcher, especially a higher
research degree candidate, must be framed by the six conditions discussed
above and the centrality of emergence and reflexivity. In learning to become
expert in this emergent research method, practice-led researchers must
manage a considerable range of challenges which infrequently trouble tradi-
tional researchers. And this is necessarily so, for while traditional methods are
designed to manage and contain complexity by seeking to control, limit and
even deny ambiguity, practice-led researchers must take these qualities into
the heart of their research enterprise. Such methodological difference means

that the fundamental principles for effective research training for practice-led researchers must be quite different from the training regimes used to induct researchers into the well established and understood methods of qualitative and quantitative research. This concluding section will consider how research training for practice-led researchers may be best undertaken by drawing on our experiences moderating an online module designed to teach practice-led research to higher research degree students.

Teaching practice-led research online has proved a surprisingly good way of working with students and their research. This example has been designed by the Australian Technology Network of Universities and is a module of instruction in practice-led research with an integrated and coherent set of tasks, references and explanations. Studied over five weeks, the heart of the course is an online forum which allows individuals to personally process the implications of this research strategy for their work. Shifts in understanding can be significant especially when students refer back, at times of their choosing, to all their earlier discussions which are available for review. Not surprisingly this module builds a critical and supportive community to tease out subtleties of understanding and how practice-led research serves their research and their practice. One of the authors was the online group moderator when this module ran in April 2008. Eight research degree candidates participated and we have included comments made by them to illustrate their practice-led journeys and suggest what may be the implications for others.

The candidates for this online module were all experienced practitioners whose track record indicated they had the capacity to undertake research at the doctoral level. To gain entry to the programme candidates were required to hold an Honours degree which involved a practice-led research project, or could demonstrate Honours equivalence with a substantial creative practice sustained over a number of years.

This discussion on research training begins with a discussion of the candidates' experience of emergence and complexity.

Experiencing emergence and complexity: '*In the swamp* . . .'

Two quotes from the online forum best describe the struggle with emergence that most typifies this group of research students:

> I think one of the most difficult things is to hang in there in 'the swamp' long enough and not to try and 'sort it all out' too early . . . so there's this balance between revealing knowledge (feeling like you have achieved something tangible) but also unknowing (being prepared to sit in a zone of uncertainty where all the knowledge actually operates) . . .

> For me, practice-led research is researching the indeterminate and
> it is often not a comfortable position to put oneself in . . . but for the
> reflective practitioner very rewarding (eventually!) . . . (hopefully!)

'In the swamp' . . . 'hopefully' . . . 'eventually' – these phrases point to the
feelings generated around this ongoing state of emergence, anxieties which
quickly surface as practitioners wade into and struggle with the six condi-
tions of practice-led research. For practice can only lead research when the
researcher is genuinely immersed in and attentive to the possibilities generated
through creative practice. While the option of the objective, arm's-length only
stance is not available to practice-led researchers, they do need to find a similar
stance from whence they can view their whole research enterprise. This can be
difficult, for once they are fully imbricated in the work they are likely to strug-
gle to find a place from which they can reflect upon and view the work they are
creating, analyse the dynamics of their practice, be alert to the larger patterns
emerging in the work, engage in theory building and claim significance for the
work.

This struggle with complexity and emergence, which can be back-breaking
enough, happens within a research environment which is often defensive,
sceptical or downright dismissive of practice-led research. As another two
candidates commented in the online forum:

> It's going to be difficult. Various people in the academy have stressed
> the need for my thesis to have rigour and display scholarship. I know
> this is required, but I think they mention this often because some of
> my methods or writing don't fit their view of what represents scholarly
> work.

> When I started my research, hurdles were articulated in academic terms
> – lit review/contextual review and format (this is what an exegesis
> looks like) – we . . . were told the creative work informed the exegesis
> and must be included . . . but, for me, the creative elements remained
> strangely apart from the academic.

Practice-led research is a recent arrival on the research landscape and there
are those, including national research funding bodies obsessed with specifiable
problems and measurable outcomes, who have not accorded it full legitimacy
as a research strategy. All of this heightens anxieties further, and points to the
need for individuals to seek out and join communities of practice-led scholars
and researchers able to support and interrogate a range of innovative research
projects of varying scope and scale.

Given this current situation it is rare to find coherent and systematic

research training programmes for practice-led researchers. One creative writer offers this starting point:

> As a writer my process/practice has always been messy; three parts hunch to one part science. I see no reason why it need change through the research degree experience. I am very taken by the ideas I have been encountering of bricolage, and of a 'scavenger methodology' (Halberstam). These sit comfortably with my creative practice in the past, which has drawn variously upon tacit knowledge, upon collaboration, upon a practical methodology of doing (writing), upon trial and error.

This points to what needs to lie at the heart of research training regimes for practice-led researchers. It acknowledges the alignment of techniques of professional practice with the methods of the practice-led researcher but also claims the importance of tacit knowledge to the process of inquiry and review. Recognising and respecting the tacit knowledge of the advanced practitioner, who in Michael Polanyi's words 'know more than they can tell' (Polanyi 1967: 4), needs to be central to any effective research training approach for practice-led researchers. Consequently it is not enough for such a programme to deal with the explicit skills required to be a practice-led researcher such as knowing how to gather data through interviewing, using endnotes, having advanced retrieval skills and so on. Additionally the practice-led candidate needs to cultivate and render explicit the tacit knowledges which are being deepened throughout the research degree. How research training identifies and deepens not only the 'how tos' but the 'know-hows' of the practice-led researcher is crucial and in this supervisors play a key role.

Supervising practice-led research: 'a variety of definitions and positions on this subject . . .'

> In my experience, supervisors have a variety of definitions and positions on this subject [practice-led research], usually reflecting their own experience as either practitioner or academic and the weighting they give to either.
>
> However, the challenging part is that the sort of things I will be bringing together (ranging from virtual reality to ethics to social-anthropology to political science) is what is making everyone cringe, but the fact is that the nature of the problem demands this breadth . . .

Because practice-led researchers place their own practice at the heart of their research methodology, some of the most unsettling and recurring questions during candidature arise around the significance of the work they are creating.

Most candidates need reassurance from their supervisors that the work they are producing has a significance and doctoral weight to it. They need this reassurance because initially there is no obvious external view available to the candidate of this significance. To help establish this view the supervisor must be active in the cultivation of reflexivity in the candidate. But how can supervisors supervise for reflexivity?

This question is a challenge for both candidates and supervisors and will be discussed across three topics: language reformulation, the significance of the research findings and finally the examination submission.

Supervising Language Reformulation

Research training needs to prepare each student for the complex task of transforming the familiar language and methods he or she has as a professional practitioner and repurposing them to suit the language and protocols of research.

> My aim is to familiarise myself with the jargon. I don't feel too impoverished conceptually but have a long way to go in terms of understanding and conversing in the right jargon.
>
> The truth is, I am still struggling with the major concepts and the language of practice-led research, as well as frantically trying to read around and catch up on years and years of critical and cultural . . . Trying to catch up on all these ideas is a very slow process . . . So, as yet, I don't believe I as yet have a clear sense of precursor sources for my work, nor any sense of how they have impacted on my research practice etc. etc.

Because many of the repurposed methods of the practitioner involve visual material and multimedia forms of documentation, practice-led researchers need training in how to gather, organise and read what they must now understand as research data. The training necessary for this shift in perception is a cultivation of reflexivity, and the supervisor needs to assist the candidate to become familiar and comfortable with processes of repurposing and translating language to build shared vocabularies. This will help to develop a mode of triangulation between the practice, the professional and critical contexts framing that practice and the research culture as a whole.

Supervising for Significance

In the final work it is often a case of learning how to read or to recognise what is significant. To read this significance it is necessary to identify patterns and

invariances in the practice and to locate the work in its broader field, identifying where it exists in relation to other works, other genres and periods. The supervisor's relative detachment from the research practice is vital in helping define, with the candidate, a critical space from which the candidate can view his or her own work. What is unique to supervisors of practice-led researchers is the degree to which this is necessary. Candidates are usually so immersed in the emerging flux of research and practice that this reflexive detachment is at times wrenchingly difficult to establish. Questioning is the key to deepening reflexivity and it will be the supervisor who needs to ask the right questions at the right time. The following examples stimulate the reflexive habit of mind, propelling particular moments of practice into larger 'whole-making' apprehensions.

1. Where are the gaps between your preferred practice and the practice of the moment?
2. What will you retain in your current practice?
3. How did you manage the unanticipated and how will you prepare for the unexpected next time?
4. Can you identify signs of practice and behaviour in yourself and others which could potentially jeopardise the project?
5. Who are you asking for feedback and what forms of feedback are you inviting?
6. What is guiding the way you receive, process and act on feedback?
7. What connections can be drawn between causes with effects?
8. What guidelines or larger principles can be drawn out of particular instances of practice?

Fixing coherent and critically reflexive positions is hard won and the final claiming of significance for the findings can paradoxically feel at odds with the dynamic flow of the research as a whole:

> . . . the further I have gotten into it the more I have wanted all of the
> parts – the hermeneutical research, the recordings, the actual weaving,
> my reflective journal – to somehow speak for themselves and sit
> together causing whatever frictions or connections that may occur.

Supervising the Examination Submission

One significant departure from traditional research lies in the examination requirements which accompany a practice-led research degree. For most researchers, once they have undertaken their data collection (such as their experiments, their interviews) they then face the challenge of representing their findings in text. However, for the practice-led researcher a double move

of representation is required. Firstly the work itself needs to be presented and submitted for examination, for it is in the work that particular knowledge claims can be demonstrated and understood. In addition to the cultural artefact it is also necessary for the practice-led researcher to then frame and elaborate upon this creative work in a textual submission – an exegesis. An exegesis is required by most research degree regulations and its worth, purpose and function is often highly contested. As one candidate in the online forum wrote:

> Most reservations and questions I have concern exegetical form, exegetical voice. I still like the idea of bringing the same playfulness applied in my practice to the process of writing the exegesis.

For all these arguments, the exegesis has a unique role to play in managing emergence and indeterminacy. Around each creative work there is a wide field of possible interpretive contexts and it is in the exegesis that some of these can be delimited. This delimiting act, which is seldom comfortably arrived at, is the gesture which enables the candidate to make a discursive claim for the significance of his or her study.

A submission for examination is most commonly made up of three components: the creative work itself, an exegesis and supporting documentation. Just how these components relate to one another is still moot. A consequence of this ambiguity is how then one can best demonstrate the significance of doctoral findings for the examination process. This is a crucial area that supervisors need to negotiate with candidates. For example, can poor creative work be compensated for by a good exegesis or should the creative work be able to 'speak for itself' while allowing the exegesis to continue the conversation. These issues and questions require open dialogic frameworks, within which answers can be hammered out that are specific to the research in question.

> The exegesis for me is crucial: it has forced me to consider who i am in my work: what are the invisible discourses that i bring to the work; what is my relationship to power; what is my relationship to truth; what is relationship to others; what is the space between performers and how important is it.

This quotation points to the need for a pervasive reflexive orientation in the supervisor/candidate relationship. Each study and relationship is unique because the professional and critical habits marking that practice establish particular and sometimes idiosyncratic connections with research. Notwithstanding the particularity of each practice-led higher degree, however, each needs to clearly set out the criteria it is attempting to meet and how they fulfil the generic doctoral criteria examiners have in mind as they approach the submission.

CONCLUSION

Until now we have found that practice-led candidates engaged in higher research degree studies have tended to work solo, as single researchers addressing an issue driven from personal motivations. Although the supervisory relationship has been predicated on this dynamic it is clear that collaboration between candidate and supervisor is pivotal to effective research training for practice-led researchers. This points to a larger future. Post-graduation it will likely be the case that practice-led researchers will work in teams with collaborators possessing different methodological strengths and it will be the supervisor/candidate relationship and its reflexive honesty that will prepare practice-led researchers for this larger contribution to our research and innovation industries.

One candidate sensed this likely future:

> I am also interested in the effect of art in a wider social context and ways of producing art that is not insular within the artist and the arts world and practice-led research seems to be a way to push this.

If this happens then the potential of practice-led research will be far-reaching, for it will have applications beyond the creative arts, design and related creative disciplines such as fashion and media. In fact this research strategy, which has been developed and made rigorous by our artists and creative practitioners, could be adopted as a potent research methodology in interdisciplinary fields as diverse as online education, virtual heritage, creative retail, cultural tourism and business-to-consumer interaction. In a very real sense the time for practice-led research is yet to come, for this approach which takes complexity and emergence into its core operation will be a required presence in every team of researchers seeking to address the significant problems which confront us – serious problems from national security to climate change and sustainability. When such a take up of practice-led research occurs it will escape its origins in art making and creative practice by enabling the professional practitioner/researcher from any field to contribute alongside researchers using established and evolving methods. How successfully practice-led researchers contribute in such teams will depend on whether they have the know-how to manage the complexity and emergence which permeates the shifting landscape of contemporary research.

REFERENCES

Corning, P. A. (1998), *Complexity is Just a Word!* (cited 19 September 2008), available at: http://www.coniplexsystems.org/comnientaries/jan98.html.

Corning, P. A. (2002), 'The re-emergence of "emergence": a venerable concept in search of a theory', *Complexity*, 7 (6), 18–30.

Culler, J. (1992), 'In defence of overinterpretation', in U. Eco, R. Rorty, J. Culler and C. Brooke-Rose, *Interpretation and Overinterpretation*, ed. S. Collini, Cambridge: Cambridge University Press.

Denzin, N. K. and Y. S. Lincoln (2005), *The Sage Handbook of Qualitative Research*, Thousand Oaks, CA: Sage.

Deutscher, M. (1983), *Subjecting and Objecting: An Essay in Objectivity*, Oxford: Blackwell.

George, D. (1989), 'On ambiguity: towards a post-modern performance theory', *Theatre Research International*, 14 (1), 71.

Goldstein, J. (2005), 'Emergence, creativity, and the logic of following and negating', *Innovation Journal: The Public Sector Innovation Journal*, 10 (3), article 31.

Gray, C. (1996), *Inquiry through Practice: Developing Appropriate Research Strategies* (cited 18 March 2003), available at: http://www2.rgu.ac.uk/criad/cgpapers/ngnm/ngnm.htm.

Law, J. (2004), *After Method: Mess in Social Science Research*, London: Routledge.

Mihata, K. (1997), 'The persistence of "emergence"', in R. A. Eve, S. Horsfall and M. E. Lee (eds), *Chaos, Complexity and Sociology: Myths, Models and Theories*, Thousand Oaks, CA: Sage, pp. 30–8.

Polanyi, M. (1967), *The Tacit Dimension*, Garden City, NY: Doubleday.

Schatzki, T. R. (2001), 'Introduction: practice theory', in T. R. Schatzki, K. K. Cetina and E. von Savigny (eds), *The Practice Turn in Contemporary Theory*, London: Routledge, pp. 1–13.

Scrivener, S. (2002), *The Art Object Does Not Embody a Form of Knowledge* (cited 15 June 2008), available from: http://www.herts.ac.uk/artdes1/research/papers/wpades/vol2/scrivenerfull.html.

Stacey, R. (1996), *Complexity and Creativity in Organizations*, San Francisco: Berrett-Koehler.

Steier, F. (1991), 'Introduction: research as self-reflexivity, self-reflexivity as social process', in F. Steier (ed.), *Research and Reflexivity*, Newbury Park, CA: Sage, pp. 1–11.

Sullivan, G. (2006a), 'Research acts in art practice', *Studies in Art Education*, 48 (1), 19–35.

Sullivan, G. (2006b), *Artefacts as Evidence within Changing Contexts* (cited 7 October 2008), available at: http://www.herts.ac.uk/artdes/research/papers/wpades/vol4/gsfull.html.

Asking Questions of Art: Higher Education, Research and Creative Practice

Judith Mottram

The will to be creative through visual or other means has been evident throughout history and explained by many theoretical frameworks. Such activities have always been part of the landscape of learning but how the creative arts currently sits within university institutions does bear some scrutiny. This chapter will contribute to that enterprise, focusing on the fine arts within the context of the United Kingdom. While working within this scope, it is envisaged that some arguments and inferences will have applicability beyond the UK and for other creative practices.

This chapter will not attempt to review creative practice across the educational curriculum, but assumes it is a part of elementary and secondary education in most countries, and of the higher education landscape. The context of the fine arts is seen as primarily cultural rather than industrial. The following discussion will focus on the period from the mid-1980s to the current day. This period has, in the UK, seen art and design schools assimilated into the university sector and significant growth in student numbers. Doctorates have become more common and constructs such as 'practice-based' or 'practice-led research' have emerged. The impact of cultural activities upon city regeneration has been recognised and new values accorded to the 'creative industries.'

The key focus will be upon research within the field of creative practice in the fine arts. The 'careful search' implied by the word 'research' is seen to imply asking questions of art. 'Research' implies investigating what art is, how it arises or what it does. The intention is to contribute to the understanding of research in relation to creative art practice in the university context. We need to ask questions of creative practice, research and higher education because research practice is still a fairly new phenomenon within the art field and there is some confusion about values, models and methods. This chapter proposes the use of generic research tools to explore our own field. Instead of constraining ourselves to only using creative practice as a means to investigate our field,

it is suggested that we open our perspective up to accommodate research practices, historical practices and possibly even statistical, experimental or philosophical practices as a means to understand or add knowledge to the field of creative practice.

The ongoing discussion about the nature of research practice in the art and design fields is evidenced in conferences, journals and online discussion. The June 2006 online workshop held as part of the UK Arts and Humanities Research Council (AHRC) Review of Practice-led Research in Art, Design and Architecture (Rust et al. 2007) explored the relevance of practice-led research to the professions and society, the development and impact of the PhD, and themes and characteristics of practice-led research, with an underlying theme of 'Being an Academic'. The online workshop reached no consensus on a definition of 'practice-led' research, but the review understood it as 'Research in which the professional and/or creative practices of art, design or architecture play an instrumental part in an inquiry' (Rust et al. 2007: 11). This interpretation was seen as applicable to most research fields, and it was considered that the 'labelling function may become redundant' (2007: 10) as the field develops. The Review noted the debate had matured from the La Clusaz conference on Doctoral Education in Design (Durling and Friedman 2000), although the proportion of inexperienced participants was still noticeable. However, the arguments in 2006 were 'better rehearsed' and there was evidence of ability and willingness to reflect carefully on past experience. Participants with recent doctorates contributed strong and relevant perspectives and provided role models of how new academics engage with their role and responsibilities. The need for professionals and teachers in the creative arts and design to find an approach to research that maintains their identity as creative practitioners was highlighted. However, while the centrality of practice is clearly important for individuals, its utility as a basis for developing a research agenda within the university context was still under question.

Some of the confusion about research and art practice stems from the high value accorded to creative drives and outputs, and the perception that they are also inexplicable. Livingston noted how the notion 'analysis leads to paralysis' was commonplace (Livingston 1989: 13), and Boden described this as a mistaken belief that creativity should not be 'sullied by the reductionist tentacles of scientific explanation' (Boden 1990: 14). The basis of creativity has been modelled in several disciplinary fields, including artificial intelligence (for example, by Boden) and cognitive psychology, by Sternberg and others (Sternberg 1999). A characteristic of this work is the proposition that creativity is a normal human attribute, not a special gift. Discussions of the creative city and urban regeneration share this model (Florida 2002; Landry 2006). Creative outcomes are seen to be based on external factors as well as on particular personality traits. Rather than being inexplicable, current models

suggest creativity needs particular conditions: thorough knowledge of a field and thinking at its forefront and boundaries, as part of a stakeholder model of constructed consensus (Csikszentmihalyi 1996), complemented by mastery of its practical tools (Weisberg 2006). Such thinking values creativity and gives scope for developing educational frameworks at all levels. It challenges the view that creative practitioners cannot be made (Sullivan 2005: 16) and provides strong steer for reconceptualising creative practice and research within higher education.

However, despite the clarity of this creativity model of fundamental human attributes combined with a broad knowledge base and practical mastery, I suggest that the seduction of engagement in practice has influenced some conceptual models for research in the fine arts. This 'seduction' is manifested in the value accorded to the trace of the artist's touch and its linkage with biography, fetishising authenticity. I have suggested (Mottram 2007) that this is rooted in an empathetic recognition of the physical effort required to replicate the marks of a visual depiction. This notion of 'feeling through' – the mimetic tendency – is applicable to other creative media, including sound, performance and literary works. The identity of fine artists as creative practitioners is linked to their propensity to generate valued objects or experiences through the actions of their touch. The use of particular sets of tools and materials, and a physical bodily engagement with them, has distinctive characteristics as a mode of being in the world, giving identity and meaning to the maker. These seductive characteristics influence thinking about practice in advanced inquiry, as conceptual models are generated to accommodate valued activities. While these actions characterise the value of the outcomes of creative practice, they do not in themselves constitute an argument that creative practice is a form of research.

The relatively recent inclusion of creative disciplines within higher education does, however, suggest some generic responsibilities beyond initiation into the atelier. If the remit of universities includes knowledge creation and innovation, than all academics share core objectives. The European Union sees its universities as key players in 'the production, transmission, dissemination and use of new knowledge' (EU 2003). While not defining their use of the term 'knowledge', related European legislation and their published summaries indicate a primary focus on knowledge that contributes to technical and scientific advance. This theoretical or practical understanding is closer to Plato's justified true belief in its ability to be taken as evidence to support action by others than the tacit, unspoken knowledge acquired by practice within creative fields. A precondition for academics would appear to be expertise in the existing knowledge base of a disciplinary field, encompassing its domain, strategic and tacit knowledge, and knowledge of tools and methods that might have generic applicability.

The generic framing of expertise that might be expected of academics does not sit easily with the core values currently enshrined in fine art education, at least in the UK. Although previously privileging immersion in the field, the tendency now is to privilege strategic over domain knowledge. Diamond's thesis (2006) on the construction of meaning and value in the visual arts elicited accounts from a range of contemporary artists and other arts professionals holding leading positions within the cultural milieu. She encountered a model where 'Engagement in the field or game is dependent upon adoption of a belief structure.' Her respondents 'disparaged notions of aesthetics, signification and visual intelligence'. Although challenging the role of seduction (her respondents deny material and visual values), her thesis highlights the importance of strong belief systems which, particularly in the value given to engagement in practice, operate as powerful binding agents for the community of academics involved in fine art within universities. In the professional arena the ability to generate novel creative outcomes is an asset that has value within a capitalist market. This sits uneasily with the intentional knowledge transfer responsibility of the educational environment. The bringing together of these belief systems with the generic responsibility for education is the basis of this exploration of definitions and value systems within the field.

Within art and design schools, the focus has not so much been on advancing knowledge as upon generating new objects of attention, with significant value accorded to continuing engagement in creative practice by academics. The value given to the creative practice of teaching staff in arts disciplines in UK universities has reached almost mythical status, although the basis for this reverence is not fully explained. The Arts Council of England's 2006 strategy for higher education notes that artists are 'part of the practitioner-academic communities of practice found in the higher education system', and the QAA 2008 Art and Design Subject Benchmark Statement sees 'practising artists' as making 'valuable contributions as part-time and visiting tutors' who 'facilitate important links to professional and creative practice.' (QAA 2008: 9). There is a happy symmetry to the model applauded by both the national development agency for the arts and the academic community, where about 5,000 graduates each year from UK fine art courses (Higher Education Statistics Agency (HESA) n.d.) have portfolio careers that are theoretically predicated on the availability of part-time work or residencies within the institutions that trained them. Despite moves to professionalise the university workforce, the dominant model in fine art still values engagement in practice over generic academic values.

The increase in doctoral completions is now presenting the possibility of alternative approaches to the role of academics in the fine art field. Although still small (under thirty each year in fine art in 2006, compared to 600 each year in history), the rising numbers of fine art PhDs provide a new opportunity

for conceptualising the nature of the disciplinary academic in the field. The utility of current models for the doctorate will need to be considered without the influence of the seductive or rosy spectacles of practice, recognising that qualifications frameworks, like educational theories of teaching and learning, address broad principles and known models of scholarship and advancement. In the UK we have the Quality Assurance Agency for Higher Education (QAA) and its framework for higher education qualifications. This document asserts that:

> Doctorates are awarded for the creation and interpretation of knowledge, which extends the forefront of a discipline, usually through original research. Holders of doctorates will be able to conceptualise, design and implement projects for the generation of significant new knowledge and/or understanding.

The focus is upon creation and interpretation of knowledge, and the methods by which this might be achieved. As the highest educational qualification available, this model reinforces the idea of knowledge creation and innovation seen in the EU aspirations. If we take a definition of knowledge that encompasses domain, strategic and tacit knowledge as constituent of expertise within a field, doctoral gatekeepers have a clear script of their responsibilities in relation to the supervision and examination of students.

Rather than work with Sullivan's critical question of whether fine art practice could 'be accepted as a form of research' for artists who work in art schools within universities (Sullivan 2005: 83), we could consider again the generic intentions of universities as places of learning and custodians of intellectual capital. Although we have had a model where artists operated across the professional and educational realm, this might not be the most appropriate basis for moving forward. If we explore the idea of the university subject field as having a role in the 'production, transmission, dissemination and use of new knowledge' (EU 2003), we could model the objective of creative practice departments in higher education institutions more firmly as a responsibility for looking after and cultivating disciplinary knowledge.

Before reviewing the new doctoral activity in fine art, it is relevant to revisit the landscape in which such practice has grown. The mid–late 1980s saw design hailed as the possible saviour for UK manufacturing and trade. Interest in how design adds value to commodities contributed to the modelling of 'the creative industries'. Building upon the theorisation of design research at the Royal College of Art in the 1970s (Archer 1979), doctoral activity began to emerge across all art and design disciplines, encouraged by the Council for National Academic Awards (CNAA). The logic employed by John Langrish at Manchester Polytechnic to argue for funding my doctorate in fine art in

1984 was that, as fine art influenced design and design was going to revive the economy, then there might be economic benefits to be gained by supporting a PhD in fine art (Langrish 1984).

The CNAA hosted a series of conferences exploring research in art and design, culminating in the 1988 event 'The Matrix of Research in Art and Design Education'. The published papers (Bougourd et al. 1989) evidence some sensitive considerations of how to develop research within the field, with consensus that the field should focus on what was special and distinctive about our disciplines. Livingston noted that the emphasis on practice meant the 'academic community has chosen to ignore its obligation to pursue and answer fundamental questions about the production of artefacts and how visual information is transmitted and received', and that this should not be left to people from other disciplines looking in at the field. The publication included the CNAA's Awards Committee for Art and Design statement of May 1989 on research and related activities in art and design. This important document in the history of art and design research activity in the UK might be the source of some of the misconceptions and confusion in the field.

The purpose of the 1989 CNAA paper was to reaffirm the 1984 policy statement on research and related activities and offer guidance on implementation. Research and related activities referred to all activities which might 'infuse teaching with a sense of critical enquiry'. The categories listed in 1984 and 1989 include 'academic research, applied research, consultancy, professional practice, scholarship, creative work and research into curriculum and pedagogy'. Applied, interdisciplinary and collaborative activities are also mentioned, and those which respond to industrial and community needs. The Awards Committee statement notes the Matrix conference's identification of issues for emerging research activity in art and design: confusion about 'the distinction between academic research and research which forms part of design activity', and the perception that creative work was 'not accepted in its own terms as legitimate "scholarly" activity'.

The committee was comfortable that practical work in art and design was encompassed by 'research and related activities', but they considered that only 'academic research' was eligible for a research degree, notwithstanding that a submission could be accompanied by material other than in written form. Academic research was regarded as referring specifically to 'research directed to the discovery of some fact or facts or to a new understanding of some aspect of existing knowledge'. This definition closely reflects the generic criteria used in most universities today as well as the current UK national framework description (QAA 2001). The CNAA added clearly: 'This is not the same as professional practice.' They went on to comment that research degrees were not designed to reward 'expressions of aesthetic value, social worth or cultural significance of particular achievements', and that as with other disciplinary

fields, professional achievement was properly acknowledged by peer recognition or a professional qualification, not by a research degree.

At this point in the late 1980s, the papers from the 1988 Matrix conference (Bougourd et al. 1989) suggest a climate of modelling new ways to engage with the field, exploring methods and looking at the potential to impact upon the professional arena. While the CNAA statement suggested that exhibitions and designs in production should be accepted as 'equal to traditional research outcomes in the contribution which they make to the academic life of an institution', it also noted the need to encourage a range of these newer activities.

By 1992, the art and design institutions were assimilated into the university system and staff engagement in research and scholarly activities was included in the Research Assessment Exercise carried out that year (RAE). Brown et al. (2004) assert that the outputs submitted by art and design departments were 'to some extent the result of *applied research* that had been undertaken within professional and industrial contexts'. They note this activity had not previously 'been understood or articulated within an appropriate typology that located it within the academy alongside other forms of knowledge.' The sorts of outputs submitted had previously been 'described mostly as "professional practice"'. They then suggest that this professional practice had been 'imprecisely expressed as research practised within the academy'.

After 1992 the research field gets more difficult to navigate, although some clear pointers emerge. The hopeful engagement in new forms of inquiry in art and design were explored by Christopher Frayling. His modelling of research in art and design (Frayling 1993) adapted Herbert Read's model of teaching for, through and into a discipline to research. According to Frayling, *research for practice* was the sort of activities that support the studio work of artists. It might incorporate the collection of material as stimuli, such as Picasso gathering material for *Les demoiselles d'Avignon*. This model equates to the compilation of the undergraduate studio 'research folder': the place to gather notes and pictures to stimulate studio work. The notion of *research through practice* is seen to encompass the iterative process of making a working prototype, testing and amending. This sort of activity feels closest to notions such as 'practice-led research' or to 'applied research', and is congruent with a simple form of experiment. Brown et al. noted how 'practice-led' (a methodological approach) has been conflated with 'applied research' (a type of knowledge) and reminds us of the need for better definition and articulation. The third type of research articulated by Frayling was *research into practice*, which might include observations of artists at work. As with research for practice, the key for studies into practice was the way in which they engage with more than the collection of information: organisation, evaluation and interpretation of material are the key differentiators of activities in the academic domain, as opposed to the expediency of stimulus for professional practice. Frayling's model has been

recognised as a useful schema for a range of activity (Archer 1995; Rust et al. 2000), but as with many propositional models generated to theorise a field, it has to date not been used systematically as an actual analytical tool itself.

Alongside modelling the nature of research in art and design and the first significant investment through institutional funding, the first conceptualisations of 'practice-led' research appear in doctoral studies (Pengelly 1996) and research papers (Rust 1998). In some institutional documents these terms appear to suggest that all inquiries in the relevant field are necessarily 'practice-based' or 'practice-led', an understanding which did not necessarily reflect already completed work. The UK's Council for Graduate Education (UKCGE) report on 'Practice-based Doctorates in the Creative and Performing Arts and Design' asserts that all 'practice-based' PhDs in art and design will necessarily include a 'creative, recordable outcome' as an integral part of the research outcome (Frayling 1997: 10). The optimism of the creative arts academics in the late-CNAA period about engaging as equals within a generic framework of advanced academic activity seemed to become subsumed into propositions based on the special case of the creative arts. While the late 1980s had seen discussion drawing upon evidence of completed work, such modelling on the basis of past examples becomes less evident in the 1990s. At this point, PhDs of the type suggested by the UKCGE report were only beginning to emerge.

By 2001, the spread of activity in the field was illustrated by the research outputs returned by art and design to the 2001 Research Assessment Exercise. The outcomes of practical activity (exhibitions, designs, patents, compositions, performances or artefacts) comprised the majority of returns. There was no evidence of a publishing network through journals of record, with only 820 journal papers submitted through 486 different journals. Only six journals published more than ten papers from the UK art and design research community over the previous four years. In fields like engineering or built environment disciplines, the proportion of practical activity submitted was less than three per cent of those total submissions, with journal papers accounting for 93 per cent of the engineering output and 60 per cent of that from the built environment field (RAE).

During the same period, from 1996 to the end of 2000, 284 art and design doctorates were awarded in the UK according to the records of the Art & Design Index to Theses (ADIT). Table 12.1 shows the gentle but steady growth in art and design doctoral numbers over the period 1986–2005 and the number of these focusing on fine art. Growth was not proportional to the general rise in study at lower levels and outstripped that of other university subjects (Mottram et al. 2008).

The abstracts of doctoral theses are considered to constitute a coherent dataset for investigation of the characteristics of emerging research agendas in the field and the ADIT database was constructed to facilitate such an inquiry.

Table 12.1 Art and design PhDs awarded in UK universities, 1986–2005, as classified in the Art & Design Index to Theses

	1986	1987	1988	1989	1990	1991	1992	1993	1994	1995	1996	1997	1998	1999	2000	2001	2002	2003	2004	2005
Art & design	18	15	17	14	19	19	30	22	34	27	42	47	61	59	75	55	71	66	44	66
Fine art	3	2	7	2	5	5	10	6	10	5	9	15	25	19	29	25	26	28	21	30

Table 12.2 Examples of different types of fine art PhD, prior to 1986

Anthropological and historical	Kasfir (1979), Pal (1966), Wilkinson (1975), Zarringhalam (1979)
Educational	Sleigh (1975), Andrews (1983), Davis (1980), Dunning (1983), Swift (1984)
Process	Goodwin (1982), Ironside (1980), Stonyer (1978), Willats (1982)

Analytical work drawing from this resource is ongoing, but the interim findings on the development of doctoral research in the fine art field are explored here. The criteria for inclusion in ADIT were theses where art or design practice was a component or object of doctoral investigation. It excluded technical studies of materials, historical studies, museology, consumer studies or philosophical studies not investigating contemporary creative practice. Theses were included if the title or abstract (if available) made it apparent that the study came from within the art and design field rather than inquiry from outside looking inwards. Additional subject classifications used the Joint Academic Classification System (JACS) to code records by sub-field (Fisher and Mottram 2006). A fundamental premise of the database was that abstracts would have been produced in accordance with research degree regulations, which usually specify a text of approximately 300 words comprising a synopsis of the thesis stating the nature or scope of work undertaken and the contribution made to knowledge or understanding in the subject field.

The ADIT database currently includes 1,015 PhD and DPhil records dating from 1955 to 2007. Prior to 1984, few records include abstracts, and subject classifications were made on the basis of the title alone. The records of theses referred to in the following tables are all available via the online ADIT database. The records from 1986 to 2005 have been subject to additional coding by this author to ascertain the utility of Frayling's model of research into, through or for practice. Fine art theses account for 331 records, or one-third.

The dominant approaches evidenced through the abstracts fall into seven categories: studies exploring art or artists from a historical, anthropological, theoretical, professional or educational perspective, or those investigating the processes or media of artistic production. The abstracts indicated research into practice and research through practice. The extent to which it is possible to track the emergence of creative practice as a central part of the research process was also considered.

The awards completed before 1986 generally focused on an object of study that is outside of and external to the author. There is evidence of work on other cultures or other artists and upon pedagogic topics relating to the training of artists or, more commonly, upon childhood learning about art (Table 12.2). Studies focusing on the processes of art making from the perspective of the

Table 12.3 The first examples of research through practice for PhD

1988	Pepper
1992	Douglas, Watson
1993	Leake
1994	Bennett, Mathee
1995	Akyuz

practitioner also emerged prior to 1986, primarily in the art and design departments of the polytechnics.

In the period from 1986, the role of practice within doctoral research begins to be more evident. From reviewing the abstracts against Frayling's model of research *for*, *through* or *into* practice, the dominant model appears to be for investigations that can be described as research *into* an aspect of the field. The first record that suggests a research approach *through* practice appears in 1988, with another six following in the period up to the end of 1995, providing a slender basis for the UKCGE Working Group's propositions (Table 12.3). Pepper's work on holography is couched in terms of carrying out experiments in the manner of a scientific inquiry, and visual records of creative practice form a central part of Douglas's 'Structure and Improvisation: The Making Aspect of Sculpture', taking on a more reflective stance than Pepper.

What is noteworthy about these early projects *through* practice is the indication that forms of experiment – literally a testing of whether something works against a perceived and stated objective, but with some understanding of scientific models – provided the dominant strategy for investigation, and there was a clear concentration on issues of media or process. Pepper makes unambiguous reference to experiments in his investigation of display holography, while Akyuz refers to 'testing several instruments' before producing his 'standard atlas of 2-dimensional pencil marks'. Douglas also makes explicit reference to experiments with materials, noting that she initially drew her methods from materials science. She recorded 'the relationship between different aspects of the material through one and two parameter testing: colour to texture, texture to form' and so on. Testing was also part of the strategy employed by Watson's exploration of chance 'as a stimulus to the creative activity known as sculpture'. This project included the development of a device, an exploration of the use of chance by other artists and a review of models for understanding creativity. Bennett more emphatically focuses on the use of reflection upon practice in what was described as an 'art teacher research report' that 'connects research to painting'. Reflection upon one's own practice is an emerging strand in this set of records.

Many of the other inquiries during the period 1986 to 1995 continued to look at the work of others, rather than at the practices of the researchers themselves, and all apart from those referred to above fit into Frayling's model of research *into* practice. Of these, four fit the model of inquiries into the

Table 12.4 UK fine art PhDs, 1988–2005, where abstracts refer to the researcher's creative practice

1988	Power
1992	Douglas
1996	Pengelly
1998	Hogarth
1999	Ayliffe, Westwood-Davis
2000	Gilson-Ellis, Machado da Silva, Purnell, Curtin, Howey, Hurlstone
2001	Allen, Carroll, Beattie, Gledhill, Dale
2002	Tucker, Clucas, Hegarty, Jiang, Jones, Riley
2003	Calow, Wallis, Chuang, Horton
2004	Fleming, Tatham, Beech, Payen, Kerr, Swindells
2005	Guptabutra, Park, He, O'Beirn, Wright, Chiu, Saorsa, Banfield, Lewin

processes of making art or the media used (Benyon 1994; Dawe 1992; Mottram 1988; Rogers 1986). The remaining fine art PhDs during this period are a combination of more historical (25), anthropological (6) or education-orientated studies (7). These studies tend to come from long-established universities without established studio practice programmes (e.g. the universities of Essex, East Anglia, Exeter and Manchester and London's Courtauld Institute). The dominant model continues to be that provided by art history, with emerging strands of experimental studies through practice and studies into the processes of contemporary practice. The researchers begin to claim their stake in the thesis with the first abstract reference to 'my past work' in 1988. This was followed by Douglas in 1992 – 'my own practice' – and by 1996, Pengelly used the phrase 'practice-led' with reference to the implicit involvement of his own professional practice as a visual artist in his research project.

In the period from 1996 to 2005, the rate at which fine art abstracts specifically mention the incorporation of the researcher's own practice increases. From 1988 to 1999, only six abstracts of fine art PhDs refer explicitly to this. From 2000 onwards, five or six thesis abstracts each year include specific references to researcher practice (Table 12.4). There is an increase in projects about the processes of art making. These account for 30 per cent of the 227 fine art theses completed between 1996 and 2005, compared to just 14 per cent from 1986 to 1995. Theses taking a historicist perspective on the work of others peak at just over 50 per cent of the twenty-five fine art doctorates awarded in 2001, reflecting the proportion following that approach in the earlier period. Since 2003 this approach has declined significantly.

The recent period has seen more projects engaging with theoretical and philosophical models, as in Park Chun's journey 'through melancholia, feminine difference and Paul Cézanne' (1999), or Crawford's 'Figuring Death: The Phantom of Presence in Art' (2002). This PhD claims to analyse 'Hegel's master/slave dialectic and de Man's notion of "prosopoeia"', to 'demonstrate

how modernist discourses construct a figure [face] of/for the artist and cover up [entomb] the recalcitrance of his or her corporeal body to be the [onto-logical] site of meaning.' Projects focusing emphatically on the 'other' include those that can loosely be described as having an anthropological focus – with examples of projects on Irish, Senegalese, Korean and Aboriginal artists (Chan 2002; Dalgleish 2000; Harney 1996; Shin 2004).

Investigations of process continue to provide a counterpoint to the histori-cal studies, bringing inquiry closer to the subject as practised in the contem-porary world. Among the sixty-seven abstracts indicating an investigation of the processes of making or of apprehending contemporary art practice, the influence of models of thinking from other subjects is strong, such as in Hand's consideration of the 'material and temporal conjuring' of artworks through psychoanalysis and aesthetics (1998). At times abstracts indicate that projects focusing on process can be largely descriptive, indicating replicable inquiries. Hogarth's account of practice through a case study method (1998) is a clear example of this. There are also examples of theses which are written to accompany studio work (Meynell 1999). It is not always clear from scrutiny of the abstract whether the contribution to knowledge is enshrined within the artworks or within the thesis. Seventeen of the project abstracts that focus on process appear to be undertaking this through art practice (Table 12.5). There is some indication that the methods employed do extend to include experi-ments or other analytical methods. Roles noted that 'Experiments explored the practical application of methods and materials which would allow for the inte-gration of the two-dimensional photographic image with three-dimensional sculptural form', and Saorsa combined a linguistic categorisation of drawing marks to explore the extent to which the medium itself could carry knowledge of its subject. In general, the abstracts of these theses tend to indicate a fairly strong emphasis on expository argumentation.

The use of specific media and specific practices have also been addressed (Pengelly 1996; Allen 2001; Corby 2001; Turner 2001; Poyall 2003). Pengelly's abstract claims the study is practice-led, although the inclusion of 'question-naire, quantitative tests of materials, participation in, and initiation of collabo-rative case studies, documenting practice and visual development of printed art works, and exhibition for peer review' indicates what could be called a multi-method approach. It is arguable that the idea of 'practice-led' research could be applied to many other disciplines, with any applied research fitting the criteria. Despite this small issue of nomenclature, the theses in this group include a number of straightforward studies that are generally characterised by their usefulness to day-to-day professional practice within the field.

It is clear that not all of the work being undertaken as a part of study towards doctoral qualifications within the fine art field incorporates the practice of the researcher. While in 2005, 30 per cent of the thirty abstracts state the project

Table 12.5 UK fine art PhDs, 1996–2005, approaching process through practice

1996	Hanrahan
1997	Roles
1998	O'Riley
1999	Lyons
2000	Francis, Machado da Silva, Purnell
2001	Dale, Gledhill
2002	Hegarty, Riley, Staff
2003	Horton
2004	Fleming, Prosser
2005	Lewin, O'Beirn, Saorsa

includes 'my practice', the proportion of theses with this focus over the twenty years under review has been 16 per cent. It may be argued that this rising pre-occupation with the creative work of the individual undertaking the doctoral research reflects the expectations of the field. However, other explanations might draw upon other influences.

If we look back at the first significant encounter of art and design with university research, through the 1992 RAE, we see differences in the outputs selected to 'best reflect the quality of work of the member of staff' and the full count of all 'publications' and other outputs realised in the assessment period. Table 12.6 shows selected and counted outputs in the different cat-egories for the art and design submission for the 1992 exercise and selected activity reported in 2001, using data drawn from records in the public domain (RAE). Some changes to the category definitions in the 1992 and 2001 records mean comparisons are not exact: the 1992 category for 'painting/sculpture' is taken as equivalent for 'exhibition', and in 2001 institutions used 'artefact' or 'exhibition' categories interchangeably. However, it is possible to make some comparisons by grouping types of output as text-based or as the outcome of practice, notwithstanding that text outputs might report upon practice.

While the total proportion of selected text-based outputs submitted in 1992 and 2001 accounts for between 22 and 29 per cent of the submissions, the pro-portion of all reported activity that is text-based in 1992 was just 12.5 per cent. This indicates that the selectors at institutional level were tending to target text-based work rather than the outcomes of practice to best reflect the quality of contribution to the field. Authored books accounted for 5.50 per cent of selected outputs, but only 1.48 per cent of all activity. Similarly, journal articles (academic and professional) accounted for 5.54 per cent of selected outputs but just 2.59 per cent of all outputs. What should be remembered is that this was the first point at which the majority of the art and design community had been involved in a national exercise to evaluate research activity. What was reported were those practical outcomes of ongoing involvement in the professional art

Table 12.6 Comparison of art and design outputs, 1992 and 2001 UK Research Assessment Exercise

1992 category code and description	1992 selected outputs – % selected	1992 outputs – % reported	2001 category code and description	2001 outputs – % submitted
1 – Authored book	5.50	1.48	A – Authored book	4.97
2 – Edited book	1.12	0.67	B – Edited book	1.62
3 – Short work	5.14	3.38	C – Chapter in book	6.10
4 – Refereed conference	2.37	2.07	E – Conference contribution	7.56
5 – Other conference	2.89	2.36		
7 – Article for academic journal	2.65	0.66	D – Journal article	8.86
8 – Article for professional journal	2.89	1.93		
Sub total text-based outputs	*22.56*	*12.55*		*29.11*
12 – Other form of output	27.76		O – Exhibition	40.54
12e – Engineering design	1.77	1.31	N – Design	10.5
12f – Painting/ sculpture	29.77	49.23	P – Artefact	9.32
12h – Other	12.54	21.81		
Sub-total practice outputs	*71.84*	*72.35*		*60.36*
Total outputs included	94.40	84.9		89.4

and design world that had always been carried out by academic staff in art and design departments. Over 70 per cent of activity reported was the generation of outputs from creative practice. For the RAE exercise in 1992, the selective returns of rather more formal text outputs than those from practice indicate a value-based decision that reflected understanding of generic models of accessible subject knowledge through text-based means of dissemination.

The volume of outputs reported to the 1992 RAE surprised the Higher Education Funding Council, and Brown et al. (2004) reported the potential impact on funding allocations. Even with some adjustment to protect traditional research fields, the post-1992 universities benefited greatly from the relative success of art and design. Although the art and design returns looked very different from those of other subjects, the contribution to funding was a useful boost for the new universities.

Since 1992 there has been a slight shift towards dissemination through

text-based vehicles, particularly journal and conference papers, although the overall ratios still reflect more than twice as many practice outcomes as text publications. When compared to the sorts of PhD that have been completed over the past twenty years, the increasing emphasis on the doctoral researcher's own practice may reflect the enduring value accorded to practice within the subject. Despite generic models of the doctorate, the creative practice of the individual may be a necessary part of study at this level in this field. However, this was not part of the majority of doctorates completed to date.

As with the study of doctoral activity, a clearer indication of disciplinary difference might be revealing. While neither of the RAEs used refined subject definitions, this author has undertaken a field coding for 75 per cent of the 9,242 outputs returned in 2001 by art and design (see Table 12.7). Through closer scrutiny of the outputs returned by different art and design fields, we get a clearer picture of how the fine art and design disciplines disseminate research. Fine art outputs are five times more likely to be disseminated by exhibition (1,907 outputs) than to be reported in text form (419 outputs), while design outputs are more likely to be text-based than take the form of the output of practice (exhibition, artefact or design).

The extent to which the academic community itself is involved as the main stakeholder in refereeing for conference and journal publication is in contrast to the other players involved in determining exhibition programmes, the main output type for fine art. The decision to exhibit work in the Waddington Galleries, Lisson, the Hayward or Documenta has little to do with its research value, although creative novelty may be a factor. Creative work within higher education that enters this world could be seen as an index of public engagement, but the discussion of bibliometrics for the future UK Research Excellence Framework (REF 2008) has not yet tackled this issue. The major difference from other academic subject fields is that the scholarly community in fine art has little or no influence over the gallery world, and that arena has little need to engage with the drivers for the academic endeavour in general. It is arguable that fine art should review whether this different approach to research dissemination continues to be tenable and what it means for the tools and competencies with which future doctorates are equipped. While the tendency to encourage 'practice-based' or 'practice-led' approaches to doctoral activity might fit well with the continuation of dominant value models for the fine art community, it might not sit so well with the wider art and design domain within higher education, or with the academic world more generally.

The continuing encouragement of advanced practice within the academic context could rest upon the contribution made to social and cultural inclusion and regeneration resulting from the opportunities for reflection and increased understanding given by new artworks. However, the determination of impact and return on investment of such benefits has not yet been modelled

Table 12.7 Types of art and design outputs, 2001 UK Research Assessment Exercise

	Exhibitions	Designs	Journal articles	Conference papers	Authored books	Edited books	Chapters in books	Total no. of outputs in sub-field
Textiles/costume/fashion	83	255	50	48	38	6	42	522
Performance/film	60	42	35	17	26	11	40	231
Other	0	4	72	58	53	24	83	294
Interiors/architecture/landscape	11	114	70	46	44	8	57	350
Industrial design/product design	7	195	190	150	21	4	43	610
Graphics/2D/web design	35	258	143	161	76	19	66	758
Fine art	1,907	22	114	52	107	47	99	2348
Ceramics/furniture/silver&jewellery	291	80	51	28	23	3	13	489
Art/design history/curating	51	1	95	40	71	29	122	409
Number coded	2,445	971	820	600	459	151	565	6011

conclusively and an alternative argument for supporting advanced design inquiry might generate a more robust economic rationale for support. There is, however, a possibility that future impact measures could drive the development of mapping and modelling tools that can contribute towards an argument for advanced arts practice also.

What is becoming evident is that the usefulness of stressing 'practice' is being questioned. A recent meeting to discuss the national network of research training provision in design agreed to use the term 'designing as a research method' as opposed to 'practice-based' as a description for the methodological approach, as the participants felt this was a much more truthful and clear description of what was happening (DART n.d.). The meeting concluded that we could replace every use of 'practice-based PhD' with 'doctoral research in a fine art/design/performance' and still understand what was being discussed. If the practical outcomes of a research project are seen as evidence supporting a hypothesis or as manifestations of the contribution to knowledge or understanding, this can be articulated as the inclusion of practice into a method, without over-privileging it as an 'ology'. Any tension between theory and practice should be dissipated if using this approach as the linkage and dependency of the two are clear: the theory can be seen as the framing of the hypothesis, research questions or objectives, and our practical outcomes are the evidence to support or disprove that hypothesis. If there is no hypothesis, question or objectives, the practice is 'normal' practice, not research-led practice.

If the will is to reward advanced practice in fine art, we may need to return to the proposition discussed in the late 1980s and develop a different advanced award. However, the relationship between advanced practice and recognition by the professional field would need careful consideration. Advanced level practical activity as a basis for an advanced qualification would require the assessment of innovation or other modelling of contribution to the field, but the market could be viewed as the essential gatekeeper for assessments of professional level.

The disinclination to engage with writing cannot be the basis for developing a new approach to advanced academic work. Writing lucidly and accurately about practice is essential for advanced contributions to a field within the university arena. It may be necessary to rethink the support needed to develop the capacity of the fine art community in this respect. The role of non-text elements needs to be understood, not taken for granted. It could be an example of evidence, a sample of data or a knowledge-bearing artefact, but the extent to which its reading is ambivalent needs balance. University regulations generally frame the doctoral thesis as an argument made evident through a written text, possibly some objects and a discussion. There may be an element of show and tell, which includes pointing to exemplars of cases or to objects that challenge the known. This viva is articulated through language. The 'textual

component' does not necessarily stand alone although words are central to the argument. Artistic presentations might have a contributory role in a thesis but are unable to speak for themselves – unless we have a talking teapot or the test-tube speaking for itself. We do want a doctorate to be of publishable quality, and this could mean being lucid, readable and coherent. As the standard international indicator of preparedness for teaching a subject at university level, these qualities would seem relevant.

The extent to which current tendencies stem from the interests of players within the community of practice should be treated with caution. There are indications in the PhD abstracts reviewed that the drive to make or engage in doing is dominating methodological development in some institutions, to the detriment of capacity to meet generic criteria for doctoral awards. What may be more crucial now is a return to asking questions about the nature of the discipline, such as suggested by Livingston twenty years ago, but with the benefit of now having a body of literature within the field that enables the evaluation of a range of methodological approaches and the identification of useful topics for attention. The analysis here is a small contribution to that endeavour. The incremental rise in doctoral activity within the UK since the 1960s is taken as a clear indicator that there is both interest and capacity for more advanced inquiry in the fine art field. The extent to which the design field has developed its capacity to utilise a range of methods to address both theoretical and real-world problems indicates capacity within the domain for developing new methods of inquiry. This model for the future may challenge the interests and mythology of the artist-academic, but the responsibility of the modern university for subject knowledge and educational objectives demands that the field comes of age in respect of its engagement with its contemporary context.

What is clearly emerging in the UK context is a desire to move beyond dependency on the use of the prefix 'practice'. Reflection on the achievements of the past twenty years is enabling recognition of the congruence of generic models of research with models that accommodate advanced use of creative practice as an element of research inquiry. During the late-summer round of UK conferences and symposia in 2008 the overwhelming impression was of an academic community moving forwards with a new clarity of understanding. At Bath Spa, the 'Doctoring Practice' symposium (Dahn 2008) heard an account of the development of doctoral degrees at one institution that demonstrated how the creative practice of individuals had very successfully been accommodated within a generic model of the PhD. In the feedback from one of the discussion sessions at the Annual Conference of the Group for Learning in Art & Design (GLAD) on 9 September 2008, the rapporteur indicated agreement on a clear distinction between research and practice in our field. The discussion forum on 'Visual Literacy' at the Design History Society Annual Conference in Falmouth on 5 September 2008 explored the basis and nature of the special

tacit knowledge base of the field, and concluded that we probably still do not know enough about how it works. Although as yet to be enshrined within the permanent records of the art and design academic community, the sense of an energetic and alert community of practice is emerging.

While Frayling's model of research into, through and for practice might have provided a useful way of thinking about what the field has done in the past, the energy now might usefully be applied to thinking about what we could address through future work. While utility models are unfashionably instrumental, reflection on twentieth-century technological development reminds us that challenging demands such as wars or economic free-fall often generate innovative thinking. While the EU, the UK Treasury and the Australian government all try to find ways to ensure they are getting a good return on their investment in research, perhaps the energy of the academic community should be upon the identification of the particular questions they can address, rather than on the personal creative expression of individuals?

The gap seen in the abstracts of doctoral projects scrutinised to date is any evidence of research *for* practice. Frayling has described the objective of such research *for* practice in art as art itself. Within fine art, new art carries with it the potential for stimulating new understanding among its audiences. I see Frayling's research *for* practice as more close to the accumulation of material to provide ongoing stimulus for creativity. I can imagine an artist being interested in geological rock strata, who through exposure to the visual form gets the idea that a dragging technique can be used in their painting as a metaphor for time and natural erosion. This would seem to characterise the type of activity which might fit within Frayling's model and is distinct from a notion of a research-led practice. From thinking about the exposure to the visual forms of natural rock strata, a research-led practice is conceivable if the artist then sets up a collaborative project with a research practitioner working on visual discrimination – together they look at natural forms and painted forms to determine the impact of colour differentiation on 'just noticeable differences' in visual discrimination, which result in the artist pushing their painted works to new levels of finesse. Could that be a research-led practice?

Whatever practical form these activities take, the challenge remains to demonstrate that new understanding is achieved and that this has an impact upon future culture and society.

REFERENCES

Archer, B. (1979), 'Whatever became of design methodology?', *Design Studies*, 1 (1), 17–18.

Archer, B. (1995), 'The nature of research', *Co-Design*, 2, 11.

Art & Design Index to Theses (ADIT) (cited 29 April 2008), available at: http://www.shu.ac.uk/research/c3ri/adit/.

Arts Council England (2006), *Arts, Enterprise and Excellence: Strategy for Higher Education* (cited 29 April 2008), available at: http://www.artscouncil.org.uk/documents/publications/artsenterpriseexcellence_phpTOmNbm.pdf.

Boden, M. (1990), *The Creative Mind: Myths and Mechanisms* (2nd edn published 2004), London: Routledge.

Bougourd, J., S. Evans and T. Gronberg (eds) (1989), *The Matrix of Research in Art and Design Education. Documentation from the Conference on Research in Art and Design Organised by the London Institute and the Council for National Academic Awards 1988*, London: London Institute.

Brown, B., P. Gough and J. Roddis (2004), *Types of Research in the Creative Arts and Design: A Discussion Paper*, Brighton: University of Brighton.

Csikszentmihalyi, M. (1996), *Creativity: Flow and the Psychology of Discovery and Invention*, New York: HarperPerennial; first published by HarperCollins, 1996.

Dahn, J. (2008), 'Doctoring Practice Symposium', 12 September 2008, Bath Spa University, UK (cited 15 September 2008), available at: http://www.doctoringpractice.co.uk/.

Design Advanced Research Training (DART) (cited 14 September 2008), available at: http://www.dartevents.net/.

Diamond, A. (2006), *Terms and Strategies of Engagement: Perspectives on Constructing Meaning and Value in Contemporary Art*, PhD, Nottingham Trent University, UK.

Durling, D. and K. Friedman (eds) (2000), *Doctoral Education in Design: Foundations for the Future*, Stoke-on-Trent: Staffordshire University Press.

EU (2003), *Europa, Summaries of Legislation, Communication from the Commission of 5 February 2003 – The Role of the Universities in the Europe of Knowledge* (COM(2003) 58 final – not published in the Official Journal) (cited 1 June 2008), available at: http://www.europa.eu/scadplus/leg/en/cha/c11067.htm.

Fisher, T. and J. Mottram (2006), 'Researching the research culture in art and design: the Art and Design Index to Theses', paper read at *WONDERGROUND*, Design Research Society International Conference 2006, in K. Friedman, T. Love, E. Corte-Real and C. Rust (eds), *Proceedings* (cited 1 June 2008), available at: http://www.iade.pt/drs2006/wonderground/proceedings/fullpapers/DRS2006_0202.pdf.

Florida, R. (2002), *The Rise of the Creative Class*, New York: Basic Books.

Frayling, C. (1993), 'Research in art and design', *Royal College of Art Research Papers*, 1 (1), 1993/4.

Frayling, C. (ed.) (1997), *Practice-based Doctorates in the Creative and Performing Arts and Design*, Lichfield: UK Council for Graduate Education.

Higher Education Statistics Agency (HESA) (n.d.), *Students and Qualifiers Data Tables* (cited 1 June 2008), available at: http://www.hesa.ac.uk/dox/dataTables/studentsAndQualifiers/download/subject0607.xls.

Joint Academic Classification System (JACS) (n.d.) (cited 1 June 2008), available at: http://www.hesa.ac.uk/jacs/jacs.htm.

Landry, C. (2006), *Lineages of the Creative City* (cited 18 February 2007), available at: http://www.comedia.org.uk/.

Langrish, J. (1984), personal communication.

Livingston, A. (1989), 'Research into the nature of the discipline', in J. Bougourd, S. Evans and T. Gronberg (eds), *The Matrix of Research in Art and Design Education*, London: London Institute, pp. 12–15.

Mottram, J. (2007), 'Marks in space: thinking about drawing', in M. Frascari, J. Hale and B. Starkey (eds), *From Models to Drawings: On Representation in Architecture*, London: Routledge/Taylor & Francis, pp. 193–200.

Mottram, J., D. Buss, N. Barfield et al. (2008), 'The research : creativity nexus', in L. Drew (ed.), *The Student Experience in Art and Design Higher Education: Drivers for Change*, Cambridge: JR Associates, pp. 99–124.

Pengelly, J. R. (1996), *Environmentally Sensitive Printmaking: A Framework for Safe Practice*, PhD, Robert Gordon University.

Quality Assurance Agency for Higher Education (UK) (QAA) (2001), *Quality Assurance Agency and Their Framework for Higher Education Qualifications in England, Wales and Northern Ireland* (cited 29 April 2008), available at: http://www.qaa.ac.uk/academicinfrastructure/FHEQ/EWNI/default.asp.

Quality Assurance Agency for Higher Education (UK) (QAA) (2008), *Subject Benchmark Statement: Art and Design*, (cited 29 April 2008), available at: http://www.qaa.ac.uk/academicinfrastructure/benchmark/statements/ADHA08.pdf.

Research Assessment Exercise (RAE) (2008), *Higher Education & Research Opportunities* (HERO) (cited 6 August 2008), available at: http://www.hero.ac.uk/uk/research/research_quality_and_evaluation/research_assessment_exercise_rae_2001.cfm.

Research Excellence Framework (REF) (2008), *Higher Education & Research Opportunities* (HERO) (cited 14 September 2008), available at: http://www.hero.ac.uk/uk/research/research_quality_and_evaluation/research_excellence_framework_ref_.cfm.

Rust, C., J. Mottram and J. Till (2007), *AHRC Review of Practice Led Research in Art, Design & Architecture* (cited 29 April 2008), available at: http://www.ahrc.ac.uk/About/Policy/Documents/Practice-Led_Review_Nov07.pdf and http://www.ahrc.ac.uk/About/Policy/Documents/Practice-Led_Review_appendices_Nov07.pdf.

Rust, C., J. Roddis and P. Chamberlain (2000), 'A practice-centred approach to research in industrial design', *Proceedings of Design Plus Research Conference*, Polytechnic Di Milano, May 2000 (cited 20 April 2008), available at: http://www.chrisrust.pwp.blueyonder.co.uk/academic/publications.htm.

Rust, C., G. Whiteley and A. Wilson (1998), 'Using practice-led design research to develop an articulated mechanical analogy of the human hand', *Journal of Medical Engineering and Technology*, 22 (5), 226–32.

Sternberg, R. J. (ed.) (1999), *Handbook of Creativity*, Cambridge: Cambridge University Press.

Sullivan, G. (2005), *Art Practice as Research: Inquiry in the Visual Arts*, Thousand Oaks, CA: Sage.

Weisberg, R. W. (2006), *Creativity: Understanding Innovation in Problem Solving, Science, Invention and the Arts*, Hoboken, NJ: John Wiley.

The Academic Mode of Production

Sharon Bell

As an academic I have been in the habit of commencing my CV with a statement that emphasises the marriage of creative and academic interests – specifically film-making, research in the fields of anthropology and ethnographic film, and tertiary teaching and administration. If recited quickly this sounds credible, perhaps evoking an effortless combination of scholarly and creative interests with academic leadership. In reality this has often been a 'marriage of inconvenience' as I have struggled to accommodate creative interests in tandem with the development of a 'credible' research profile and increasingly demanding roles as a senior academic leader.[1] This chapter draws on this experience and interrogates expectations of creative arts practice – and practitioners – within the academy. It draws on the experience of producing creative works that have started with research (research-led practice) and works that have started with a creative project but have proved a rich field for theoretical exploration (practice-led research).

In setting forth ideals for creative production in the academy it is tempting to argue that such works of art, in comparison with those produced outside the academy, might be expected to be: more nuanced for the underpinning research; more sensitive for the prolonged and intense processes of reflection; more competently realised due to the practitioner's mastery of technique; more communicative due the artist's sophisticated understanding of their art form and the context in which a body of work has been produced; more 'authentic' due to the lack of a commercial imperative; or more confronting due to the intensely critical and analytical academic environment which at its best encourages risk-taking and innovation. In reality many colleagues in higher education would say that their creative output is: derivative due to their preoccupation with comparative practice; compromised due to the unbounded demands of teaching and conventional research (and now add community engagement and consultancy); technically underdeveloped due to

the lack of time and space to refine the realisation of creative concepts; highly theorised and therefore less accessible to an audience; and conservative due to the high levels of accountability and uniformity demanded by the contemporary university. Of course this posits an artificial dichotomy but perhaps this dichotomy serves to highlight the tensions inherent in the 'academic mode' of creative production.

Such an assertion assumes of course that we understand the nature of the academic mode of production and the environments that sustain this, and perhaps assumes 'difference' or 'distinctiveness' on the part of the creative arts. As noted by Vickers et al., in universities the humanities, social sciences and creative arts are usually grouped together; however:

> . . . each has its own specific set of histories, defining features and
> trajectories, and there is great diversity within each field. As the name
> implies, the Social Sciences can be closer in their methodologies to
> the Natural Sciences, sharing an interest in developing inductive
> and deductive methodologies to test hypotheses. The Humanities
> are generally defined by their humanist or cultural and interpretative
> orientations . . . Some disciplines in the Humanities and Social Sciences
> also have strong critical dimensions, that is they are oriented towards
> interrogation of basic assumptions, or use criteria of judgement to
> assess the bases on which truth claims are made and to analyse how
> systems of representation operate and intersect with the advancing
> of such claims. Other disciplines are more empirical and quantitative
> in their approaches to the objects of analysis . . . The Creative Arts,
> elsewhere designated as 'Fine Arts', can be distinguished from the
> Humanities and Social Sciences because of their major concern with
> creativity rather than interpretation; however, recent developments in
> cultural theory are increasingly blurring the lines separating creative
> from critical work . . . The Humanities and Social Sciences can be said
> to produce 'new' knowledge through interpretation, while work in the
> Creative Arts is produced through the modes identified above as well as
> through improvisation. (pp. 2–3)

While I am mindful that the discipline of music has occupied a 'comfortable' place in this arena since around the twelfth or thirteenth centuries, many of the creative arts – especially the screen and digital arts – are newcomers to the academy and are in the process of forging an identity and appropriate pedagogy and methodologies. In reality we know all too little about knowledge production within the academy and the place of creative arts production within this.

In this chapter I will focus my attention on understandings generated by my own academic disciplines: anthropology and ethnography. As discussed

elsewhere (Bell and Moss 2002) rather few anthropologists have in fact turned their attention to their own immediate professional context. The few professional anthropologists who have analysed the academy have chosen parts of its territory remote from their own professional experience – their focus has primarily been on the bounded communities of the research elites where the nature of the enterprise has meant that the subjects could be studied *in situ*. We can find studies of social relations and culture among particle physicists in Japan and the US (Traweek 1989), molecular biologists at work in their laboratories (Latour and Woolgar 1979; Knorr-Cettina 1999) and medical researchers in Australia (Charlesworth 1989). I wonder if this is because a scientific laboratory or a medical research institute looks rather like a neatly bounded peasant village or tribal territory?

Although now dated, these studies of knowledge production undertaken in the 1970s and 1980s lie at the core of what we know about the social organisation of research and scientific knowledge production (Knorr-Cetina 1999: 9). In the humanities and social sciences we have only the reports of participant observers in novel-writing mode – Kingsley Amis, A. S. Byatt, John Barth, David Lodge, Malcolm Bradbury and the countless 'campus novels' produced by our American colleagues. Here in Australia only occasionally – and again through the arts – do we capture glimpses of the academic mode of creative production.

Playwright David Williamson, not one to shy away from difficult subjects, provides his take on the contemporary (poststructuralist) university in his 1995 stage play *Dead White Males*:

> The genesis of *Dead White Males* occurred at a literary conference some years ago when a young male academic gave a paper on deconstruction and poststructuralism to a roomful of writers. No one in the room understood a word he said. When one writer rose at the end and asked for a plain English translation, we were told that we shouldn't bother ourselves with it. 'Just keep writing', was the response, 'and we'll tell you what you've done.' (Williamson 1995: vii)

While Williamson is unforgiving in his characterisation of the contemporary academy, it is more usual that these works of fiction, even when the intent is satirical, are written with great affection for the institutions and the larger-than-life characters that inhabit the academy. As Alice Garner notes in her recent (2006) work *The Student Chronicles*:

> I loved the [Baillieu] Library so much I wrote a really bad poem about it in second year. I found it in my diary. I can only bring myself to quote the last few lines, which imagined the consequences of the sun going out (?!), one being that reading in libraries would no longer be possible:

no more backs of hands
on pink cheeks, keeping
the face from dropping onto the text

<div align="right">(p. 44)</div>

Yet in the demanding space that the contemporary university inhabits these affectionate and romantic images (often close to our own imagined pasts) are a long way from the construction of reality generated by the academic experience as reflected in my own attempts to 'marry' academic and creative endeavour.[2]

Close to thirty years ago on my return from two years' anthropological field research in a rural village in Sri Lanka I produced four documentary films, one of which directly reflected my, I thought uncontroversial, fieldwork subject – the impact of the British rubber economy on the position of women in southwest Sri Lanka.[3] Both my proposed thesis focus on the life histories of individual women and my documentary films generated discomfort among the senior male colleagues of the anthropological clan (at that time all senior colleagues in the department were male). 'Did I not understand', my colleagues warned, 'the nature of scholarly research, or my role as a doctoral student to place one small building block of knowledge on the wall that is the established canon?' Obviously I did not. I also did not understand why I was advised not to submit the documentaries as a component of my doctoral thesis, or why, as proposed, this was likely to have a negative impact on the doctoral examination process.

Looking back I suspect that this explains why I am now a professor of creative arts rather than a professor of anthropology. My journey from anthropologist (academic) to film-maker (creative practitioner) was in fact a journey born of frustration with the reified world of anthropology – a world I perceived, in my youthful arrogance, to be turning in on itself. I was impatient with the fact that the outward-oriented anthropological fieldwork experience all too often translated into prose that was dense, pedantic and jargon ridden. I felt that most anthropologists were avoiding their responsibility to communicate. As Mary Louise Pratt observes in Clifford and Marcus's *Writing Culture*:

> For the lay person, such as myself, the main evidence of a problem
> is the simple fact that ethnographic writing tends to be surprisingly
> boring. How, one asks constantly, could such interesting people doing
> such interesting things produce such dull books? (p. 33)

To avoid the spectre of unwittingly, worse still unknowingly, becoming enmeshed in producing tomes of turgid anthropological prose, not just alien to the cultural 'other' (the subjects of my research and writing) but to most members of my own society (let alone the risk of becoming 'boring'), I turned

my attention to ethnographic film. After all, the *raison d'être* of film, I reasoned, was to communicate.

Ironically, or perhaps predictably given my lack of 'creative' education,[4] my early films bore the clear markings of an anthropological thesis[5] – an accurate, even if sanitised, reflection of the appropriate (that is acceptable) fiction of the fieldwork experience. I am occasionally evidenced in frame, speaking the language. The films document, or at least make reference to, an economic reality, a social hierarchy, even a political milieu, interspersed with or illustrated by various rituals and 'rites de passage'. They make no reference to my 'lived experience' in the field: the loneliness so intense that it generated nausea; the tropical illnesses of dengue and filariasis; the numbing and time-consuming daily rituals of survival in a house without electricity or running water; or the adoption of an asexual persona (immature, unmarried woman) in the interests of 'anthropological integrity'.

My film-making colleagues might well have asked (as the anthropologists had a few years previously) do you not understand the art of film-making? Do you not see that these films are flat, uninvolving, unemotional . . . uncreative? Do you not see that these films fail to 'evoke' the fieldwork experience even though they 'represent' it? I obviously did not (Bell 1998).

Perhaps too many documentary film-makers at that time were wedded to the veracity of observational film techniques which in reality capture only a thin layer of actuality. They failed to see (as I had) that if not carefully, scrupulously, imaginatively and dramatically reworked in the editing process such films can be a poor imitation of 'being there' – that research-led practice demands the creative transformation of the research methodology, not just the reproduction of it.[6] This understanding of the creative process was an important part of my subsequent development as a creative practitioner, learnt largely through the harsh lessons delivered by audiences who did not carry the same engagement or social or emotional connections with the subject, as I.

A decade later in Sri Lanka in 1988 my one time friend Vijaya Kumaratunga, who in the intervening years had become a screen idol and political leader, was viciously murdered outside his family home in Colombo. Vijaya was a charming, charismatic young man whom I had first met in the mid-1970s. At that time I was learning the colonial art of being an anthropologist in the field. The village in which I lived was about an hour and a half from the city, so on weekends, or when I was desperate, I could travel to Colombo and be with friends who shared my passion for cinema, and who (even if they were women) weren't averse to a cold beer. I look back and wonder why I felt guilty – why I regarded this as an escape from fieldwork, from the pursuit of 'informants', rather than an integral part of the learning experience that is (or rather was) fieldwork. It was in this context, among Vijaya's predominantly Marxist

friends (who turned out to be most valuable 'informants' and lifelong friends), that I was introduced to Sri Lankan politics.

Almost ten years after Vijaya's assassination the official government-commissioned report into his death was released. This, together with the change in national government that brought his widow Chandrika Bandaranaike Kumaratunga to power in 1994, were the triggers for my determination to make the documentary film *The Actor and the President* (SBS 2000). The original motivation behind the documentary was not just to document Vijaya's life and death, but to explore the complex web of an increasingly violent Sri Lankan society – a society grown accustomed to, and worse still grown ready to, accommodate political violence. The intention was also, through the use of personal narrative, to invoke empathy and, hopefully, generate greater interest in an ethnic conflict in which the world had shown very little interest. In the two decades since I had lived and worked in Sri Lanka as a postgraduate student of anthropology, a political environment had developed in which the violent settling of old scores was condoned, political jealousies and caste rivalries condemned individuals, and local level factional disputes were inflamed and reinvented as part of broader political movements. The concept of 'the disappeared' had become part of everyday parlance and my closest friend from those fieldwork years now headed an NGO that worked with women in frontline villages to negotiate access to essential services and also traced 'the disappeared'.[7]

It was a country where ethnic conflict over this period transformed local and national politics in complex ways and political assassination became commonplace. The 'war' in the north and east which pitted the Sinhala majority against Tamil nationalists (the Liberation Tigers of Tamil Eelam – LTTE) was a shocking conflict that by the mid-1990s, when I started researching the film, had claimed over 60,000 lives. It was also a war that provided the justification for political repression, extraordinary police and defence force powers, media censorship and during the late 1980s generated a reign of terror and counter-terror by Sinhala extremists in the south of the island that left a further 40,000 dead and thousands of others disappeared (Perera 1998: 44). But for the rest of the world it was a conflict that was not strategically important enough to warrant too much attention – on the strategic scale, tea is less important than oil!

Even in the years since the making of *The Actor and The President*, Sri Lankan politics have moved on, a peace process has come and gone, and I now find that the film is being 'read' to reflect the new politic – read in ways that I could not have envisaged. In the 2004 national election campaign Vijaya's death assumed new importance. The Sri Lanka Freedom Party (SLFP) was lead by Vijaya's widow, President Chandrika Bandaranaike Kumaratunga. In a bid to retain government the President forged a political alliance with those

cast in the film as deeply implicated in Vijaya's death, the one time revolution-
ary party, the JVP (Janatha Vimukthi Peramuna – People's Liberation Front).
While this dramatic shift in political alliances was not unusual in Sri Lanka,
it was a high-risk strategy as Vijaya was still believed by many Sri Lankans
(Sinhalese and Tamil) to have had the capacity to end the ethnic conflict. If
only he had lived. It was thus necessary for the President to shift responsibility
for the assassination away from the JVP and place it more squarely onto the
opposition party, the United National Party (UNP). In so doing a new narra-
tive was created that was not entirely consistent with the film narrative.

From concept to realisation the development of this documentary took
over ten years (1988–99) and it was this time that was critical. It was time
driven by political imperatives and possibilities. It was time it was possible to
'buy', albeit in snatches and excursions to and from Sri Lanka, as an academic
remaining engaged with the developing political situation through research
and networks. The research process over these years imitated that of the
humanities: literature searches, media analysis and limited 'participant obser-
vation', but the intended outcome was always to be a 'creative interpretation'.
This 'practice-led research' has since lead to the production of a paper on art
and violence[8] and a book chapter on the 'foreign researcher' that theorises the
changing nature of the relationship between researcher and 'subjects' over an
extended period (Bell 2009). At the time of the making of the film it would
have been difficult to imagine that the creative work would be the basis for
other conventional research outputs. In particular the opportunity to theo-
rise the role of the foreign researcher was an unexpected challenge, following
Carter (2004: 13), 'the always unfinished process of making and remaking
ourselves through our symbolic forms'.

More recently my documentary production interests have turned to
the creative process itself. Perhaps this is a reflection of my academic roles
(another aspect of the academic mode of production?): the opportunity for the
development of a 'discourse coeval with those [creative] processes rather than
parasitic on it' and hopefully offering more than 'a rather pretentious post hoc
rationalization' (Carter 2004: 9). Perhaps the focus on the creative process
also represents continuity in the exploration of how the multiple voices of
anthropological fieldwork might be used to construct an 'authentic' narrative.
The documentary film, *The Fall of the House* (ABC 2004), is set in a nine-year
period of Australia's cultural history. It deals with the arrival in Australia in
1947 of the internationally famous English conductor Eugene Goossens, his
involvement and interaction with Sydney society and its postwar moral values,
and his departure from Australia, in disgrace, in June 1956.

Eugene Goossens, often described as a musical genius, took the provincial
and unexceptional Sydney Symphony Orchestra and made it one of the great
orchestras of the world. He insisted that Sydney needed a great opera house;

he chose its ideal location and set in motion the mechanisms for its construction. He supervised the training of dozens of young Australian musicians and composers – yet he was unceremoniously given no option but to leave the country on the basis of a mysterious customs offence.

Implicated in Goossens' story is a female character, a self-confessed 'witch' who stalked the streets of Sydney's Kings Cross. Rosaleen Norton, Pan-worshipper and erotic painter, fatally crossed paths with Eugene Goossens as they both pursued the occult, spiritual music and (for the time) unconventional sexual practices. The downfall of the House of Goossens was a Judas betrayal by Sydney society, enacted by the august board of the Australian Broadcasting Commission, who turned their backs on their star conductor.

The documentary narrative is constructed around the works of three contemporary Australian artists – a playwright, a novelist and a composer (*Complicity* (1998) by Timothy Daly, *Pagan* (1990) by Inez Baranay, and an opera, *Eugène & Roie* (2005), by composer Drew Crawford). The utlilisation of the creative works enables an evocative recreation of the time and circumstances but also enables an exploration of the fine line between fiction and reality. This is a narrative that has generated numerous conspiracy theories, important in their own right as evidence of cultural norms and expectations, but also impossible to untangle from any concept of documentary 'truth'. In this case the creative works (lending another dimension to practice-led research?) enable the exploration of facets of the narrative that were impossible to explore through research based solely on documentary evidence.

Dennis Strand in his influential 1998 study *Research in the Creative Arts* argues that there are three approaches to the question of research in The Arts:

1. The conservative approach: research is research . . . we know it when we see it.
2. The pragmatic approach: an awkward halfway house . . . argues that research does require extended, dispassionate commentary . . . that could be self-reflective.
3. The liberal approach: asserts that creative arts practice is a vital non-teaching contribution to university and national life, and in the absence of any other suitable category needs to be rewarded in the research category. (1998: 40)

My original intention in this chapter was to present an account of the research processes associated with the development of creative works, processes which very obviously mirror and thus sit comfortably with the methodology of humanities research (Strand's first option). But as I began this process of documentation I decided that my advocacy for film and the creative arts generally should in fact be much more powerful than a case study evidencing imitation.

Artists, for a very long time and often with great insight and sensitivity, have engaged in the processes of reflection, of contemplation on self, on other, on audiences and interpretation and on how questions of representation might be most appropriately articulated (Strand's second option).

When I first began my academic career in the 1990s this might have seemed somewhat presumptuous. Since then the world has discovered 'the creative class', courtesy of Richard Florida (2002), and the pursuit of innovation has become a national preoccupation, so the argument that there is much to learn from the creative arts has greater currency. But to suggest that higher education is an environment where the incorporation of the creative arts into the academy has resulted in a happy, unproblematic marriage would be misleading.

We still debate the relative value of works produced 'by the heart rather than the head'; we agonise over the appropriate form of the exegesis, or indeed whether there should even be an exegesis; and at examination, candidates are often judged as if they should have reached the peak of their creative practice rather than as practitioners who are just starting a lifelong journey (as is the case in many other disciplines, particularly the sciences) (Duxbury et al. 2008: 10–11).

Of interest to me, as I observe higher education being shaped by the consequences of our largely uncritical adoption of the culture of audit, are those aspects of the creative process that are ill-defined, less tangible, often intuitive but oh so important dimensions of the creative process that don't lend themselves to analysis – and the concomitant fear that analysis might somehow simplify rather than elucidate complexity and detract from rather than enhance understanding of creative work. Yet that dimension of our practice that resists conclusion (Carter 2004: 9), that opens possibilities and new implications rather than answers [research] questions (Duxbury et al. 2008: 9), is ultimately at the core of our enterprise and, in the end, is what makes us and the products of our research different.

Sir David Watson notes that the challenge for the contemporary university is about 'charting uncertainty' (2003: 16). Yet we increasingly frame our knowledge production in the language of audit: inputs and outputs, quality assurance, cost-effectiveness, key performance indicators, benchmarks and standards, timelines and target audiences. We give priority to that which is measurable and inevitably the quantitative colonises the qualitative (which is acknowledged but to which value is so difficult to assign). Unconsciously we render ourselves auditable.

At this point we might productively return to the discipline of ethnography. As Marilyn Strathern points out in relation to the growing culture of accountability: in higher education accountability endorses a particular reading of what 'producing' knowledge is all about (2000: 287). This conceptual framework of

accountability tells us little about the experience – the old-fashioned ethno-graphic questions of what is it like to be there, doing this or that. And of course it is these old fashioned questions that are critical to our students. What is it like to be here? What is it they value? What will endure in their learning that will ensure that they are contributive professionals to the higher aims of society?

There is also one further reason why ethnography is especially valuable in describing what is actually happening in contemporary universities. It lies in the capacity of what Strathern (2000: 284) has called the 'self-driven, multi-stranded and open-ended' character of ethnographic inquiry. If, as Michael Power suggests (1997: 145), 'auditing has the character of a certain kind of organizational script whose dramaturgical essence is the production of comfort', one of my aims has been, and remains, to use ethnography to produce discomfort – to unsettle the descriptive monopoly which audit-speak currently enjoys and to identify the important features of teaching and schol-arship which its clumsy categories ignore. Forms of intelligence gathering, which are not institutionalised, especially those designed to collect 'dirtier data' (Marx 1984: 79) and generate a discourse that is 'generically disrespectful and promiscuous' (Carter 2004: 9), may contribute to discomfort in the sector. Yet more open 'research' paradigms and methodologies are needed to gener-ate understanding of our academic modes of production and a more nuanced understanding of the place of creative production within the academy.

NOTES

1. My doctoral research was in the field of anthropology and ethnographic film. In the post-doctoral period I worked outside the academy as a documentary film-maker and returned, in the early 1990s, to take on senior leadership roles as a dean, pro vice-chancellor and then deputy vice-chancellor. My creative work has been produced in tandem with my partner, cinematogra-pher and director Geoff Burton.

2. The following section of this chapter on my Sri Lankan experience and the production of the documentary draws on the critical reflection made possible by the presentation of a paper to the Australian Academy of the Humanities in 1997 (Bell 2000) at the height of debate on research in the creative arts generated by the report by Denis Strand, *Research in the Creative Arts* (1998).

3. My PhD thesis (1986) was entitled *Women and Wage Labour: The Impact of Capitalism in Southwest Sri Lanka*, and I co-directed and produced a series of four documentary films: *The Sri Lanka Series*, one of which, *Four Women*, focused on the same women as the life histories reproduced in the thesis.

4. As an undergraduate I studied anthropology, geography and government.
5. *The Sri Lanka Series*: *Four Women* (1979), *Dancers Were Only Allowed to Dance* (1979), *Fishermen of Duwa* (1979) and *The Exorcist* (1981).
6. This is in fact an overly harsh judgement of the value of the films. At screenings in recent years in Sri Lanka it is obvious that the films capture and record important aspects of (prewar) Sinhalese society that it is now, in a country wracked by civil war in the ensuing decades, impossible to imagine.
7. INFORM negotiates local political solutions with women on the front line that enable Sinhalese and Tamil children to attend school and generally go about the business of daily life by minimising the danger that they will be caught in the ethnic conflict. In recognition of this work Sunila Abeyesekera was awarded he UN Peace Prize in 1998.
8. S. Bell (2000), 'Running in the family: an exploration of violence and art in Sri Lanka', *Sinhala Pravada*. This paper has been independently translated into Sinhala and Tamil, which, given its subject matter is a significant endorsement of its import from two communities at war.

REFERENCES

Bell, S. (1998), 'Reinventing Chatwin's "The Songlines" for the screen: scholarly or creative process?', in *Our Cultural Heritage*, Occasional Paper 20, Papers from 1997 Symposium of the Australian Academy of the Humanities, Canberra: Australian Academy of the Humanities.

Bell, S. (2000),'Running in the family: an exploration of violence and art in Sri Lanka', *Sinhala Pravada*, No. 15, January–March, pp. 80–91.

Bell, S. (2003), 'Writing (research) culture in re-searching research agendas: women, research and publication in higher education', in B. Groombridge and V. Mackie (eds), *Proceedings of the Australian Technology Network – Women's Executive Development (ATN-WEXDEV) 2003 Research Conference*, Perth: Learning Support Network, pp. 13–22.

Bell, S. (2009), 'The distance of a shout', in C. Brun and T. Jazeel (eds), *Spatializing Politics: Culture and Geography in Postcolonial Sri Lanka*, London: Sage, pp. 72–99.

Bell, S. and D. Moss (2002), 'The Language Clans', unpublished paper presented at the meeting of the Deans of Arts, Social Sciences & Humanities, James Cook University, Townsville.

Carter, P. (2004), *Material Thinking: The Theory and Practice of Creative Thinking*, Melbourne: Melbourne University Press.

Charlesworth, M. (1989), *Life Among the Scientists: An Anthropological Study of an Australian Scientific Community*, Melbourne: Oxford University Press.

Clifford, J. and G. Marcus (1986), *Writing Culture: The Poetics and Politics of Ethnography*, Berkeley, CA: University of California Press.

Duxbury, L. et al. (2008), *Thinking Through Practice: Art as Research in the Academy*, Melbourne: School of Art, RMIT.

Florida, R. (2002), *The Rise of the Creative Class: And How It's Transforming Work, Leisure, Community and Everyday Life*, New York: Basic Books.

Garner, A. (2006), *The Student Chronicles*, Melbourne: Melbourne University.

Knorr-Cettina, K. (1999), *Epistemic Cultures. How the Sciences Make Knowledge*, Cambridge, MA: Harvard University Press.

Latour, B. and S. Woolgar (1979), *Laboratory Life: The Social Construction of Scientific Facts*, Beverly Hills, CA: Sage.

Marx, G. (1984), 'Notes on the discovery, collection and assessment of hidden and dirty data', in J. W. Schneider and J. I. Kitsuse (eds), *Studies in the Sociology of Social Problems*, Norwood, NJ: Ablex.

Perera, S. (1998), *Political Violence in Sri Lanka: Dynamics, Consequences and Issues of Democratization*, Colombo: Centre for Women's Research.

Power, M. (1997), *The Audit Society: Rituals of Verification*, Oxford: Oxford University Press.

Special Presidential Commission of Inquiry (1997), *Report of the Special Presidential Commission of Inquiry into the Assassination of Mr Vijaya Kumaratunga*, Colombo: Sri Lankan Government.

Strand, D. (1998), *Research in the Creative Arts*, Canberra: DETYA.

Strathern, M. (2000), 'Accountability . . . and ethnography', in M. Strathern (ed.), *Audit Cultures. Anthropological Studies in Accountability, Ethics and the Academy*, London: Routledge.

Traweek, S. (1989), *Beamtimes and Lifetimes: The World of High Energy Physicists*, Cambridge, MA: Harvard University Press.

Vickers, A. et al. (n.d.), 'Research in the Humanities, Social Sciences and Creative Arts', unpublished R&D Discussion Paper No. 5, University of Wollongong.

Watson, D. (2003), *Universities and Civic Engagement: A Critique and a Prospectus*, keynote address for the 2nd biennial 'Inside-out' conference on the civic role of universities – 'Charting Uncertainty: Capital, Community and Citizenship', Ipswich, QLD, July.

Williamson, D. (1995), *Dead White Males*, Sydney: Currency Press.

Appendix: Questionnaire to Creative Arts Practitioners

This is a questionnaire compiled by Hazel Smith and Roger Dean, Writing and Society Research Group and MARCS Auditory Laboratories, University of Western Sydney, Australia (hazel.smith@uws.edu.au; roger.dean@uws.edu.au) in relation to a book they are editing for Edinburgh University Press, UK, *Practice-led Research, Research-led Practice in the Creative Arts*. The book focuses on the role of these activities in higher education (HE) institutions such as universities, and the role that HE plays and can play in promoting creative work.

You are invited to respond and to return it to one of the editors at the e-mail address above; when you do, please indicate whether you would like your statements to be:

(a) anonymous – in this case we will not list your name as being among the respondents; or

(b) attributed (except if used in a statistical summary of course) – in this case we will list you as being among the respondents and may quote some of your remarks that are particularly relevant or illuminating, with your name attached to any quotation.

1. Do you see 'research' and 'creative work' as:
 (a) Two separate things?
 (b) Two overlapping things?
 (c) One thing?
 (d) Could you summarise your reasons for this view?

2. Could you offer your working definition for 'creative work' and for 'research' (unless you see them as 'one indistinguishable entity' in which case please give one definition covering both).

3. (a) Do you work within a university?
 (b) If so, how many hours per week on average do you work for a university? (We realise these may not all involve your physical presence there.)
 (c) For how long have you worked within the university environment?
 (d) Is this a preferred working environment for you?
 (e) Why?

4. (a) Do you produce creative work that is made publicly available?
 (b) How many hours per week on average do you do creative work?
 (c) For how long have you done it?
 (d) Would you like to be able to change your working time distribution or mode?
 (e) If so, how?

5. Do you find your view of the relationships between research and creative work is consistent with those of your peers/colleagues:
 (a) in the academic higher education (HE) environment?
 (b) in that part of your creative community outside HE?

PLEASE TAKE THE FOLLOWING QUESTIONS IN THE LIGHT OF YOUR RESPONSES ABOVE (as we will):

6. (a) Do you combine research and creative work?
 (b) Do you regard your creative work as a form of research?
 (c) In what sense, if any, does your creative practice involve a research component?
 (d) What, if any, research methodologies do you engage with as part of your creative work?
 (e) Do you engage in some research which is independent of your creative work?
 (f) How would you describe the relationship between creative practice and research in your work? What terms would you use to describe the relationship?
 (g) Do you usually start with research and then move into creative work? Or the reverse? Or do you (try to) divorce the two things?
 (h) Would you describe your work as practice-led research or research-led practice? Why?
 (i) How do your creative practice and research inform each other?
 (j) Do they extend each other?

(k) How do you organise your time and routine with regard to research and creative practice?

(l) Do you document/theorise your own creative work?

(m) Do you work with hybrid forms which combine creative and critical work?

7. (a) Do you find the university environment supportive/stimulating with regard to your creative practice?

(b) What are the reasons for your view?

(c) Do you think the status of creative practice could be improved within the university environment? If so, how?

8. Do you think it is useful for a creative practitioner to be conversant with contemporary cultural and critical theory?

9. Do you think all academic researchers need to have familiarity and facility with the arts? (Please summarise your reasons and thoughts in each relevant case.)

(a) All of the arts?

(b) Contemporary arts only?

(c) Classical arts?

(d) Arts of many cultures?

10. Are there any other issues you would like to raise about the relationship between research and creative practice?

Many thanks

Hazel Smith and Roger Dean

Notes on Contributors

Keith Armstrong has practised for seventeen years in collaborative, hybrid, media-arts, focusing upon innovative performance forms, site-specificity, networked interactivity and alternative interface design. His research examines how scientific and philosophical ecologies can influence and direct such work. He is a part-time Senior Research Fellow at Queensland University of Technology and an internationally recognised freelance artist.

Professor Sharon Bell is Senior Program Developer at the L. H. Martin Institute, University of Melbourne, Australia. Throughout her career she has melded creative and academic interests: specifically film-making, ethnographic research and tertiary teaching and administration. She has held a number of synergistic academic leadership positions in the Humanities and Creative Arts.

Simon Biggs was born in Adelaide in 1957 and has been resident in the UK since 1986. Having studied electro-computer music at Adelaide University from 1979 to 1981 his interactive artworks have been widely shown internationally. He is also a theoretical writer and active curator and is currently Professor at Edinburgh College of Art.

Anne Brewster teaches at the University of New South Wales. Her books include *Literary Formations: Postcoloniality, Nationalism, Globalism* (1996) and *Aboriginal Women's Autobiography* (1995). She has published extensively in the areas of fictocriticism and indigenous writing and is working on a book about indigenous literature in Australia.

Andrew R. Brown is the Research Manager for the Australasian Cooperative Research Centre for Interaction Design (ACID) and Associate Professor in

Music at the Queensland University of Technology. He is an active computational artist working in music and visual domains. His research interests include technology support for creativity and learning, computational aesthetics and the philosophy of technology.

Roger T. Dean is a composer/improviser and a Research Professor in Music Cognition and Computation at the MARCS Auditory Laboratories, University of Western Sydney. He founded the ensemble austraLYSIS. His creative work is on thirty commercial audio CDs and he has released many digital intermedia pieces. His 400 research publications include seven humanities books. Previously he was CEO of the Heart Research Institute, Sydney and Vice-Chancellor of the University of Canberra.

Jane Goodall is the author of three psychological thrillers and several books on the performing arts including *Stage Presence* (Routledge, 2008). She is currently an Adjunct Professor with the Writing and Society Research Group, University of Western Sydney.

Brad Haseman is a professor, having worked as a teacher and researcher for over thirty years pursuing his fascination with the aesthetics and forms of contemporary performance and pedagogy. Brad is also chief researcher on a major practice-led research project in Papua New Guinea to develop applied performance programmes for HIV and AIDS education. In 2008 he was appointed to the Australia Council for the Arts where he chairs the Community Partnerships Committee.

Baz Kershaw is a director/writer in experimental, community-based and ecological performance. He led the major research project PARIP (Practice as Research in Performance, 2000–6). His books include *Engineers of the Imagination*, *The Radical in Performance* and *Theatre Ecology* (Cambridge University Press 2007). He is currently Professor of Performance, University of Warwick, UK.

Daniel Mafe is an exhibiting artist and is represented in public collections in Australia and abroad. His research interests include practice-led research and contemporary abstract painting. He is completing a practice-led PhD on the nature of 'artist's voice' and its value to research. Daniel is a Senior Lecturer in Visual Arts for the Creative Industries Faculty at Queensland University of Technology.

Shirley McKechnie is a pioneer of contemporary dance education and research in Australia. She established the first degree course in dance studies

at Rusden College (now Deakin University) in 1975. The most recent of her several honours is Honorary Doctorate of Visual and Performing Arts, University of Melbourne (2007).

Judith Mottram is Professor of Visual Art at Nottingham Trent University. She is an AHRC Postgraduate panellist for Visual Arts and Media and AHRC Peer Review College member, and sits on the Editorial Boards for the *Journal of Visual Art Practice* and the journal *Colour: Design & Creativity*.

Hazel Smith is a Research Professor in the Writing and Society Research Group at the University of Western Sydney and a founding member of the intermedia arts group, austraLYSIS. Her latest books are *The Writing Experiment: Strategies for Innovative Creative Writing* (Allen & Unwin, 2005) and *The Erotics of Geography* (book with CD-Rom, TinFish Press, 2008).

Andrew Sorensen is a computer scientist and active performer and composer of digital audio/visual works. His main research interest is the development and utilisation of programming environments for designers, artists, scientists and other creative users. Andrew is a Research Fellow at the Queensland University of Technology.

Catherine (Kate) Stevens applies experimental psychology methods to the study of auditory and temporal phenomena including music, dance and environmental sounds. She holds BA (Hons) and PhD degrees from the University of Sydney. Kate is an Associate Professor in the School of Psychology and MARCS Auditory Laboratories, University of Western Sydney.

Graeme Sullivan is Professor of Art Education, Teachers College, Columbia University. He researches the cognitive practices of artists and the creative and critical approaches used in studio-based inquiry. He is the author of two books on the visual arts and numerous articles published in the USA, UK, Europe, Australia and Asia.

Kathleen Vaughan is a visual artist, educator and academic based at Concordia University, Montreal, whose work explores thematics of identity and belonging, memory, storytelling and the cultural artefact, and the spirit of place. In her work on art as research she is also elaborating collage as an interdisciplinary research method and exploring links between artistic and teaching practices.

Index

Page numbers in italics denote tables or figures. Surnames plus initial denote academic authors, while surnames plus full given name denote artists/writers.